Bikes, Dykes, Dope, Dogs, Drum, Bass, Techno, Trance & Jungle now in a new location over on *Haight & Runaway* after a mysterious fire. A new apartment block being built on the old lot at a standstill due to a decline in interest. /////////////////
Books Not Burgers also gone after a mysterious fire. Work now halted on the new apartment block being built at the site due to a downturn in the economy. /////////////////////////////////////
Books, Bags, Babies, Brooms, Babaganoush, Barbecue, and Brews also closed following the latest babaganoush crisis in the Middle East. ///////////
Dance Not Drugs evicted. Now located in a mobile home on *3rd Street* between *Ecstasy & Gigabyte.* ///
The top story today: The Really Greedy Corporation taken over by the **Really Really Greedy Corporation. Pencils.com** swallowed up by pencilsharpeners. com. **Paper.com** swallowed by paperclips.com. /////
General Predator announces a merger with **Universal Soft Drink,** all now part of the giant **Office Pig** conglomerate. /////////////////////////////////////
On the sidewalk the Chinese waiters were eating burritos. The Mexican waiter was eating a piroshki. The Lebanese cook was eating Vietnamese spring rolls, the Indian pizza chef was eating sushi, the Thais were eating pizza, the Japanese chef ordered a cheeseburger, and the waitress from **We Used to Be Crepes Till the Rent Went Up** went for fish & chips at the Korean restaurant next door to the **We Bury Your Stiffs But We Also Tow Your Cars Funeral Home.** A car was being towed from the parking lot. /////////////////////////////

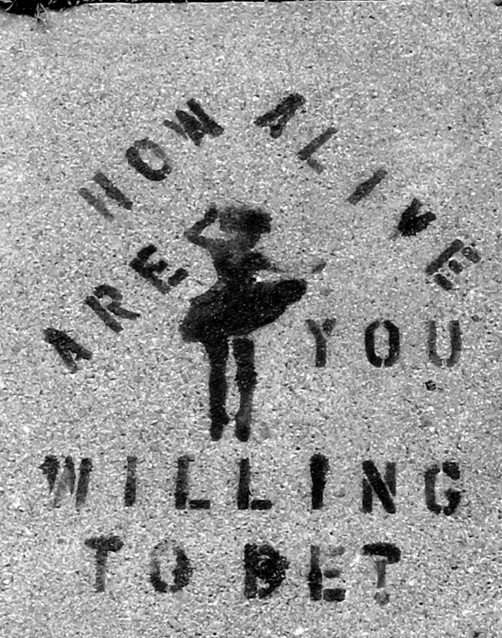

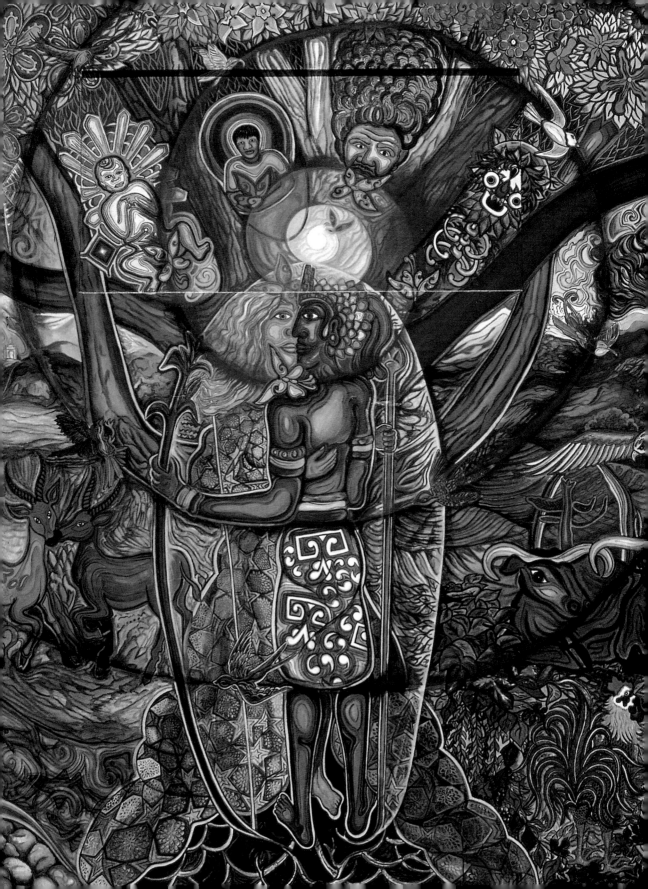

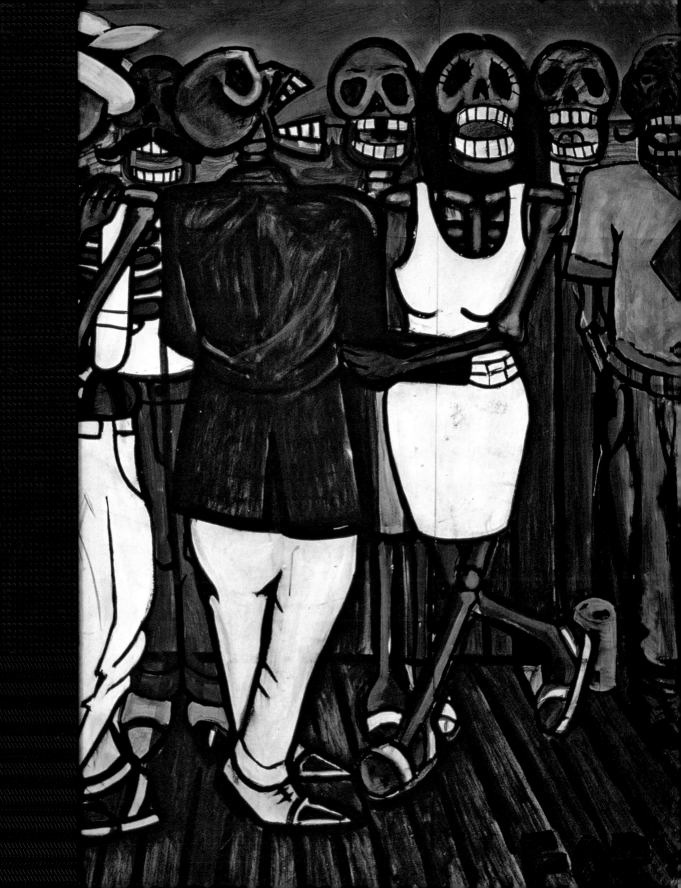

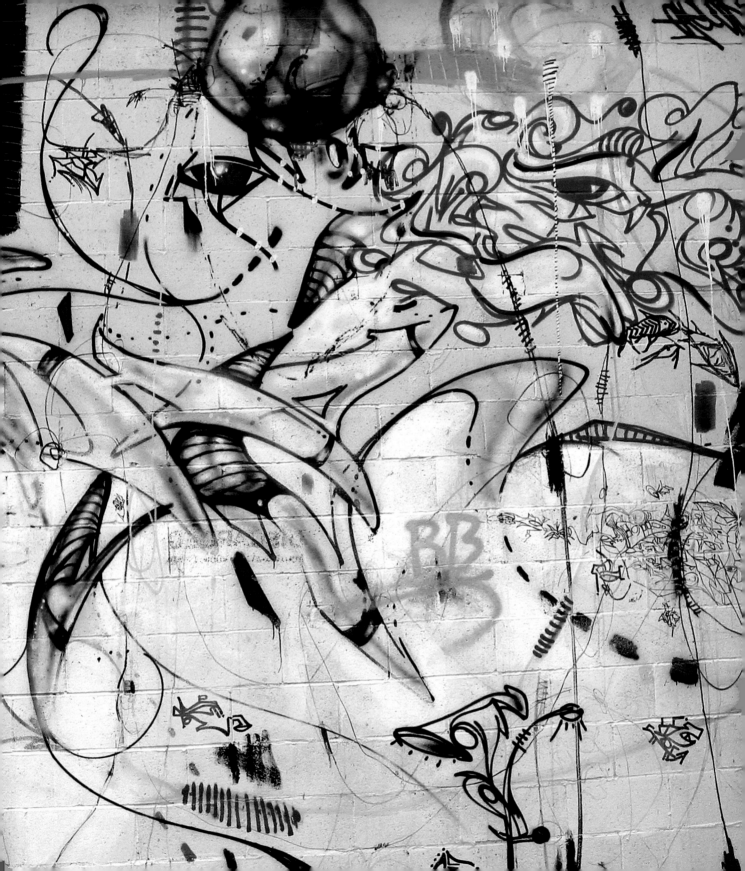

STREET ART
SAN
FRANCISCO

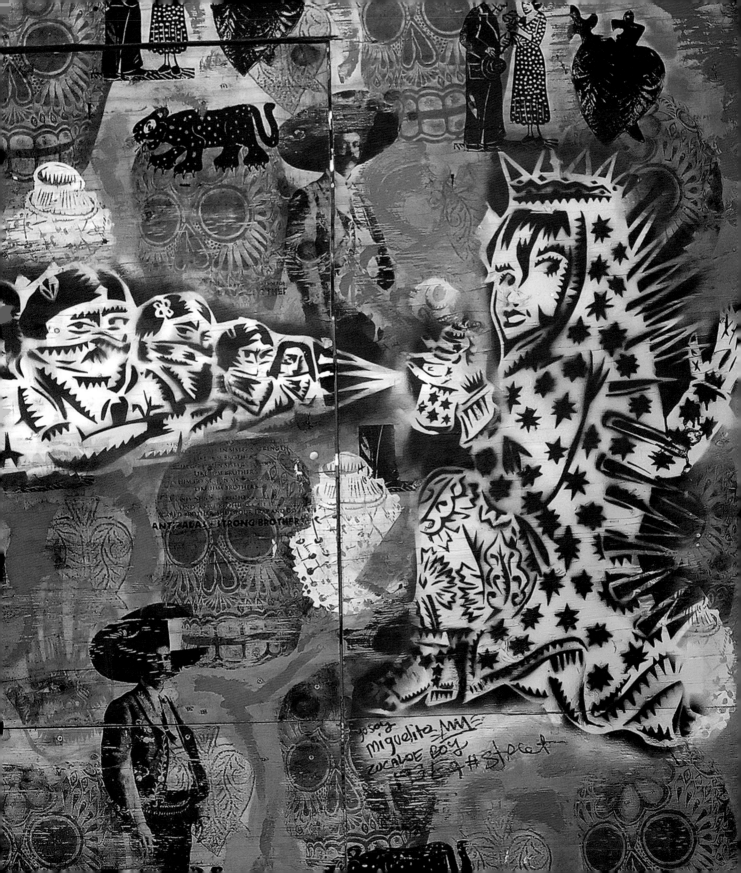

STREET ART SAN FRANCISCO
MISSION MURALISMO

Edited by **Annice Jacoby**
for **Precita Eyes Muralists**
Foreword by **Carlos Santana**

Abrams, New York

Editor *Elisa Urbanelli* //
Designer *Martin Venezky's Appetite Engineers* //////////////////////////
Production Manager *Jules Thomson* //////////////////////////////////////

Library of Congress Cataloging-in-Publication Data

Street art San Francisco : Mission muralismo / edited by Annice Jacoby ;
foreword by Carlos Santana.
 p. cm.
ISBN 978-0-8109-9635-9 (harry n. abrams, inc.)
1. Street art—California—San Francisco. 2. Mural painting and
decoration, American—California—San Francisco. 3. Mission District (San Francisco,
Calif.) I. Jacoby, Annice.

ND2635.C22S367 2009
751.7'30979461—dc22

2008053686

EDITORIAL NOTE: The documentation of street art can be elusive. Every effort was made to correctly identify the artists whose works are reproduced in this book. The captions reflect this research, giving names, titles, and dates of the works where known. Much of the artwork is not officially titled. In many cases where the date of the work cannot be verified, the date of the photograph, if known, is indicated in parentheses.

Abrams books are available at special discounts when purchased in quantity for premiums and promotions as well as fundraising or educational use. Special editions can also be created to specification. For details, contact specialmarkets@hnabooks.com, or the address below.

HNA ▮▮▮▮▮
harry n. abrams, inc.
a subsidiary of La Martinière Groupe
115 West 18th Street
New York, NY 10011
www.hnabooks.com

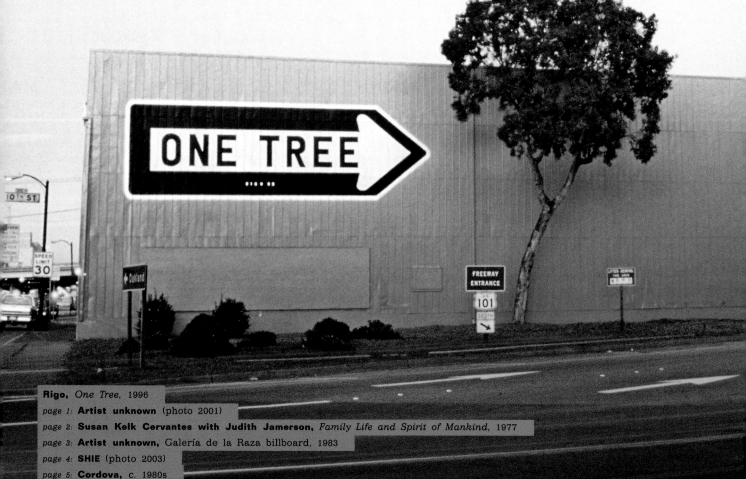

Rigo, *One Tree*, 1996
page 1: **Artist unknown** (photo 2001)
page 2: **Susan Kelk Cervantes with Judith Jamerson,** *Family Life and Spirit of Mankind,* 1977
page 3: **Artist unknown,** Galería de la Raza billboard, 1983
page 4: **SHIE** (photo 2003)
page 5: **Cordova,** c. 1980s
page 6: **Michael Roman** (photo 2006)

endpapers: **Peter Whitehead,** *How Do You Like the Neighborhood?*

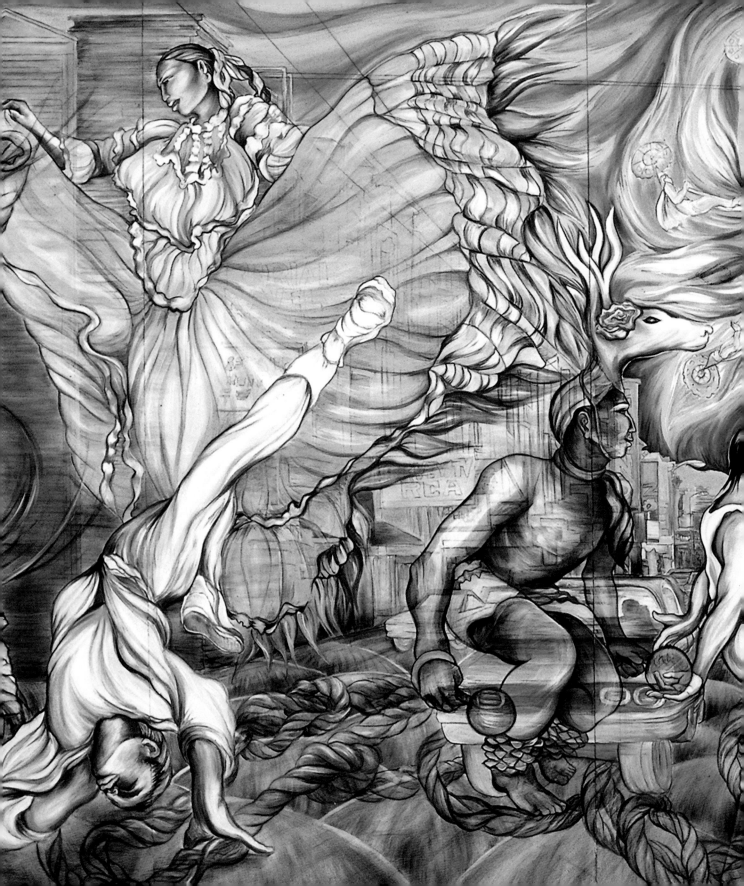

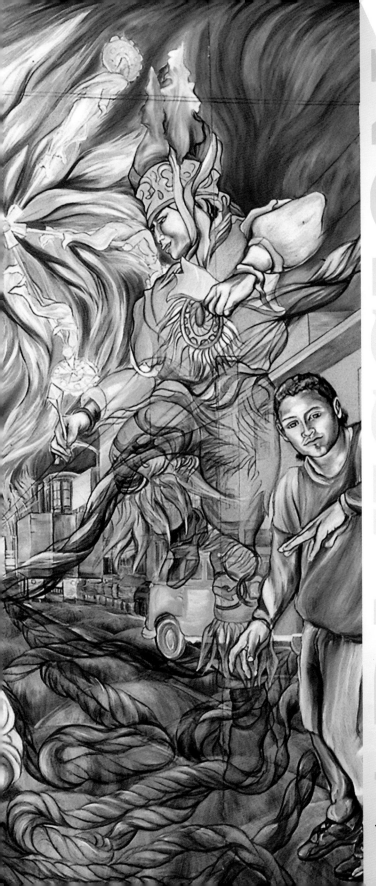

SKY

they scratched
SKY on my belly
crying for the blue
tropical sky
back home
I'm a colorful
sheet covering
a bed of cement

— *Francisco Alarcón and
Juan Pablo Gutierrez*

Juana Alicia, *Mission Street Manifesto,* 1990

11

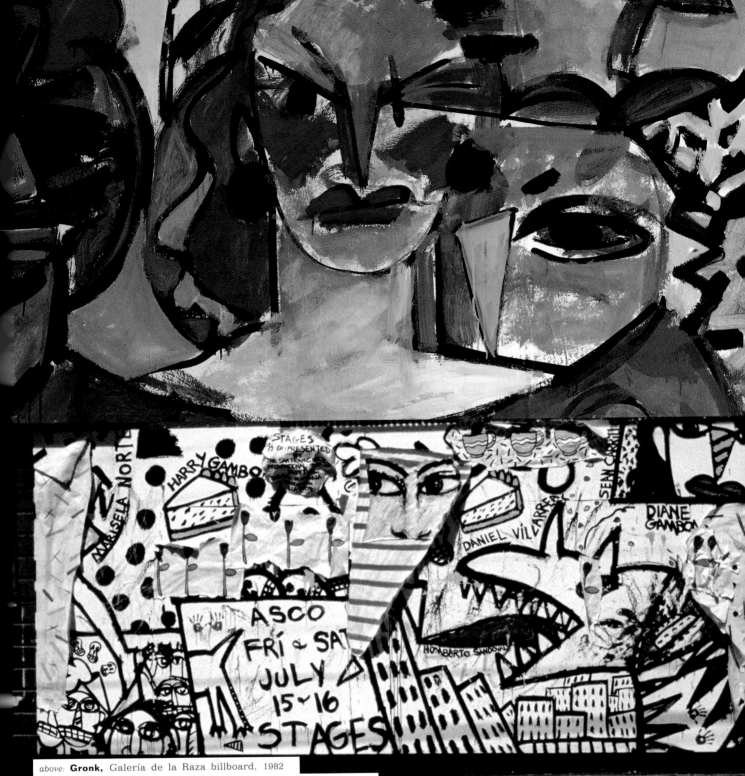

above: **Gronk,** Galería de la Raza billboard, 1982
below: **Gronk,** *Stages: ASCO (Galería de la Raza billboard),* 1983
opposite above: **Jane Norling,** *Darles armas y también enseñarles a leer/Give Them Weapons and Teach Them How to Read Too,* 1984
opposite below: **Artist unknown** (photo 2003)

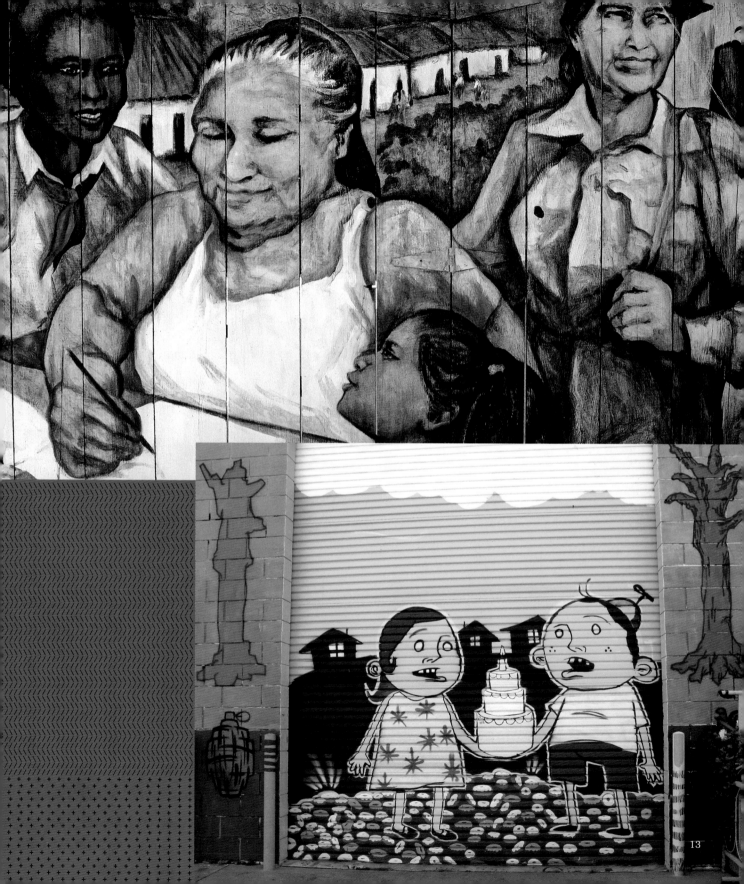

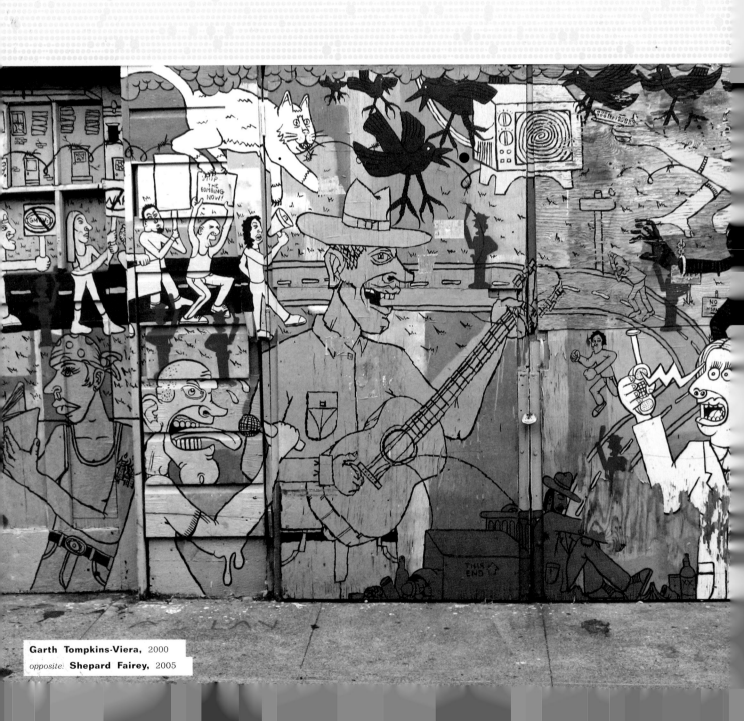

Garth Tompkins-Viera, 2000
opposite: **Shepard Fairey,** 2005

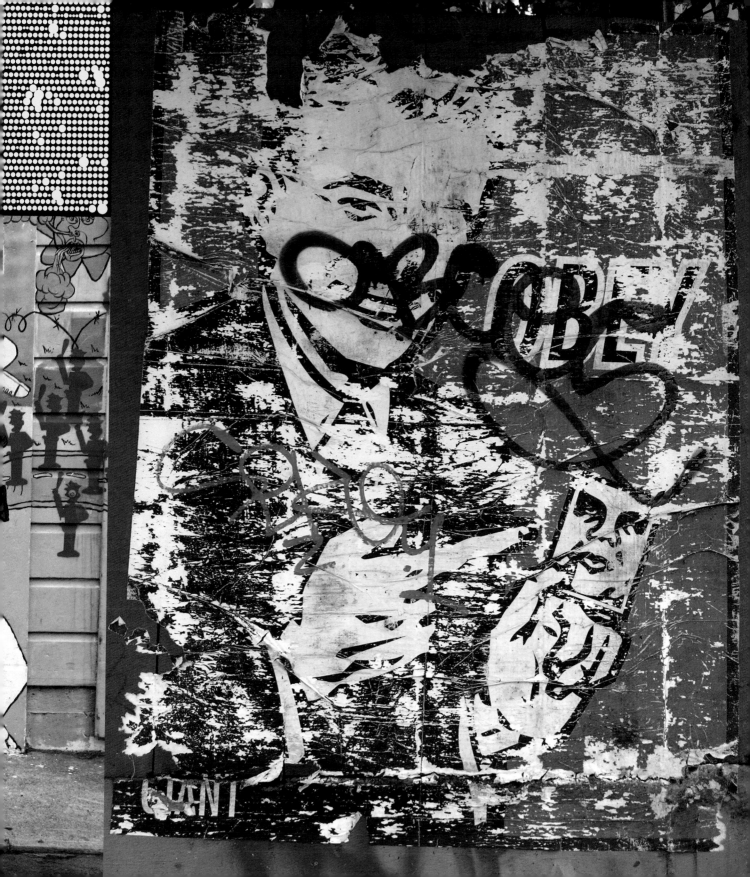

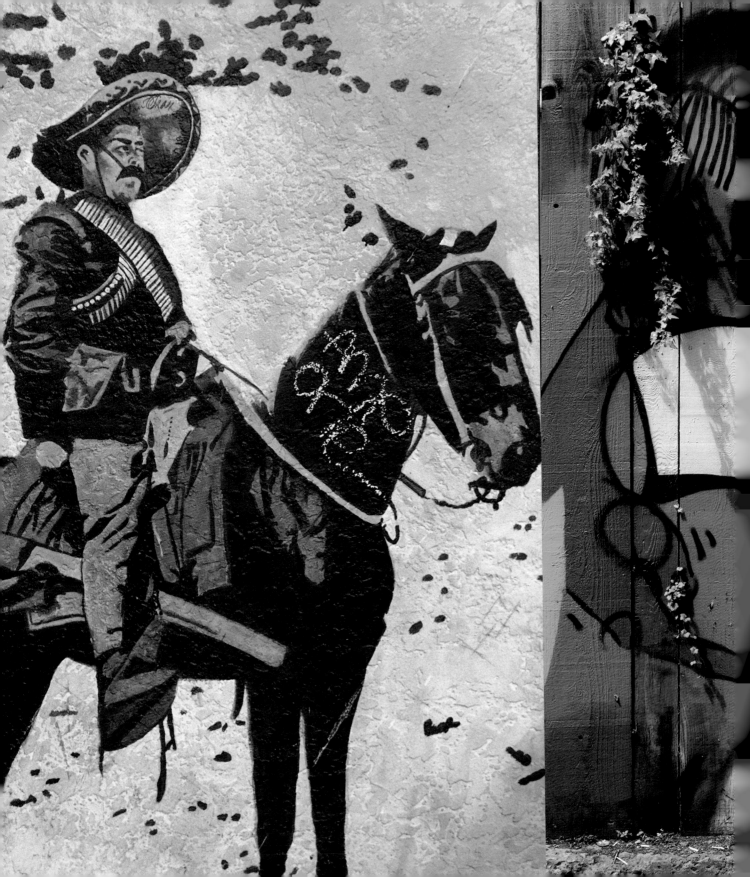

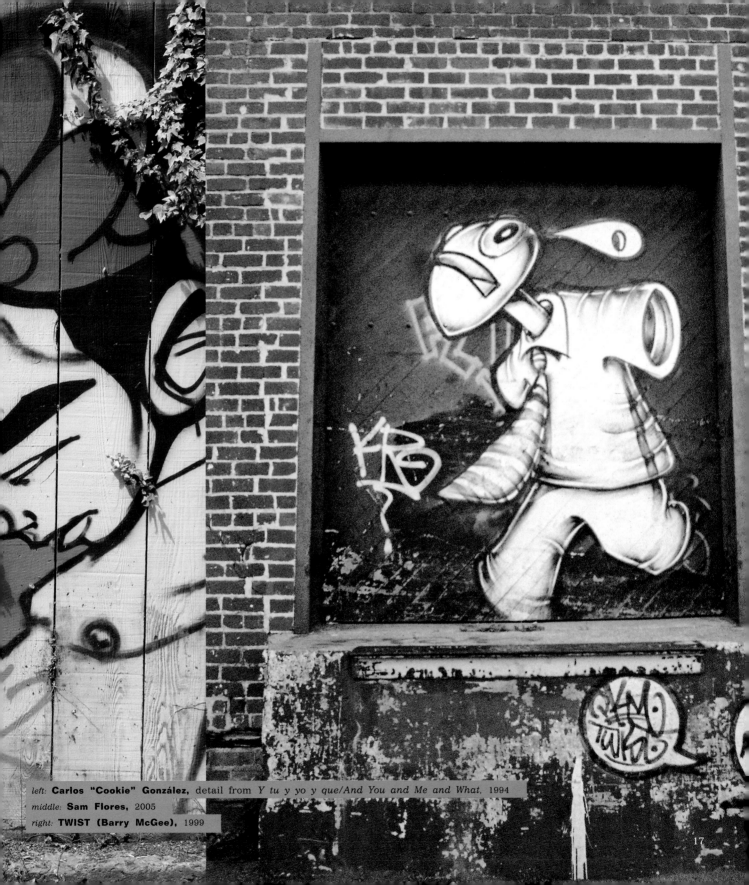

left: **Carlos "Cookie" González,** detail from *Y tu y yo y que/And You and Me and What,* 1994
middle: **Sam Flores,** 2005
right: **TWIST (Barry McGee),** 1999

17

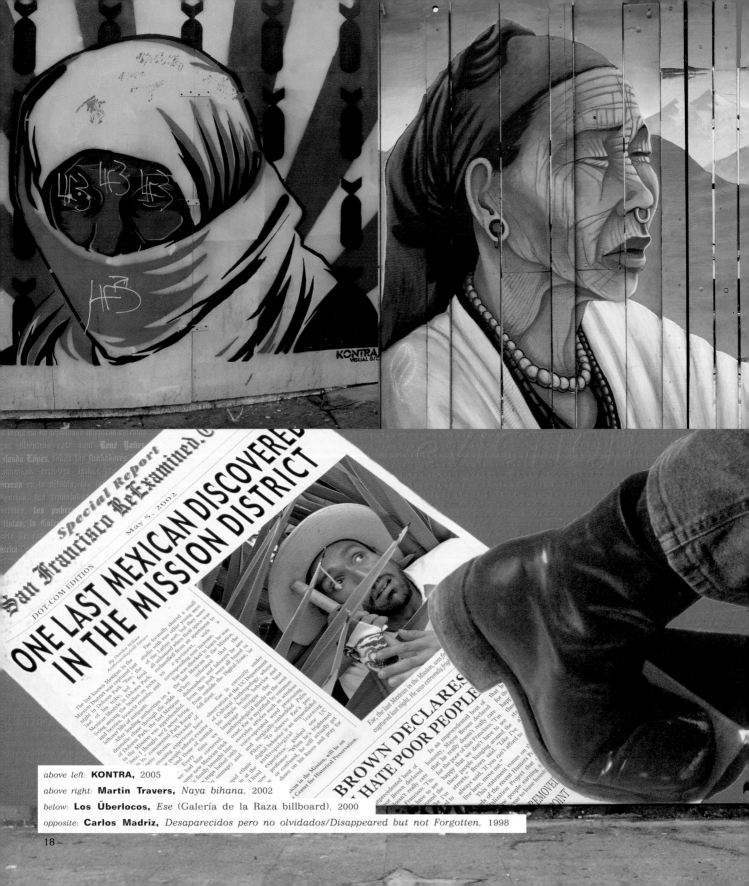

above left: **KONTRA,** 2005
above right: **Martin Travers,** *Naya bihana,* 2002
below: **Los Überlocos,** *Ese* (Galería de la Raza billboard), 2000
opposite: **Carlos Madriz,** *Desaparecidos pero no olvidados/Disappeared but not Forgotten,* 1998

Artist unknown
opposite above: **San Francisco Print Collective,** (de)Appropriation Wall
opposite below left: **SWOON,** 2007
opposite below right: **Los Cincas (Wendy Miller, Barbara Curtis Thatcher, Maria Ercegovic, Janet Storm, Michelle Tavernite),** *New Un-Improved Wash-n-War,* 1984

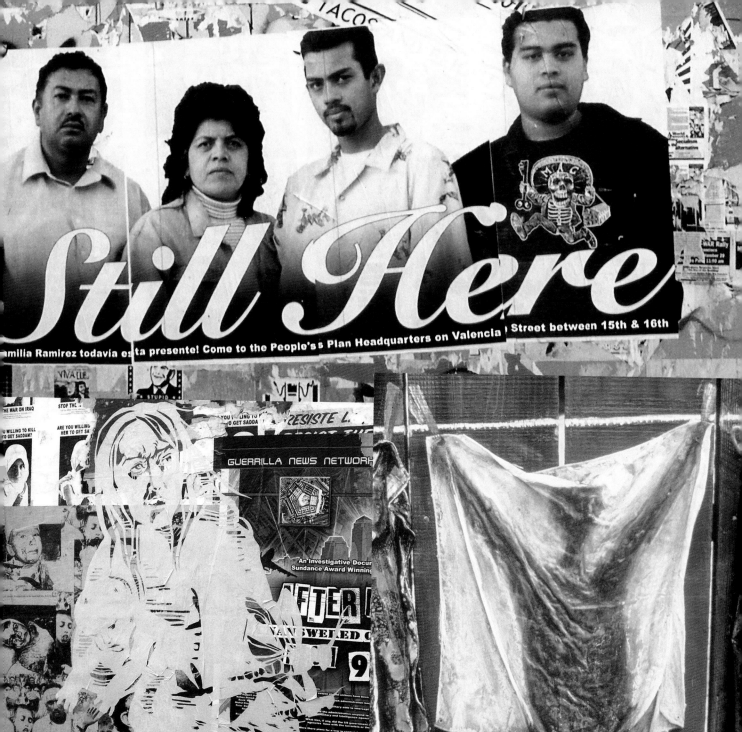

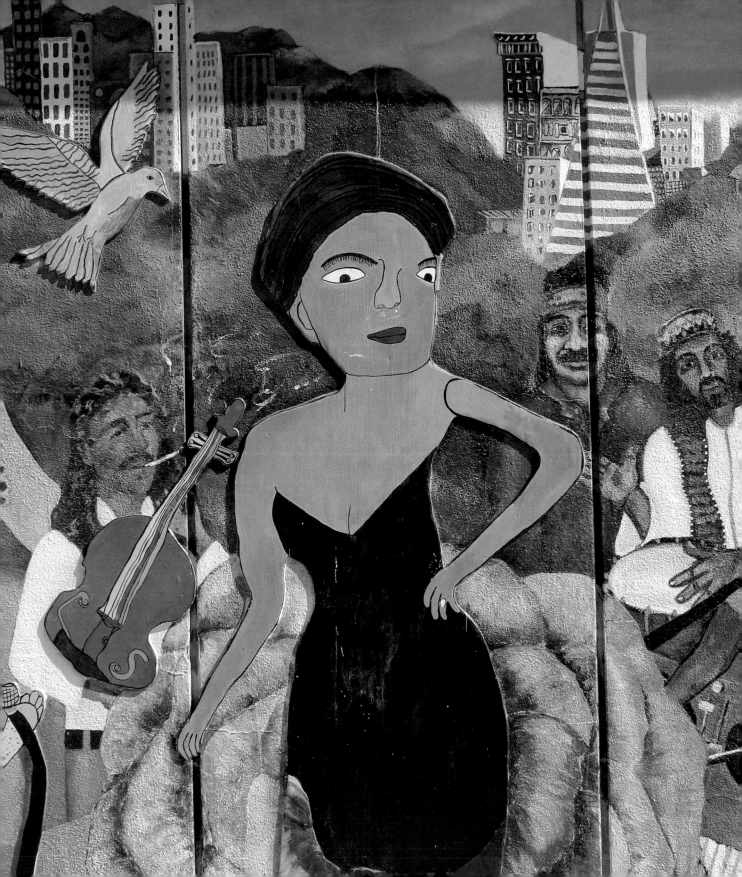

Foreword ///
///

Carlos Santana ///
///

Each city has its own fingerprint of style and story. However, here in the Mission, in San Francisco, I see a level of CULTURA that inspires the world.

My first gig in the Mission District was at Salon Mexico, between 22nd and 23rd. It was a *bautiza*, like a baptism or a Latin Bar Mitzvah. Salon Mexico was on top of a movie theater. We played quite a repertoire of surfing songs, Latin standards, and rock. I was trying to play music that was different from salsa and mariachis. Latinos can be very stubborn about their traditions, and I couldn't stomach it. I thought, I am going to play music that children of immigrants will love, music people can enjoy. I am a native son of the Mission, where I started to make music that borrowed from my roots and ran with rock and roll. The people making pictures around me at the same time, like Michael Rios, Susan Cervantes, and Chuy Campusano, were painting Aztec gods in a barrio playground, giving the children a new alphabet. Artistically, the Mission speaks for itself. ///////////////////////
///
///

As the revolution generated a revival of muralism in Mexico, the upheaval in the sixties in the United States inspired a new muralism in this country. This movement was not backed by church or government but by people in the community seeking alternative information as a tool to develop awareness and rally people to action—the grassroots against the status quo.
///
///

Before the Chicano movement, Mexicans in the United States were victims of derogatory stereotypes. Chicano art was branded as "folk" art. The explosion of Chicano culture, which carried the tide of the rock and roll I played in the Mission, changed the American cultural landscape and had a particularly strong impact on the mural movement in San Francisco. ///////
///
///

In no other city has the movement remained so focused on the participation of everyone, attempting to include any residents who can pick up a paintbrush and open their eyes. The murals are the heart, eyes, hands, voices, and spirit of immigrants, workers, children, teachers, and activists, as well as artists. San Francisco's Mission District is the only neighborhood that can truly call its mural activity a "movement," producing new styles of painting while remaining true to its individual and collective roots. ///////////////////////////////////
///
///

In a band, the music is not a product of just the leader, but a group effort. The Mission muralists invited the community to join them. As a result, the murals are not just the expression of individual artists. This community-based mural movement flourished in the Mission and continues today to embrace new styles, tactics, and subjects. I think the whole Mission neighborhood is a massive public artwork, both sacred and profane, brimming with graff and goddesses. Enlivened by people moving about the alleys and the palm-lined streets, the murals function as stage sets for a cast of characters: exiles and hipsters, day workers and night clubbers. ///////////////////
///
///

Passions that raise people's consciousness give the murals energy and rhythm. This Mission tradition of painting murals is done with respect and reverence for a native past. The art splashes along the streets like the ever-changing cadence of sunlight and rain on sidewalks. As a community of music makers and street painters, we invite your eyes to start dancing. The rest of you will follow. ///////////////////////////////////
///
///
///

Creativity Explored project (Susan Greene, director), *New Visions 2,* 2006

Carlos Santana came to the Mission District from Tijuana, Mexico, in his teens. In 1966 he formed the Santana Blues Band with other young Mission District musicians, creating a new genre of music—Latin rock. At many festive mural dedications, the band played to a neighborhood dancing in the street. In 1987, Michael Rios painted an iconic three-story mural of Carlos Santana. His eyes are closed and his head is cast skyward, suggesting sensual ecstasy and spiritual ascendance. The mandala represents both Santana's and Rios's immersion in Buddhism. Today the mural is badly weathered. Its condition exemplifies the conflict between permanence and temporality in the ever-changing landscape of Mission murals.

Annice Jacoby

Growing up in the Mission in the seventies and eighties, I felt like the walls looked like me. I remember this one mural at 22nd and South Van Ness. It had Carlos Santana in the middle. I remember thinking *"Wow, that's amazing. That's Santana, he's known around the world, but he's also a local guy on our mural."* That mural is deep in my memory of the Mission.

—*Veronica Majano*

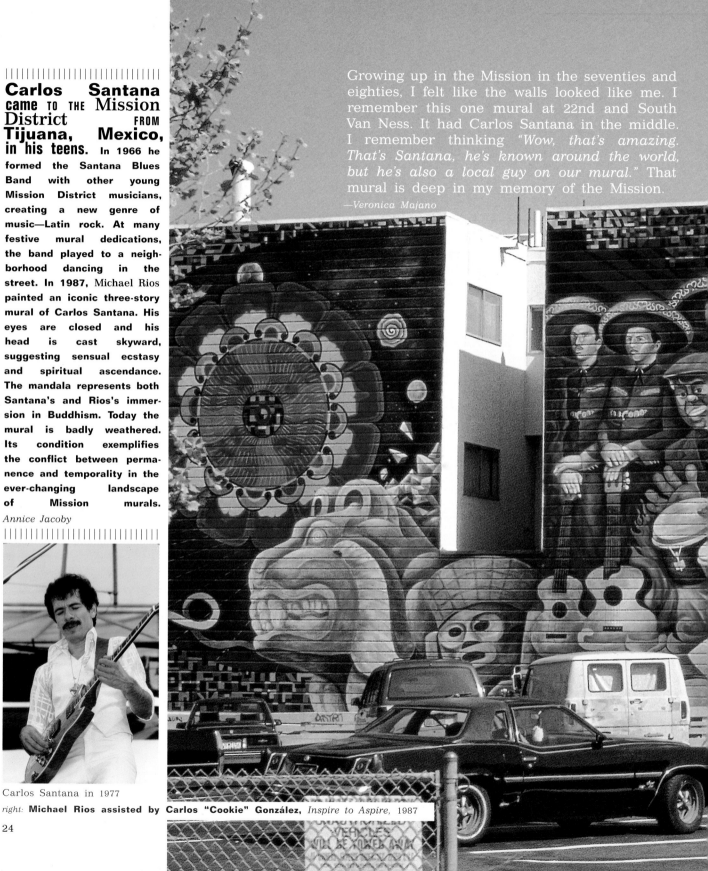

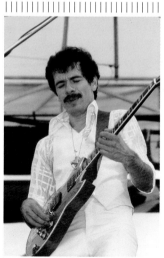

Carlos Santana in 1977

right: **Michael Rios assisted by Carlos "Cookie" González,** *Inspire to Aspire,* 1987

24

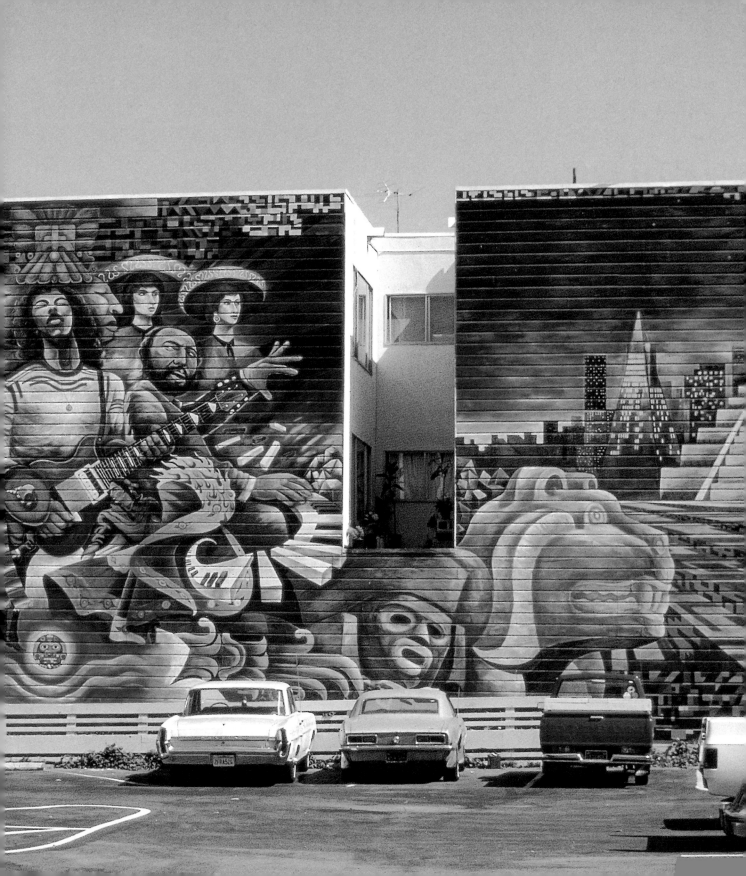

Susan Kelk Cervantes
Founding Director, Precita Eyes Muralists

In 1997 I conceived a book recognizing the ACHIEVEMENTS of the Mission mural movement.

Starting with a handful of dedicated artists, the movement is still growing and very much alive. More than five hundred murals—showing an unmatchable range of styles, diverse modes of expression, and varied levels of experience—have been created in the Mission alone in the past forty years. From children's murals in schools to monumental collaborative works such as *Maestrapeace* to graffiti, spray-can art, stencils, and posters, the art in our streets is alive with intent, spontaneity, and urgency. The creative outpouring of public community mural art in the Mission District celebrates our human spirit and enriches our lives. We offer this book to preserve our vision of muralism and to share its power with the people of the community and beyond.

It is a great experience to be out in public, painting on a really large scale. But more important is to see muralists collaborating. Our bonding commitment is to respect each other's contribution and paint what is important to the community. People who talk to the muralists while they are working realize how important it is for these artists to be visible, and how good it is that art is a part of our environment and everyday life. The Mission is our home; it is where we work, live, and raise our families. We are proud of it.

All of my efforts to bring this book to fruition I dedicate to my late husband, Luis Cervantes, who helped make this dream a reality, sharing our vision of life-giving creativity.

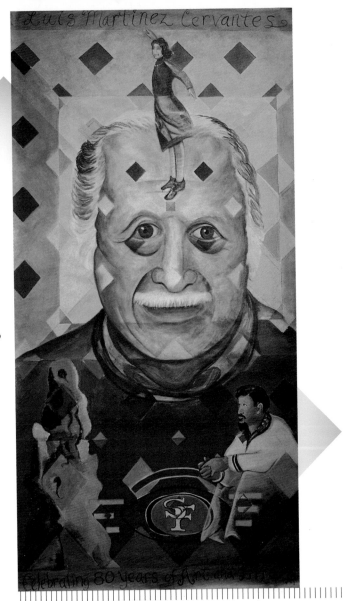

THE LATE **Luis Cervantes** (1923–2005), cofounder of PRECITA EYES MURALISTS, **inspired many artists.** He assisted on many Precita Eyes projects and was lauded as an artist of visionary painting and sculpture. A World War II veteran and labor leader, he served as president of the Furniture Workers' Union. He met Susan Kelk at the San Francisco Art Institute. Together they created a center for muralism and community work.
Precita Eyes Archives

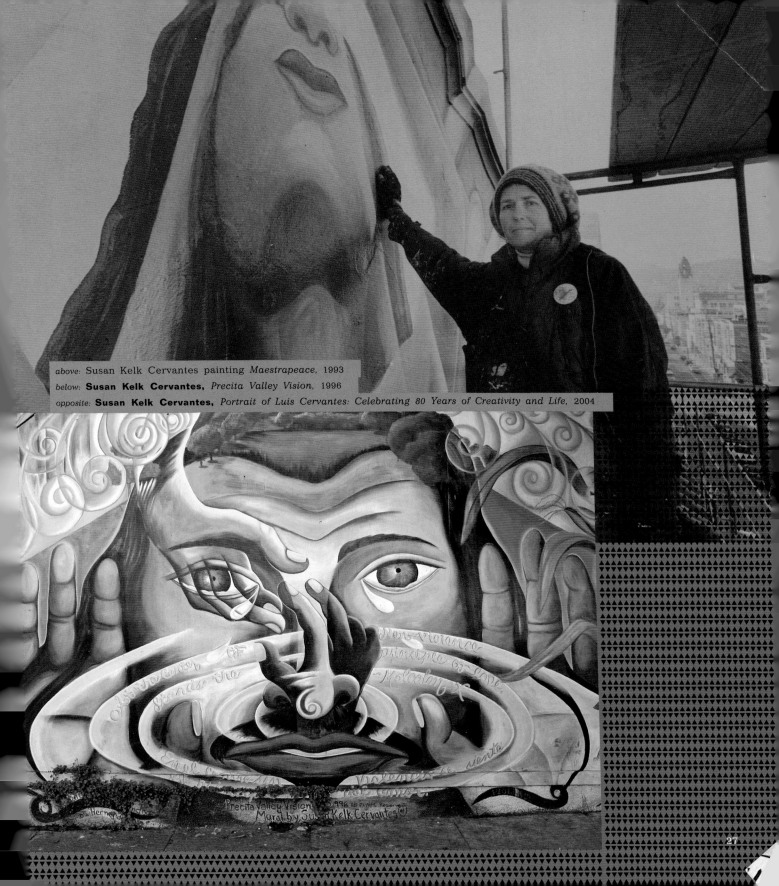

above: Susan Kelk Cervantes painting *Maestrapeace*, 1993

below: **Susan Kelk Cervantes,** *Precita Valley Vision*, 1996

opposite: **Susan Kelk Cervantes,** *Portrait of Luis Cervantes: Celebrating 80 Years of Creativity and Life*, 2004

The best way to view the murals of the Mission is through the cracked windshield of the MEXICAN BUS that regularly tours the neighborhood, inspired by the festively decorated buses in Mexico often named for girlfriends or romantic landscapes.

Our bus is called *El volado* (The Flirt). *God is my co-pilot* is painted in Spanish alongside slogans making fun of the condition of the roads. In the rear cove of the bus, the South American muralist Carlos Cordova painted a scene of a never-forgotten home, similar to the paintings in many bodegas and bars of the Mission, which are saturated with nostalgia for relaxation, palm trees, and beaches at sunset. The windshield wipers keep rhythm with the music. Our mural guide asks Cornelius, the driver, if it's okay to whisper directions in his ear. "Yes," he replies as he steers sharply, "I like women whispering in my ear." ///////////////////////////////////////
///
///

The *New York Times* in 2005 called the Mission District "eclectic, eccentric, electric." Millions of international visitors come to the Mission District, long known by cognoscenti as one of the "hippest neighborhoods in America," for a very different look at this country. Maybe San Francisco's reputation for speculation, innovation, and bohemian pursuits reinvents itself each generation. As the oldest section of the city, the Mission neighborhood has attracted the Ohlone, conquistadores, and missionaries, as well as Irish, Asian, Caribbean, and Latino settlers. Increasing in style and number, artists and alternative thinkers are part of a diaspora from the drier parts of the American landscape. We are not referring to humidity, but soul. Like the Loisada of New York or the Left Bank of Paris, the Mission is a cafe society that scoffs at excess, complains about money, drinks the elixir of art and action, and provides its own poetry and mythmaking. Part of the spectacular appeal of this neighborhood is its outdoor gallery, which reveals a rich creative life, provocative attitudes, and multicultural influences. //////////
///
///

The Mission has the highest concentration of mural making in the country. There are hundreds of murals in a quadrant of thirty blocks, a figure many scholars believe supersedes that of any city in the world. The Mexican mural movement, Works Progress Administration (WPA) public painting traditions, and the civil-rights and United Farm Workers movements influenced the murals of the Mission. From the richness of this historical legacy, the Mission mural movement, or Muralismo, manifests an unabashed contemporary style that exerts international influence. The artists who paint new life onto drab surfaces do more than choose a surface to mark. Muralismo is a political/community aesthetic that changes the way everything looks and everyone sees. ///
///
///

Mango and jalapeño. Sweet and scorching themes of art and revolution flourish with tricks of magical realism in San Francisco's Mission District. Murals mix the impossible and

Mats Stromberg, 1995

the ordinary in monumental tableaus, and Mission muralists claim a territory of pictorial anarchy rich with social and spiritual upheaval. Mission artists practice with anecdotes, malleable folk idioms, and fears. Mission Muralismo collectively chronicles a fractured narrative belonging in theory to the people, schooled and unschooled, huddled together on a common turf. //////////// // //

The Mission has been San Francisco's nerve center since it was the end of the Camino Real established by Father Junípero Serra. No one is afraid to mix art and politics. In the Mission, they are *la vida*—clenched fists, volcanoes, cactus, mothers and children, low riders, Popocatépetl, warriors carrying women, and calendar art morphing into manifestos and memorials. // // //

The Mission District is a cultural laboratory for public art, home to a host of seminal, radical organizations: the San Francisco Mime Troupe, the Mission Cultural Center, Galería de la Raza, the Precita Eyes Muralists, the Billboard Liberation Front, Media Burn, the Farm, McSweeney's, Global Exchange, Code Pink, Art & Revolution, Burning Man, Intersection for the Arts, Youth Speaks, Los Siete, and CELLspace. The Symbionese Liberation Army held Patty Hearst in a Victorian house by Precita Park. "The history of the Mission has a lot to do with waves of radicals who came here to escape failed revolutions elsewhere," says historian Chris Carlsson in the *New York Times*. A center for activism, the Mission spawned the December 1999 World Trade Organization (WTO) protest in Seattle, and it continues to vigilantly support a long-running show of art provocateurs. The artists have assigned themselves a job motivated by political solidarity. The Mission brand of public art placed ideology out in plain sight, merging traditional representation with inventive guerrilla art tactics. // // //

Muralismo is a chaotic art movement, an American twenty-first-century mix of style, content, and multiculturalism. The individual and collective efforts challenge boundaries of ownership, space, and social agency. Painting styles range from WPA formalism to Zap Comix to punk urban oddities to day-glow expressionism. Descendants of Bruegel and Bosch create complex social satires with wry observation of human foibles. ////// // //

The first generation of Mission muralists, influenced by the civil-rights movement and Los Tres Grandes—the Mexican muralists Diego Rivera, David Alfaro Siqueiros, and José Clemente Orozco—brandish brushes with stylistic orthodoxy to make ideological and religious tableaux. Many of their giant outdoor paintings are orchestrated with permission and public ritual. The artists range from hip social satirists to activist cadres galvanizing around urgent issues such as war, pesticide poisoning, injustice, and violence. The next generation of artists, often working at night, leaves stealth messages on raw concrete—graffiti and cartoons, both angry and playful. //////// // //

The output of the Mission muralists is outscale, outspoken, and often outrageous. The work is deliberately temporal, subject to weather, time, defacement, and deterioration, and yet it bursts with indelible images that provoke many questions. Who owns visual space? Good intentions? Bad painting? Good painting? Bad intentions? Who assigns significance? Dismissed? Validated? Manipulated? Muralismo raises these controversies daily, as the street-theater director Peter Schumann advocates, because art is like good bread. In defiance of the pristine environment of a gallery, the mural does not set the stage or lower the lights, or keep the audience behind velvet ropes. A mural joins the dynamic opera of street life. /// // //

Mission Muralismo battles over ownership of ideas and images. Who owns the interpretation of an image—the politicians, the church, the community, the advertisers, or the artists? The Mission muralists have not let the advertisers prevail. Mission Muralismo is not just a medium but also a form of media, aggressively reporting and cleverly editorializing. Does a yellow circle of circumscribed triangles mean a gas station or an Aztec god? Mission artists exploit traditions, directly challenge the status quo, twist puns from capitalist conceits, and resurrect buried histories. // // //

Diego Rivera was invited to San Francisco to paint murals at the Pacific Stock Exchange Lunch Club (now the City Club) (1931), the San Francisco Art Institute (1931), and the Golden Gate International Exposition (1940). The painter Maynard Dixon noted, "San Francisco got a big belly laugh when Rivera, as his farewell gesture to the sycophants, painted a lot of his

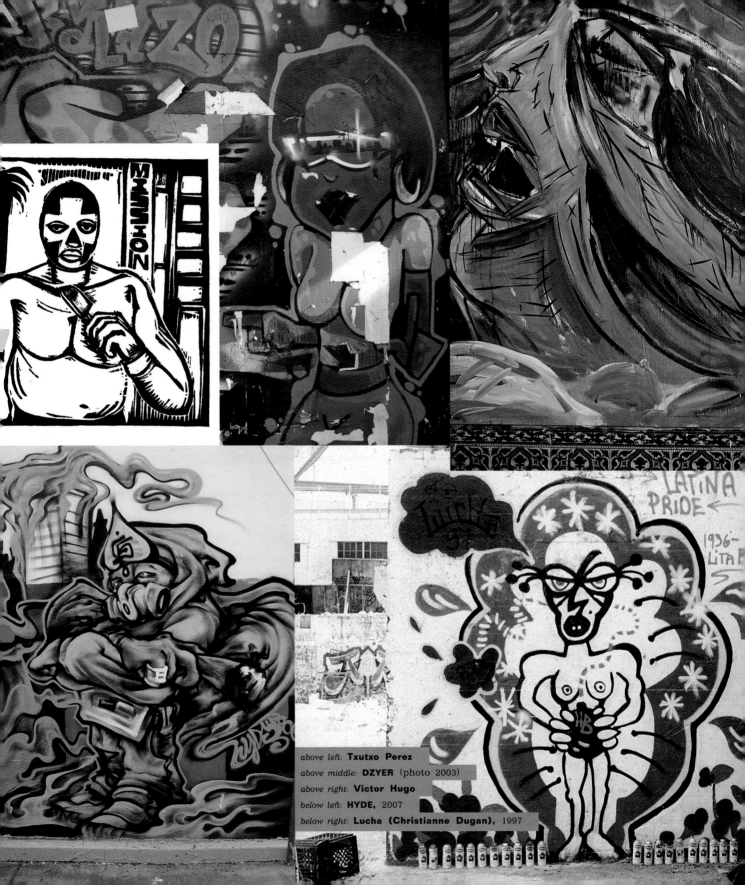

above left: **Txutxo Perez**
above middle: **DZYER** (photo 2003)
above right: **Victor Hugo**
below left: **HYDE,** 2007
below right: **Lucha (Christianne Dugan),** 1997

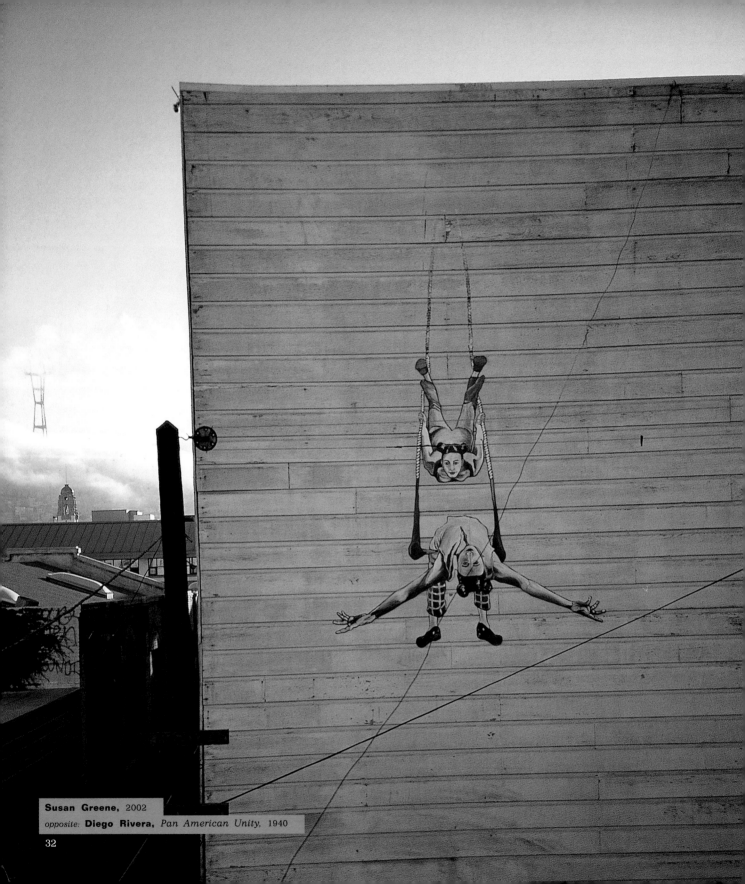

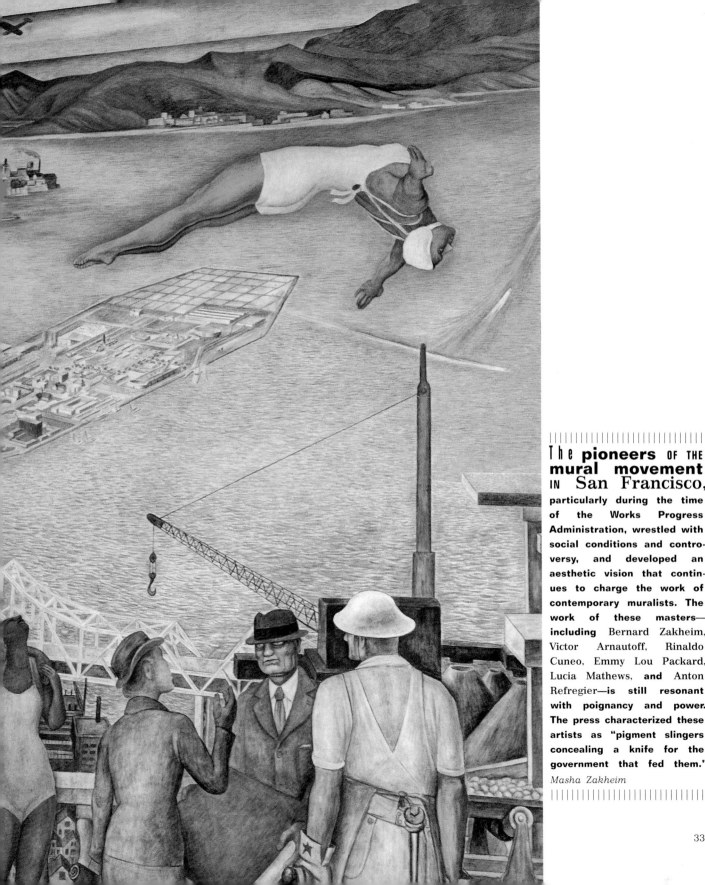

The **pioneers** OF THE **mural movement** IN San Francisco, particularly during the time of the Works Progress Administration, wrestled with social conditions and controversy, and developed an aesthetic vision that continues to charge the work of contemporary muralists. The work of these masters—including Bernard Zakheim, Victor Arnautoff, Rinaldo Cuneo, Emmy Lou Packard, Lucia Mathews, **and** Anton Refregier—is still resonant with poignancy and power. The press characterized these artists as "pigment slingers concealing a knife for the government that fed them."

Masha Zakheim

capitalist followers on the art school wall facing his big behind." With its aggressive blend of art and politics, Rivera's work inspired respect for workers, reverence for history, optimism for technology, and condemnation of greed. In San Francisco, his influence is seen in the industrious period of art sponsored by the WPA. Many of the WPA artists who had worked with Rivera, including Bernard Zakheim, Emmy Lou Packard, Stephen Dimitrof, and Lucienne Bloch, went on to mentor the emerging muralists of the seventies through the early nineties in everything from fresco techniques to politics. //////////////////////////// // //

Rivera's work, charged with fame and controversy in his time, was viewed as dated and polemical by the fifties. The San Francisco Art Institute faculty considered whitewashing its Rivera mural because it did not resonate with modernist values. In the late sixties political dissatisfaction fired a renewed interest in murals. Artists wanted to voice their concerns about an unpopular war, and the racism and unemployment that overwhelmed the inner cities. ////////////////////////////// // //

The murals are no longer the expression of one generation. At any given time, there are a dozen new mural projects yielding wild styles and potent public messages, both topical and referential. Juana Alicia, Jesus "Chuy" Campusano, Susan Kelk Cervantes, Michael Rios, Manuel "Spain" Rodriguez, Ray Patlan, Enrique Chagoya, Miranda Bergman, Andrew Schoultz, Barry McGee, Rigo, Isis Rodriguez, Sam Flores, and Joel Bergner are just a few of San Francisco's outstanding artists of the contemporary mural movement. Over the decades a diverse group of artists, including Gronk, Felipe Ehrenberg, R. Crumb, Martin Travers, SWOON, Shepard Fairey, Os Gêmeos, Doze Green, and Robbie Conal have added to the Mission's fervor with murals and wild postering. ////////////////// // //

In 1977 a group of artists, under the leadership of Susan Kelk Cervantes, first came together as the Precita Eyes Muralists. For several decades Precita Eyes has been a hub for muralists, budding artists, and families, creating everything from new playgrounds to memorials for victims of urban violence. Their efforts have helped unify the community by providing countless classes, celebrations, and an ongoing body of work that vibrates with color, history, spirituality, and nonviolent messages. Precita Eyes uses the mural-making process as

community education and healing. Sara Foust, a Precita Eyes artist, said, "Mission muralists began collaborating on a new style of monumental art addressing the themes of culture and community. Murals strengthen neighborhoods, transmute the darkness of the Mission into its strength, convert violence into beauty, and provide an alternative vision." //////////////////////// // //

The genesis of the Precita Eyes Muralists was in sync with the rise of the Chicano movement in the United States. During the last several decades this movement has revived the mural tradition as part of a search for cultural roots and as a way to deal with marginalization, immigration, and other interwoven issues close to the hearts of the community. The murals integrate and juxtapose images of Mayan pyramids and historical struggles with contemporary icons, neighborhood personalities, and political issues. They offer nonviolence and tolerance as options. // // //

Like many art movements, Mission Muralismo is contentious and competitive. The Surrealists were mythologized for wild parties and fierce ideological battles. Mission muralists are also as dedicated, self-serving, and resourceful, producing both clichés and cultural landmarks. A street story that Michael Rios sold his blood to buy paint suggests the ongoing struggle and sacrifice. // // //

When Marc Chagall returned to Russia from Paris after the 1917 revolution, he brought his idealism to an art for the people. He was quickly banished for including dreams and folktales in his paintings because the eager Politburo feared that people were subject to superstition and fantasy. Chagall's approach conflicted with the Soviet prescription for the new proletariat. His mural of dancing figures for the lobby of the Yiddish Theater in Moscow was the last work he painted in Russia before returning to France to seek freedom from formulas and control. The Mission muralists have also fought over method, content, and power. They struggle to avoid the mistake of the Politburo, in its suppression of imagination for social control. Mission muralists produce agit-prop as unapologetic and confident as commercials, sometimes faltering on its own brand of approved formulas, sometimes rivaling great church art in reverence and beauty. /////////////////////////////// //

Chris Monroe, *A Brief History of Murals,* 2005

Except for Mission Dolores, the Mission is not a neighborhood that is polished for holiday snapshots. There are garbage-strewn streets. Homeless people sleep under cardboard blankets and walk the streets talking to themselves. Mariachis pluck unvarnished guitars in bustling taquerias. Evangelista storefronts are packed for vespers while low riders boom the bass on the street outside. In the braided solidarity of conflict, *South Africa, Fresno, Chiapas, South Central* become interchangeable emblems of oppression. Like slogans, the murals sometimes simplify and sometimes explode. They are admired and mimicked, discovered and destroyed. Travelers marvel, decoding the murals via the aid of handbooks on the lives of saints and the cosmology of the Aztec gods.

The murals mix and match context and intent—shamelessly. Emma Goldman greets Cesar Chavez. George Bush meets Quetzalcoatl. The critic John Berger notes, "People cut off from the past are far less free to choose than those able to situate themselves in history. This is why the entire art of the past has now become a political issue." The selective use of ancient images and symbols gives the community continuity with the past.

Some of the streets are too narrow for a bus to turn into. "The Mission is a colorful part of the city in the first place," says muralist Meera Desai. "All of the homes are painted in different colors." On the corner of York and 24th Street we once saw *Las lechugueras,* Juana Alicia's 1983 rendering of migrant farm workers that has became an icon of the plights of women and workers everywhere. As they toil with magnetic beauty and strength in the field, they are subjected to pesticides sprayed by prop planes. The painting uses a Dutch Master technique in which a transparent wash is overlaid with opaque filigree, creating an illusion of lace over skin or X-ray vision. Workers in the fields tie bandanas over their faces to keep the dust and chemicals from choking them. Their masks billow with their breath and the pride and strength of their stride. The naked yellow spray of light broils. The scene is sharpened by a triumphant trick of the eye. A pregnant woman's belly echoes the shape of the lettuce heads the women are picking. Her soft blouse suggests organdy, her transparent belly exposes the growing baby curled inside, sharing the elements with brave mothers working the harvest.

These pictures are a form of public education, carrying the warning that political indifference shows disrespect toward life.

For a couple of decades this painting was an homage to rural life and a feisty declaration of reckless labor practices for the millions who have worked the fields and for many living in the neighborhood. When the building suffered water damage, Juana Alicia had little interest in repainting the image, which was already indelible in the public imagination. At that time war and terrorism were the dominant issues. Her choice was not to re-create *Las lechugueras* but to show a continuity of concerns: the treatment of women, environmental devastation, and the cycle of violence.

Rigo, a conceptual muralist, returned to the Mission from his native Portugal after the long first summer of the Iraq War. That mission had been declared accomplished as the dying continued. On an uncharacteristically balmy night, he walked out of the St. Francis, a vintage Art Deco parlor still serving homemade ice cream, across the street from York and 24th. In the spot where he remembered *Las lechugeras,* he was confronted by the *La llorona,* its aggressive ocean of practically monochromatic blue, thinly veined with red, flowing from destructive dams, women's tears, greed, global warming, an ongoing oil war, and oncoming water wars. "Wow," Rigo shouted, "Juana's got the blues!"

Barry McGee, a critically acclaimed street artist known as TWIST, faced the physical demise of his iconic mural on Clarion Alley, a corridor of contemporary murals off Valencia Street. He handled this situation with high-art ceremony. When the garage door had to be replaced, Clarion Alley director Aaron Noble and his crew ritually removed, in a day of laborious sanding, any trace of the now-famous McGee work. They were preempting a "robbery" that would put the door in the hands of a collector, giving free street art a gallery price tag. Dressed in cool goggles, the artists passed out souvenirs of mural dust in tiny plastic baggies—an art joke performed in a corridor dominated by junkies.

Topical or enduring, unsubtle and mocking, Mission Muralismo is an art free-for-all that raises issues about temporality and

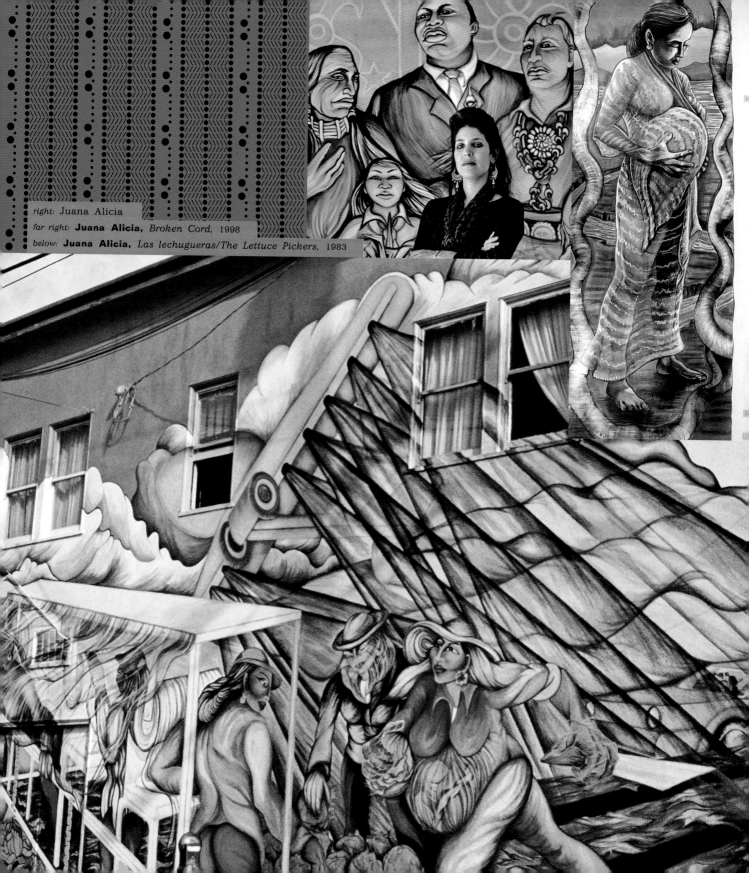

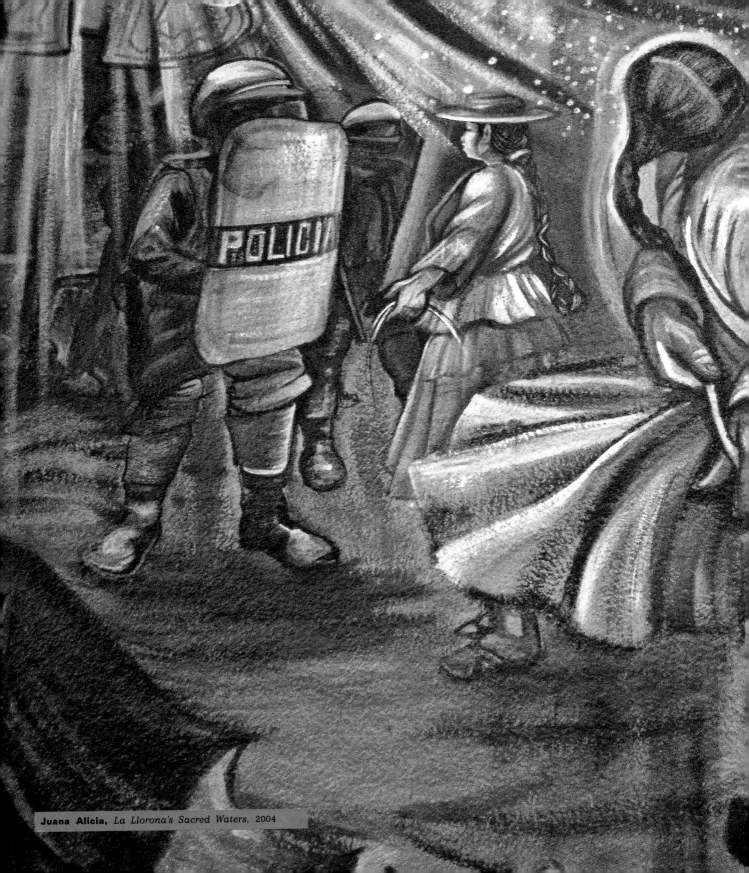

Juana Alicia, *La Llorona's Sacred Waters*, 2004

PAINTING THE RIVER CLEAN
LETICIA HERNANDEZ-LINARES

MANY myths about female water spirits are tales of warning. Maybe we should be warned, because no doubt the water spirits are anxious. The water spirits were certainly present on the day I visited Juana Alicia's new mural, *La Llorona's Sacred Waters*. The artist has planted a river in the middle of a concrete neighborhood where many immigrant families live, far from their rivers and folk tales. The mural towers like a dam over the York Street sidewalk in bold blues, with a single red stroke separating it from the sky.

The mural highlights Bolivians in Cochabamba who have fought to keep the Bechtel Corporation from buying the water rights; farm workers in India's Narmada Valley protesting in the flooded waters of their homes against their government's devastating dam projects; and women in black protesting the unsolved murders of women in Juarez, in the shadow of the Rio Bravo and the *máquiladoras*.

Twenty-fourth and York Street was, until recently, the site of Alicia's first big mural project, *Las lechugueras*, painted in 1983. It was her experience as a farm worker and organizer for the United Farm Workers (UFW) that led her to merge art and politics on a large scale—through mural making. In *Las lechugueras*, Alicia looked at women workers and their battles against working conditions and pesticide poisoning in California.

In both murals, Alicia reminds us that women are leading environmental struggles and carrying the weight of poverty on their backs. This mural merges the battles against overwhelming subconscious mythologies, persistent political realities, and the struggles of everyday life.

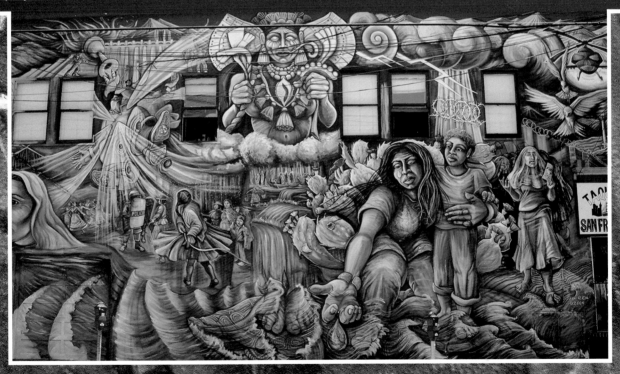

ownership of art free to all. The artists climb scaffolds and dodge sirens. This is not gallery work. It is not safe, protected, or anointed by a critical elite. The murals condemn some who are the heroes of others and make heroes of the humble and dismissed. Before the 2004 presidential election, after reviewing a sweep of contemporary politically engaged art, the *New York Times* asked, "Is lightening up the way to go in political art?" and quoted Randall Bourne from a century earlier about America: "With our deep-seated distrust of social equality, our genius for race-prejudice, our inarticulateness and short-sightedness, it seems highly probable that we shall evolve away from democracy instead of towards it." The article rebutted, "At the same time, from early in our history, we have had an alternative tradition of visionary thinking and refusenik action. That tradition is all over our art." Mission Muralismo distills that alternative impulse, brewing the volatile spirits of democracy.

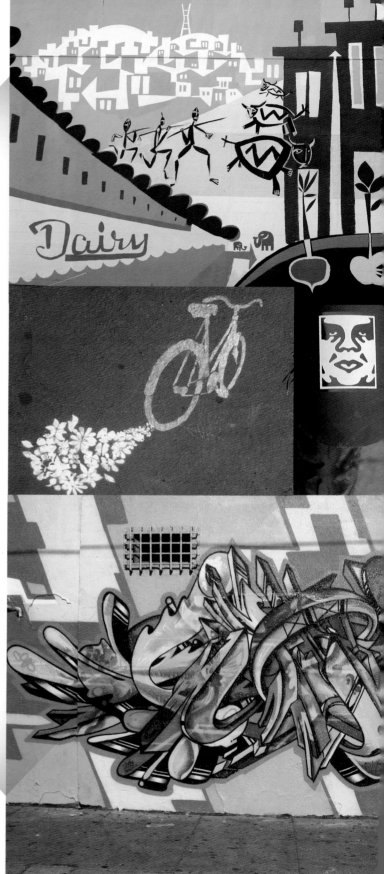

above: **Brian Barneclo,** 2006
middle left: **Artist unknown**
middle right: **Shepard Fairey**
below: **APEX and NEON,** 2005
opposite above: Mural by **TWIST (Barry McGee),** 1993
(inset) Aaron Noble removing mural, 2001
opposite below: **Artist unknown** (photo 2004)

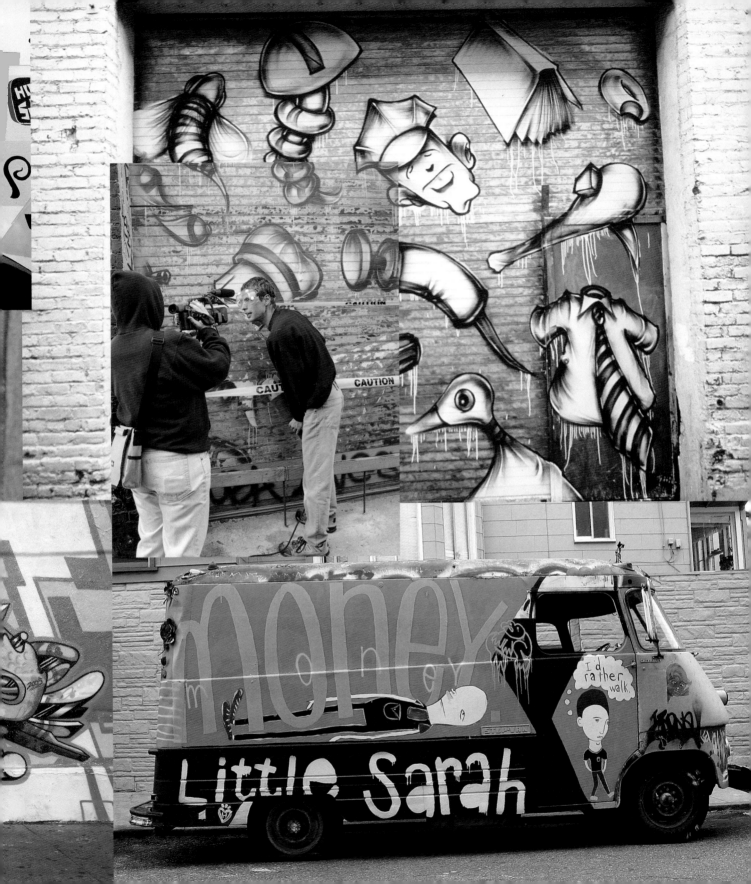

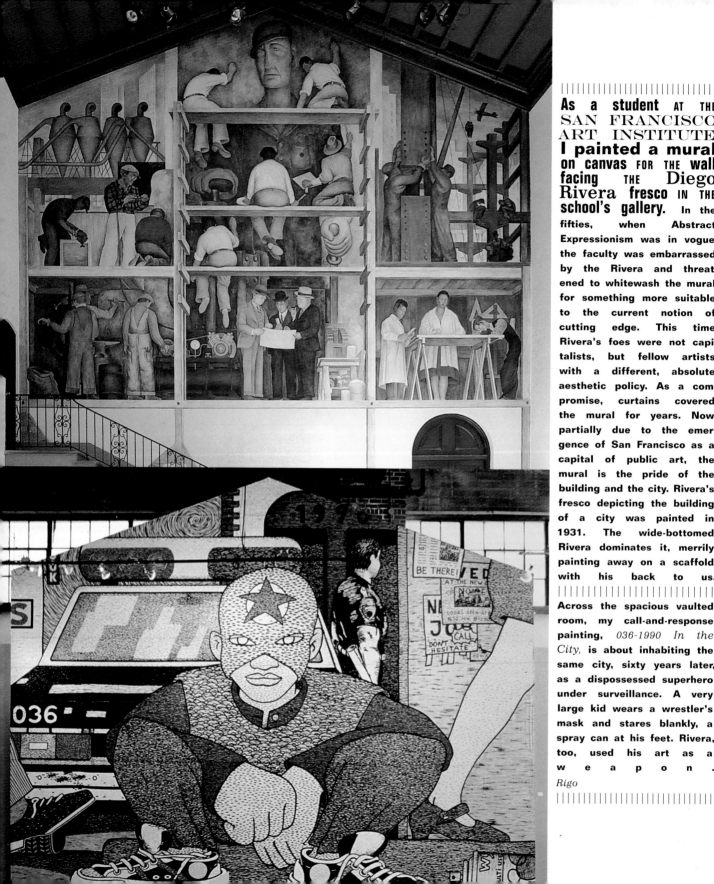

As a student AT THE SAN FRANCISCO ART INSTITUTE, I painted a mural on canvas FOR THE wall facing THE Diego Rivera fresco IN THE school's gallery. In the fifties, when Abstract Expressionism was in vogue, the faculty was embarrassed by the Rivera and threatened to whitewash the mural for something more suitable to the current notion of cutting edge. This time Rivera's foes were not capitalists, but fellow artists with a different, absolute aesthetic policy. As a compromise, curtains covered the mural for years. Now, partially due to the emergence of San Francisco as a capital of public art, the mural is the pride of the building and the city. Rivera's fresco depicting the building of a city was painted in 1931. The wide-bottomed Rivera dominates it, merrily painting away on a scaffold with his back to us.

Across the spacious vaulted room, my call-and-response painting, *036-1990 In the City,* is about inhabiting the same city, sixty years later, as a dispossessed superhero under surveillance. A very large kid wears a wrestler's mask and stares blankly, a spray can at his feet. Rivera, too, used his art as a w e a p o n .

Rigo

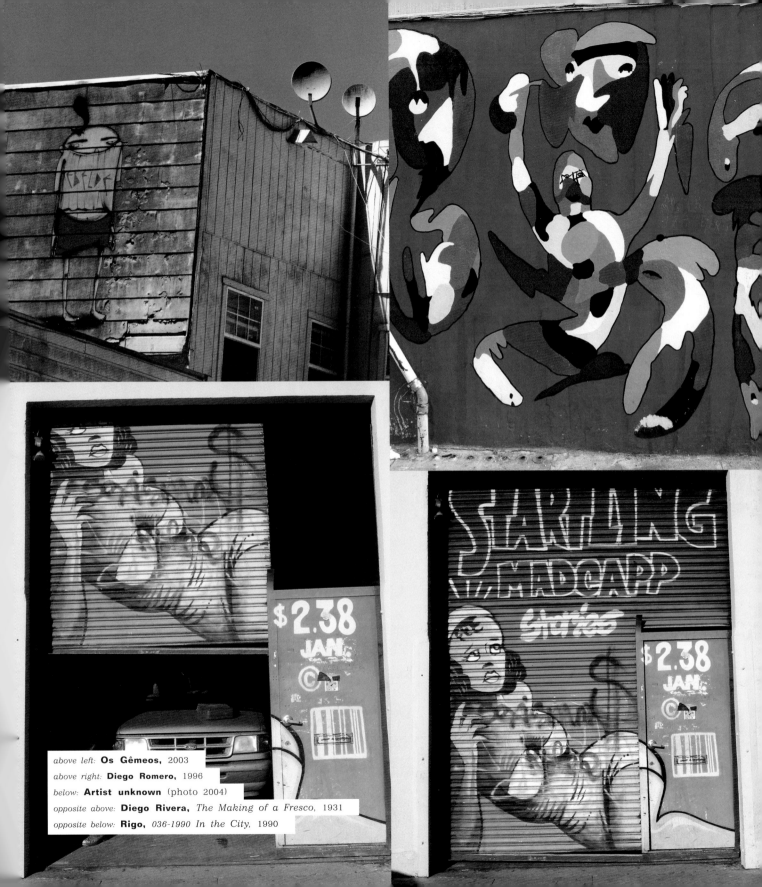

above left: **Os Gêmeos,** 2003
above right: **Diego Romero,** 1996
below: **Artist unknown** (photo 2004)
opposite above: **Diego Rivera,** *The Making of a Fresco,* 1931
opposite below: **Rigo,** *036-1990 In the City,* 1990

1334

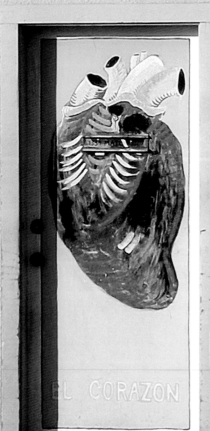

EL CORAZON

HEART

Artist unknown (photo 2002)

BACKDROP FOR A NEW BOHEMIA

Mystery:
How come the Mission is sunnier and warmer
than the rest of the city?
Is it a Latino thang?
Do we have more sex in this part of the city *¿o qué?*
Why do people come here?
Are we seduced by the promise of bohemia
in a country of restricted imagination?
In an era of constrained freedoms?
Are we part of the ongoing wave of international exiles
escaping failed revolutions and civil wars?
Or the wave of sexual and artistic misfits escaping
orthodoxy in our homelands?
Why am I still here? I ask myself all the time.
The Mission has been the stage and laboratory for my art,
my love, my friendships, and my escapades into forbidden
territories both on the street and in my psyche.
This poem and tour is homage to the hood that has hosted
and nurtured my madness.

Guillermo Gómez-Peña

René Yañez,
Street Interventions, 1988

46

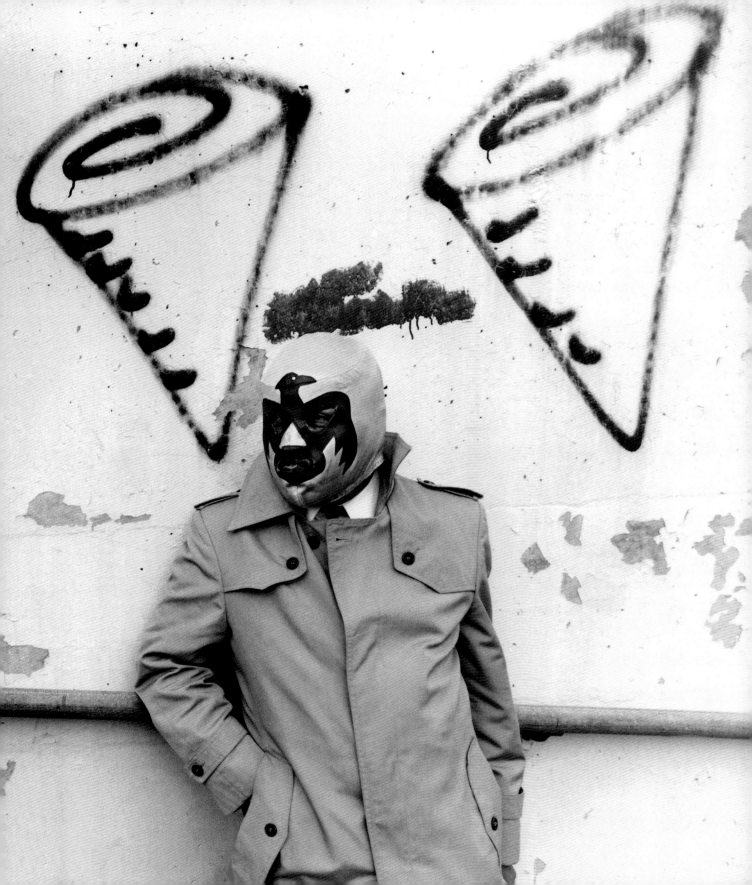

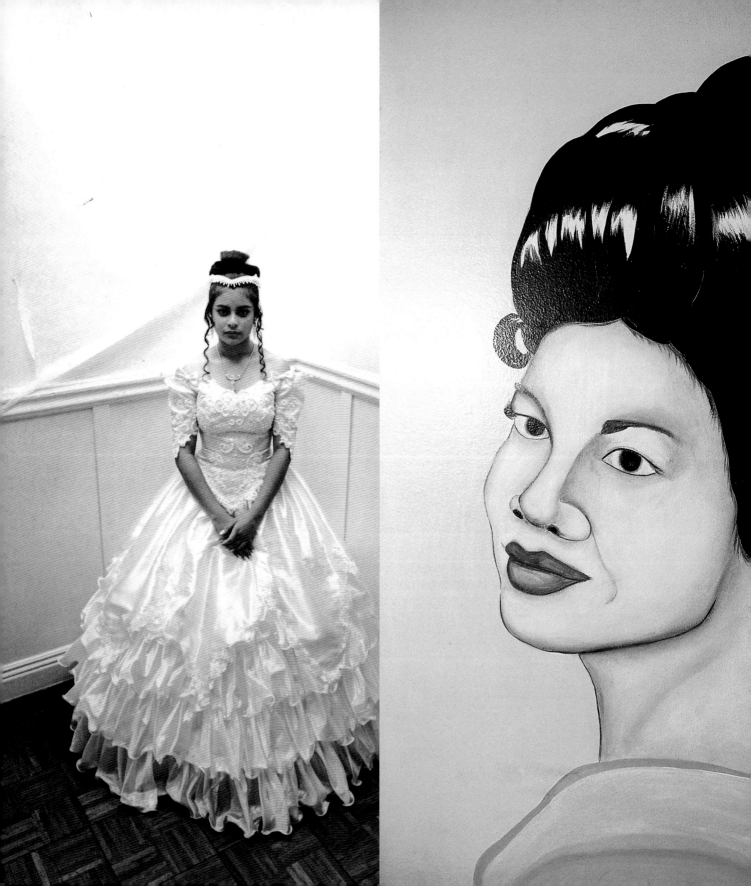

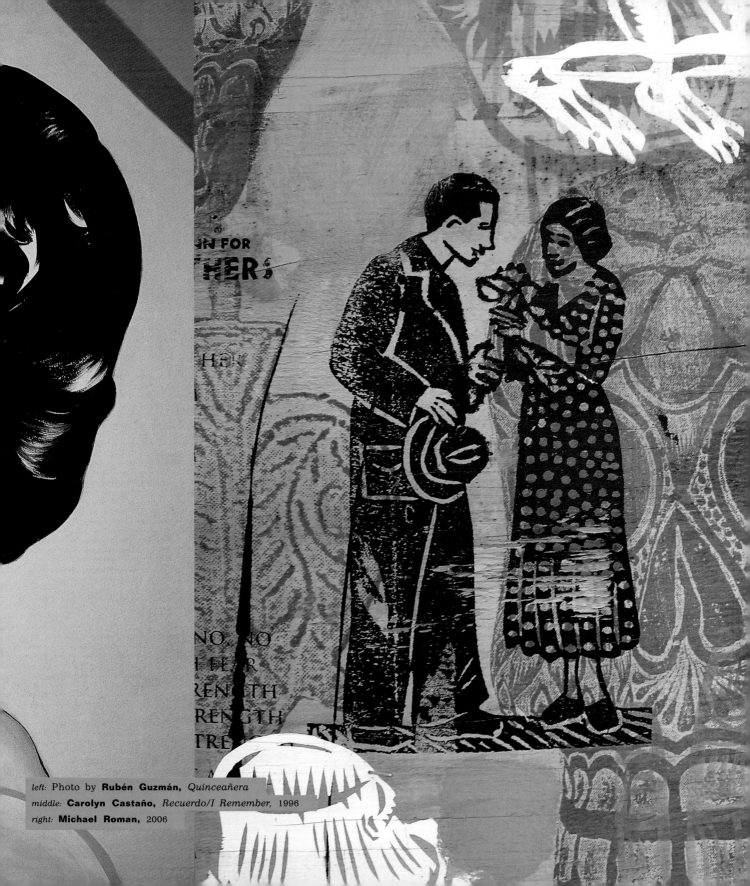

left: Photo by **Rubén Guzmán,** *Quinceañera*
middle: **Carolyn Castaño,** *Recuerdo/I Remember,* 1996
right: **Michael Roman,** 2006

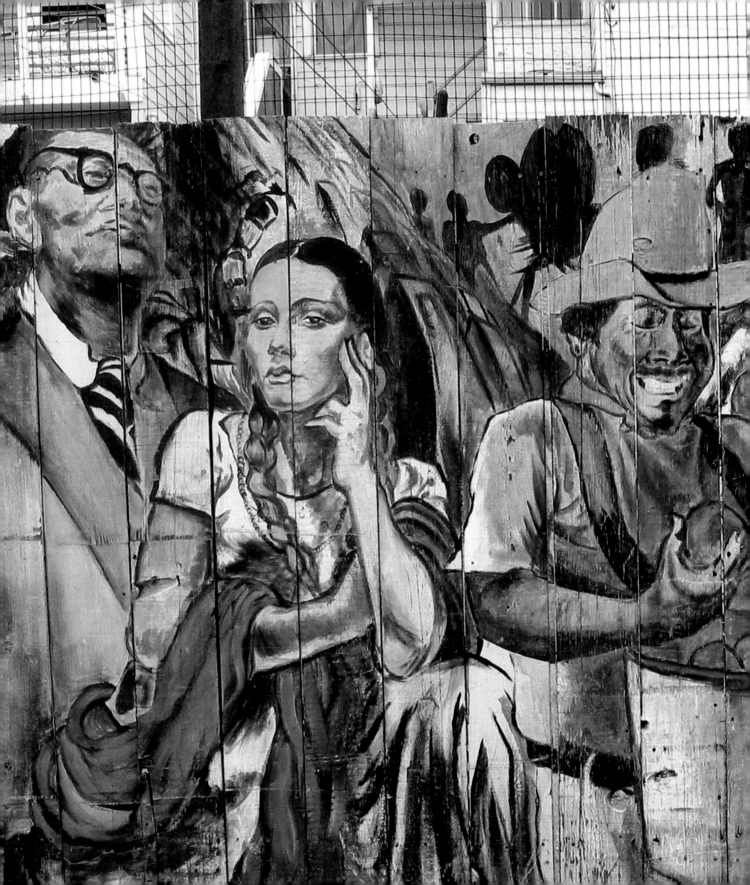

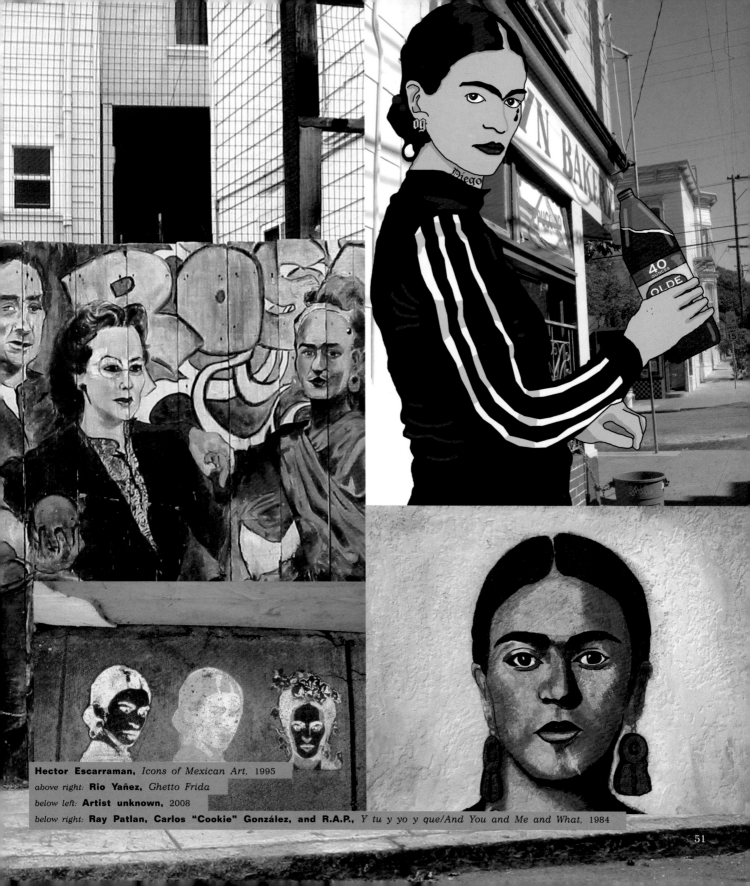

Hector Escarraman, *Icons of Mexican Art*, 1995
above right: **Rio Yañez,** *Ghetto Frida*
below left: **Artist unknown,** 2008
below right: **Ray Patlan, Carlos "Cookie" González, and R.A.P.,** *Y tu y yo y que/And You and Me and What*, 1984

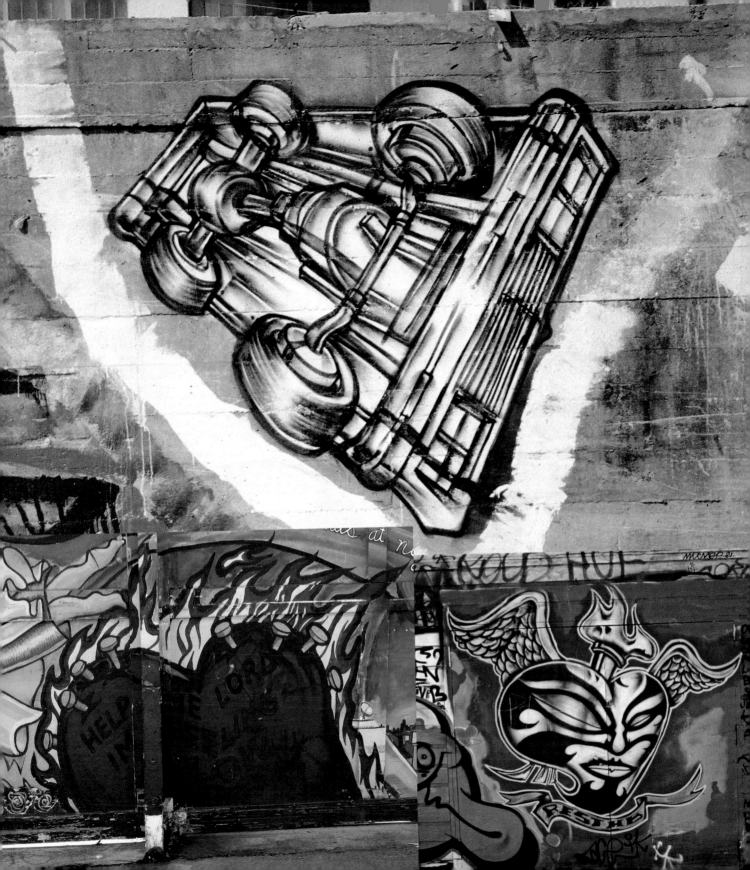

The H.O.M.E.Y. Organization (Eric Norberg, lead artist), *Misión Empire*, 2000

opposite above: TWIST (Barry McGee), c. 1991

opposite below left: Daniel Segoria, detail from *A Hard God Is Good to Find*, 1997

opposite below right: Artist unknown (photo 2002)

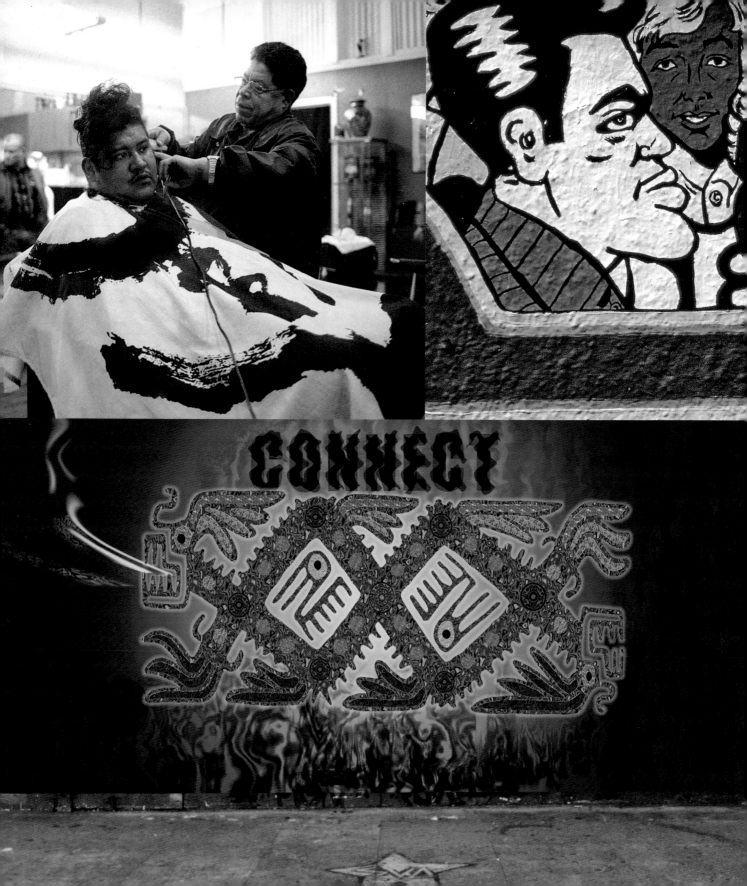

CONNECT

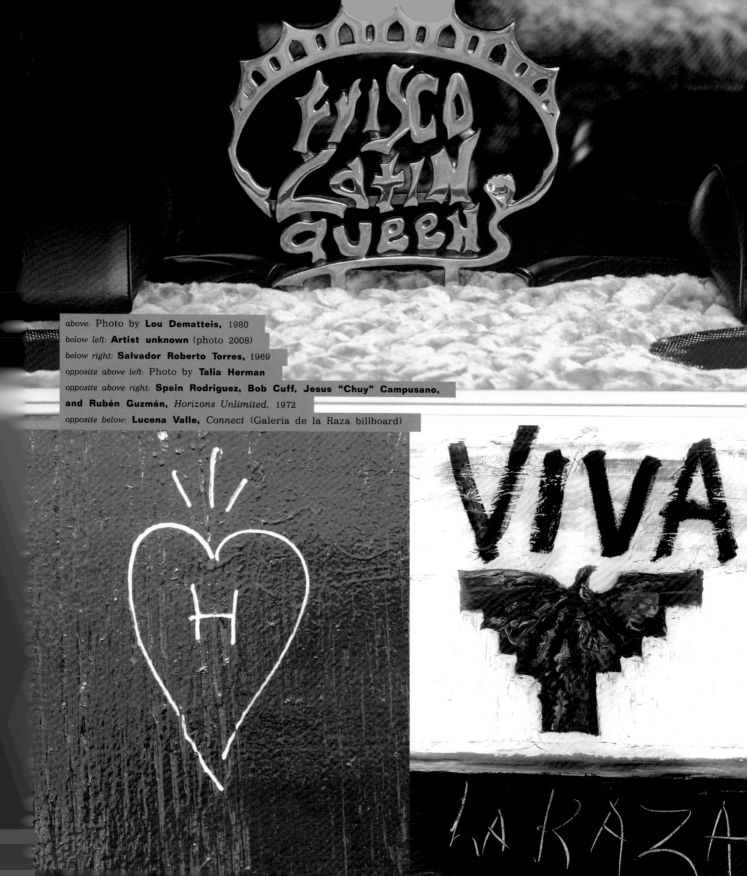

above: Photo by **Lou Dematteis**, 1980
below left: **Artist unknown** (photo 2008)
below right: **Salvador Roberto Torres**, 1969
opposite above left: Photo by **Talia Herman**
opposite above right: **Spain Rodriguez, Bob Cuff, Jesus "Chuy" Campusano, and Rubén Guzmán,** *Horizons Unlimited,* 1972
opposite below: **Lucena Valle,** *Connect* (Galería de la Raza billboard)

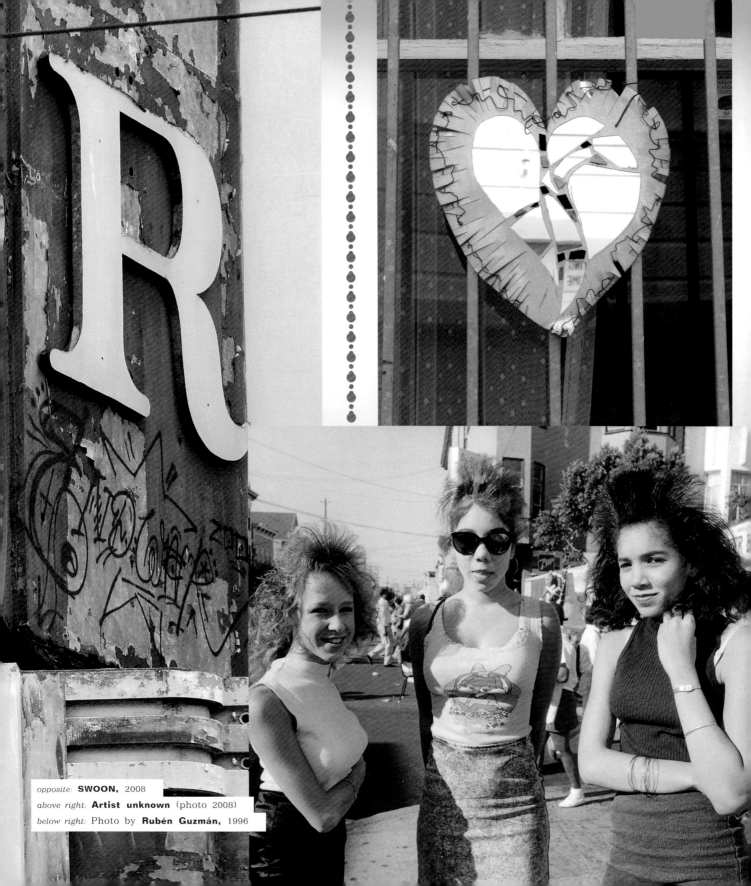

opposite: **SWOON,** 2008
above right: **Artist unknown** (photo 2008)
below right: Photo by **Rubén Guzmán,** 1996

Beauty Is a Verb: Mission Muralismo 1971–1982 ///////////
///
Jaime Cortez ///
///
Primer ///
///

To speak of the early years of Muralismo is to speak of the political waves that washed up across the San Francisco Bay Area in the late SIXTIES and early SEVENTIES.

In that period, movements were indeed moving. The organized challenges to the Vietnam War, sexism, and racism were ambitious, media savvy, and high profile. Radical movements, which included the Black Panthers, the Brown Berets, the Red Guard, and the American Indian Movement, were unprecedented in their range of activity. Together they helped form the milieu in which the Mission District's mural movement developed, but it was from *Chicanismo* in particular that the early muralists drew energy, direction, and symbolic strategies. //////
///
///

Spain Rodriguez, *An Average Day on Mission Street Where Beautiful Women (Who Give the Area its Reputation as San Francisco's Sexiest District) Are Annoyed by the Crude Advances of Young Men (Known to Sociologists as Machismo),* 1975

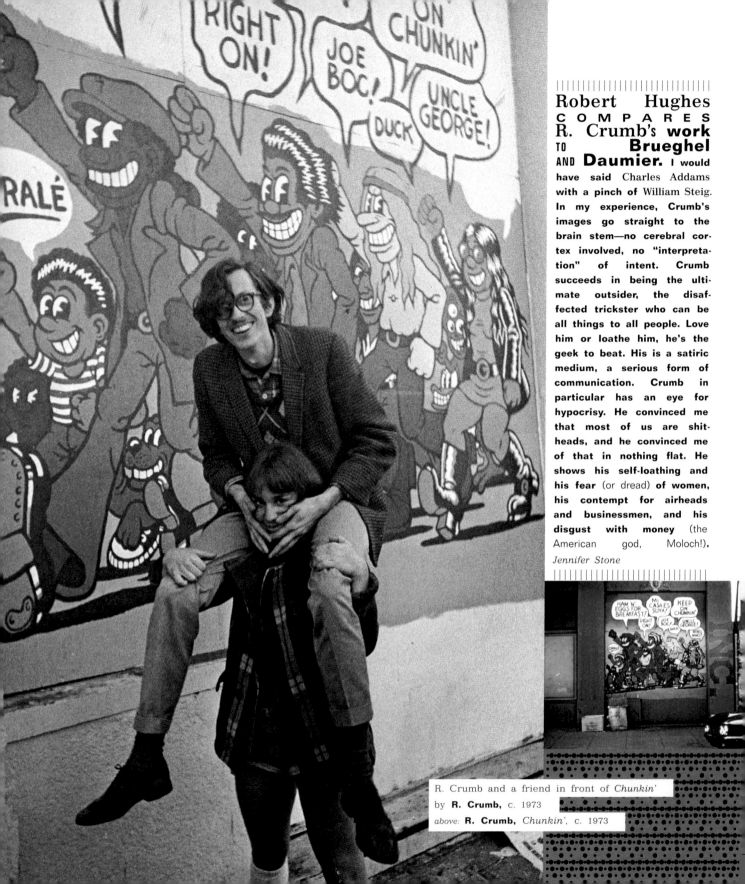

Robert Hughes COMPARES R. Crumb's work TO Brueghel AND Daumier. I would have said Charles Addams with a pinch of William Steig. In my experience, Crumb's images go straight to the brain stem—no cerebral cortex involved, no "interpretation" of intent. Crumb succeeds in being the ultimate outsider, the disaffected trickster who can be all things to all people. Love him or loathe him, he's the geek to beat. His is a satiric medium, a serious form of communication. Crumb in particular has an eye for hypocrisy. He convinced me that most of us are shitheads, and he convinced me of that in nothing flat. He shows his self-loathing and his fear (or dread) of women, his contempt for airheads and businessmen, and his disgust with money (the American god, Moloch!). *Jennifer Stone*

R. Crumb and a friend in front of *Chunkin'* by **R. Crumb,** c. 1973

above: **R. Crumb,** *Chunkin',* c. 1973

Chicanismo demanded political empowerment, education, and visibility for Americans of Mexican descent. Murals were intimately connected with the movement. "Chicanismo was central to our mural philosophy, and murals were powerful visual manifestations of Chicanismo," says veteran muralist Ester Hernandez. "We didn't control media—not newspapers, not television, not radio stations. Murals and screenprinting were our way of getting out our ideas, visions, and concerns in public spaces at a low cost. We were inspired by Chicanismo's emphasis on collective work and by Diego Rivera and José Clemente Orozco, who demonstrated how artists could be of public service, both beautifying and informing their communities." //

Even though it had its roots in Chicanismo, Muralismo was free of a central manifesto, allowing it to blossom organically as a vibrant part of the spectrum of political and cultural organizing occurring across the Bay Area in the early seventies. Galería de la Raza cofounder and veteran arts organizer René Yañez recalls the decentralized mushrooming of murals in the Mission: "There were different groups doing murals. College students. Immigrants. Some of them were paid by agencies or businesses and some by CETA, the Comprehensive Employment and Training Act, a short-lived but crucial federal program of the seventies that paid artists and other professionals to provide services to communities." ///////////////////////////

It was logical that Muralismo would develop in the Mission District. By the early seventies, many neighborhood residents had already seen murals adorning the walls of bars, movie theaters, and other businesses. Many San Franciscans were already familiar with public murals created during the era of the Works Progress Administration (WPA), the grandparent of the CETA program. The electrifying presence of international art superstar Diego Rivera during that era also had a lasting impact on the arts in the city, and his murals at the San Francisco Art Institute and San Francisco City College remain art jewels of the city. Furthermore, many Mission District residents were immigrants from Mexico, where public murals were widespread and highly regarded, so much so that the great mural artists were national celebrities, complete with adoring protégés and groupies. Add to that San Francisco's own long history of left-of-center political and cultural activism, and the Mission District was primed for the rise of Muralismo.

Start Up

In 1971, famed underground cartoonist Spain Rodriguez unveiled *Horizons Unlimited*, one of the first outdoor paintings of the mural movement in the Mission. Sponsored by Horizons Unlimited, a youth job-training and substance-recovery service center, the mural was a hit with the staff and clients of the building. Rodriguez recalls the comic strip–inspired piece in detail. "It was on the Folsom Street side of the building at 22nd Street. Chuy Campusano, Bob Cuff, and Rubén Guzmán painted the border and I painted images in four panels. One had a bunch of guys playing congas. I'd sketched those guys weeks before when they were playing in Dolores Park. There was a landscape with a Paul Bunyan statue at a gas station on South Van Ness and a scene of Mission Street. Finally, there were paintings of the faces of the youth who came by Horizons Unlimited. People loved having their pictures painted on the wall." The use of *Horizons Unlimited* to reflect the neighborhood back to itself showed how murals could create a dialogue between art and site instead of dropping into a locale like some alien invader armed with a pre-determined agenda, ignoring what existed there already. Other artists and agencies soon inaugurated their own murals, kick-starting an art movement that would leave the Mission District ablaze in public art.

From the onset, artists used murals as public forums in which to address both acute and longstanding community issues, all the while cultivating neighborhood allegiances. "Muralists were a very specific kind of artistic group," says forty-year mural veteran Ray Patlan. "We were working in low-income communities. This gave us a community and an identity." One catalyst for early mural activity was the 1972 Mission redevelopment plan put forth by developers. Lured by the idea of creating a business district around the newly opened BART (Bay Area Rapid Transit) subway station at 24th and Mission Streets, developers proposed a radical demolition and reconstruction of the neighborhood. Mission District activists, citizens, and business owners formed the Mission Coalition Organization to stop the redevelopment. ///////////////////////

As the redevelopment plans threatened to erase entire segments of the Mission District, artist Michael Rios created a

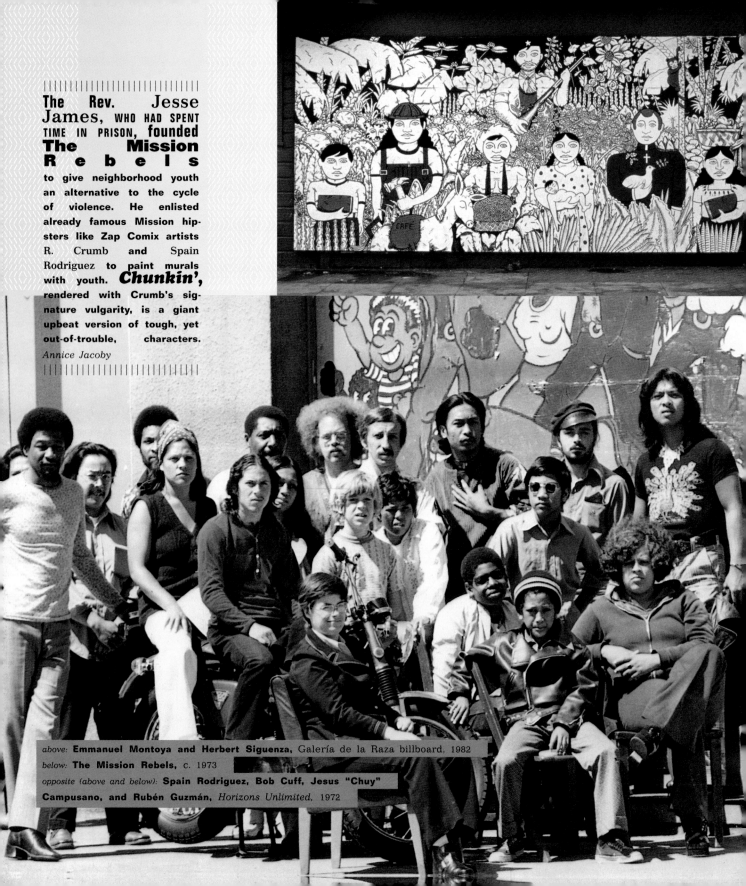

The Rev. Jesse James, WHO HAD SPENT TIME IN PRISON, founded **The Mission Rebels** to give neighborhood youth an alternative to the cycle of violence. He enlisted already famous Mission hipsters like Zap Comix artists R. Crumb and Spain Rodriguez to paint murals with youth. ***Chunkin'***, rendered with Crumb's signature vulgarity, is a giant upbeat version of tough, yet out-of-trouble, characters.

Annice Jacoby

above: **Emmanuel Montoya and Herbert Siguenza,** Galería de la Raza billboard, 1982

below: **The Mission Rebels,** c. 1973

opposite (above and below): **Spain Rodriguez, Bob Cuff, Jesus "Chuy" Campusano, and Rubén Guzmán,** *Horizons Unlimited,* 1972

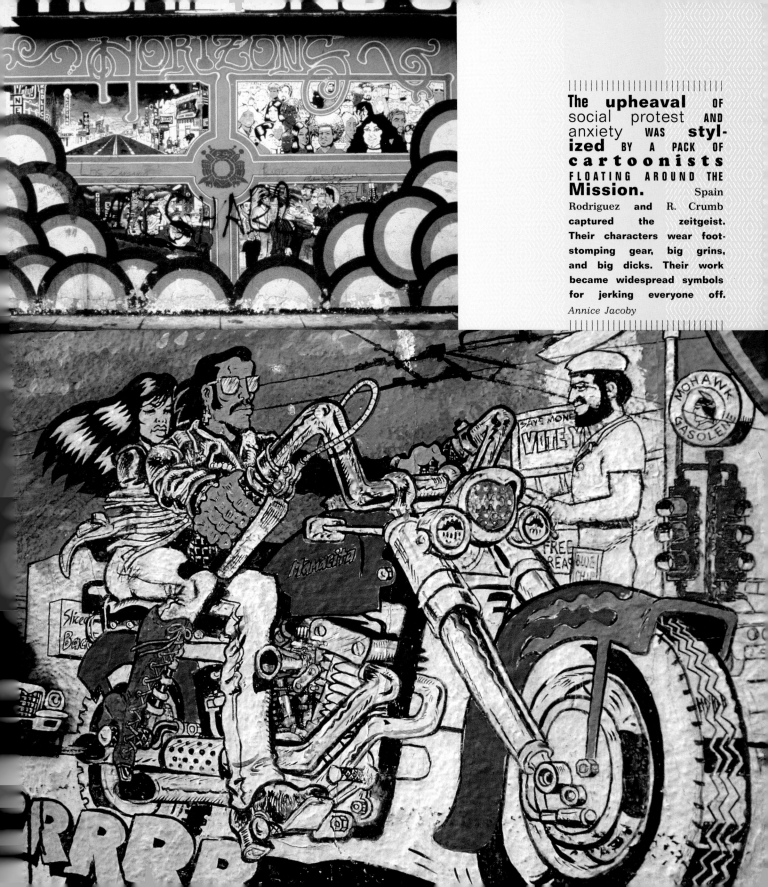

The **upheaval** OF social protest AND anxiety WAS **styl-ized** BY A PACK OF **cartoonists** FLOATING AROUND THE **Mission.** Spain Rodriguez and R. Crumb captured the zeitgeist. Their characters wear foot-stomping gear, big grins, and big dicks. Their work became widespread symbols for jerking everyone off.

Annice Jacoby

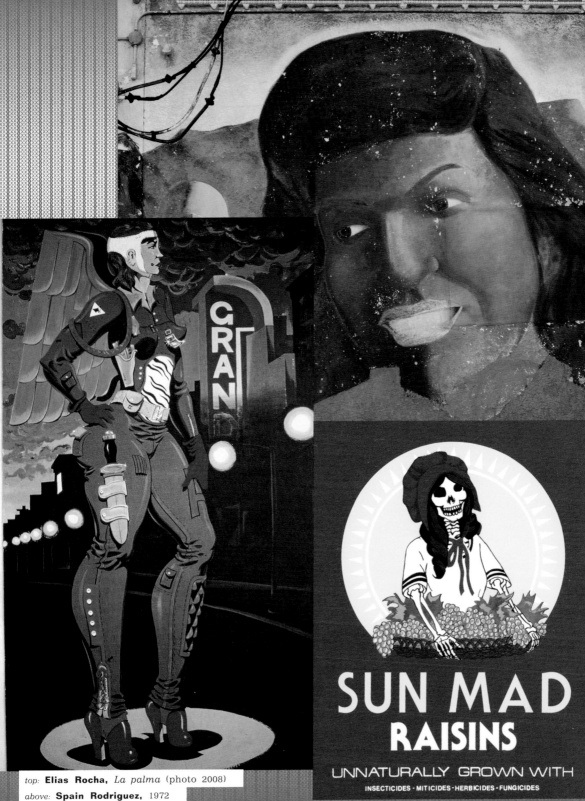

SUN MAD
RAISINS
UNNATURALLY GROWN WITH
INSECTICIDES · MITICIDES · HERBICIDES · FUNGICIDES

top: **Elias Rocha**, *La palma* (photo 2008)
above: **Spain Rodriguez**, 1972
right: **Ester Hernandez**, *Sun Mad*, 1982

mural that asserted a neighborhood perspective on the question of mass transit investment. On a strategic wall overlooking the 24th Street BART station, he painted a mural that challenged the glittering vision of mass transit offered by the city and developers. "I wanted to show how the people of the neighborhood would shoulder the tax burden for this transit system," says Rios. In the mural, a BART train speeds through a San Francisco cityscape on elevated railway tracks. The cross beams supporting the tracks are in fact humans, who are literally shouldering the elevated trains as surely as they shouldered its cost. Below, the proverbial huddled masses bear witness to the scene. Faded from years of exposure to the elements, the mural remains a determined if not fatalistic period piece of resistance that now seems at odds with the bustling intersection that is 24th and Mission, where multinational corporations, mom-and-pop takeouts, street vendors, and drug dealers maintain thriving businesses supported by people transferring on and off the BART system. //
///
///

Rios and his fellow muralists wrestled with issues of public representation, aesthetics, responsibility to the neighborhood, and their artistic vision. "We were forever placing audience first in our work as muralists," says Patricia Rodriguez, a founding member of the mural collective Las Mujeres Muralistas. "We created a mural called *Para el mercado* [For the Marketplace] because in urban settings like San Francisco, a lot of kids simply didn't know where food came from. We would ask them where milk came from and they'd say, 'from the corner store.' So we painted this mural that showed where fish, dairy, and vegetables come from." //
///
///

The early seventies were intense and galvanizing; aesthetic ruptures among artists, collectives, and organizations happened constantly. "You almost had to take sides on everything," recalls Ray Patlan. "It wasn't just the Chicanos either. There was an identity being formulated in all the communities. The Asians, Blacks, Latinos, even in the white communities, they were defining themselves as Poles or Lithuanians, not just white. If you claimed that you wanted to paint something for 'the community,' there were many demands placed on your artistic expression. Sometimes it felt like you had to be culturally correct to get anywhere as a muralist." /////////////////
///

Because historically there had been so few public visual representations of the marginalized communities of the Mission District, every new mural had to sort out dense questions of race, ethnicity, gender, artistic responsibility, and activism. The varied strategies used by artists caused conflicts. "We had artistic arguments, shouting matches, and even *chingasos* [blows]," reports Ester Hernandez. They argued about what was bourgeois and what was revolutionary, what was sexist and what was inclusive, what was worthwhile and what was garbage, beautiful and ugly, self-indulgent or communal. Decades later, those questions and more continue to be negotiated by each succeeding wave of muralists who want to bring art to neighborhoods whose residents rarely feel encouraged or empowered to set foot in galleries and museums. /////////////
///
///

Counterintelligence ///
///

Many of the early mural artists were concerned with advancing counter-narratives—radical retellings of history that put front and center the concerns of communities and individuals ignored or reviled by mainstream cultural, governmental, and commercial interests. This grew out of frustration with the master narratives delivered by schools, the media, and governmental sources. //
///
///

Ray Patlan also recalls the pervasive sense of art-school rejection. "Murals were thought of as trashy and gauche. The bias I encountered was cultural, racist, and against social engagement. Art wasn't supposed to be about reality. It was supposed to be this ephemeral, fantastic thing, which came from inside of you, your suffering, your torture, your anguish." //
///

Changes were happening quickly, with political awareness and dissatisfaction at unprecedented levels among artists, students, and activists. As artists created murals in those first years, they challenged established understandings of history, culture, and politics by monumentalizing Mexican, Latin American, working-class and third-world images and symbols. They celebrated people and places of the Mission District, which was perceived by some at the time as a violent and criminal ghetto of negligible artistic significance. //////////////////////////////////
///
///

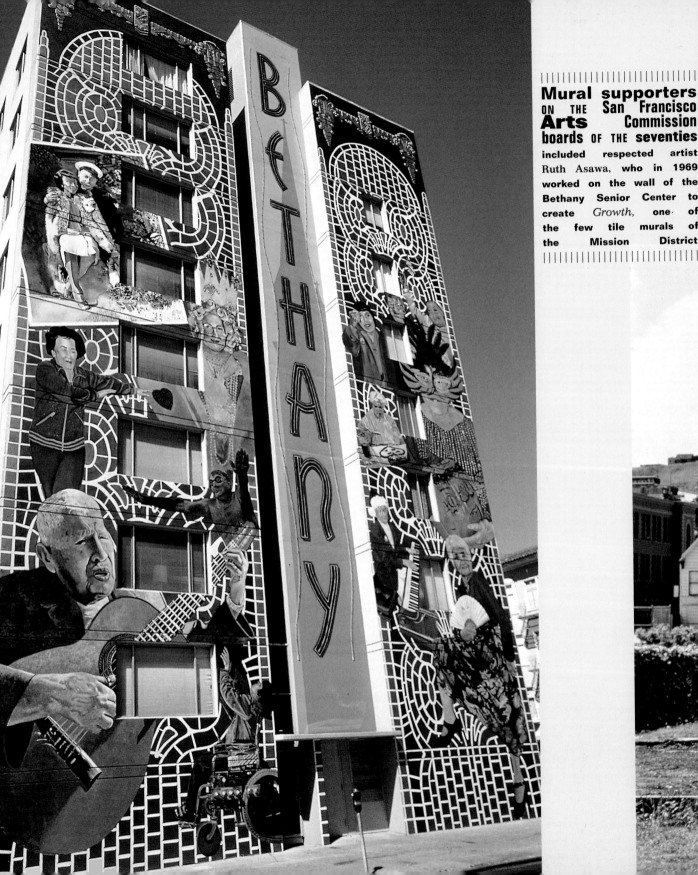

Mural supporters ON THE San Francisco **Arts** Commission **boards** OF THE **seventies** included respected artist Ruth Asawa, who in 1969 worked on the wall of the Bethany Senior Center to create *Growth,* one of the few tile murals of the Mission District.

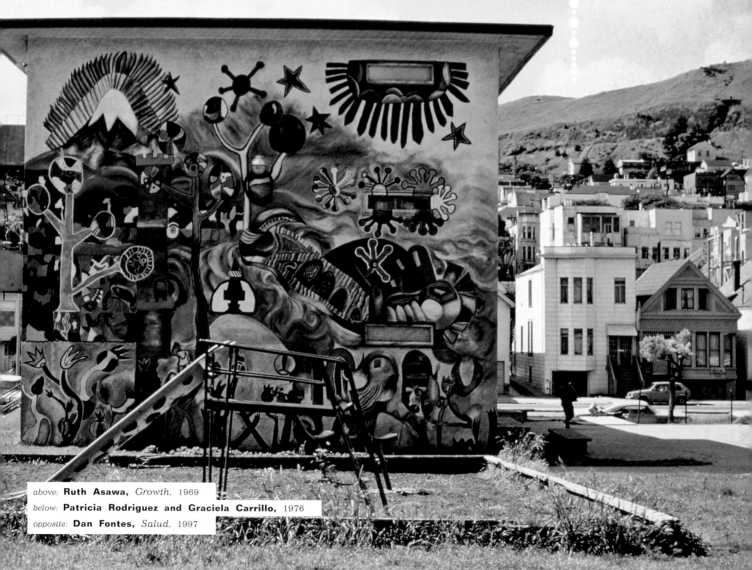

above: **Ruth Asawa,** *Growth,* 1969
below: **Patricia Rodriguez and Graciela Carrillo,** 1976
opposite: **Dan Fontes,** *Salud,* 1997

Within two years, numerous murals had gone up in the Mission, and with them, a palpably male-centered, Chicano mural aesthetic was being established. The aesthetic was often visually vigorous, assertive, politically grand, and inclined toward revolutionary images. Chicanos were reclaiming their identities and in the process taking their American alienation as brown outsiders and turning it into a badge of honor. Out came the plumed Aztec warriors, cacti, and the dusky Virgin of Guadalupe. "Yes," the symbols seemed to assert, "We really are that different. *Y que.*" //
//
//

The emphasis on iconic imagery worked against some artists. Alternative visions of expressing Chicano experience were not embraced or encouraged. Patricia Rodriguez recalls competing with fellow muralist/activist Ray Patlan for an art teaching position at UC Berkeley. "It was a huge interview process that included sixty students and ten faculty. Ray Patlan showed his slides before me. His murals were very male. They had to do with hands. Labor. Muscles. Fists holding hammers, building things. Heroic. They loved it. Then I showed my work, in which I looked at our movement through *familia*, love, sensitivity, and children. I got hissed at. The students challenged me and said, 'That's not Chicano art.' They only wanted the symbol set of Chicano art. The United Farm Workers' eagle, the Brown Berets, Zapata." ///////////////
//
//

As a forceful mural aesthetic took root in 1973, Las Mujeres Muralistas emerged and began creating their own counternarratives. The group would produce dozens of murals over the next eight years. The original core group consisted of Graciela Carrillo, Consuelo Mendez, Irene Perez, and Patricia Rodriguez. Other painters would join the collective over time, including Ester Hernandez, who recalls, "At the time, the Chicano movement had a super nationalistic element, and a lot of the murals were reinterpretations of Mexican masters. The *mujeres* in the collective forced us to get real about what Latino community really meant because they were not all Chicanas. They were from a lot of different backgrounds. They were South American, Puerto Rican. They were Afro-Latino, Euro-Latino, you name it, and they made us deal with our diversity, which we are still trying to deal with today." //
//
//

Ironically, as political groups of the seventies advanced radical ideas of liberation, they often upheld sexism. Muralismo was no exception. Reaction to the advent of women muralists could be hostile in the early years. Some of the worst interactions happened during the first few Mujeres Muralistas projects. "When we first started," says Patricia Rodriguez, "the Chicano male artists were not supportive. Some of the guys would say things like 'give it up' or 'you can't handle it' or 'you're not artists so get off the scaffolding' or 'that's not revolutionary imagery.' But my revolution was to be a woman getting up on the scaffold of a three-story building and doing what they were doing all along. We *were* the revolution." ////////////////////////
//
//

Ray Patlan also recalls his own initial difficulty of understanding the women's approach. "When I first saw the Mujeres Muralistas murals, I said, 'why are they doing these portraits with parrots and palm trees?' In Chicago, we were painting people all angry, snarling at each other, cops coming at people, Malcolm X, Martin Luther King, Cesar Chavez. We were aggressive, but they weren't. I kind of felt cheated. I expected to see the San Francisco artists doing the same thing, but that was ignorant of me. I didn't understand the environment till I moved here, and then I really began to understand how the Mujeres Muralistas were such an important aspect of the mural movement. Their art made a difference in the way people looked at murals, the way artists looked at each other, and the way men began to look at women." ////////////////////////
//
//

Rodriguez recalls when the Mujeres Muralistas were working with a male lead artist on a park mural project: "His images for the park were tractors, guns, and images that advanced ideas of revolution," she recalls. "We women were immediately thinking about the audience for the mural. Children and seniors would use the park, and we created images for that audience." Gender was only one of the sources of muralist rivalry. "Muralists were just plain old competitive with each other," says René Yañez. "Each new mural project tried to outdo the previous one. We wanted to show the Mission's character, beauty, and personality, define its concerns and boundaries," recalls Yañez. The artists looked back into history *and* down the street for inspiration. Time, space, and genre collapsed and reconstituted themselves in the murals. Tricked-out low-rider cars appeared, endowed with all the fetishistic beauty and portent of the sedans in Chevrolet's latest

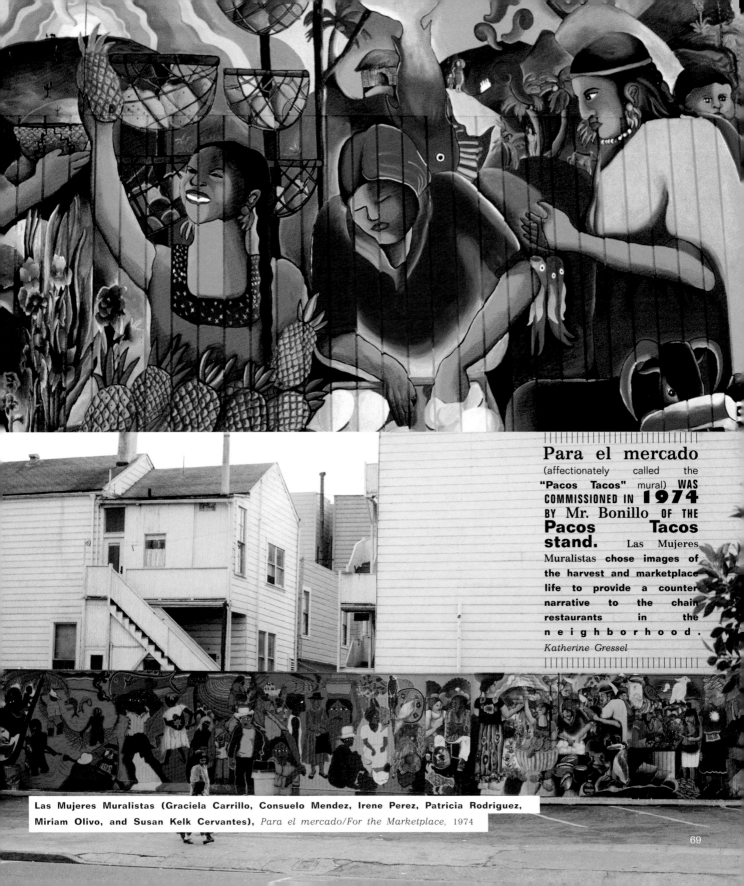

Para el mercado (affectionately called the "Pacos Tacos" mural) WAS COMMISSIONED IN 1974 BY Mr. Bonillo OF THE Pacos Tacos stand. Las Mujeres Muralistas chose images of the harvest and marketplace life to provide a counter narrative to the chain restaurants in the neighborhood.

Katherine Gressel

Las Mujeres Muralistas (Graciela Carrillo, Consuelo Mendez, Irene Perez, Patricia Rodriguez, Miriam Olivo, and Susan Kelk Cervantes), *Para el mercado/For the Marketplace*, 1974

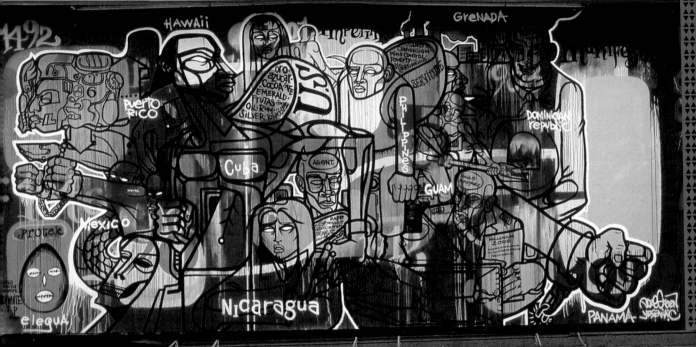

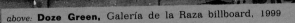

above: **Doze Green,** Galería de la Raza billboard, 1999
below: **Kenneth Huerta and Diana Cristales,** *Mal burro* (Galería de la Raza billboard), 1995

billboards. The Virgin of Guadalupe took a leave from the Hill of Tepeyac to watch over the backs of homeboys on 24th Street. Comrades Che, Cesar, Malcolm, Frida, and Monseñor Romero loomed over Mission District streets with the titanic scale of pop stars and the moral gravity of modern political saints. In time, those radical figures would be bled almost dry of revolutionary juice in preparation for pop-cultural delectation. In 2001, Cesar Chavez's image appeared on billboards for Apple Computers. Denzel Washington and Salma Hayek eventually starred in Hollywood biopics of Malcolm X and Frida Kahlo, respectively. They had become palatable, almost safe icons, but in those early years of Muralismo, the visual sampling and manipulation of their images was fresh, bold, and inspiring for neighborhood artists and residents alike. ///////////
//
//
With so many murals being produced, and commissions and notoriety coming to numerous artists, it was inevitable that Muralismo would begin to "go legit" by professionalizing and centralizing mural art activity. This growing legitimacy was in evidence by 1977, when a very significant new stakeholder to the mural arts appeared. A group of muralists involved in a community workshop organized by Susan Kelk Cervantes created a portable mural titled *Masks of God, Soul of Man*. Most of the artists were from the Precita Valley neighborhood, so when it came time to sign the mural, they signed it "Precita Eyes Muralists." In 1979 they became a formal organization, which continues today as the Grand Central Station for Mission mural activity. Muralismo now had an address and a headquarters from which to expand. This was a critical step in the development of the Muralismo infrastructure, and a groundbreaking feat of arts organizing. Up until then, there had never been a Bay Area organization solely devoted to mural creation, preservation, and education. To this date, there are only four established mural centers in the United States. Precita Eyes has originated and refurbished dozens and dozens of murals, making the streets of the Mission District some of the most artistically dynamic in the entire country. /////////////
//
//

And in This Corner ///
//
Mission District murals have always competed with billboards for prominence in the streetscape. It is natural that murals and billboards should simultaneously rival and borrow from each other. Both are monumental visuals full of color and

grand gestures. Both serve as territorial markers for the sponsor of the images. Both occupy a strong place in the neighborhood, sometimes cohabiting at eye level with pedestrians, sometimes looming over everything, but always contributing to the meaning of the area they occupy. Both murals and billboards embody the grand presumption of guiding the beliefs, thoughts, and actions of the people in the neighborhood. Most striking is the congenitally utopian tendency of both murals and billboards to point viewers toward the ever-more perfectible life. *Stop smoking. Don't get pregnant. Buckle up. Buy this canned soup. Buy this liquor. Buy this car. Be proud of your heritage. Boycott grapes. Challenge U.S. militarism abroad.* Commercial billboards assure us that we can consume our way into a better life. Public service billboards assert that prudent actions, as dictated by public agencies, improve our lives. Murals insist on the centrality of civic engagement, education, and action in creating a better world. ///
//
//
An interesting example of the billboard/mural interplay can be seen in the history of the mural space on the Bryant Street wall of Galería de la Raza. In 1974, Galería's co-director René Yañez initiated one of the Mission District's earliest repurposing of a commercial billboard. It started when Yañez contacted the advertising company that owned the billboard on Galería's Bryant Street wall. He informed the company that he did not want any more ads for Colt 45 or cigarettes on that billboard. "I told them I had never seen those kinds of billboards in Pacific Heights or the Marina. Just in the poorer neighborhoods. They told me to fuck off." When word of the exchange got out, community members were angered. One artist painted a mural over the billboard. The billboard company threatened to sue, and Yañez called their bluff. "Go ahead and sue me," he said. "I could use the publicity." The company retaliated by taking the entire billboard down, and once again community artists responded. They began liberating and outright vandalizing the company's billboards all over the Mission. The situation became intolerable for the advertising company. They replaced the billboard, and for the past three decades it has served as a site for dozens and dozens of temporary murals painted one atop the other. //////
//
//
If you took a power saw and sliced through the Galería billboard, the cross section would reveal a thirty-year history of

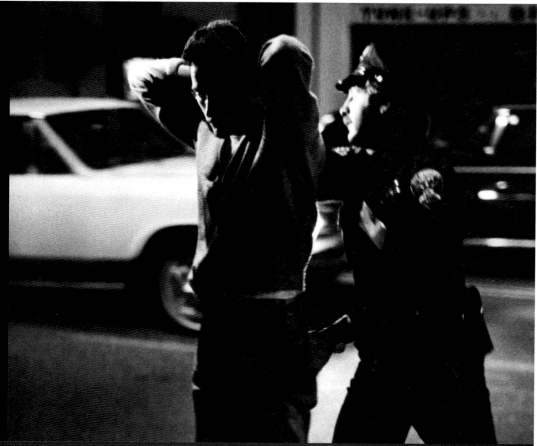

EL BARRIO AND THE DREAM
WILLY LIZARRAGA

AT THE end of 1978, the Mission was a funky, predominantly Latino neighborhood experiencing its first and rather gradual metamorphosis into an alternative bohemian hangout. A few cafes had just opened. There were no fancy restaurants. Rainbow's organic produce store had opened next to the Roxie Cinema, which had recently shed its porno-theater skin and become an artsy film house. There was the loud and tough presence of dykes on and off bikes along Valencia Street. The punks on 16th Street, with their red, purple, and green hair, were the most surreal agents of gentrification.

Among all the colorful, urban tribes in the barrio, however, the real kings of the Mission were the low riders, pit bulls included. On weekends, they would cruise Mission Street and transform it into a bumper-to-bumper car and fashion parade: the *rucas* in full makeup and tight, skimpy dresses; the *vatos* showing off the creases on their pressed zoot suits; and the cars, transformed into baroque art installations. The cops did not view these weekend *pachuco carnavals* with approving eyes. So they crushed them, in one of the most brutal chapters of police brutality in the city.

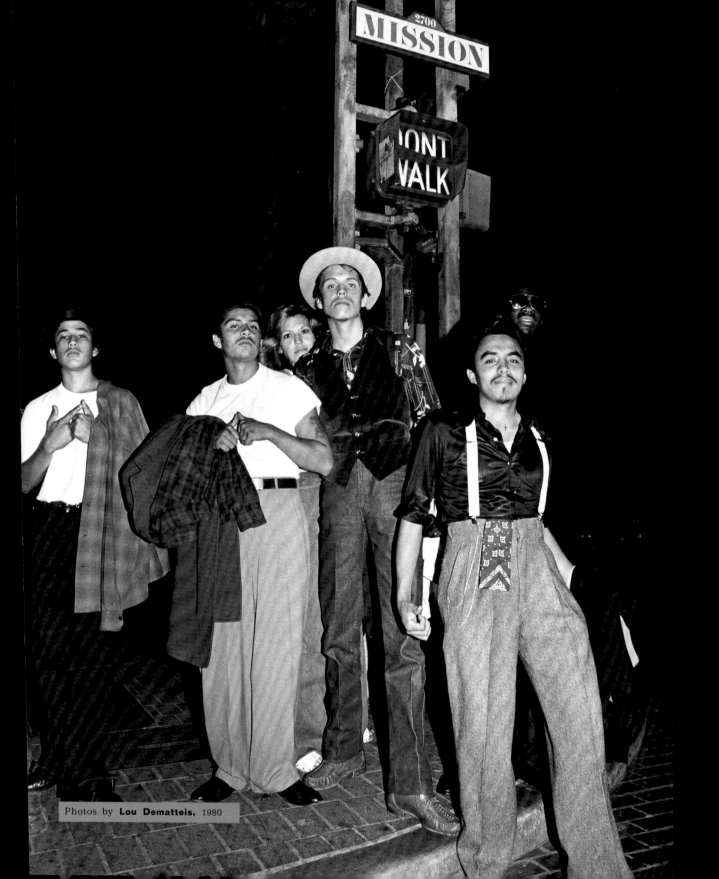

Photos by **Lou Dematteis,** 1980

73

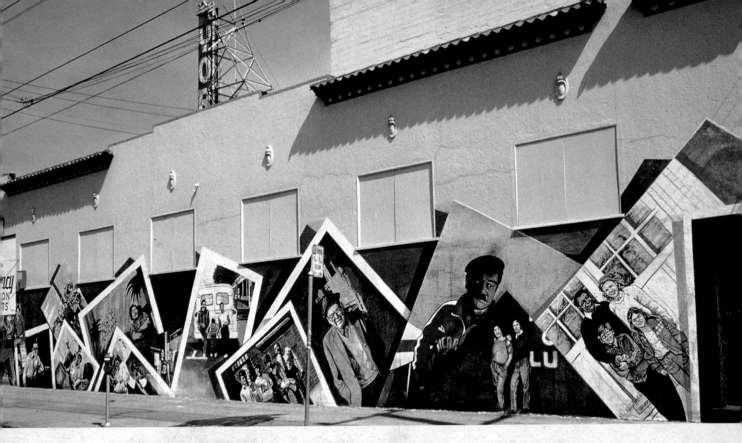

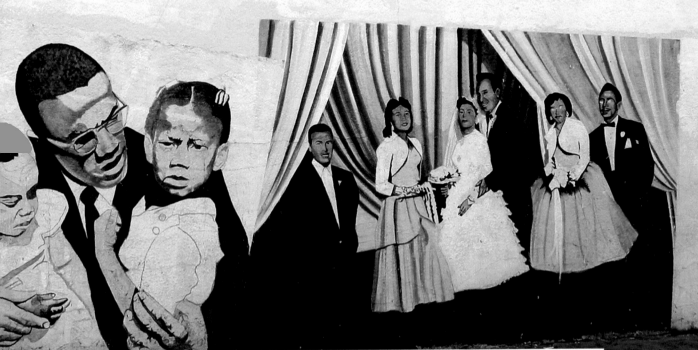

above: **Ray Patlan, Carlos "Cookie" González, and R.A.P.,** *Y tu y yo y que/And You and Me and What,* 1984
below: section repainted by **Carlos "Cookie" González and R.A.P.,** 1996

artistic activity. At the very bottom layer, you would find the original liquor ad depicting some dandy in hip-hugger jeans with his groovy girlfriend. In the huge middle part of the cross section, you would see vibrant layers of paint and primer, an almost geological stratification of hope, celebration, and protest in paint that ended with a 1998 anti-imperialist mural by master graffiti artist Doze Green. On the very top layer, which represents the last six years of murals commissioned by Galería, you would find residue left behind by adhesive-backed photomurals that artists design digitally and send to a Tennessee-based commercial billboard company for printing. After more than twenty-five years, Galería's mural wall has come home to its billboard roots. //////////////////////////////////////
//
//

Beauty Is a Verb //
//

How do we define success and beauty in public art? In engaging this question, Muralismo offers a new vision of what public art can and should do. Throughout the Mission District, dozens of murals uphold the traditional notion of the artist as a highly skilled handler of paint who is heir to the fresco masters of the Italian Renaissance and later the Mexican muralists. The colors are beautifully blended, the landscapes inviting, and the figures inspiring. Within a block of those finely crafted murals, however, we might see a mural painted by adult beginners or even children. The temptation is to see the latter mural as a botched art project, lacking in compositional strength, color theory, or subtlety. Even staunch mural advocates recognize this. Muralismo, however, has expanded the criteria for evaluating mural art. Technical proficiency is just one standard among several for judging a mural. Painterly skills matter, but, in murals, text can matter too. Placement can matter. Timeliness can matter. Community involvement most certainly matters. //
//
//

Yañez recalls the importance of community input for the early murals: "We'd have meetings at Galería de la Raza. We'd post flyers telling folks we were going to have murals going up and that we were seeking neighborhood input. I remember once neighbors complained about a mural. We organized a meeting with the artist, and he ended up painting over his own mural with another one because the neighbors felt so strongly against it. Replacing the mural was part of the artist's relationship with the community. It was a good thing." //////////////////////////////

Precita Eyes Muralists codified a richly collaborative mural-making procedure. Muralists are encouraged to invite the mural's future neighbors and stakeholders to participate in conceptualizing the images and symbols. Some neighborhood residents actually help paint the murals, regardless of their skill level. This process advanced art as a community-building activity. After painting on a mural for days or weeks, a child can walk past her finished work and feel a proud sense of ownership and engagement. By honoring the importance of the community process, Muralismo reveals a new kind of beauty, the beauty of intent, personal growth, and artistic labor as a form of service to the neighborhood. This is different from the way murals were evaluated traditionally, and worlds away from commercial gallery-based markers of success, with their focus on individual stardom based on an artist's track record of impressing curators and/or critics, or (better yet) attracting collectors. //
//

Players //
//

Every act of artistic presentation involves stakeholders. In a museum, an exhibition might require the participation of the artist, collectors, civic agencies, and sponsors. Murals in the Mission District have their own unique chain of stakeholders who can have an impact on the content and look of a mural. Consider the following scenario, which is not all that unusual. San Francisco Hotel Tax Fund monies are channeled to the San Francisco Arts Commission. The commission may then award grants to a neighborhood organization with a plan to create public art. The organization selects and pays an artist to work with neighborhood residents to create the mural. The artist group might then consult with the owner of a local apartment building about painting a mural on one of his walls. Once the apartment owner agrees, the artists may then consult with neighbors about what kind of mural they want, run the designs by the building owner, and amend as needed before laying the first brushstroke to the wall. The final mural is painted on private property but is sometimes protected from destruction by federal and state ordinances such as VARA (Visual Artists Rights Act) and CAPA (California Arts Preservation Act), laws that protect the rights of artists' work. //////////////////////////////
//
//

In another scenario, a corner store proprietor could hire graffiti artists to do a mural in exchange for a small stipend and the cost of the paints. This not only beautifies the store, it also engages the artists in a legal mural that they can work and rework at their own pace without fear of getting fined or arrested. The artists may or may not consult neighbors but will most likely show the store owner the designs and negotiate the content, colors, and style as needed. The owner may do this to support the artists while protecting his store from vandalism, especially if the artists are respected in the neighborhood and the graffiti community. ///////////////////////////////
///
///

The most stripped-down stakeholders are those muralists who work without permission. For example, a group of artists with a political or aesthetic message might simply take over a wall or other space without asking anyone. This work might happen in the late-night hours or other times when their production will attract the least amount of police or onlooker attention. In this case, the artists are the main stakeholders. No one commissions the work. The neighbors may love or hate the mural, but they are not consulted in the process. The guerrilla mural may be whitewashed in days or remain for years. The artists' identities may remain unknown or be coded through the use of evocative pseudonyms. In this scenario, the artists assume both maximum freedom and maximum risk. ///////////////////////
///
///

Presente ///
///

When the heady seventies came to a close and key art-funding streams dried up, Mission District muralists adapted with varying degrees of success. The counter-narrative strategy of Muralismo had succeeded all too well, and the once-potent symbols and images of the murals became increasingly predictable and clichéd. Despite this, the eighties and nineties were by no means periods of stagnation. New energy was infusing itself into Muralismo. Chicano-centric politics and content ceased to have a hegemonic hold over the content of murals as artists addressed the issues of refugees and immigrants from Nicaragua, El Salvador, Guatemala, Chile, Cuba, Colombia, and Argentina. Ray Patlan recalls the jolt provided by the mural work taking place beyond the United States and Mexico: "Eva Cockcroft had gone to Chile and brought this new concept of mural work relating to the Chilean coup, and documented the work of the Ramona Parra Brigade. Those artists were

actually being shot on the street for doing murals, so they would have to come and finish one in twenty minutes before the cops got there. They were incredible. People in other countries were willing to sacrifice their lives to do art. It was phenomenal. It stimulated us, gave us courage, and taught us new ways of working with our communities." ////////////////////
///
///

In 1984, Balmy Alley, the mural showcase of the Mission, had been dormant for almost a decade, with no new mural production going on and the existing murals fading and chipping by the year. Balmy Alley resident Patricia Rodriguez and fellow artist Ray Patlan, inspired by a New York group called Artists Call Against U.S. Intervention in Central America, decided to organize a series of Balmy Alley murals. Nine months and twenty-five murals later, the alley had once again become an artistic hotbed. It has remained active to the present, reflecting a thirty-year span of mural production and innovation. ////
///
///

In the past two decades, graffiti artists both disrupted and furthered the mural movement with their gestural tags and exquisitely rendered "pieces" (masterpieces) that gave Muralismo an overdue infusion of technical innovation and panache. Creative muralists from outside the Latino communities made their mark on Muralismo. Sometimes called the Mission School, this group of artists brought a new pop aesthetic and street sensibility that they transported back and forth from the gallery to the street. At Galería de la Raza, Executive Director Carolina Ponce de León initiated the era of media-savvy digital murals. The works appropriated and subverted the slick technologies of commercial billboards to address police harassment, immigration, and gentrification. Waves of heroin, cocaine, speed, and crack moved through the neighborhood, bringing violence and debilitating addiction to some. There were recessions, economic bull markets and the extraordinary dot-com gold rush of the nineties, when Mission District rents skyrocketed, displacing hundreds of residents and focusing the muralists' attention on gentrification, "economic cleansing," and globalization in the Mission and beyond. Throughout it all, murals have remained the defining visual characteristic of the neighborhood, marking both the heart of the district and the broad expanse of its imagination. ///////////////////////////////
///
///

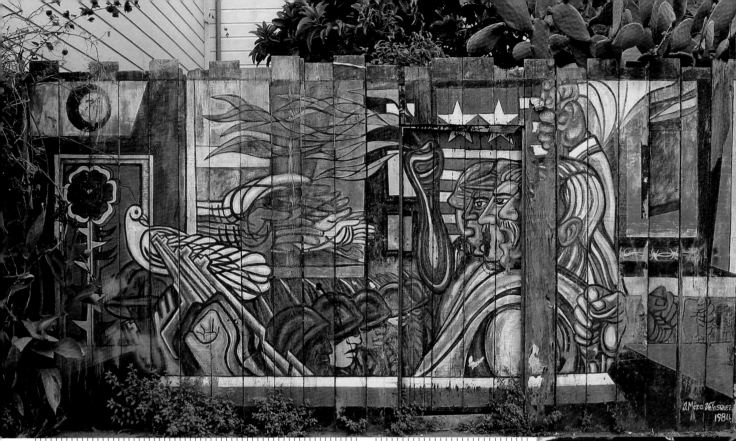

As a child I learned to paint the **beautiful things** that surrounded me at the ranch in Jalisco, M e x i c o , where I lived until the age of thirteen. My parents were farm workers. My mother was a Mestiza with Spanish blood. I grew up in a wholesome way, bathing in the rivers and streams, surrounded by beautiful countryside and mountains. I painted with my fingers in the sands of the river, with charcoal on the white rocks of the forest, and with pieces of burnt wood I took from my mother's kitchen stove. I was always writing and drawing on the walls of my house. I painted my drawings with garden and field flowers, tree leaves, prickly pear and other fruit juices, and the dyes of the calamari and the *chinchilla,* an insect that gives off a brilliant red, magenta color, using an indigenous technique I learned from my f a t h e r .

José Mesa Velásquez

My parents were **both** Mexicanos who immigrated here as **youngsters.** I studied at the San Francisco Art Institute, the California College of Arts and Crafts, and Stanford. I was a founding member of Galería de la Raza, Cine Acción, and Danza Xitlalli, a Mexican traditional dance company. I am working on "The Mexican Presence in San Francisco 1920–1950," an oral history project documenting our elders.

Francisco X. Camplis

above: **José Mesa Velásquez,** *United in Struggle,* 1984 (photo 2003)
right: **Francisco X. Camplis**

REFRIED AND REITERATED

ANNICE JACOBY

NANCY MIRABEL coined the phrase "Refried, Refracted, Reduced, Reiterated, and Reread" in reference to the impact of gentrification on Mission Latino life. As the neighborhood's social pressure cooker heated up, gourmet dining spots, from fancy to funky, waged a hand-to-mouth battle to out-*sabroso* taquerias for the popularity of the Mission as a gustatory heaven. The Mission boasts an international mix of populations and fabulous cuisines—from Africa, Cambodia, India, the Middle East, the Caribbean, and every Latin American country. Amid this splendor the number of taquerias is daunting, sometimes five or six on one block. Loyalty to the molé of one or the salsa of another creates hungry posses seeking the taco or burrito with the best street creds.

Most taquerias are elaborately decorated with murals that spark memories of Mexico. Mission Muralismo can't be separated from what feeds it, what it hungers for, what it remembers, what it dreams. *Cordova* is the signature in the bottom corner of many scenes, such as the Cathedral Plaza in Taxco or the *corrida* in Puebla, which announce the distinction of regional flavors. The murals instantly transport everyone away from contemporary America to a place of *gusto* and *picante*. Cordova's protégé, Ernesto Paul, took up the job of embellishing the taquerias with saints and jalapeños sporting sombreros. On the roof of Taco Loco, an upright taco is chased by a pistol-toting chili pepper. Both characters are running on skinny legs through the desert, acting out a familiar cartoon of disaster identified with the jokes and farces of everyday life. Mission artist Claire Bain says, "That's because El Taco Loco is next to the *pulque* bar with very loud *ranchera* music. Maybe the wailing *corrido* is about running from the police or *La Migra* (the INS)." The Cruisin' Coyote, Ernesto's nom-de-brush, has led many other artists to create a stylistic hybrid of taqueria art that ranges from the evocative *folklórico* of *retablos* to avant-garde revivals of ancient gods.

Cordova, 1970s
opposite above left: **Ernesto "Cruisin' Coyote" Paul**, *Aztec Calendar* (photo 2007)
opposite above right: **Ernesto "Cruisin' Coyote" Paul** (photo 2008)
opposite middle right: **Cordova**, 1980
opposite below: **Redesigned by the Precita Eyes Muralists Youth Arts Program**, *Leyenda Azteca*, 2000

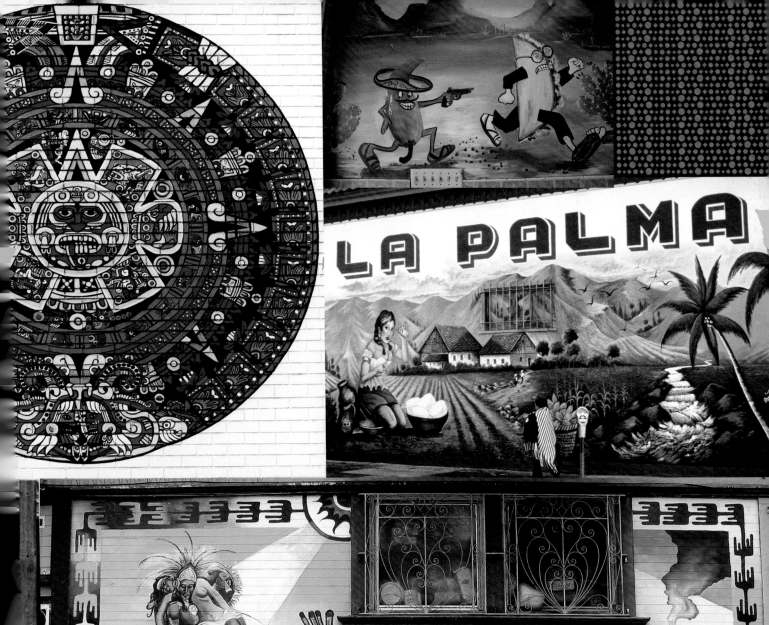

LA PALMA

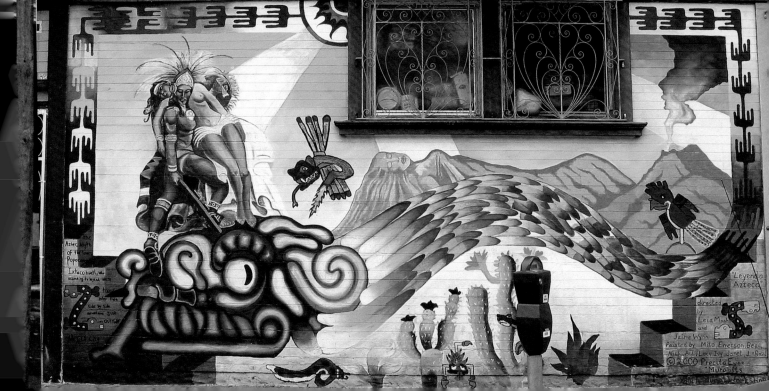

"Leyenda Azteca"

directed by
Leia Maal
and
Jaime Wynn
Painted by Milo Emerson, Ben
Neil, A.J., Lucy Ivy, Janet J. Raul
© 2000 Precita Eyes
Muralists

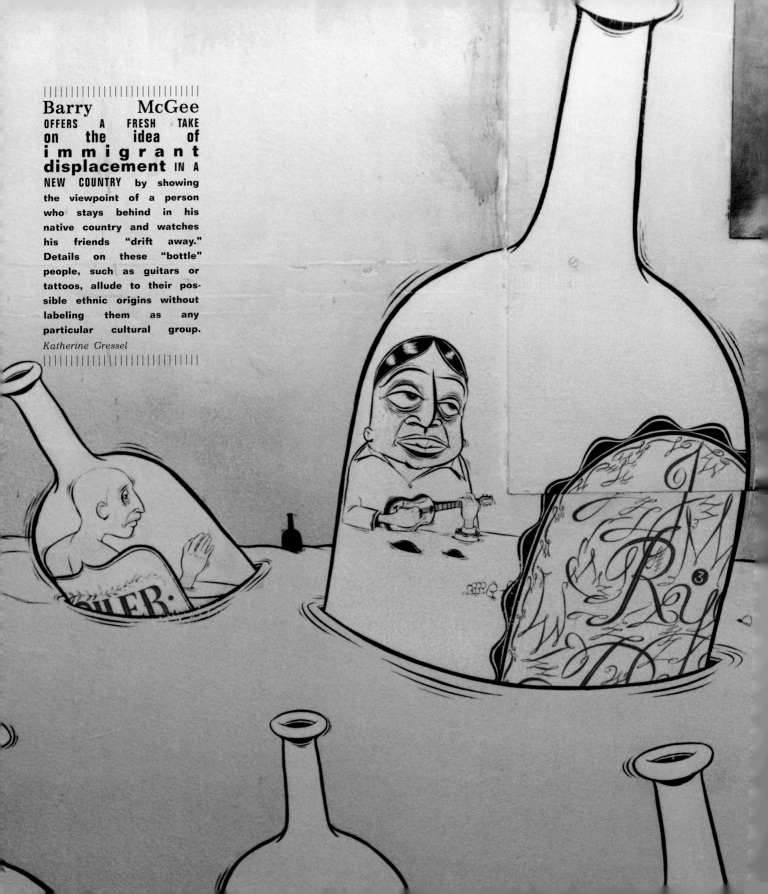

Barry McGee OFFERS A FRESH TAKE **on the idea of immigrant displacement** IN A NEW COUNTRY by showing the viewpoint of a person who stays behind in his native country and watches his friends "drift away." Details on these "bottle" people, such as guitars or tattoos, allude to their possible ethnic origins without labeling them as any particular cultural group.

Katherine Gressel

THE REDSTONE BUILDING
KATHERINE GRESSEL

BUILT in 1914, the Redstone Building, named the "Labor Temple" until 1968, was a headquarters of San Francisco's labor movement. The famous 1934 General Strike was organized there. In 1966 Dow Wilson, the firebrand leader of Painters Local 4, was assassinated near the building on the orders of a corrupt district official of his own union, with the apparent sanction of national leadership. In 1968 the labor council sold the building, which has since been occupied by diverse arts and advocacy groups. Today the Redstone Building functions both as a history museum and a contemporary art gallery, without the formality that characterizes most cultural institutions.

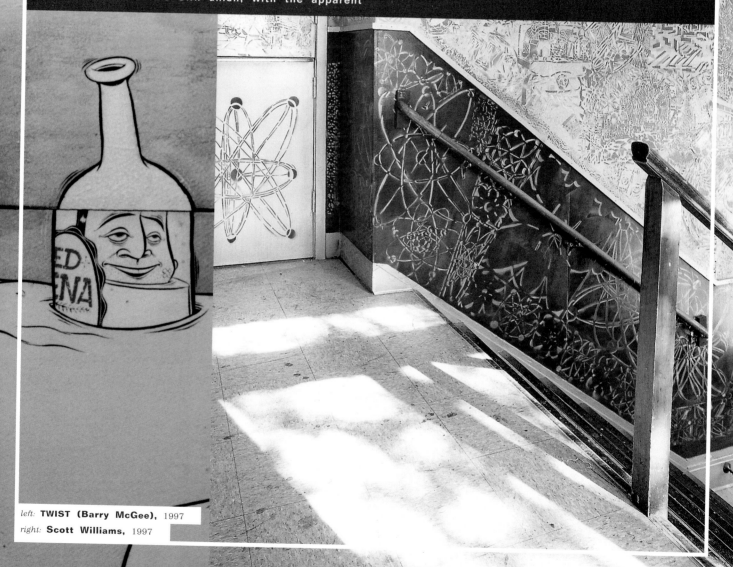

left: **TWIST (Barry McGee)**, 1997
right: **Scott Williams**, 1997

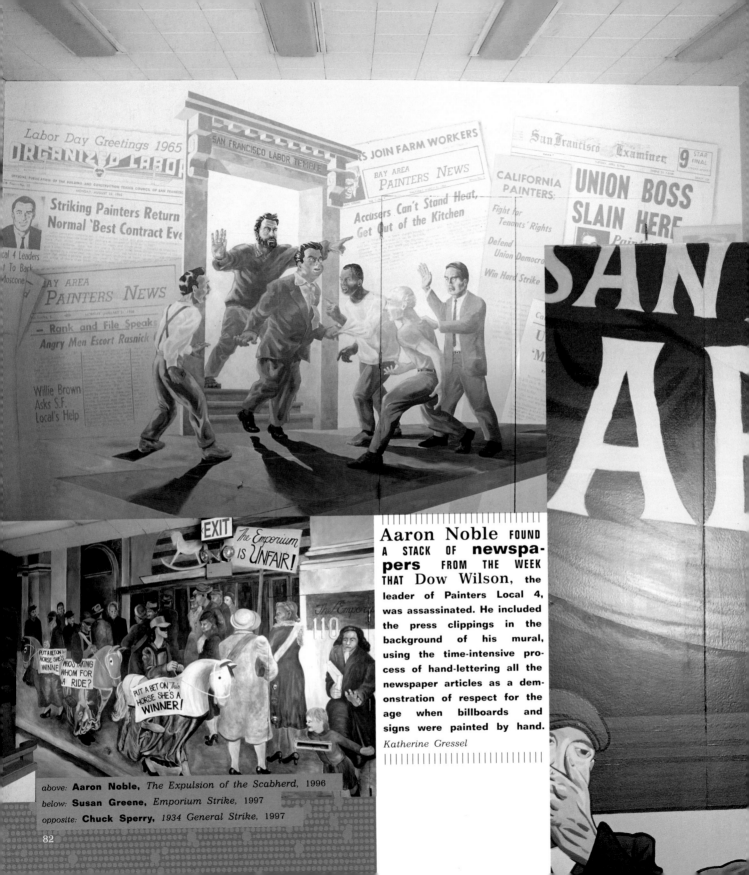

Labor Day Greetings 1965
ORGANIZED LABOR

Striking Painters Return
Normal 'Best Contract Eve

BAY AREA
PAINTERS NEWS

— Rank and File Speaks

Angry Men Escort Rasnick

Willie Brown
Asks S.F.
Local's Help

RS JOIN FARM WORKERS

BAY AREA
PAINTERS NEWS

Accusers Can't Stand Heat,
Get Out of the Kitchen

CALIFORNIA
PAINTERS:

Fight for
Tenants' Rights

Defend
Union Democra

Win Hard Strike

San Francisco **Examiner** 9 STAR FINAL

UNION BOSS
SLAIN HERE

SAN

EXIT The Emporium IS UNFAIR!

PUT A BET ON HORSE SHE'S WINNE
WHOS TAKING WHOM FOR A RIDE?
PUT A BET ON This HORSE SHE'S A **WINNER!**

Aaron Noble FOUND A STACK OF **newspapers** FROM THE WEEK THAT Dow Wilson, the leader of Painters Local 4, was assassinated. He included the press clippings in the background of his mural, using the time-intensive process of hand-lettering all the newspaper articles as a demonstration of respect for the age when billboards and signs were painted by hand.

Katherine Gressel

above: **Aaron Noble,** *The Expulsion of the Scabherd,* 1996
below: **Susan Greene,** *Emporium Strike,* 1997
opposite: **Chuck Sperry,** *1934 General Strike,* 1997

82

Chuck Sperry DEPICTS THE **1934 Labor Council** planning meeting IN THE **Redstone auditorium** when legendary labor leader Henry Bridges led a massive strike of the International Longshoreman's Association (ILA). On the morning of "Bloody Thursday," July 5, one thousand police officers attempted to clear picketers from the waterfront so that strikebreakers could do the work of the striking dockworkers. In the ensuing riot, sixty-four people were injured and two strikers were killed. The governor sent in the National Guard to prevent further violence. The mural shows the union hall auditorium, which was once part of the Redstone Building.

Katherine Gressel

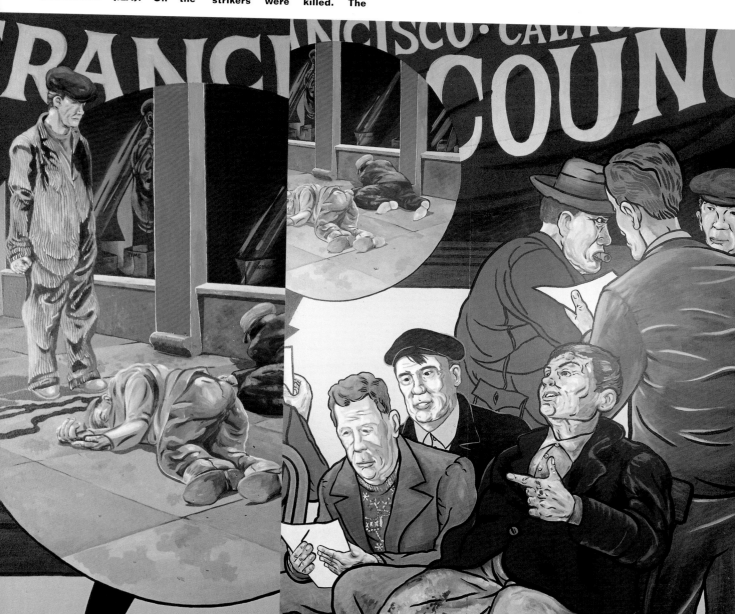

I painted this series of **tango singers** BASED ON OLD RECORDS FROM **my dad's collection.** Aaron Noble and Rigo saw my Luggage Store Gallery show and thought that it would make a good mural. Tango for me was pop art, but from a Latin perspective. Music from the street—about love, life, and loss. *Celia Cruz Dancing on Clarion Alley* is my first mural. Its simple message is: live and be happy.

Carolyn Castaño

M a r g a r e t Kilgallen WAS AN AVID **banjo player.** **"Slaughter"** refers to Matokie Slaughter, a female banjo player from the 1940s, who was one of the artist's heroes and inspiration for one of her tags.

Jocelyn Superstar

|||||||||||||||||||||||||||

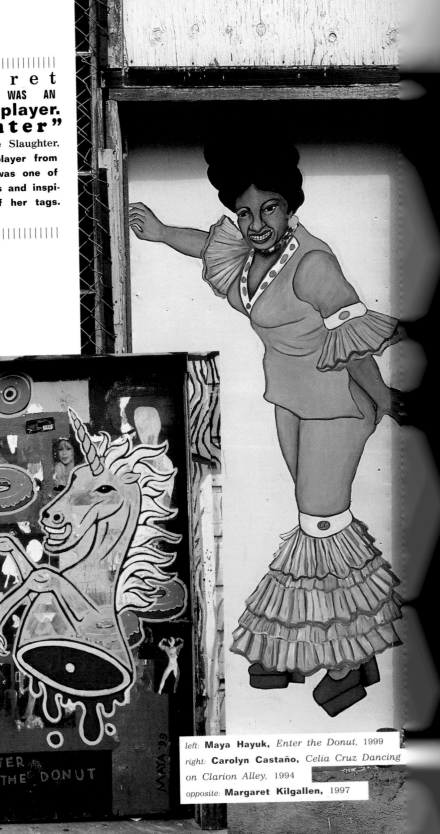

ENTER THE DONUT

MAYA '99

left: **Maya Hayuk,** *Enter the Donut,* 1999

right: **Carolyn Castaño,** *Celia Cruz Dancing on Clarion Alley,* 1994

opposite: **Margaret Kilgallen,** 1997

84

THE SO-CALLED MISSION SCHOOL
AARON NOBLE

A FEW ARTISTS who had worked on Clarion Alley started to gain some art-world success in the late nineties. People started casting around for a catchall term with which to discuss and perhaps hype up this socio-aesthetic vibe that had taken form. The problem was that if you included all the artists who seem to be involved and respected, you found yourself with an unnameable diversity, but if you winnowed it down to a core of aesthetically related artists, then you severed the community from a group of artists for whom community itself is a signal aesthetic value. At the same time that the San Francisco scene was being described as "Urban Rustic" and "Mission School," curators in New York and Los Angeles were identifying a trans-global youth underground and calling it "New Folk" or "The Disobedients." All these labels pretty much suck, but my least favorite is the one that unfortunately works the best: Mission School. It feels like a slight to the Mission District to give its name to one segment of one generation of artists who flourished in the atmosphere created by their peers and elders here. The Mission has produced school after school of art styles and lifestyles, typically inseparable from social struggles or cultural critiques that are more or less independent of the discourse of the art world. Muralists, punk collagists, and stencil artists; cyber-latino performance artists; outlaw billboard revisionists; the techno freaks of Burning Man; underground cartoonists from Last Gasp in the sixties to *Filth Magazine* in the nineties; Mission Gráfica printmakers at the Mission Cultural Center, and later the San Francisco Print Collective; acid jazzmen at the Elbo Room; digital muralists at Galería de la Raza; political puppeteers; the found-footage filmmakers associated with Artist's Television Access; anarchist bike messengers; low riders; and radical queer cabaret acts—these are random entries in an endless list. This is the faculty of the school that I attended, and I recognize no Mission School that doesn't include them all.

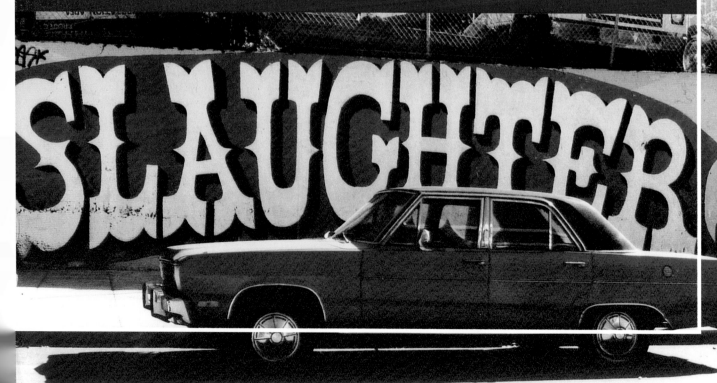

Chris Johanson
BROUGHT A **laid-back style** OF **skate-Zen** TO THE Mission.

His street work and installations at Adobe Books on 16th Street created a signature that linked the hapless cardboard pleas of the homeless with quick-witted satire. The naïve-looking stick figures of his marker drawings, with their utterly human thoughts and mutterings, started appearing in random spots in the Mission like arrows from a blind archer. Chris is like a weatherman, making notations of the mental climate. He passes no judgment. "The truth is fucked," says the first man. "Then I guess you're fucked," says the second.

Aaron Noble

I DRAW FROM **dreams, nightmares,** apparitions, and the far corners of the psyche, all pointing toward a mysterious thing. I don't know what, which is why I keep making things—to try and bring to the surface unseen things from the unseen world, the subconscious. I've studied Braille for many years in an attempt to become more fluent and articulate in unseen matters. Instead, I have become fluent in Braille.

Carolyn Ryder Cooley

Chris Johanson (photo 2002)
opposite: **Carolyn Ryder Cooley and Lena Wolf** (photo 2007)

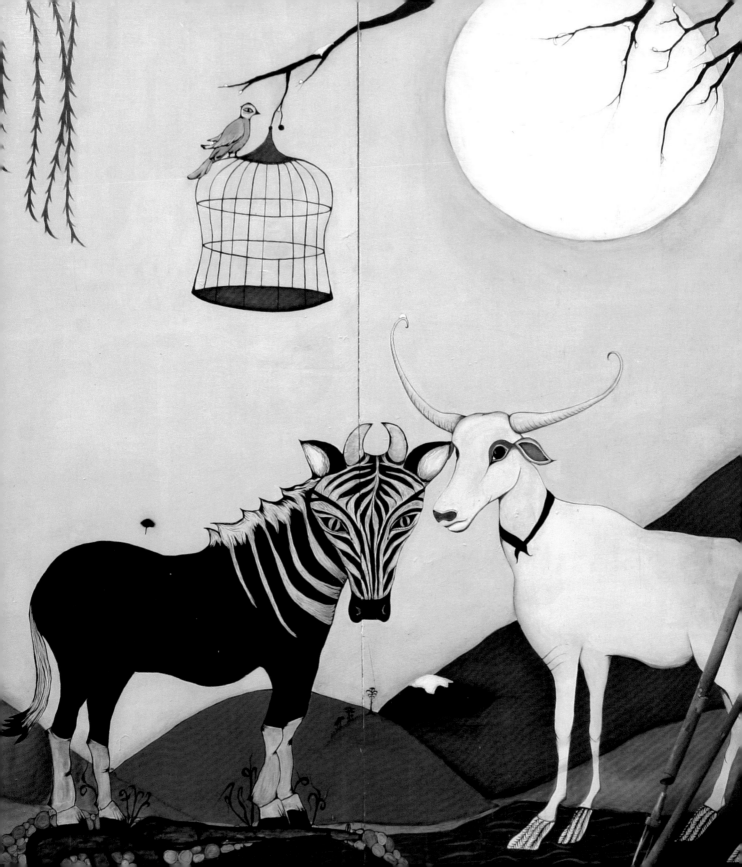

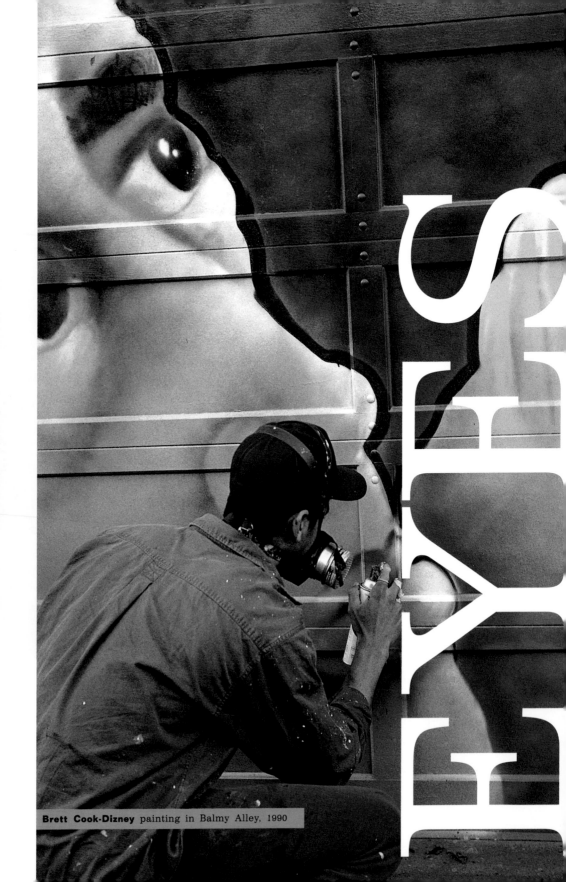

Brett Cook-Dizney painting in Balmy Alley, 1990

Eye-opener:
Borders, mas borders
The Mission is crisscrossed by myriad borders,
Invisible and overt: porous and dangerous.
The border between South and North America
Old and New San Francisco
San Andreas y la Sierra Nevada Occipital
The border between Valencia and Mission
Between the documented and undocumented
Between bohemia and neglect
Between club life and church life
Between bookstores and gun shops
The border between high and low art
High and low religion
High and low desire
Stop!
The murals command
Look in the corners, look beyond the obvious.
Look up.
Look down. Look around.

— *Guillermo Gómez-Peña*

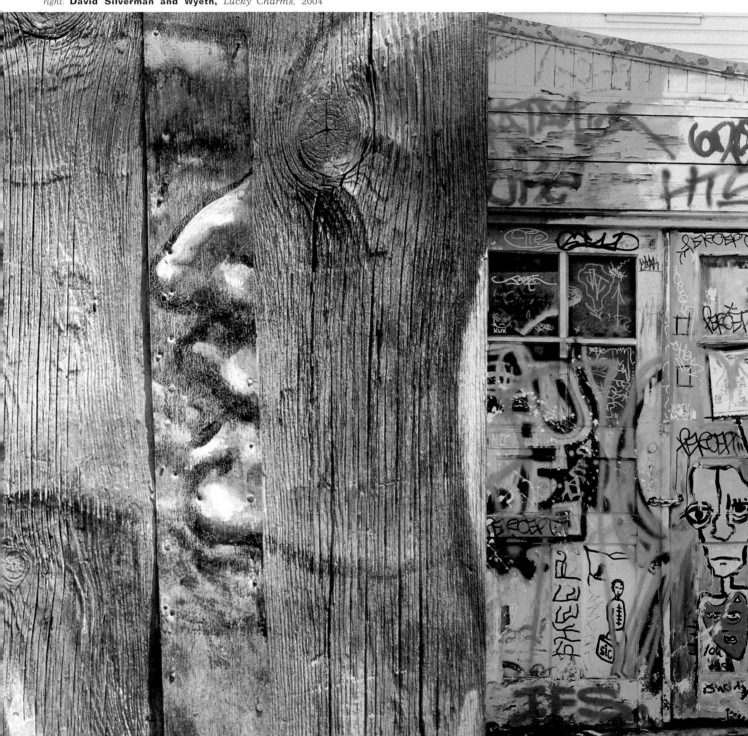

left: **Zela Nevel,** *Honor a todos los indios de America/*
Honor to All of the Native Americans, 1984 (photo 2001)
middle: **Brandon Bauer,** 2000
right: **David Silverman and Wyeth,** *Lucky Charms,* 2004

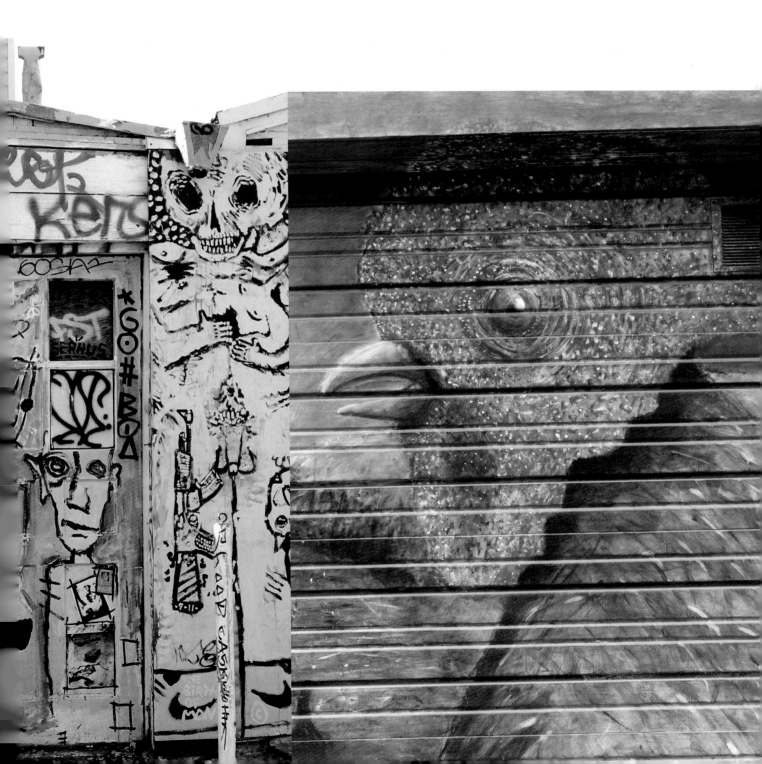

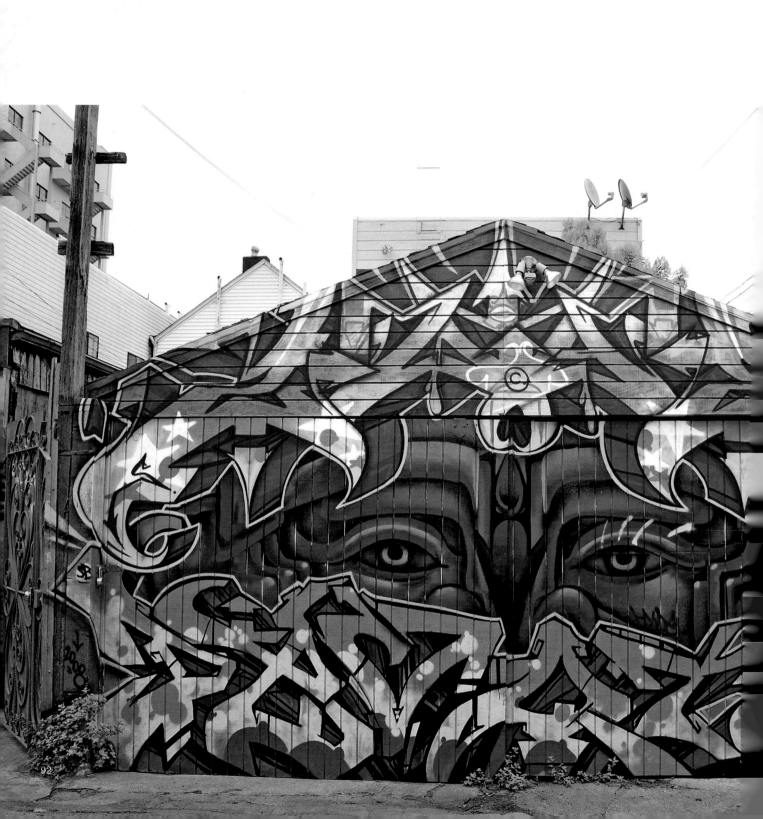

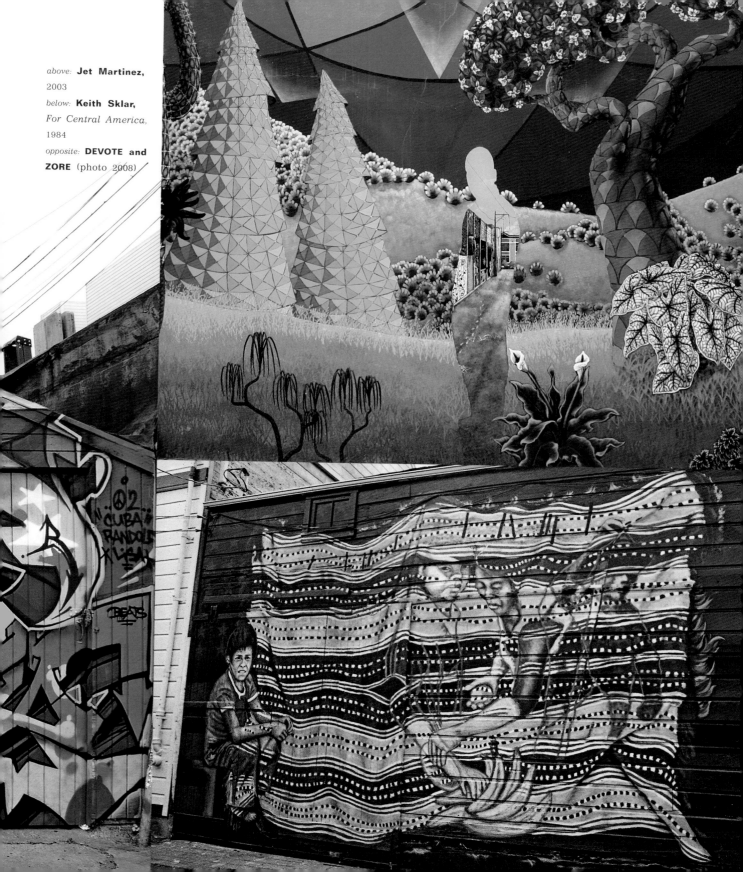

above: **Jet Martinez,** 2003
below: **Keith Sklar,** *For Central America,* 1984
opposite: **DEVOTE and ZORE** (photo 2008)

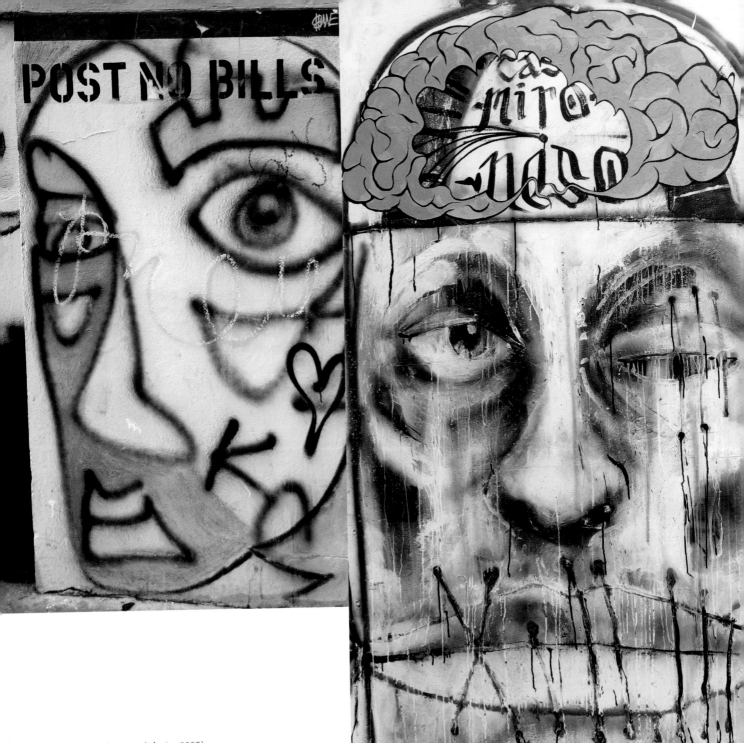

POST NO BILLS

left: **Artist unknown** (photo 2005)
right: **Artist unknown** (photo 2005)
opposite left: **Artist unknown** (photo 2002)
opposite right: **Artist unknown** (photo 2002)

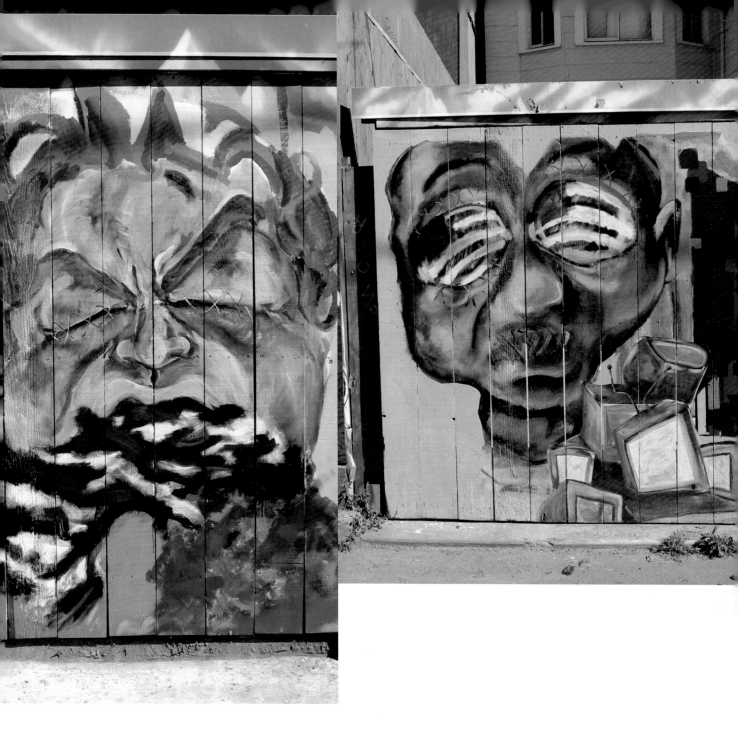

"KIND OF BLUE II

RENOS, 2004
opposite: Andrew Schoultz, 2000

96

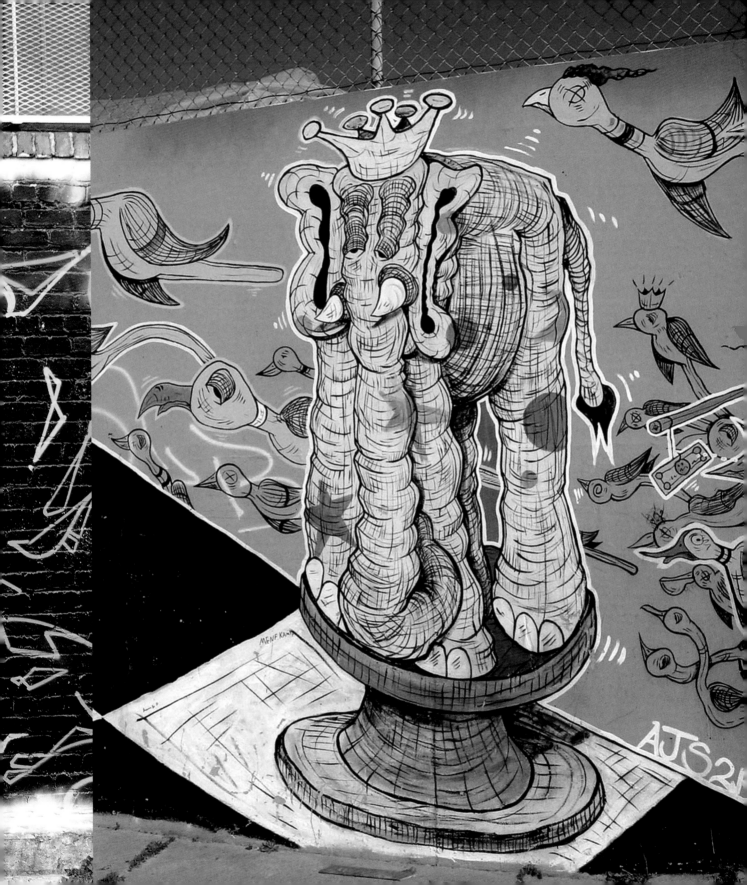

BALMY ALLEY

ALEJANDRO MURGUIA

THIS ALLEY of mostly small, post-Victorian houses, old wooden garages, and fences is covered with murals, and every mural is a challenge: a gauntlet against forgetting, an attempt to recover the memory and history—as painful as it has been these past fifty years—of our continent. Monsignor Romero, the assassinated Archbishop of El Salvador, stares wide-eyed from a garage door a few yards from a mural honoring the memory of the disappeared in Latin America.

At one end, the entrance to Balmy Alley hosts a popular taqueria, where working men gather late at night under a dim bulb, after going on a *paranda*. Across from the taqueria is a community center that housed a Nicaraguan solidarity office in the 1980s and before that was a working man's bar.

The mural that greets you as you enter the alley is reminiscent of Huichol yarn paintings and represents the five sacred colors of corn. Opposite, Nepalese women are painted on a fence with power and sensitivity; the grain of the wood patterns their faces. Fists clenched, they stare the viewer right in the eye—demanding we acknowledge the struggle of people everywhere.

There are the recurring homages to Frida Kahlo, Diego Rivera, José Clemente Orozco, and David Siquieros. Down the way, highlights from the golden era of Mexican cinema feature Dolores del Rio, Cantinflas, María Félix, and Tin-Tan, the *pachuco* comedian. Another mural depicts a *cholo* with old English script reading "Latino Pride." And, at the far end, a life-sized figure of La Virgen de Guadelupe faces a Hindu deity, joining faiths as guardians of the alley.

This parade of murals is an explosion of colors and shapes, stimulating memories of sage-blessed processionals, street protests, the landscape of the tropics, volcanoes rumbling, and monkeys and parrots screeching overhead. Some murals are adventurously abstract, others pointed and specific. A quote by W. B. Yeats emboldens a fence, reminding us: "Things fall apart / the center cannot hold / mere anarchy is loosed upon the world." Indeed, things do change, falling apart and coming back together. There are as many issues spoken in the murals as there are painting styles, mixing church art and anime, revolution and reverence.

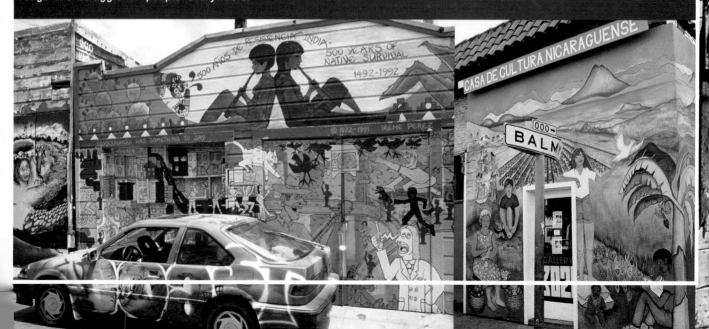

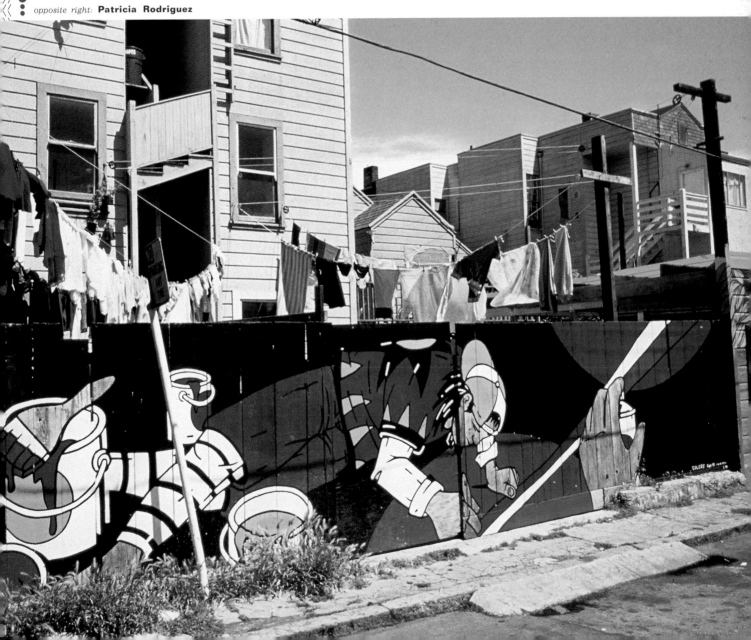

Rigo, *I Dream of Balmy Alley,* 1993

opposite left: (top) **Irene Perez,** *500 años de resistencia,* 1972;
(bottom) **Garth Tompkins-Viera,** 2000

opposite right: **Patricia Rodriguez**

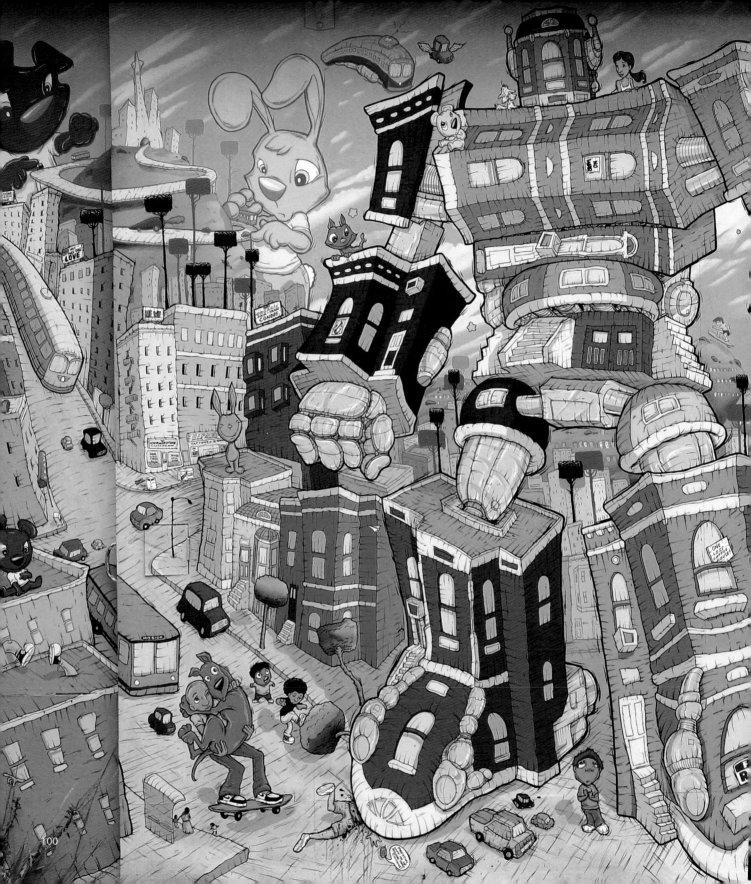

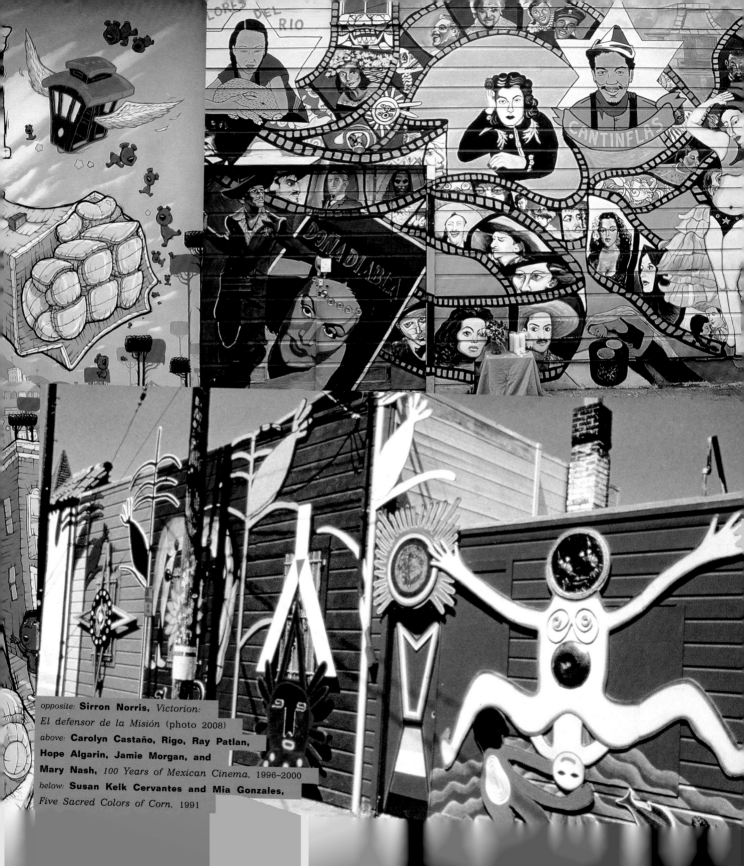

opposite: **Sirron Norris,** *Victorion:*
El defensor de la Misión (photo 2008)
above: **Carolyn Castaño, Rigo, Ray Patlan,**
Hope Algarin, Jamie Morgan, and
Mary Nash, *100 Years of Mexican Cinema,* 1996–2000
below: **Susan Kelk Cervantes and Mia Gonzales,**
Five Sacred Colors of Corn, 1991

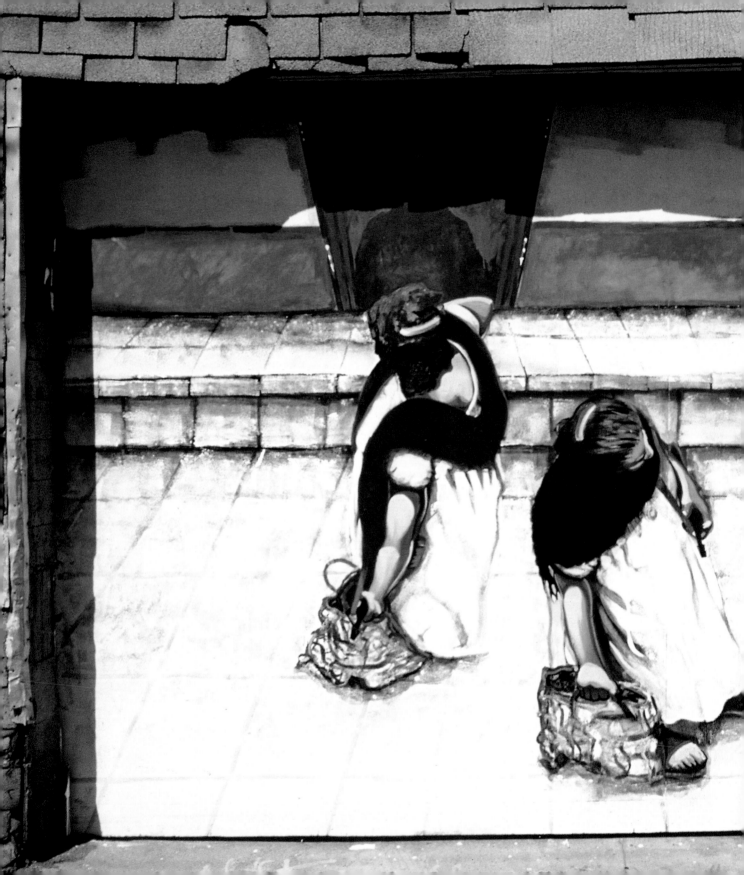

PLACA
WILLY LIZARRAGA

IN THE eighties many North Americans were traveling to Central America and returning with disconcerting reports of the war that were quite different from the "official truth." A group of artists responded to the conflicts by painting murals in Balmy Alley. Ray Patlan, the first director of the project and one of the most prolific and well-known muralists in the country, lives on the alley: "We decided to call ourselves PLACA. In Spanish it means identity mark, as well as a cop, police car, signature, or license plate. We liked the name because we wanted to leave a mark. And we started by talking to the people who lived in the alley. At first they were a little reluctant—after all, it was an act of protest against the government—but then they agreed very willingly. The only condition was not to paint overtly bloody scenes." Ray was so busy organizing the whole thing that he didn't have time to paint his own mural until the very last day. It covers one garage door. Two stout indigenous women, dressed in traditional clothes, walk to the market— *Camino el mercado*. They are seen from above, and the odd perspective produces a magical and disorienting effect. "I wanted to paint a tribute to women," Patlan says, "to their strength under the most difficult conditions; a tribute to life itself, the fact that people go to the market even in the middle of a war." The women have automatic rifles tucked into their shawls, as if ready to ambush.

Ray Patlan, *Camino el mercado/On the Way to the Market,* 1984

The first thing we see is his eyes. They are wise and unflinching, tinted and framed by a pair of larger-than-life eyeglasses. At first we might mistake this kind-looking gentleman for a deceased grandfather that we know only from photographs. His white collar, however, identifies him as a clergyman, and then we notice the words "Monseñor Oscar Romero" on the bottom right corner, near the collar. Romero was the only Catholic bishop who stood up for the common people during the civil war in El Salvador.

On March 24, 1980, Romero was assassinated while delivering a homily to the poor. "I do not believe in death without resurrection," he said. "If they kill me, I will be resurrected in the Salvadoran people." Juana Alicia has resurrected Romero in Balmy Alley. We will see in him our own best aspirations, reflected like a patch of light in his glasses.

Katherine Gressel

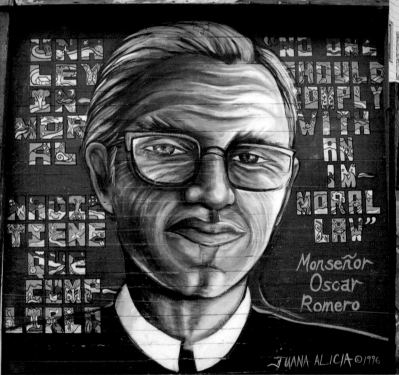

above: **Herbert Siguenza,** *Después del triunfo/After the Triumph,* 1984 (photo 2003)

below: **Juana Alicia,** *Una ley inmoral, nadie tiene que cumplirla/No One Should Comply with an Immoral Law,* 1996

opposite: **Miranda Bergman and O'Brien Thiele,** *La cultura contiene la semilla de la resistencia que retoña en la flor de la liberación/ Culture Contains the Seed of Resistance, Which Blossoms into the Flower of Liberation,* 1984

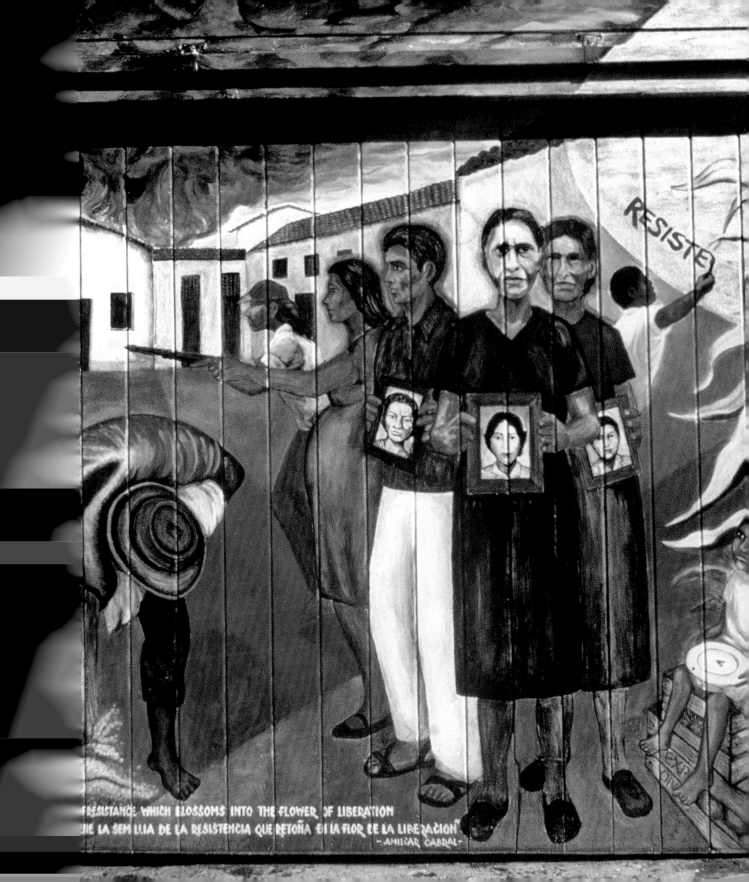

RESISTE

"RESISTANCE WHICH BLOSSOMS INTO THE FLOWER OF LIBERATION
...IE LA SEMILLA DE LA RESISTENCIA QUE RETOÑA EN LA FLOR DE LA LIBERACIÓN"
-AMILCAR CABRAL-

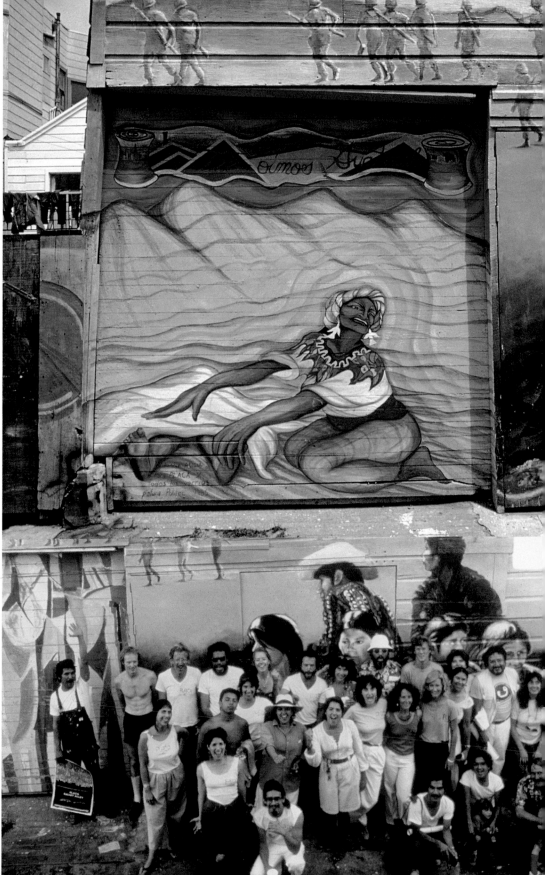

When I was working on my master's degree in painting, I frequently passed a mural project A BLOCK FROM MY HOME. Daniel Galvez, Keith Sklar, and Karen Sjoholm were painting from a pulley-operated plank scaffold. The images of the mural began to appear magically. I was amazed by the transformation of an ugly, noisy underpass into an uplifting artwork. I showed them my portfolio, and they asked me to join them. I loved the physicality of climbing on the scaffolding and using my whole body. The immediate positive feedback of passersby shouting from their car windows was a pleasure after suffering through somber critiques and delivering slides to apathetic gallery attendants. I was hooked.

Brooke Fancher

above: **Juana Alicia,** *Te Oimos Guatemala/We Hear You Guatemala,* 1984
below: PLACA dedication, 1984
opposite: (top and bottom) **Brooke Fancher,** *My Child Has Never Seen His Father. Volan lejos los sentimentos cuando los amados han muertos todos,* 1984 (top photo 1984, bottom photo 1994)

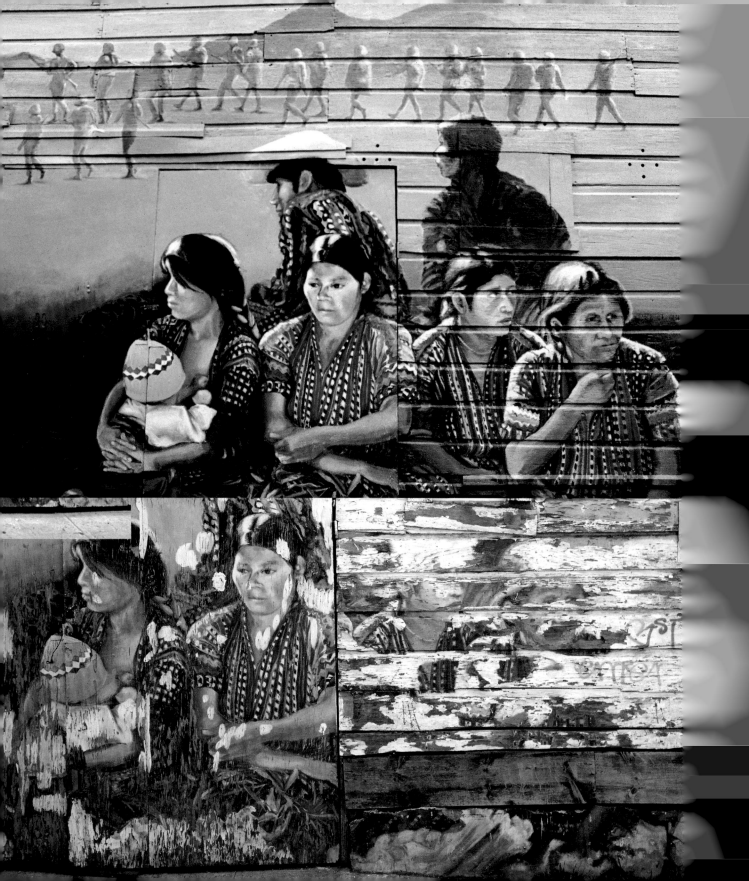

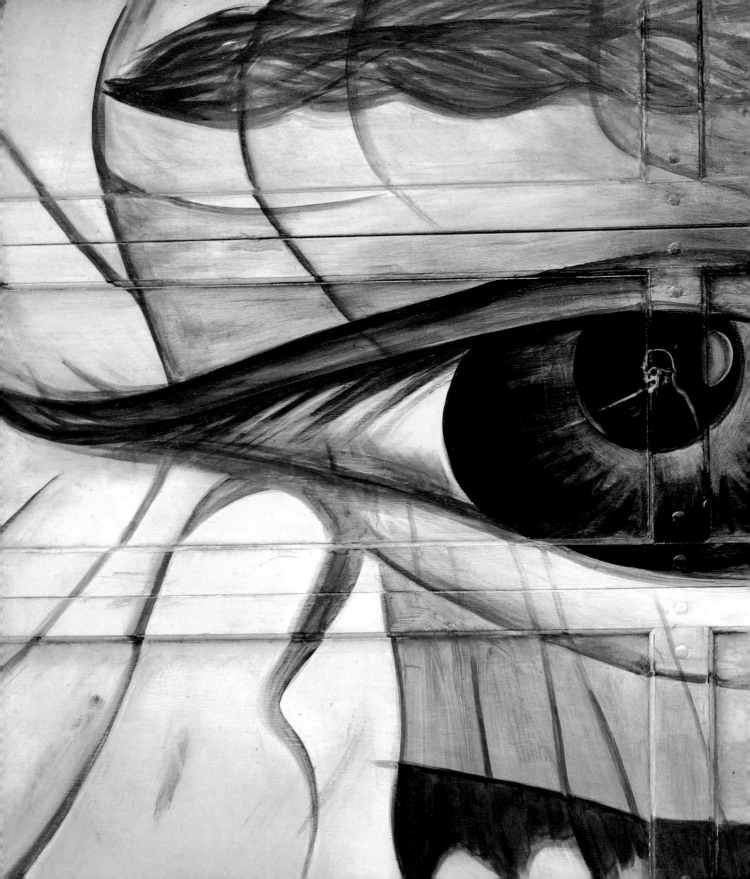

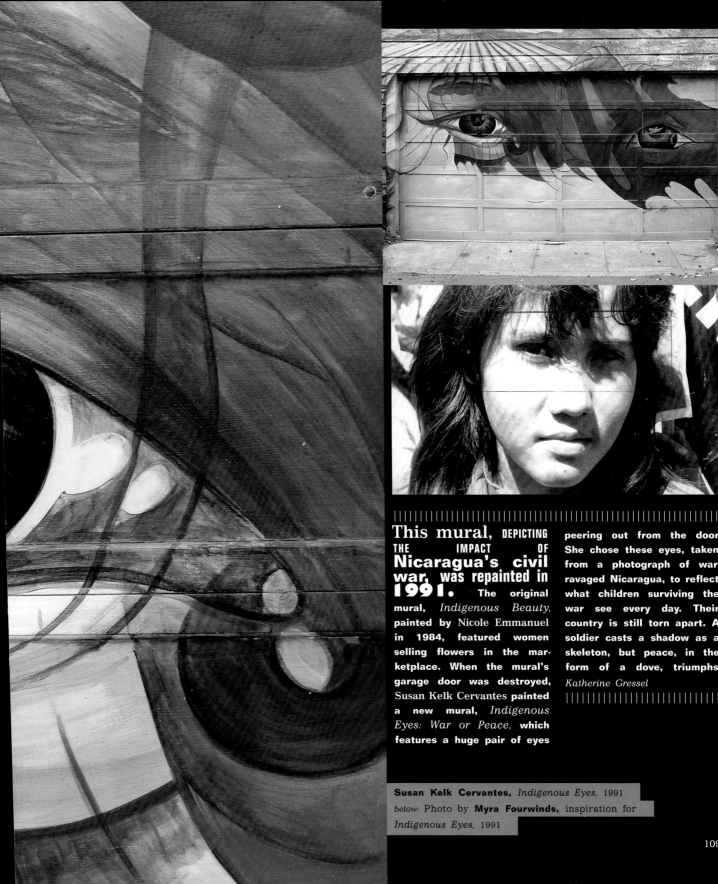

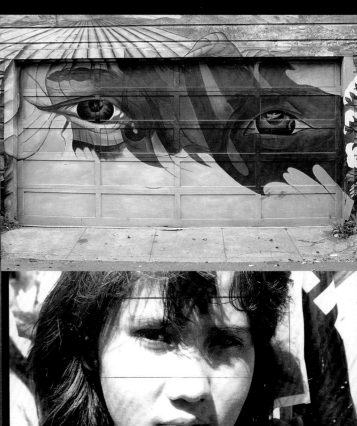

This mural, DEPICTING THE IMPACT OF Nicaragua's civil war, was repainted in 1991. The original mural, *Indigenous Beauty,* painted by Nicole Emmanuel in 1984, featured women selling flowers in the marketplace. When the mural's garage door was destroyed, Susan Kelk Cervantes **painted a new mural,** *Indigenous Eyes: War or Peace,* **which features a huge pair of eyes** peering out from the door. She chose these eyes, taken from a photograph of war-ravaged Nicaragua, to reflect what children surviving the war see every day. Their country is still torn apart. A soldier casts a shadow as a skeleton, but peace, in the form of a dove, triumphs.

Katherine Gressel

Susan Kelk Cervantes, *Indigenous Eyes,* 1991
below: Photo by **Myra Fourwinds,** inspiration for *Indigenous Eyes,* 1991

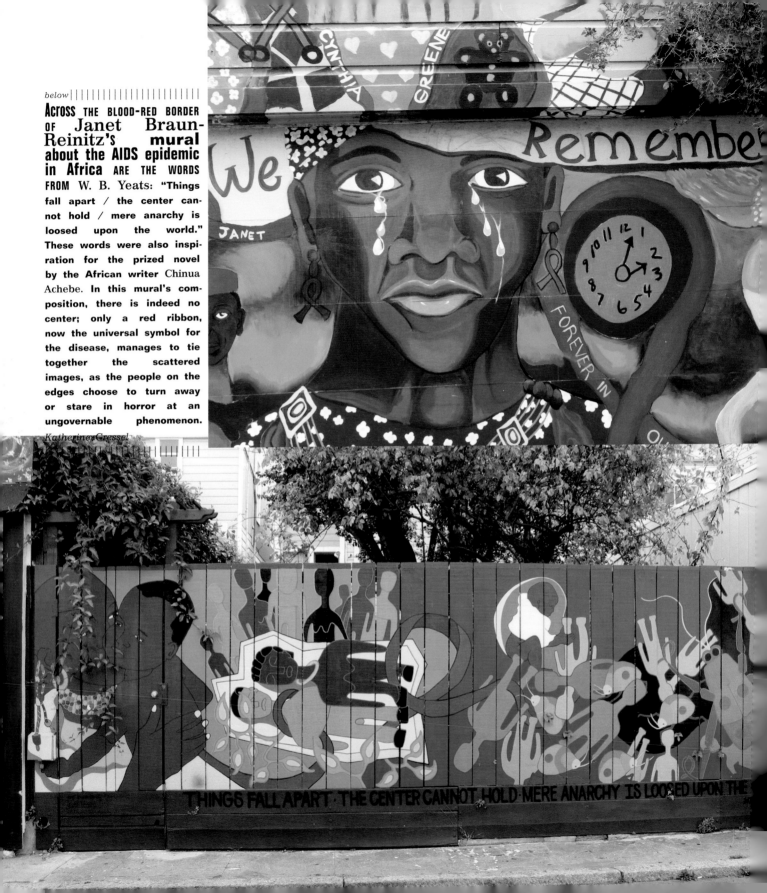

below ||||||||||||||||||||||||

Across the blood-red border of Janet Braun-Reinitz's **mural** about the AIDS epidemic in Africa are the words from W. B. Yeats: "Things fall apart / the center cannot hold / mere anarchy is loosed upon the world." These words were also inspiration for the prized novel by the African writer Chinua Achebe. In this mural's composition, there is indeed no center; only a red ribbon, now the universal symbol for the disease, manages to tie together the scattered images, as the people on the edges choose to turn away or stare in horror at an ungovernable phenomenon.

Katherine Gressel

I started painting murals through drawing side-walk chalk pictures every day WITH MY FRIEND Elvi. We were homeless and hoping for outlets for our creativity. One day an outreach worker approached us and asked if we would like to participate in a mural project. We said yes and were taken under the wing of Maestra muralist Edythe Boone, **helping to paint the** *Those We Love, We Remember* **mural in Balmy Alley. Edythe gave me the skills and knowledge to paint murals on my own.**
Trish Tripp

||||||||||||||||||||||||||||||||||

In Joel Bergner's second Mission mural, UN PASADO QUE AUN VIVE, **the Salvadoran figures first resemble plump, ruddy cartoon characters.** They prepare *desayuno* in open-air huts and tend to their children, who ride rickety bicycles or chase after dogs. Yet a closer look reveals a different collective memory: the civil war of 1980–1992 that disrupted order and killed the innocent. The faces of deceased loved ones are etched into buildings and mountains, and people being shot by death squads are shown in minute silhouettes. A woman clutches a letter from her husband who has moved to the United States to find work, a common practice that breaks apart families.
Katherine Gressel

|||||||||||||||||||||||||||||||||

Joel Bergner, *Un pasado que aun vive/A Past That Still Lives,* 2004
opposite above: **Children from the H.O.P.E. Project (Edythe Boone, director),** *Those We Love, We Remember,* 1995
opposite below: **Janet Braun-Reinitz,** *Things Fall Apart,* 2004

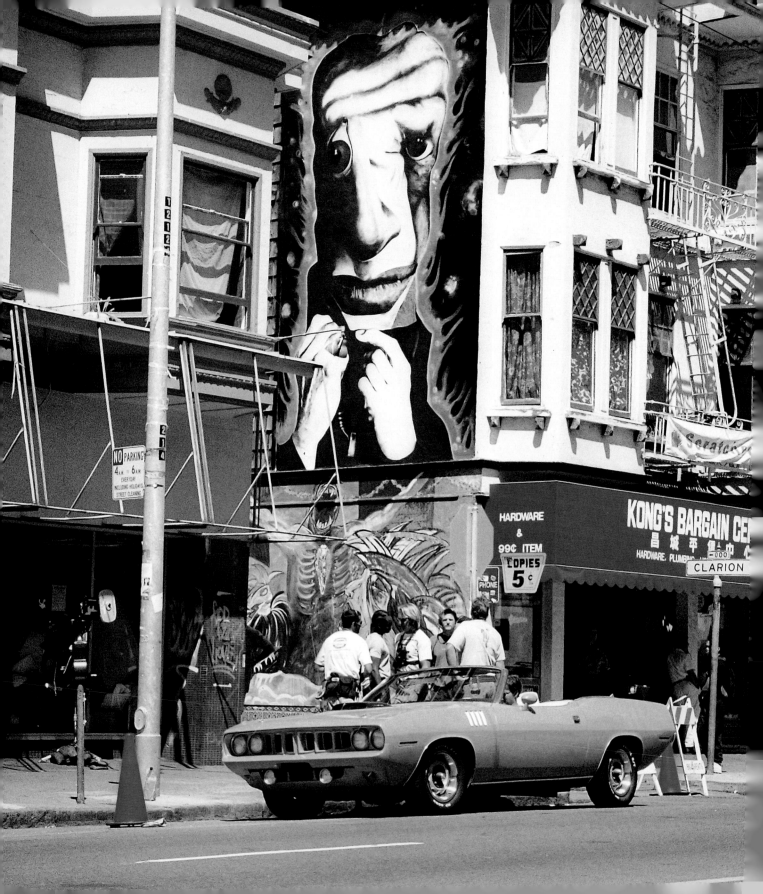

The shortest path from the cop shop on VALENCIA to the crack market on Mission, Clarion Alley is an outdoor gallery that has been cobbled together in many messy negotiations.

I was there for the first decade and can recall how it began. ///////////
//
//

Respect Is Not for Nothing ////////////////////////////////////
//

We were amateurs; we did it for fun, for love, to change the world, for no reason. Rigo was the only muralist of the six founders. Michael O'Connor, who made furniture around the corner on Valencia, was active in the hip-hop community. Aracely Soriano started *Revista Parallax*, a bilingual literary magazine; Sebastiana Pastor was a painter, a teacher, and a single mother. MaryGail Snyder worked in housing development. I was a performance artist or something. A seventh person, Michael's sister Fiona, was a photographer who documented the project for years. We were all living or working within a few blocks of each other and the alley. ///
//
//

Rigo and I had adjoining studio spaces at 47 Clarion at the beginning of the nineties. He was from Portugal, and I was from Oregon. We had met at Artists' Television Access (ATA), an artist-run nonprofit on Valencia Street, and found we had fishing boats and Marvel comics in common. Our first idea was to paint something on the wall of our own ramshackle home. There was already an ecstatic pig that ATA cofounder Lise Swenson had painted when she lived there, an eye of Horus on the 17th Street side of the building, and all kinds of other tags, doodles, and stains. Talking about what we might paint on our building was so pleasurable that we started talking about painting on other buildings, and soon we had talked the whole mural project into being, in our minds anyway. Rigo had the idea to paint one entire side of the alley a uniform blue. He was probably thinking of cobalt blue—from storefront to railroad flat to fence to cottage to garage to warehouse to backdoor—all blue. This is the first entry on my mental list of great murals that never got painted on Clarion Alley: a block-long swath of pure color, foregrounding the shapes, shadows, and grains of the alley like a gigantic Louise Nevelson sculpture. As we were about to find out, however, the alley was calling for a more dirty-ass democratic approach. ////////
//
//

One day in Indian summer of 1992, I was stopped at my door by an intense, dark-haired guy who asked me the question we would soon take to every owner and resident of Clarion Alley: "What would you think about having a mural painted on your house?" This was Michael O'Connor, a second-generation North Mission native who had independently had the same idea about the alley. The magical serendipity of this seemed to kick the project into gear. Suddenly all seven of us were having meetings in Michael's shop. We opened a bank account. We wrote letters to landlords, organized benefits, and wrote grants. We went to City Hall to research building ownership, canvassed support from local businesses, and went door to door to get the neighbors on board. ////////////////////
//
//

Fourteen murals were painted in the first year of the project, including works by Isis Rodriguez, Barry McGee, Mario Joel, and Scott Williams. There are receipts for cleaning, office

Kenneth Huerta, *Mojo Man* (originally titled *What Were You Thinking?*), repainted 1996

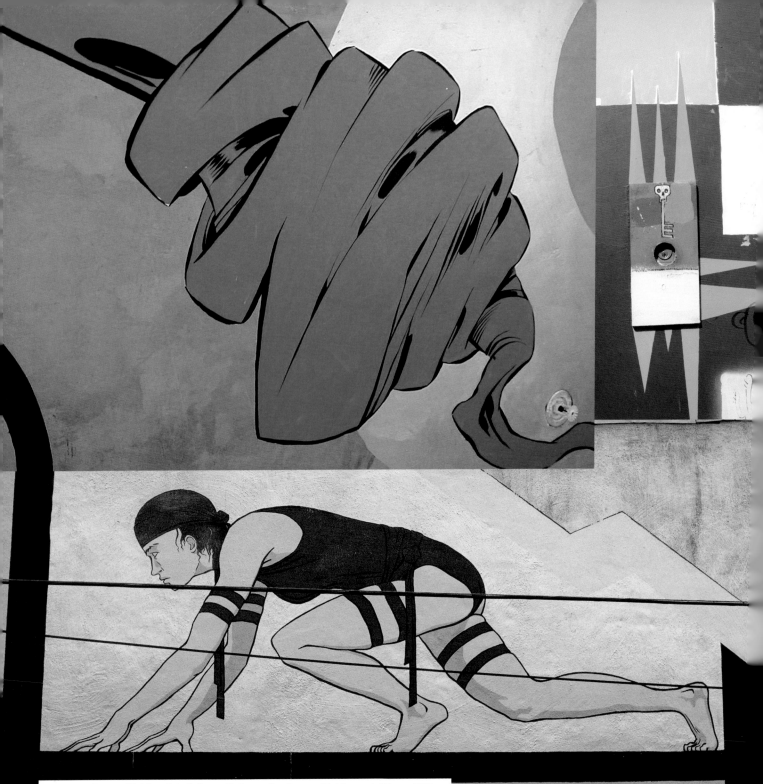

above left: **Aaron Noble,** detail from *Kaboom* by **Aaron Noble and Rigo,** 2003

above right: **Artist unknown** (photo 2007)

below: **Aaron Noble,** detail from *Superhero Warehouse* by **Aaron Noble and Rigo,** 1997

and photo supplies, hardware, and paint. The total cost of painting Daisy Zamora's poem on the alley was seven dollars and forty-eight cents. ///
//
//
I think everyone in the founding group would agree: Clarion Alley exists because Balmy Alley existed. Balmy, the transformed alley on the other side of the Mission, was the archetype in our heads. In the first years of CAMP we asked the elder muralists in the Mission to participate in each round of mural production. Rigo, trilingual and gregarious, was central in this. He was already building a name as a muralist and establishing personal relationships in the Mission mural scene. Chuy Campusano, Ray Patlan, Eduardo Pineda, Susan Cervantes—established masters of San Francisco muralism—all came and painted for free. The results were profound. Something solid was laid in at the base, and since then the project has survived many smart-asses and departures. ///////
//
//
We also had an idea that new kinds of murals were getting ready to be made. Rigo was already pursuing a radical simplification in his own work (his first big traffic-sign murals, including *One Tree*, were just over a year away). Michael had connections with key spray-can artists like CUBA and SPIE, and we knew some artists at the San Francisco Art Institute (SFAI) who were mixing fine-arts training with graffiti practices. After Julie Murray painted a giant black-and-white photorealist escalator on Bing and Ivy Chang's garage door in the first summer of painting, and it was instantly popular, I started to think of Clarion as a laboratory for the future of street painting. ///////////////////////
//
//

The Spray-Can Solution ///
//
While CAMP was making space for new and old styles to bump around together and trying to educate the local kids to stop tagging murals, a lot of artists had already jumped the fence and taken a shortcut past the whole problem. Barry McGee, also known as TWIST, was rising to the top of the San Francisco graffiti hierarchy on the strength of his originality and groundbreaking can control. Michael had gone to high school with him and Rigo had been at the San Francisco Art Institute with Barry and various other members of a loose cohort that was cross-pollinating graffiti and "high-art" practices to the benefit of both. Their predawn raids on the blank, industrial surfaces of the city produced a surreal menagerie of soft screws and sad sacks (TWIST), good-natured horses and mopey girls (Ruby Neri, a.k.a. REMINISCE), giant melting dogs (Dave Arnn, working rapidly with house paint and brush), and a storm of dazzling signatures from KR, META, PROBE, AMAZE, and others. At the same time, another spray-can artist, Brett Cook-Dizney, was doing giant portrait collaborations with Aaron Wade in which Brett painted half the face with spray while Aaron painted the other half with a brush. From across the street you couldn't tell the difference. There was another artist around then (I never knew who it was) who just threw paint at the wall, creating splash-drip pieces that suggested sinister life-size figures with such economy of means that you questioned whether or not you were looking at a deliberately made artwork. The violent undertow of these pieces pointed back to the punk interventions of the preceding decade, a history that underlies the dripping and erasures of the nineties. ///////////
//
//
These illegal and rapidly executed artworks cut through the conventions of muralism with irresistible verve, dispensing with backgrounds, borders, wall preparation, permission, community outreach, and preliminary designs. In so doing, they pointed a way out of the ghettoization that afflicted traditional murals in the eighties. On the other hand, the works produced by these artists follow the mural traditions of collective effort (recast as the graffiti crew) and socially engaged content. Dave Arnn's dogs were specifically motivated by his animal-rights agenda. Ruby Neri and Alicia McCarthy were acting as feminist agents in the largely male graffiti scene, introducing emphatically non-macho elements into that boastful discourse. McGee and Cook-Dizney maintained a humanizing focus on the down and out. These public artworks were bereft of heroic revolutionaries but full of ordinary soul. //////////////////////
//
//
They were also responsive to the physical environment of the city, exploiting decayed surfaces as found background and picking up style from old hand-painted signage, as in the work of Margaret Kilgallen. They employed simple, muted color schemes that fit, with a kind of humility, into their faded industrial locations, and threw up random fragments of text like litter from a more handcrafted world. The effacing marks left by private citizens and city employees—big Rothko-esque rectangles of mismatched paint—were accepted as edits and exploited as fresh fields. In these aspects, and in their

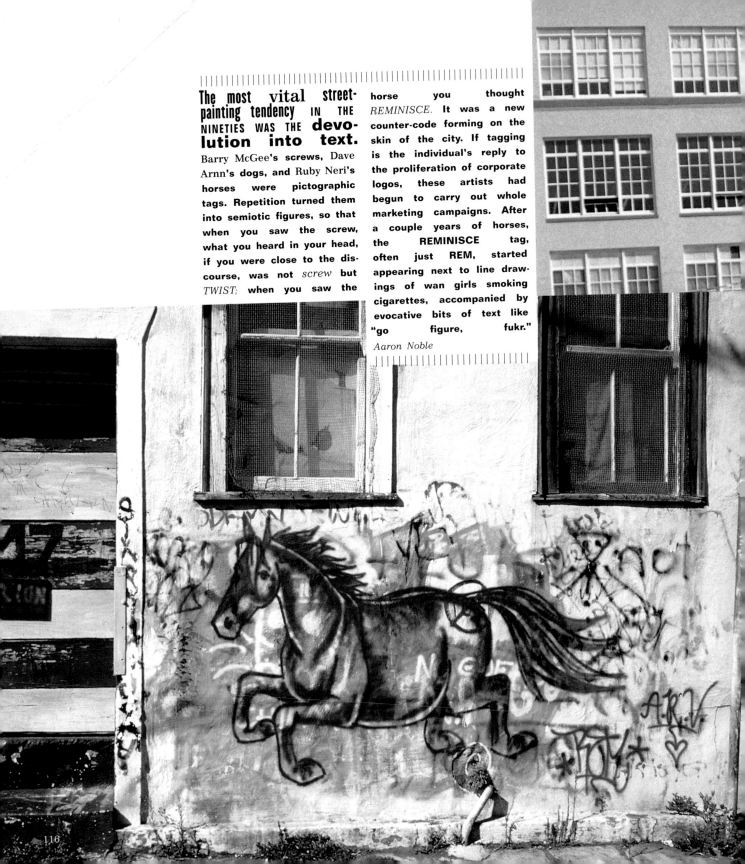

The most vital street-painting tendency IN THE NINETIES WAS THE **devolution into text.** Barry McGee's screws, Dave Arnn's dogs, and Ruby Neri's horses were pictographic tags. Repetition turned them into semiotic figures, so that when you saw the screw, what you heard in your head, if you were close to the discourse, was not *screw* but *TWIST;* when you saw the horse you thought *REMINISCE.* It was a new counter-code forming on the skin of the city. If tagging is the individual's reply to the proliferation of corporate logos, these artists had begun to carry out whole marketing campaigns. After a couple years of horses, the REMINISCE tag, often just REM, started appearing next to line drawings of wan girls smoking cigarettes, accompanied by evocative bits of text like "go figure, fukr."

Aaron Noble

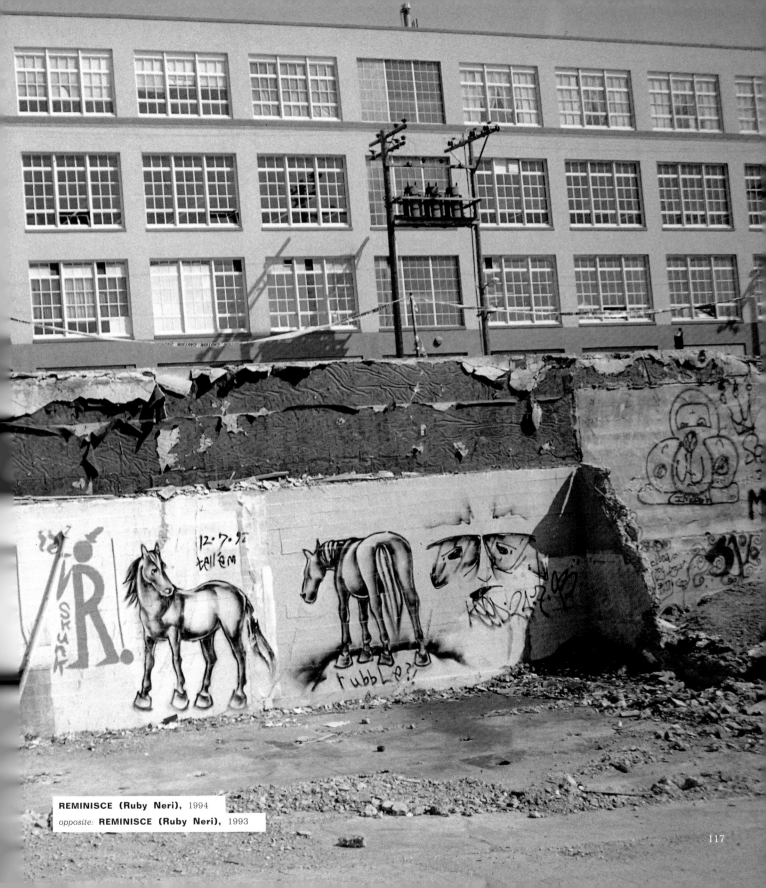

REMINISCE (Ruby Neri), 1994
opposite: **REMINISCE (Ruby Neri)**, 1993

117

indifference to preservation, they also departed from muralism's view of itself. /// /// ///

This practice, which conflated the tagger's understanding of competition with a high-art discourse on ephemerality, offered an unspoken challenge to the traditional muralists. It is not a small thing to take a public wall, inscribe it inch by inch with your version of painting, your version of history, cover it with eight coats of varnish and Graffiti-Guard, and demand that it should stand untouched for fifteen or twenty or one hundred years while advertisements and tags and shop signs and posters and songs and fashions come and go in the common space. Whatever claim to virtue a mural might make—whether it represents the aspirations of a people, it is a gift of beauty, or it speaks truth to power—it is unavoidably an act of hubris. It implies a heroic model of the artist, especially when scaffolding is involved. The SFAI group proposed a transient and criminal model instead. /// /// ///

Clarion Alley, with a foot in both camps, was glad to work with most of these artists over the years. But it's worth noting that few of them (McGee excepted), and few of the "traditional" spray-can writers we've hosted, attained the level of their best work in the permissible oasis of Clarion. That work was built for speed, cover, and impulse. The sense of liberation was tangible. They didn't need or thrive on the daylight leisure, negotiated spaces, and public accountability of the alley. ///// /// /// /// /// /// /// /// /// /// /// /// /// /// /// /// /// ///

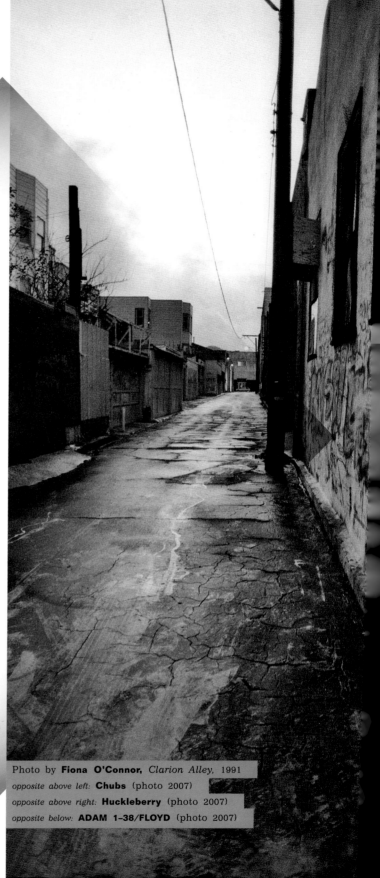

Photo by **Fiona O'Connor**, *Clarion Alley*, 1991
opposite above left: **Chubs** (photo 2007)
opposite above right: **Huckleberry** (photo 2007)
opposite below: **ADAM 1–38/FLOYD** (photo 2007)

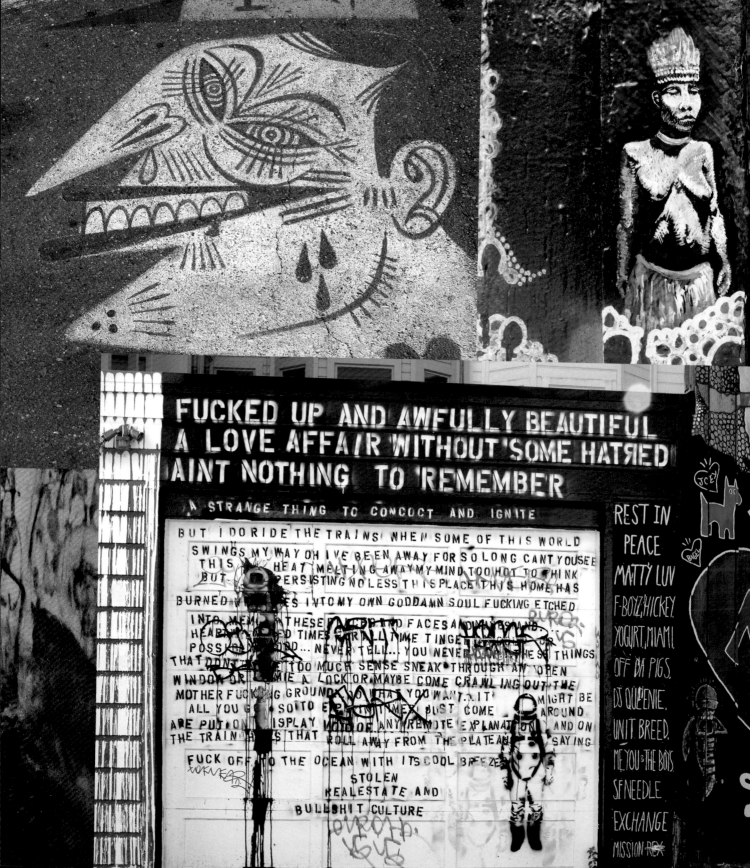

FUCKED UP AND AWFULLY BEAUTIFUL
A LOVE AFFAIR WITHOUT SOME HATRED
AINT NOTHING TO REMEMBER

A STRANGE THING TO CONCOCT AND IGNITE

BUT I DO RIDE THE TRAINS WHEN SOME OF THIS WORLD
SWINGS MY WAY OH I'VE BEEN AWAY FOR SO LONG CANT YOU SEE
THIS HEAT MELTING AWAY MY MIND TOO HOT TO THINK
BUT PERSISTING NO LESS THIS PLACE THIS HOME HAS
BURNED ITS WIRES INTO MY OWN GODDAMN SOUL FUCKING ETCHED
INTO MEMORY THESE FACES AND UMM STAND
HEARTS AROUND TIMES FRIN UME TINGET THESE
POSSI BORD... NEVER TELL... YOU NEVER THINGS
THAT DONT MAKE TOO MUCH SENSE SNEAK THROUGH AN OPEN
WINDOW OR BLAME A LOCK OR MAYBE COME CRAWLING OUT THE
MOTHER FUCKING GROUND SO WHAT YOU WANT TO IT MIGHT BE
ALL YOU GO SO TO EXPLAIN IT JUST COME AROUND
ARE PUT ON DISPLAY WITHOUT ANY REMOTE EXPLANATION AND ON
THE TRAIN WALLS THAT ROLL AWAY FROM THE PLATEAU SAYING
FUCK OFF TO THE OCEAN WITH ITS COOL BREEZE
STOLEN
REALESTATE AND
BULLSHIT CULTURE

REST IN
PEACE
MATTY LUV
F-BOYZ, HICKEY,
YOGURT, MIAMI,
OFF DA PIGS,
DJ QUEENIE,
UNIT BREED,
ME, YOU & THE BOYS,
SF NEEDLE
EXCHANGE
MISSION REX

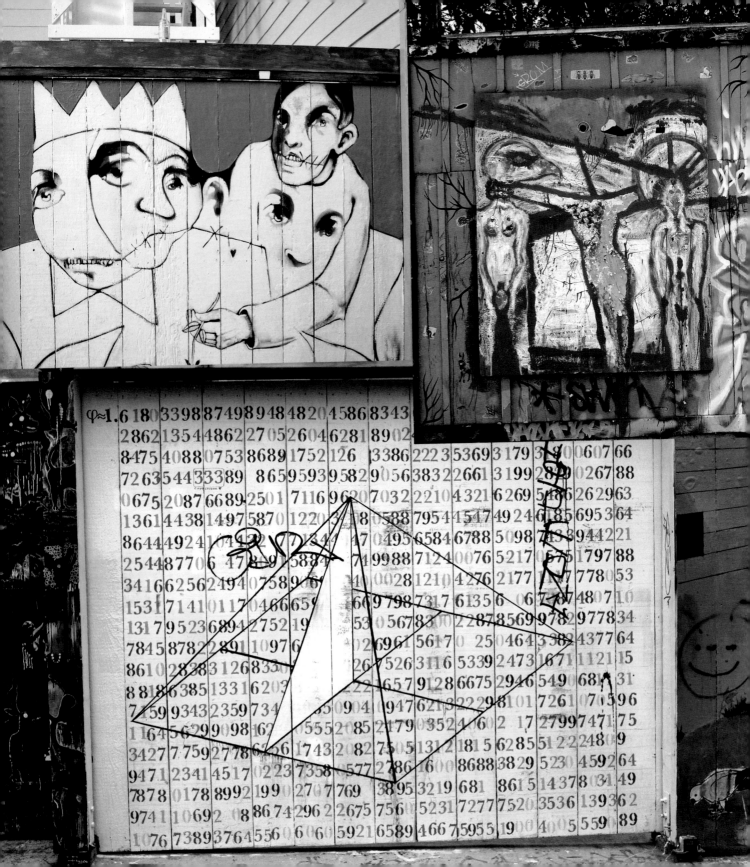

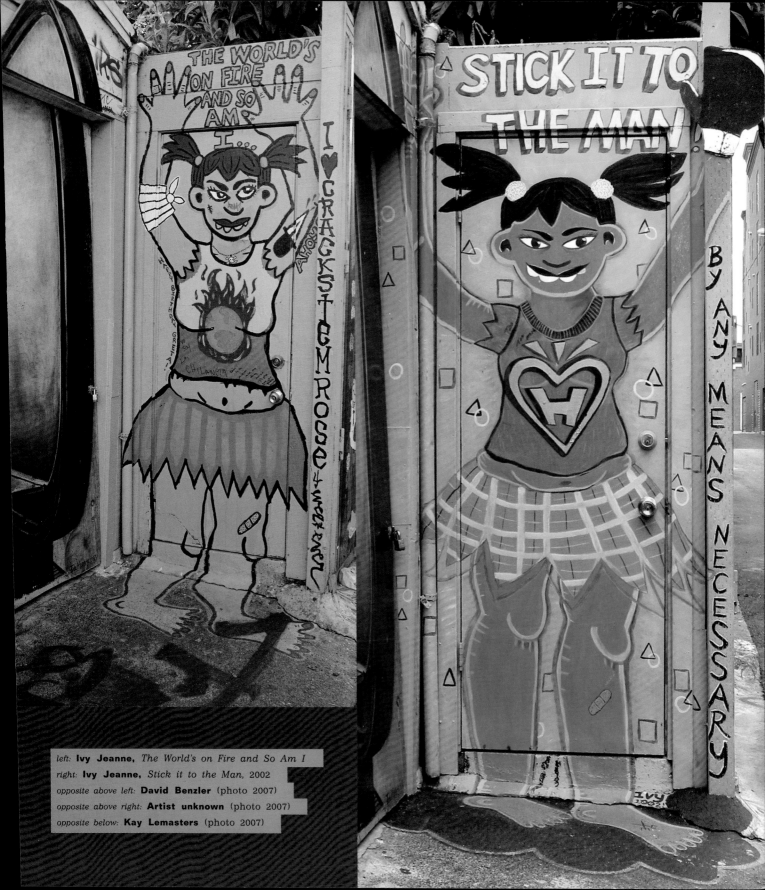

left: **Ivy Jeanne,** *The World's on Fire and So Am I*
right: **Ivy Jeanne,** *Stick it to the Man,* 2002
opposite above left: **David Benzler** (photo 2007)
opposite above right: **Artist unknown** (photo 2007)
opposite below: **Kay Lemasters** (photo 2007)

VATOS MEXICANOS LOCOS
AARON NOBLE

THE VATOS Mexicanos Locos were a little kid gang that claimed Clarion Alley. They would hang out on the alley doing little pencil and marker *cholo* tags that said "SUR 18th St VML" (*Sur* is short for the gang name Sureños) and their nicknames, like Diablo, Joker, Li'l Diablo, and Gremlin. They used birdcalls to warn each other of approaching adults and to call each other down from their apartments.

These gangsta kids, part of the actual population of the alley, couldn't be bothered with the multicultural ideals of Muralismo. Nor did they care what the adult residents and property owners on the alley thought. Their sensibility was shaped by video games, gang culture, and hip-hop, and they operated within a vividly coherent visual culture of their own, marked by a rigid and destructive symbolism. They explained to me why they exalted blue and denigrated red, why they X-ed out the letter "N" whenever it occurred in their own graffiti or elsewhere, and how this was related to invisible territories within the Mission. Undercutting my position as guardian of murals, I felt a personal sympathy with the kids' pop-culture aesthetics.

They agreed to let me help them paint a mural after they found out that I could draw superheroes. When they finished their wall I would draw them a picture of Wolverine, from the X-Men. Work on the mural broke down repeatedly. Some days more paint was spilled or thrown than got on the wall.

The mural they finally made included one gang-related homicide (decapitation by gunfire), and a dope-crazed knife-wielding fiend, and Beavis and Butthead, among other stuff. They decided to call it *No mas drogas,* which always mystified me, as they never seemed to be anti-drug.

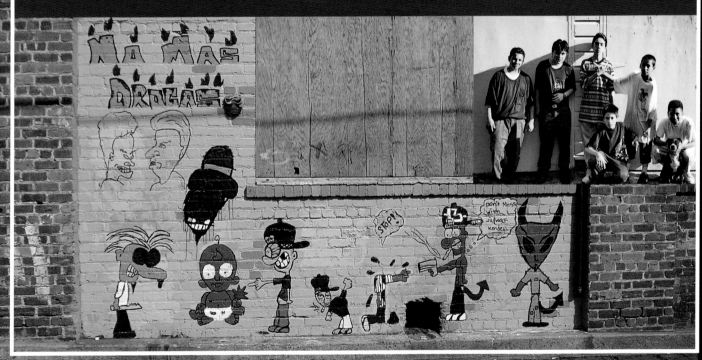

With only Beavis and Butthead left to color in, they suddenly picked a fight with me. It blew up in minutes to a huge screaming match with threats of unlimited mural defacement. I closed the door on them and tried to calm myself. In the evening I went out on the alley and saw the changes they had made. A few murals nearby were hit with sloppy tags, but it was their own mural that took the brunt. They emptied two cans of spray, silver and black, onto it, mostly in blotches, effacement, and scribble. After a few minutes I heard a bird call, repeated, then answered.

The kids slipped out of their houses and gathered silently. I acknowledged them with a little nod. Orland said, "Hey, we finished our mural, can we have our picture of Wolverine?"

This was good, but nobody laughed. "We'll see," I said. An image had appeared full blown in my head, of the masked, feral, razor-clawed superhero curled up on the ground, sucking his thumb like an infant. So that's what I painted on the outside of my house the next day, while the little *vatos* rode their low-rider bikes up and down Clarion Alley.

Years went by, the kids got bigger, and the alley filled up with murals (more than one hundred have been painted. Rigo and I turned our wall into a whole warehouse of depressed superheroes, and I eventually became a real muralist, specializing in deconstructed superhero imagery.

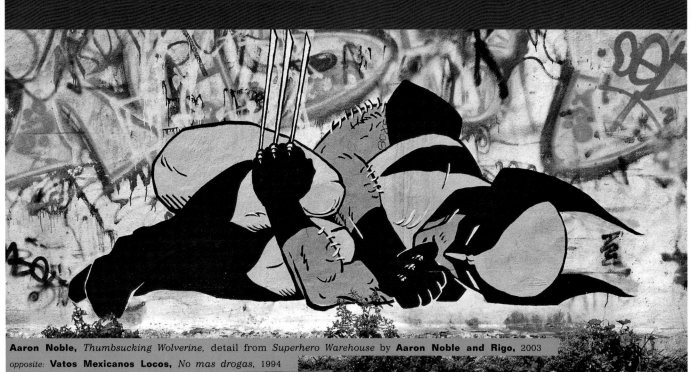

Aaron Noble, *Thumbsucking Wolverine,* detail from *Superhero Warehouse* by **Aaron Noble and Rigo,** 2003
opposite: **Vatos Mexicanos Locos,** *No mas drogas,* 1994
opposite above: **Vatos Mexicanos Locos,** 1994

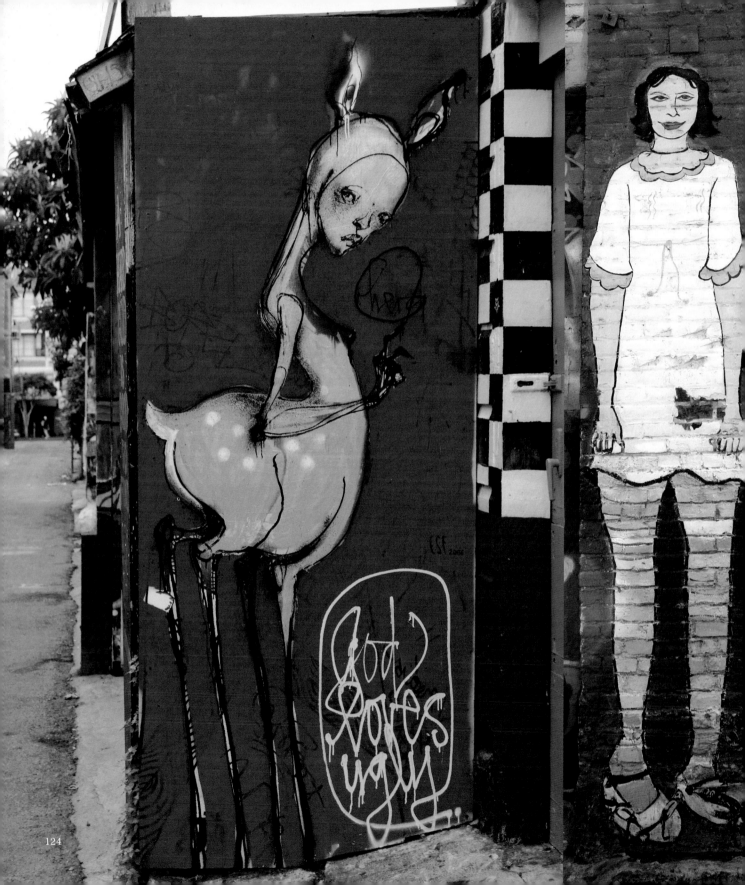

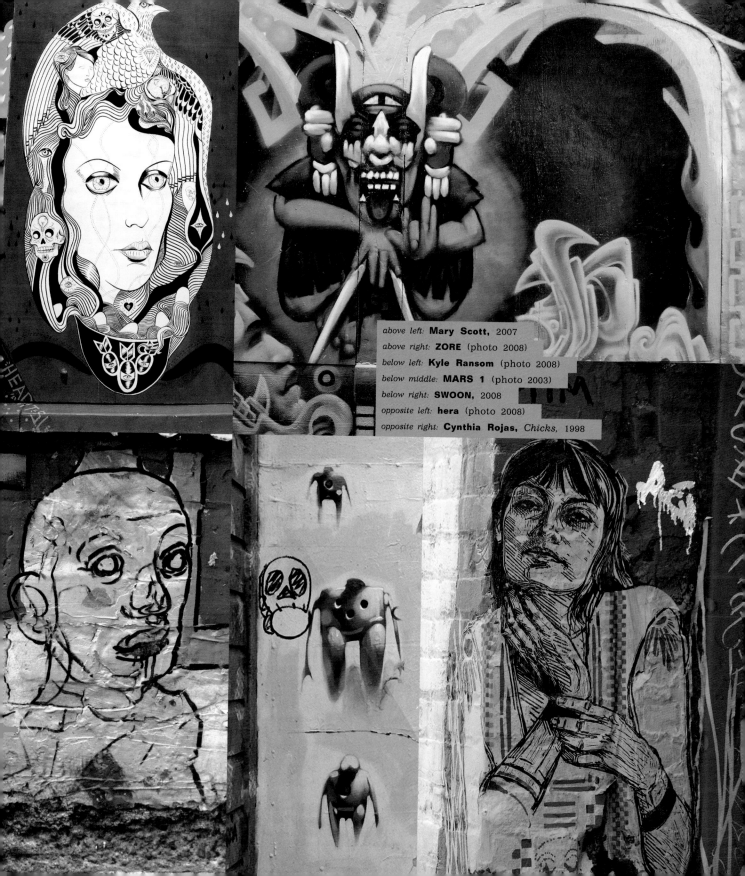

above left: **Mary Scott,** 2007
above right: **ZORE** (photo 2008)
below left: **Kyle Ransom** (photo 2008)
below middle: **MARS 1** (photo 2003)
below right: **SWOON,** 2008
opposite left: **hera** (photo 2008)
opposite right: **Cynthia Rojas,** *Chicks,* 1998

MOVING STAIRWAY TO HEAVEN
JULIE MURRAY

I WANTED my mural to be as incongruous in its subject matter as it was un-baroque in its rendering, and to interact with its surroundings, providing a cartoon-like portal from one world to another. It worked better at night, when in the dimmed light and shadow it became eerily 3-D.

My design, after much wrenching internal debate, was drawn from a photograph of an escalator that I had come across in the book *What's What: A Visual Glossary of the Physical World.* It contained more interesting items of intrigue, if only by virtue of the mystery surrounding their inclusion. Subjects for examination and explanation included things such as: bathtub, root system, labeling, satellite, coffin, badminton, decorative stitching, river, toothbrush, spider, bride, etcetera, each with just enough legend to achieve the point of being totally obvious. I chose as inspiration, from this glossary of the physical world, a picture of an escalator.

I began plotting the image by squaring off the picture and then drawing a corresponding enlarged grid on the garage door's surface. I rendered the picture first in charcoal, which prepared it well for the next application of a very black synthetic charcoal that would achieve strong contact and help attain the illusory 3-D quality I was aiming for.

Although the surrounding garage wall had originally been painted a single shade of white, over time it had weathered, and in some areas the color had shifted. I intended to link the escalator to these qualities. A yellowish tint was added to the base paint and applied to the left and right sides of the escalator, which, when layered with charcoal, enhanced the dimensional illusion. Once completed, I repeatedly dusted the drawing with spray varnish to secure the powder. Then it was rolled with a few more coats of varnish, and plans were made to coat it with a newly available material that was removable, and thus guarded against graffiti.

When the mural was complete, a lonely drunk walking the alley one night was heard to call out in hoarse surprise, "Hey, maan, stairway t'heaven, man. Cool." Much fun was had by the temporary residents of the alley, who, high as kites, would self-mockingly mime the attempts of imaginary escapees. This brand of hilarity was not solely confined to the financially strapped or the chemically impaired.

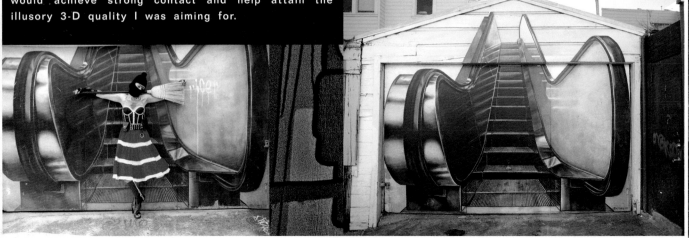

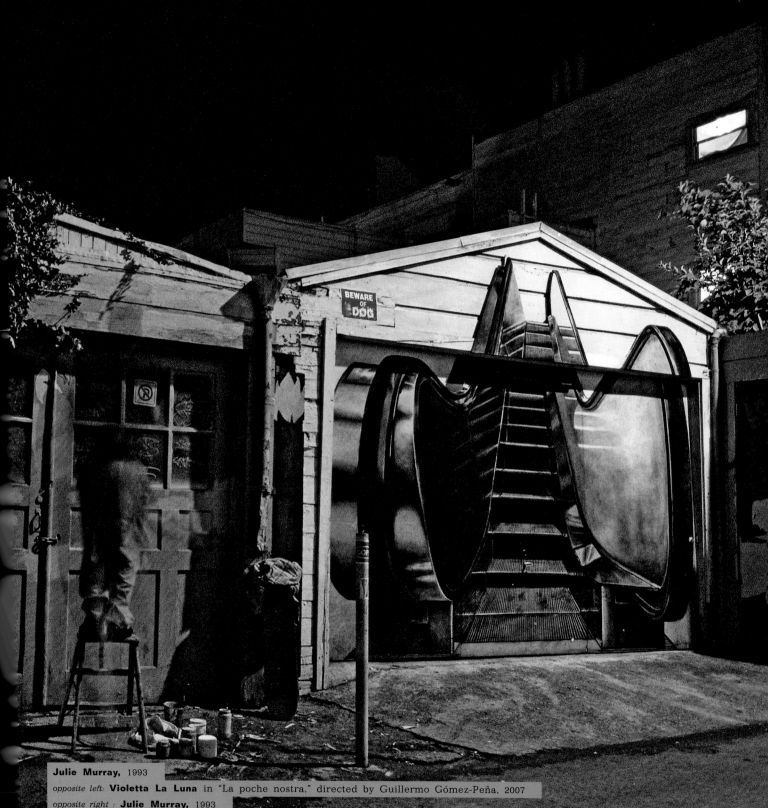

Julie Murray, 1993
opposite left: **Violetta La Luna** in "La poche nostra," directed by Guillermo Gómez-Peña, 2007
opposite right : **Julie Murray,** 1993

127

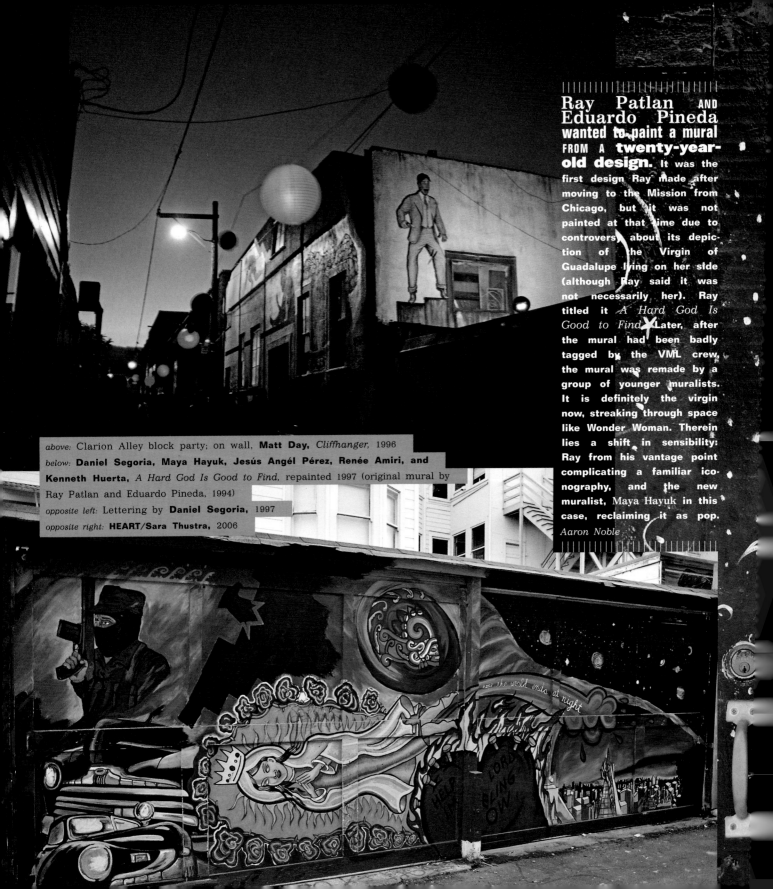

Ray Patlan AND **Eduardo Pineda** wanted to paint a mural FROM A **twenty-year-old design.** It was the first design Ray made after moving to the Mission from Chicago, but it was not painted at that time due to controversy about its depiction of the Virgin of Guadalupe lying on her side (although Ray said it was not necessarily her). Ray titled it *A Hard God Is Good to Find.* Later, after the mural had been badly tagged by the VML crew, the mural was remade by a group of younger muralists. It is definitely the virgin now, streaking through space like Wonder Woman. Therein lies a shift in sensibility: Ray from his vantage point complicating a familiar iconography, and the new muralist, Maya Hayuk in this case, reclaiming it as pop.

Aaron Noble

above: Clarion Alley block party; on wall, **Matt Day,** *Cliffhanger,* 1996

below: **Daniel Segoria, Maya Hayuk, Jesús Angél Pérez, Renée Amiri, and Kenneth Huerta,** *A Hard God Is Good to Find,* repainted 1997 (original mural by Ray Patlan and Eduardo Pineda, 1994)

opposite left: Lettering by **Daniel Segoria,** 1997

opposite right: **HEART/Sara Thustra,** 2006

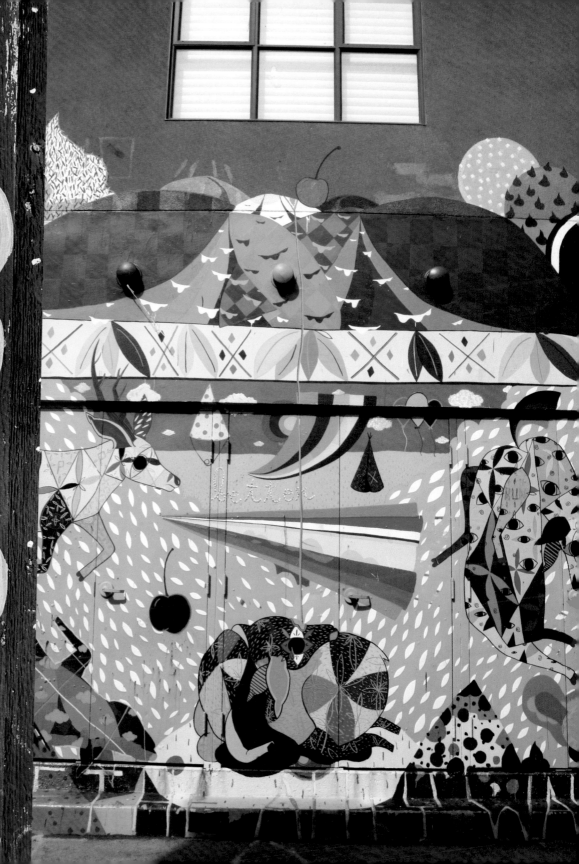

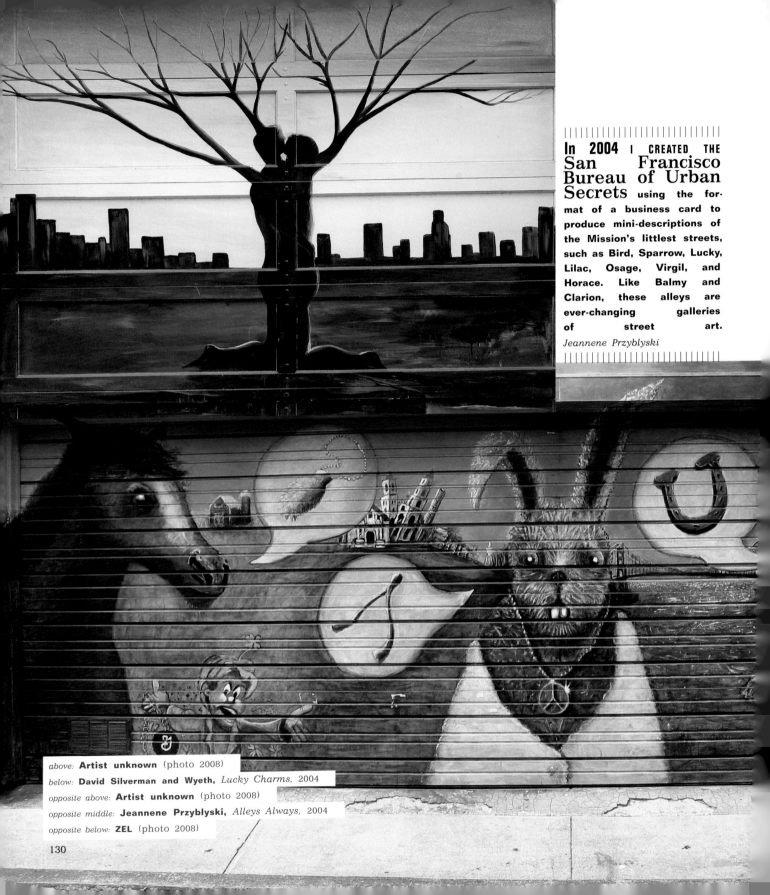

above: **Artist unknown** (photo 2008)
below: **David Silverman and Wyeth,** *Lucky Charms,* 2004
opposite above: **Artist unknown** (photo 2008)
opposite middle: **Jeannene Przyblyski,** *Alleys Always,* 2004
opposite below: **ZEL** (photo 2008)

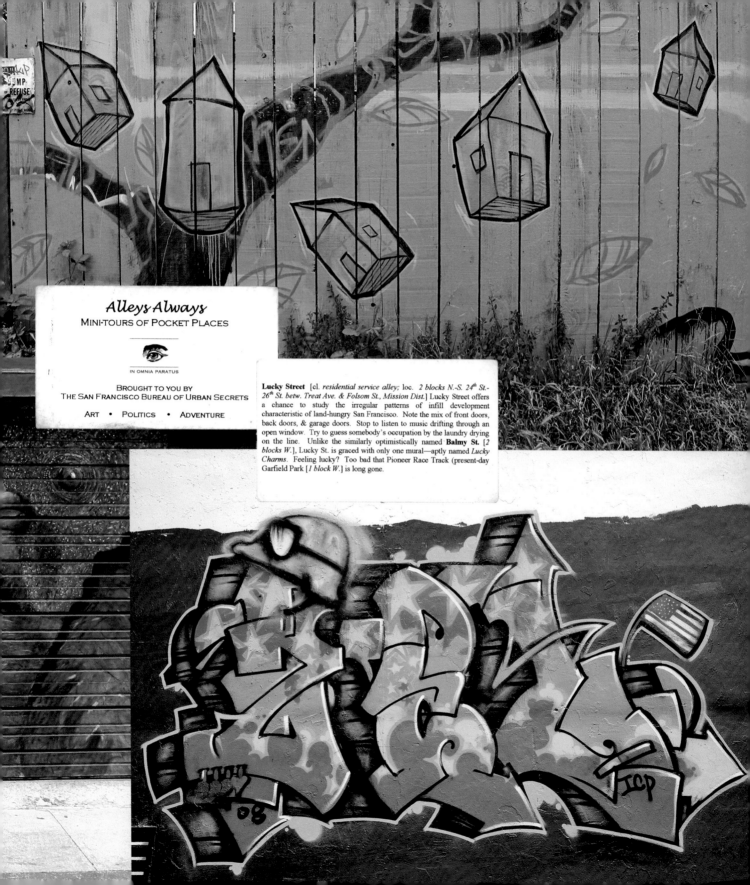

Alleys Always
MINI-TOURS OF POCKET PLACES

IN OMNIA PARATUS

BROUGHT TO YOU BY
THE SAN FRANCISCO BUREAU OF URBAN SECRETS

ART • POLITICS • ADVENTURE

Lucky Street [cl. *residential service alley;* loc. *2 blocks N.-S. 24th St.-26th St. betw. Treat Ave. & Folsom St., Mission Dist.*] Lucky Street offers a chance to study the irregular patterns of infill development characteristic of land-hungry San Francisco. Note the mix of front doors, back doors, & garage doors. Stop to listen to music drifting through an open window. Try to guess somebody's occupation by the laundry drying on the line. Unlike the similarly optimistically named **Balmy St.** [*2 blocks W.*], Lucky St. is graced with only one mural—aptly named *Lucky Charms*. Feeling lucky? Too bad that Pioneer Race Track (present-day Garfield Park [*1 block W.*] is long gone.

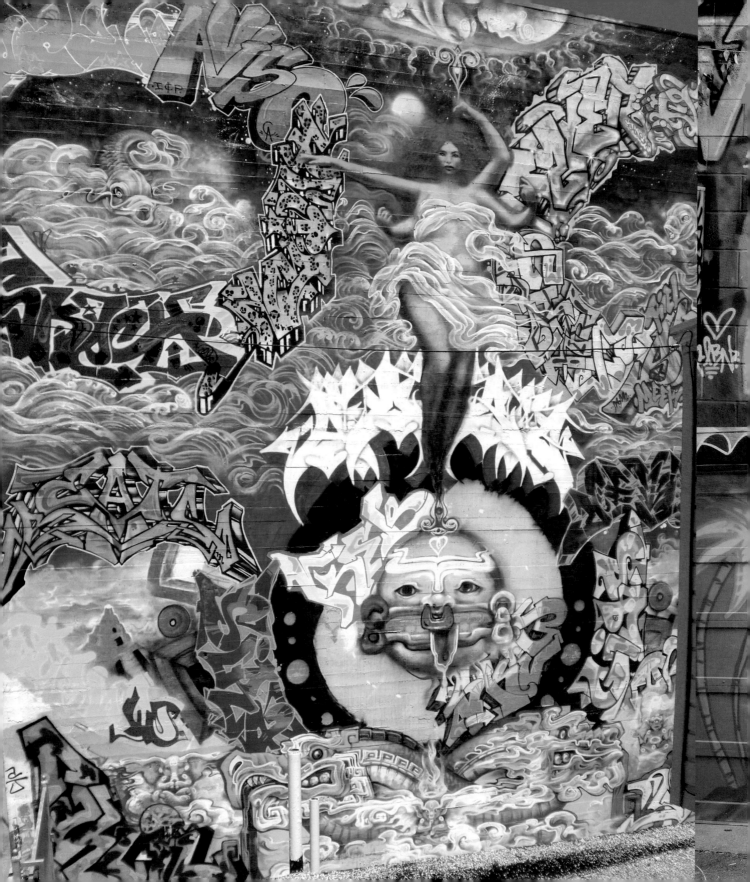

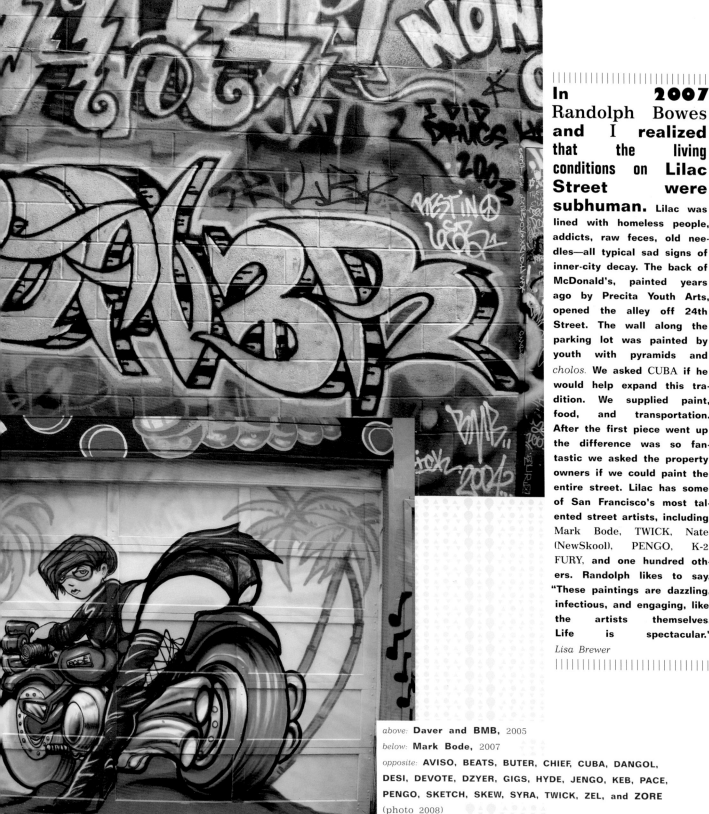

In **2007** Randolph Bowes **and I realized** that the living conditions on **Lilac Street** were **subhuman.** Lilac was lined with homeless people, addicts, raw feces, old needles—all typical sad signs of inner-city decay. The back of McDonald's, painted years ago by Precita Youth Arts, opened the alley off 24th Street. The wall along the parking lot was painted by youth with pyramids and *cholos.* We asked CUBA if he would help expand this tradition. We supplied paint, food, and transportation. After the first piece went up the difference was so fantastic we asked the property owners if we could paint the entire street. Lilac has some of San Francisco's most talented street artists, including Mark Bode, TWICK, Nate (NewSkool), PENGO, K-2, FURY, **and one hundred others.** Randolph likes to say, **"These paintings are dazzling, infectious, and engaging, like the artists themselves. Life is spectacular."**
Lisa Brewer

above: **Daver and BMB,** 2005
below: **Mark Bode,** 2007
opposite: **AVISO, BEATS, BUTER, CHIEF, CUBA, DANGOL, DESI, DEVOTE, DZYER, GIGS, HYDE, JENGO, KEB, PACE, PENGO, SKETCH, SKEW, SYRA, TWICK, ZEL, and ZORE**
(photo 2008)

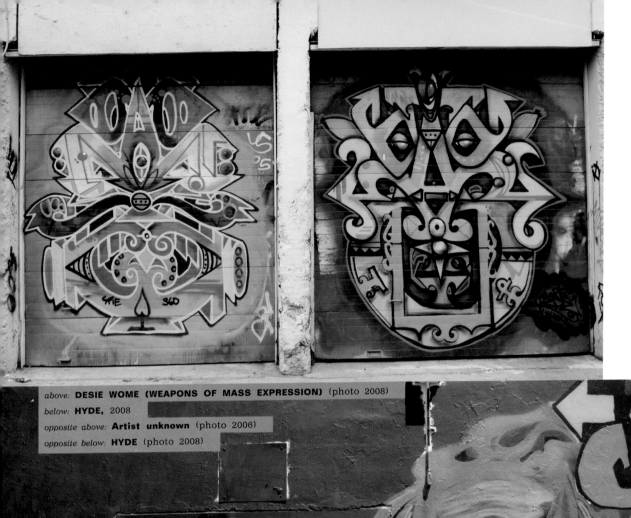

above: **DESIE WOME (WEAPONS OF MASS EXPRESSION)** (photo 2008)

below: **HYDE,** 2008

opposite above: **Artist unknown** (photo 2006)

opposite below: **HYDE** (photo 2008)

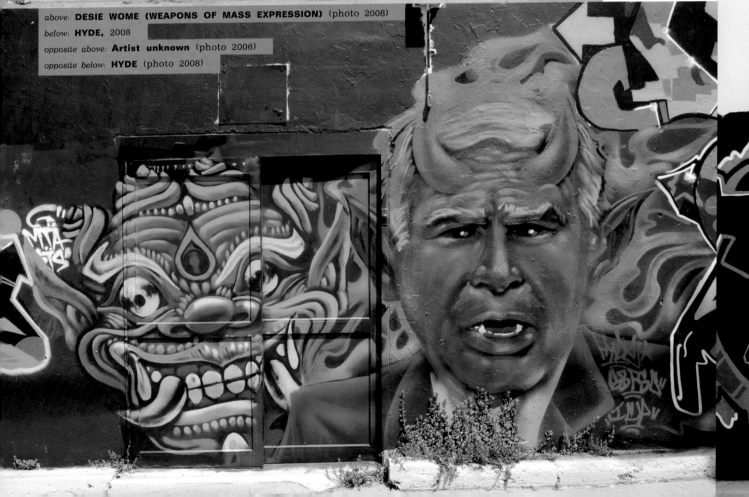

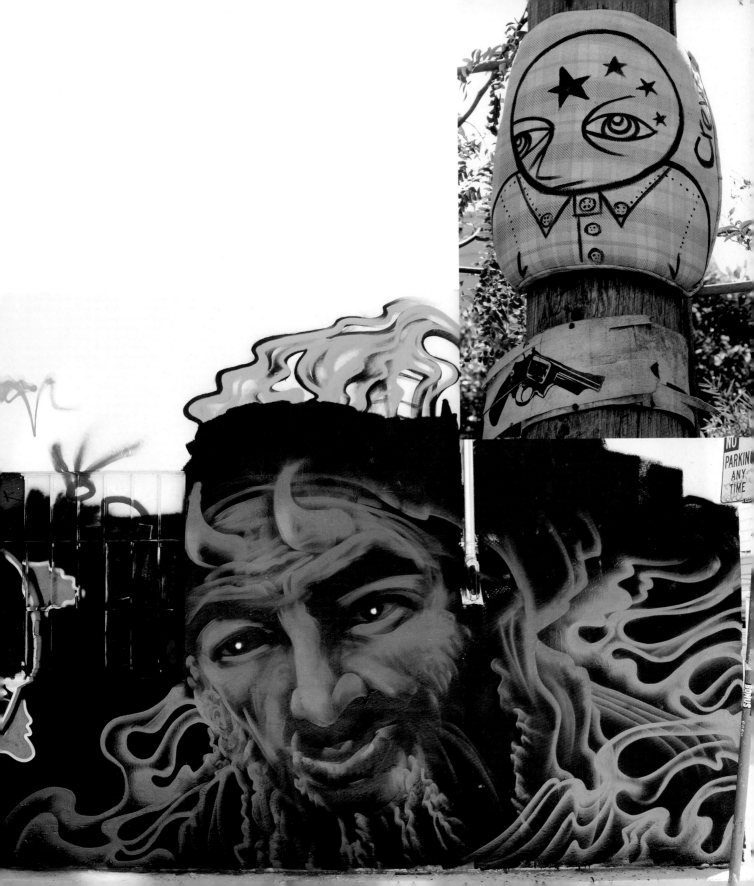

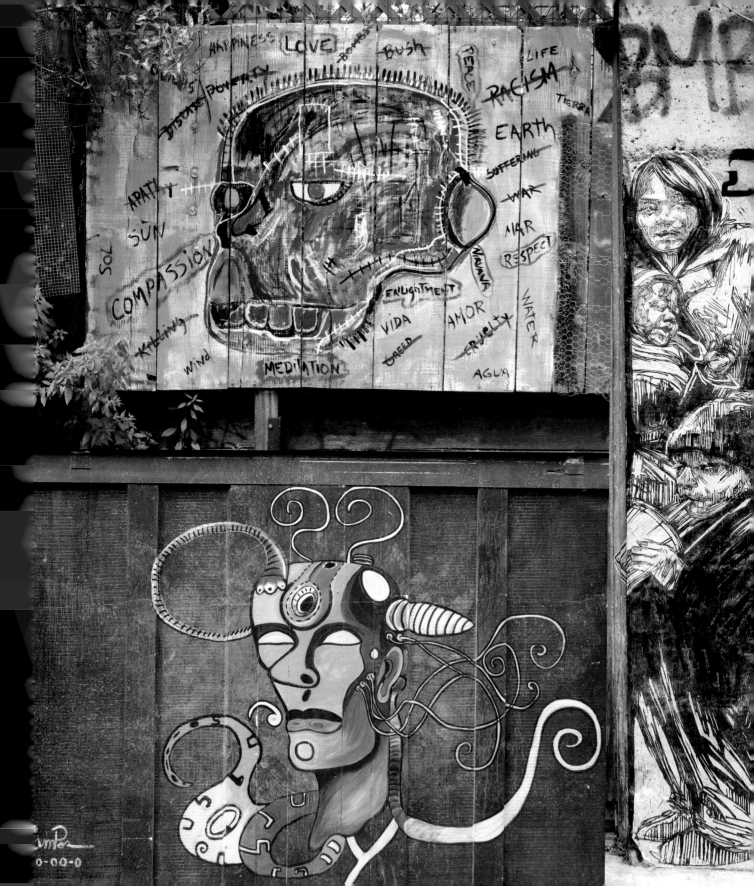

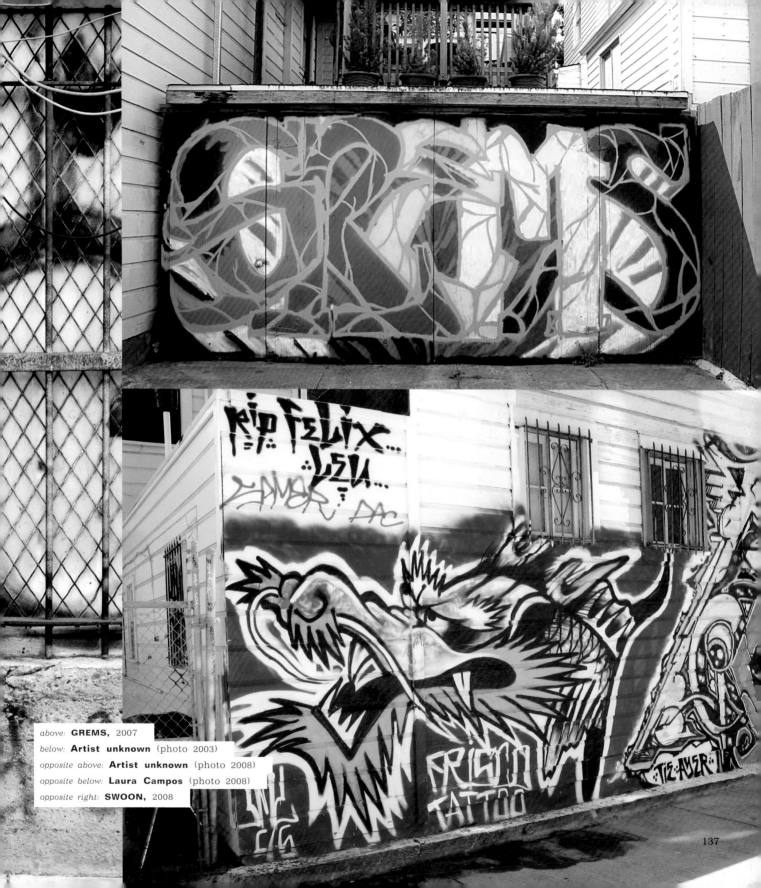

above: **GREMS,** 2007
below: **Artist unknown** (photo 2003)
opposite above: **Artist unknown** (photo 2008)
opposite below: **Laura Campos** (photo 2008)
opposite right: **SWOON,** 2008

137

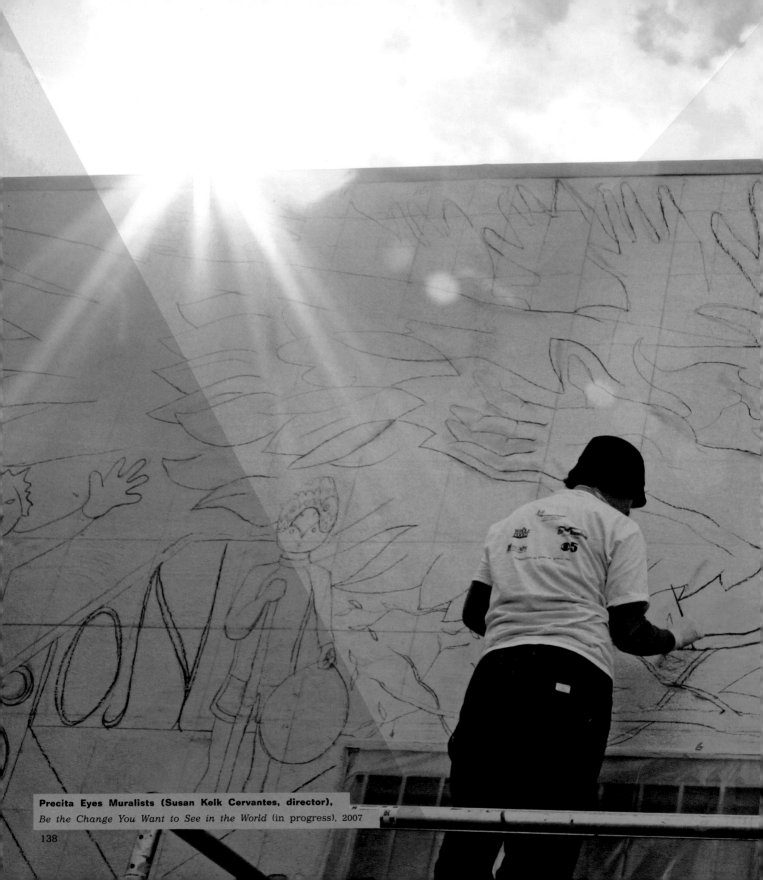

Precita Eyes Muralists (Susan Kelk Cervantes, director),
Be the Change You Want to See in the World (in progress), 2007

138

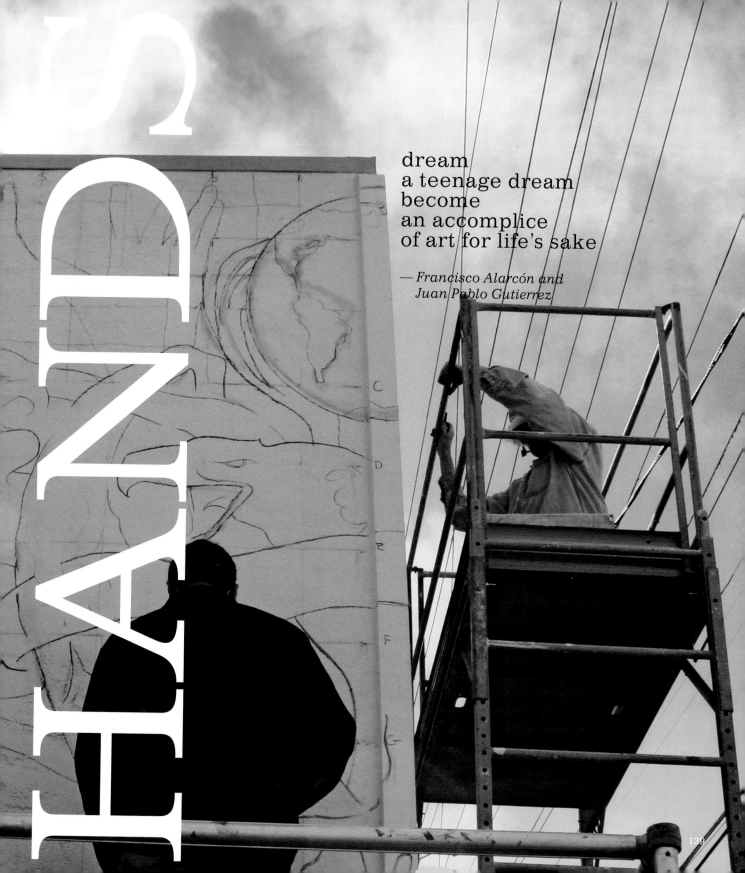

HANDS

dream
a teenage dream
become
an accomplice
of art for life's sake

— *Francisco Alarcón and*
Juan Pablo Gutierrez

139

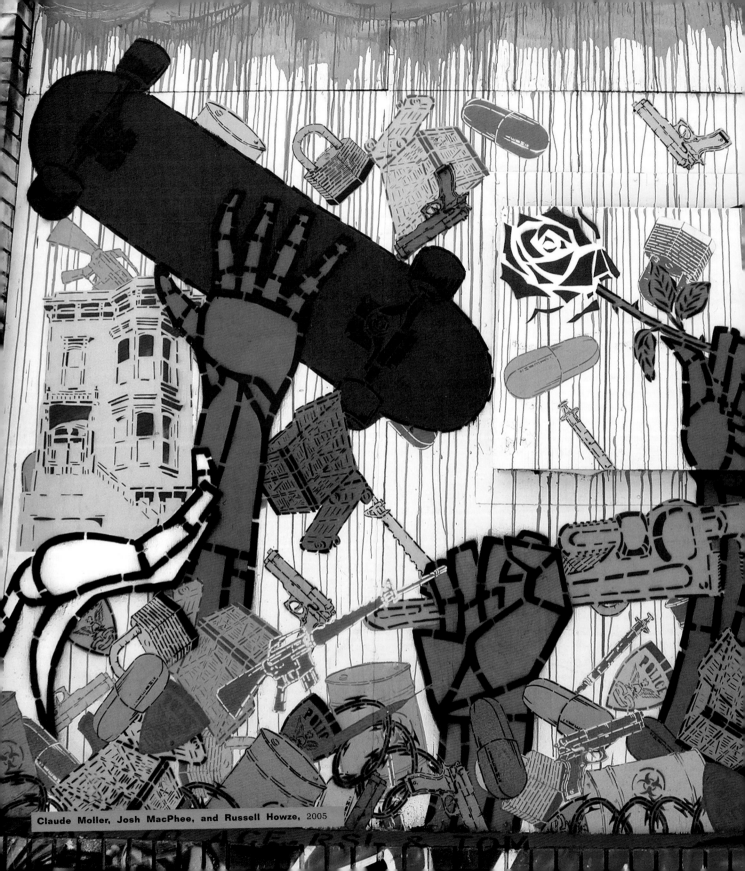

Claude Moller, Josh MacPhee, and Russell Howze, 2005

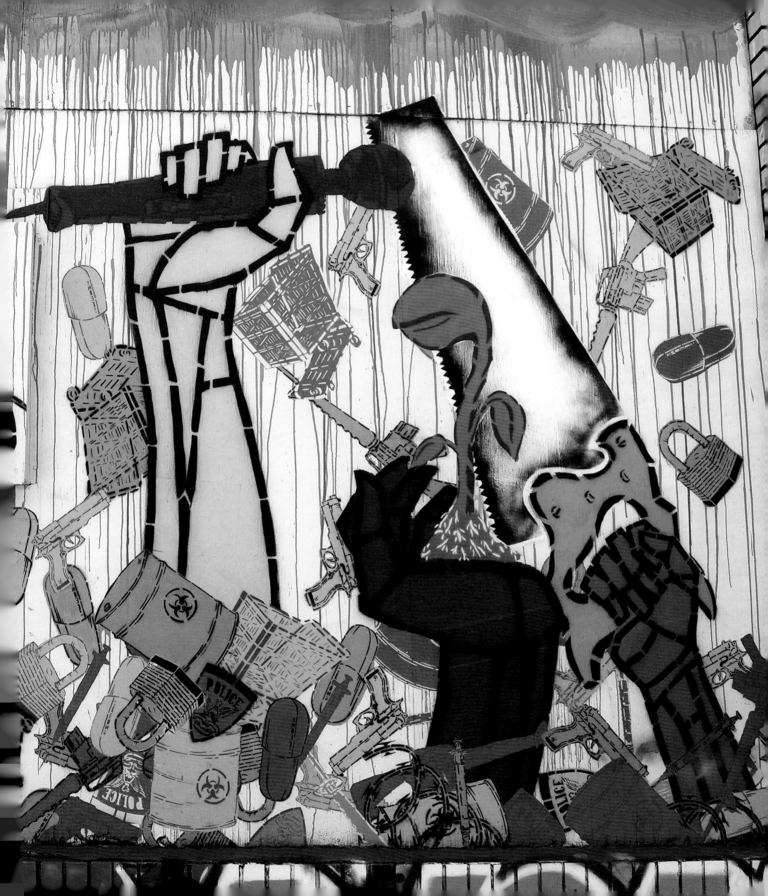

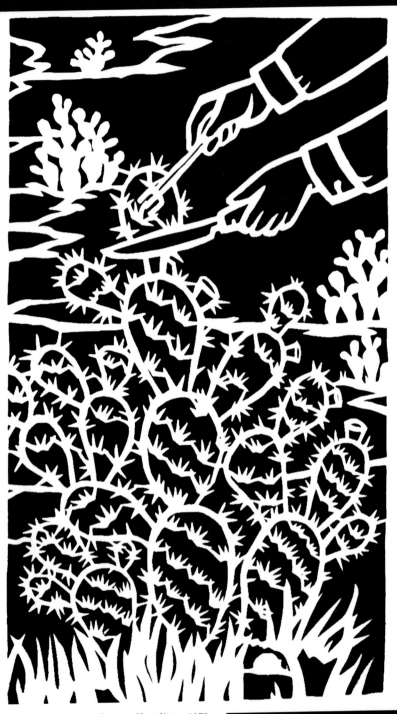

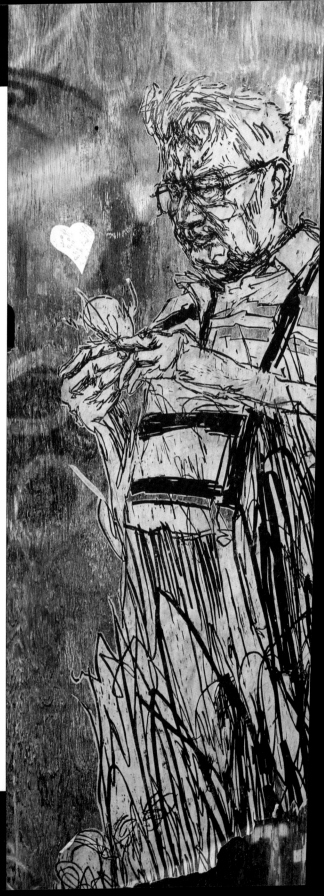

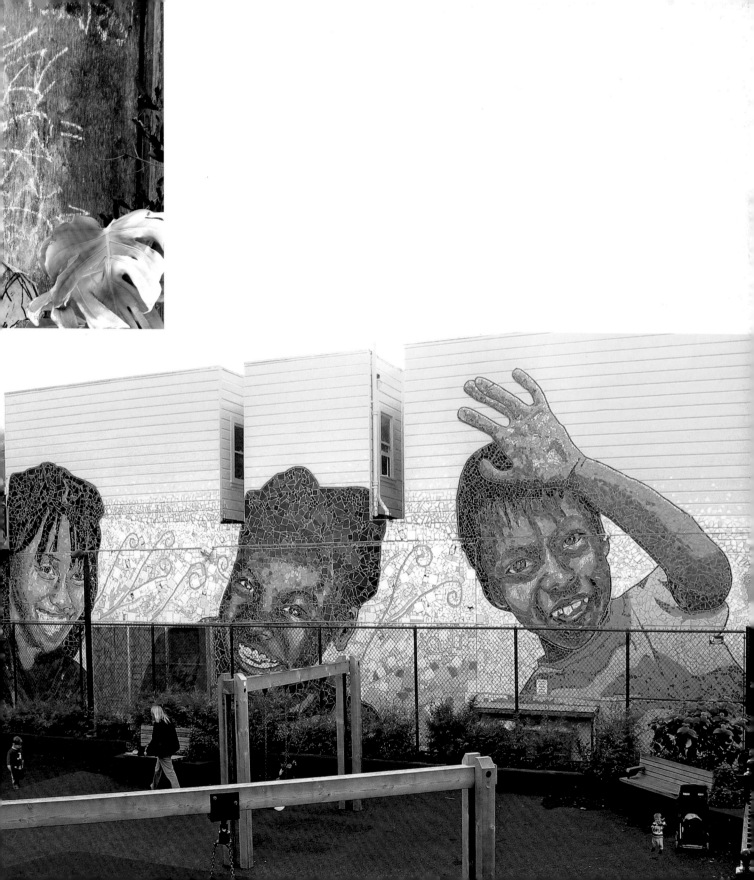

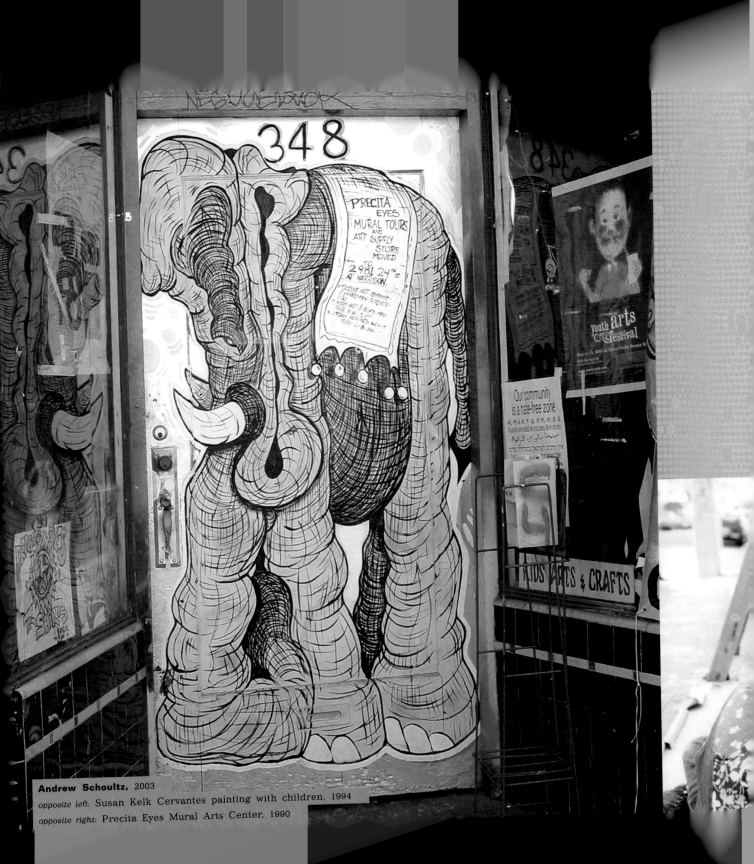

348

PRECITA
EYES
MURAL TOURS
AND
ART SUPPLY
STORE
MOVED
TO
2981 24TH ST
AT HARRISON.

youth arts Festival

Our community
is a hate-free zone

KIDS ARTS & CRAFTS

Andrew Schoultz, 2003
opposite left: Susan Kelk Cervantes painting with children, 1994
opposite right: Precita Eyes Mural Arts Center, 1990

HANDS IN THE COMMUNITY: PRECITA EYES MURALISTS

KATHERINE GRESSEL

THE STORY of the Precita Eyes Muralists begins with Susan Kelk Cervantes, a painter from Texas trained at the San Francisco Art Institute. During the strident times of Chicano renaissance, Susan came of age as an artist and community organizer. By April 2007 Precita Eyes Mural Arts Center was the focus of a *New York Times* "Museum Section" special featuring the organization's impact in schools, in the community, and around the world.

Precita Eyes muralist and tour coordinator Patricia Rose recalls her first meeting with Cervantes: "Susan made tea and told me stories for two hours, and gave me the telephone numbers of other notable muralists. The most significant thing she gave me was an invitation to come to the Thursday evening workshop and paint with Precita Eyes. This changed the direction of my life." Rose's story echoes that of the many artists, children, tourists, and art enthusiasts for whom Precita Eyes has fashioned a new definition of and direction in art.

Involvement in Precita Eyes usually begins with a conversation with Cervantes. She is as likely to invite visitors to her home, draped with mural maquettes and shrines to her late husband, Luis, as she is to engage them as participants at a community mural-training workshop. Susan's memories of more than three decades of pioneering community muralism pour from her like the tea she offers, as carefully catalogued in her mind as the photographs, slides, and descriptions of no longer extant murals in the organization's archives. Susan has lived as simply as she has lived richly, strength of hands paired with strength of vision to craft a life of creativity, spirituality, family, and community. These core values have guided Precita Eyes as the gatekeeper of a community arts practice that is as specific as it is inclusive, as rooted in place and tradition as it is spread across artistic genres—graffiti, indigenous sculpture, folk art.

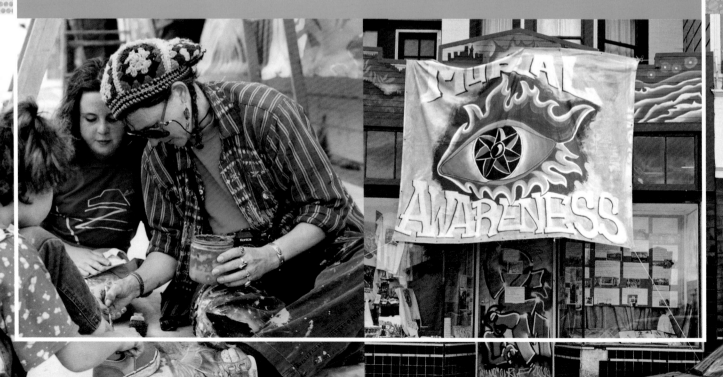

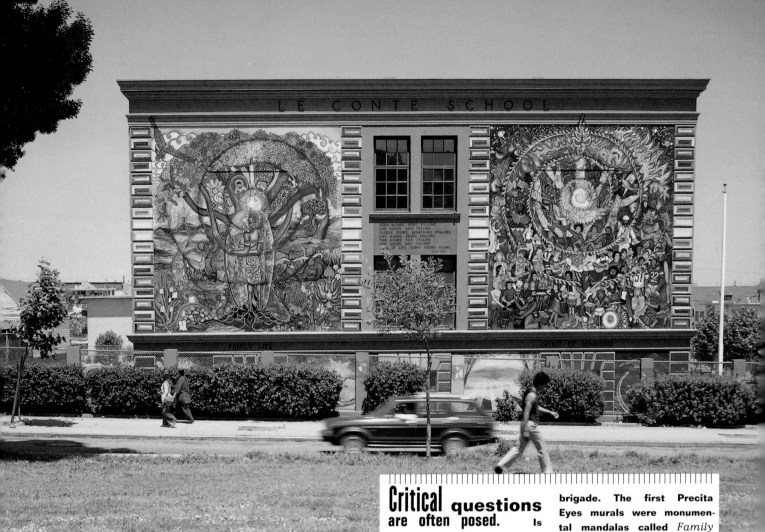

Susan Kelk Cervantes with Judith Jamerson, *Family Life and Spirit of Mankind*, 1977

opposite: **Susan Kelk Cervantes, Denise Meeham, Margo Bors, and Anthony Parrinello,** *A Bountiful Harvest,* 1978

Critical questions are often posed.

Is Precita Eyes simply producing beloved community portraits through its self-proclaimed "deep commitment to creating art that is accessible, both physically and conceptually, to viewers from diverse backgrounds and cultural interests?" Is this art your grandmother would hate? Or art only your grandmother could love? The answer is that the muralists seem to embrace it all. Their production runs the aesthetic and political spectrum, like a rainbow coalition flag flapping in a post-millennium brigade. The first Precita Eyes murals were monumental mandalas called *Family Life and Spirit of Mankind,* featuring an amorous Edenic couple that looks as if it was inspired by both Paul Cézanne and Peter Max. Susan Kelk Cervantes will smile if you ask if that image is a portrait of her and Luis. Precita Eyes has delivered, mostly on sheer personal moxie, and very modest funding, one of the boldest commitments to an ongoing grassroots community in this country.

Annice Jacoby

DURING THE DECADES **when it was illegal to trade with China,** a lone, brave book company DISTRIBUTED PUBLICATIONS AND ARTWORK FROM THE **People's Republic.** In 1978 China Books asked Susan Kelk Cervantes to paint the front of its 24th Street store. This mural was Precita Eyes' first commission. The colorful, positive images of rural life were based on the work of the peasant painters of Huhsein County, China. China Books closed a few years after the death of its visionary founder. Today the mural is a smiling artifact, a pastel homage to multiple idealisms. Nostalgia fuels the appealing, propagandistic views of sunny life in rural China. The mural cheers the legal and illegal workers on 24th Street, many of whom have done time in the fields.

Annice Jacoby

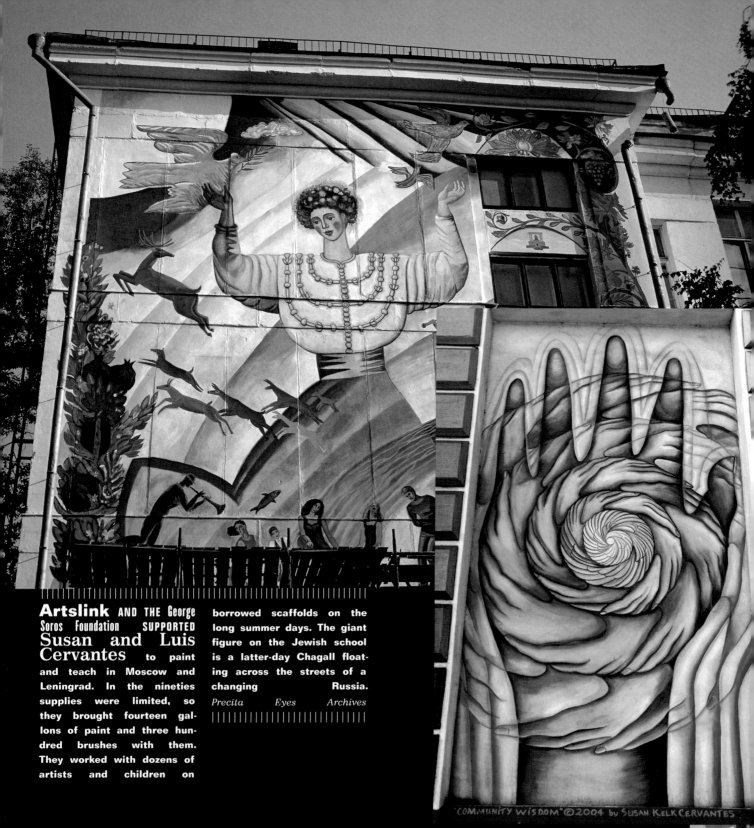

Artslink AND THE George Soros Foundation SUPPORTED **Susan and Luis Cervantes** to paint and teach in Moscow and Leningrad. In the nineties supplies were limited, so they brought fourteen gallons of paint and three hundred brushes with them. They worked with dozens of artists and children on borrowed scaffolds on the long summer days. The giant figure on the Jewish school is a latter-day Chagall floating across the streets of a changing Russia.

Precita Eyes Archives
|||||||||||||||||||||||||||||||||||

"COMMUNITY WISDOM" ©2004 by SUSAN KELK CERVANTES

THE "POLYFRESCO" TECHNIQUE
SUSAN KELK CERVANTES

THE "POLYFRESCO" mural technique was inspired in 1992 during a fresco workshop at Precita Eyes Mural Arts Center conducted by Lucienne Bloch and Stephen Dimitrof, former apprentices to Diego Rivera for the Rockefeller Center and Detroit Institute of Arts murals. It dawned on me that acrylic paste was very similar to the slacked lime putty traditionally used in true fresco. I applied the same traditional formula for true fresco to the acrylic material and experimented with it. Dimitrof, a dedicated fresco muralist and master plasterer, encouraged me to complete my experiment and test it over time.

The experiment exceeded my expectations. In 2004 I created the first public "polyfresco" called *Community Wisdom* on the side of the Leonard R. Flynn Elementary School. "Polyfresco" has several advantages over traditional fresco and contemporary mural painting. The most fascinating is the fact that the acrylic color is absorbed into the polished wet surface of the wall, which has been prepared like true fresco, and dries embedded into the wall. A muralist can continue adding acrylic color to the surface even after it has dried and still find it very absorbent. It is the most beautiful surface I have ever painted on.

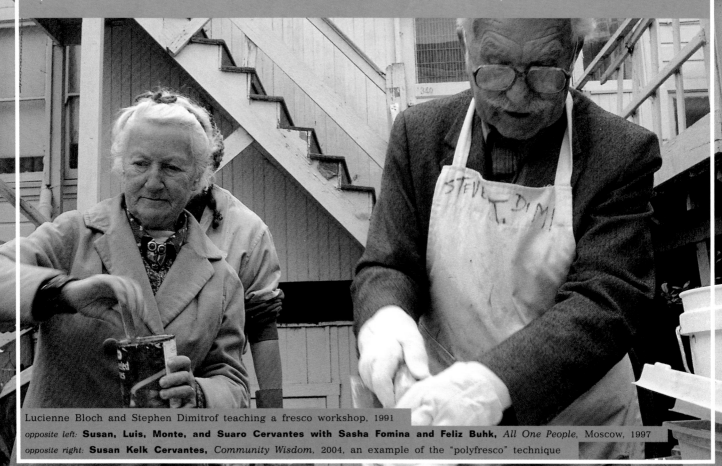

Lucienne Bloch and Stephen Dimitrof teaching a fresco workshop, 1991

opposite left: **Susan, Luis, Monte, and Suaro Cervantes with Sasha Fomina and Feliz Buhk,** *All One People,* Moscow, 1997

opposite right: **Susan Kelk Cervantes,** *Community Wisdom,* 2004, an example of the "polyfresco" technique

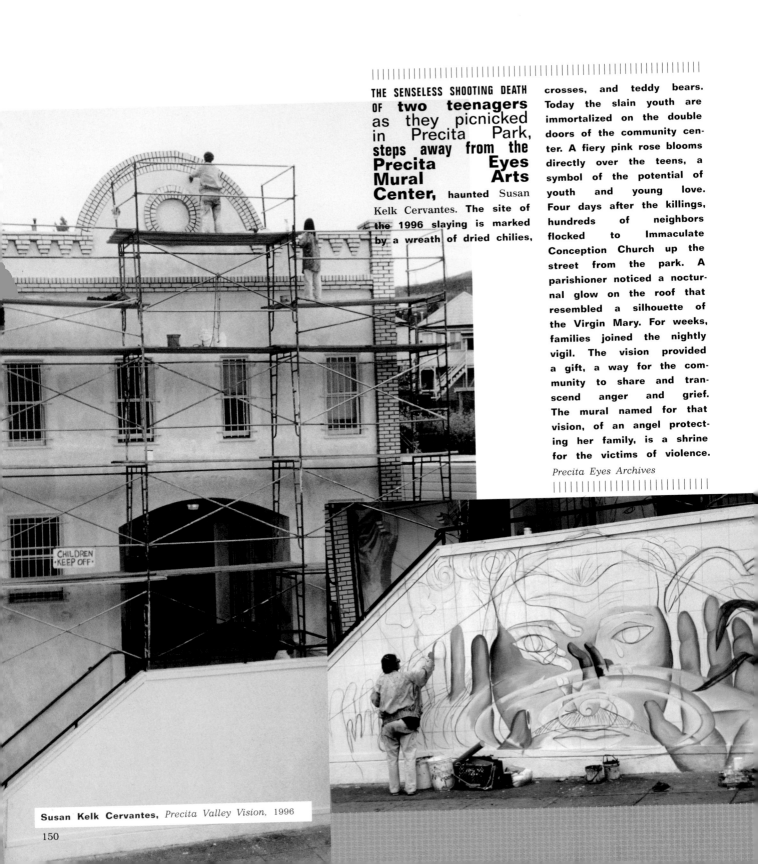

THE SENSELESS SHOOTING DEATH OF **two teenagers** as they picnicked in Precita Park, steps away from the **Precita Eyes Mural Arts Center,** haunted Susan Kelk Cervantes. The site of the 1996 slaying is marked by a wreath of dried chilies, crosses, and teddy bears. Today the slain youth are immortalized on the double doors of the community center. A fiery pink rose blooms directly over the teens, a symbol of the potential of youth and young love. Four days after the killings, hundreds of neighbors flocked to Immaculate Conception Church up the street from the park. A parishioner noticed a nocturnal glow on the roof that resembled a silhouette of the Virgin Mary. For weeks, families joined the nightly vigil. The vision provided a gift, a way for the community to share and transcend anger and grief. The mural named for that vision, of an angel protecting her family, is a shrine for the victims of violence.

Precita Eyes Archives

Susan Kelk Cervantes, *Precita Valley Vision,* 1996

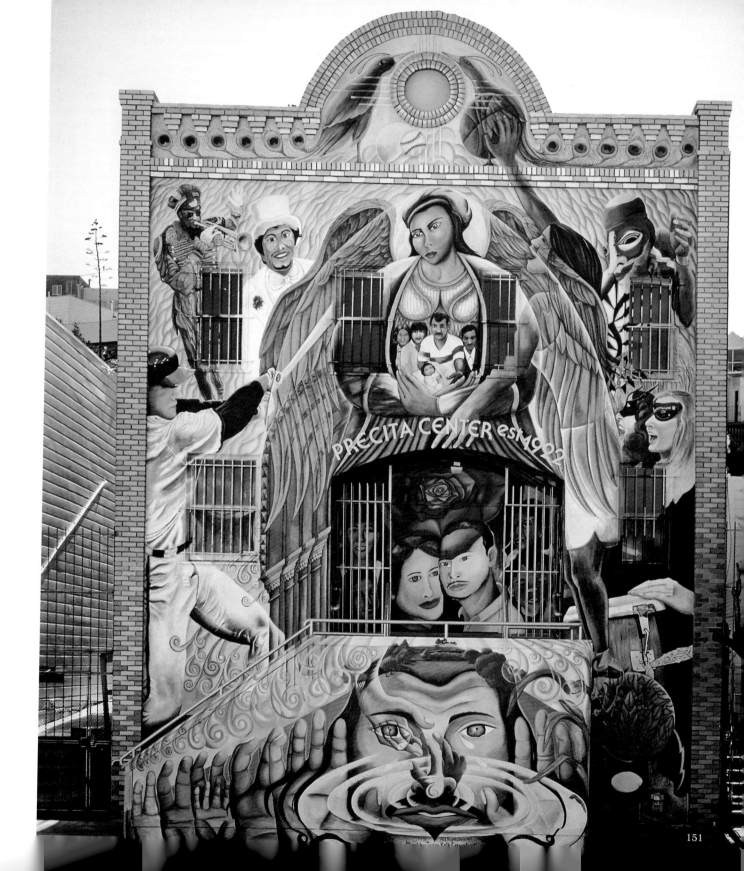

151

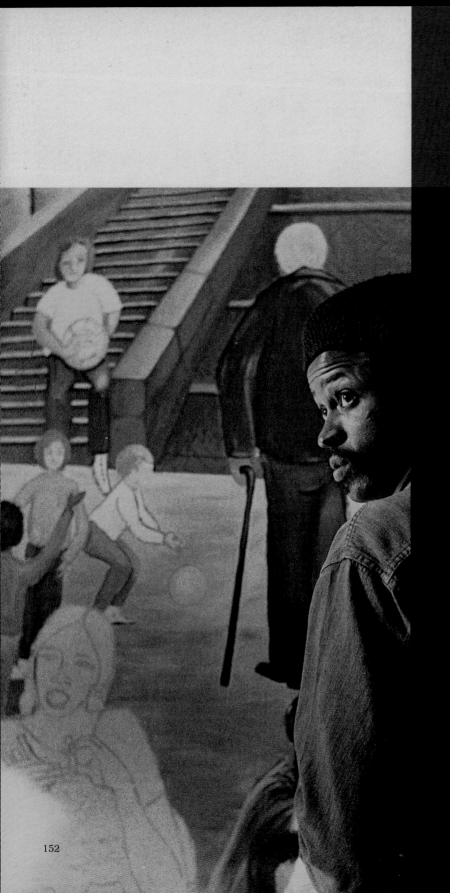

I am originally FROM Arkansas. I started mural painting by responding to a volunteer ad. I was curious and open to a new way of thinking about art, and about my self-transformation. *Soul Journey* was the highlight of my mural experience. I had been glued to a canvas, a chair, and a studio, and now I was seeing a long, huge, crude wall, nearly a half-block long. It was staggering to me. I came unglued. All the artists' visions combined and the joy, excitement, and camaraderie between the artists lifted me to the ceiling. This was my Michelangelesque e x p e r i e n c e . *John "Diallo" Jones*

GRAFF-ROOTS
KATHERINE GRESSEL

SUSAN KELK CERVANTES recognized the artistic actions of the graff community, which had been marginalized by law enforcement and media censure. In 1985 she started the Urban Youth Arts program, providing classes for youth interested in making graffiti-inspired murals. Precita Eyes pioneered a method of combining the individual virtuosity of graffiti with community muralism's respect for collaborative work. Instead of relying on slow, methodical sketching, gridding, and color-mixing processes, Urban Youth artists work freestyle, without a predetermined design, adding to and building upon each other's spontaneous signatures. There are ground rules in the Urban Youth Arts classes. A theme is determined by consensus before the mural is begun. Each person's contribution is respected, and no one paints over another's design. The group must find a way to unify the final piece. Susan Cervantes believes this approach teaches youth "to make something no one individual could have achieved alone, and to reap the benefits of cooperation and shared expression."

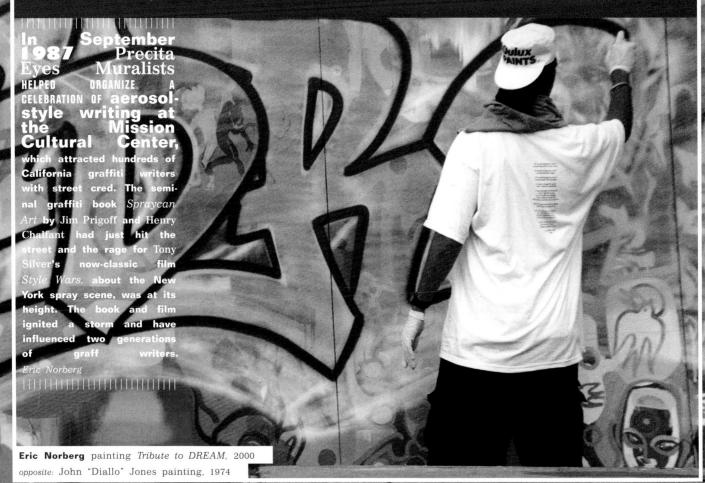

In September 1987 Precita Eyes Muralists HELPED ORGANIZE A CELEBRATION OF aerosol-style writing at the Mission Cultural Center, which attracted hundreds of California graffiti writers with street cred. The seminal graffiti book *Spraycan Art* by Jim Prigoff and Henry Chalfant had just hit the street and the rage for Tony Silver's now-classic film *Style Wars*, about the New York spray scene, was at its height. The book and film ignited a storm and have influenced two generations of graff writers.
Eric Norberg

Eric Norberg painting *Tribute to DREAM*, 2000
opposite: John "Diallo" Jones painting, 1974

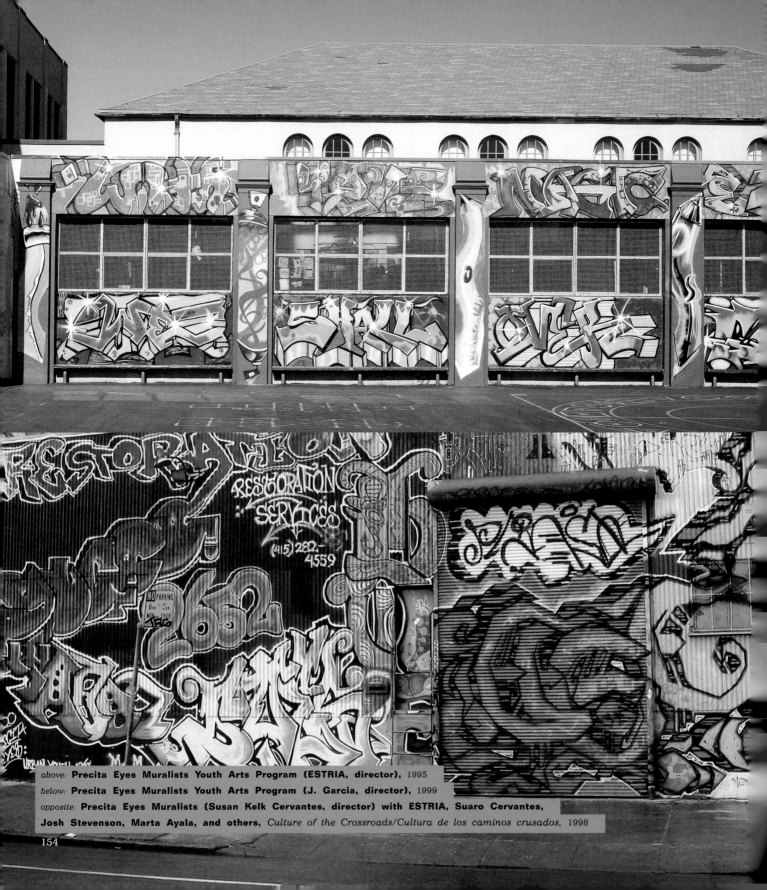

above: **Precita Eyes Muralists Youth Arts Program (ESTRIA, director),** 1995
below: **Precita Eyes Muralists Youth Arts Program (J. Garcia, director),** 1999
opposite: **Precita Eyes Muralists (Susan Kelk Cervantes, director) with ESTRIA, Suaro Cervantes,
Josh Stevenson, Marta Ayala, and others,** *Culture of the Crossroads/Cultura de los caminos crusados,* 1998

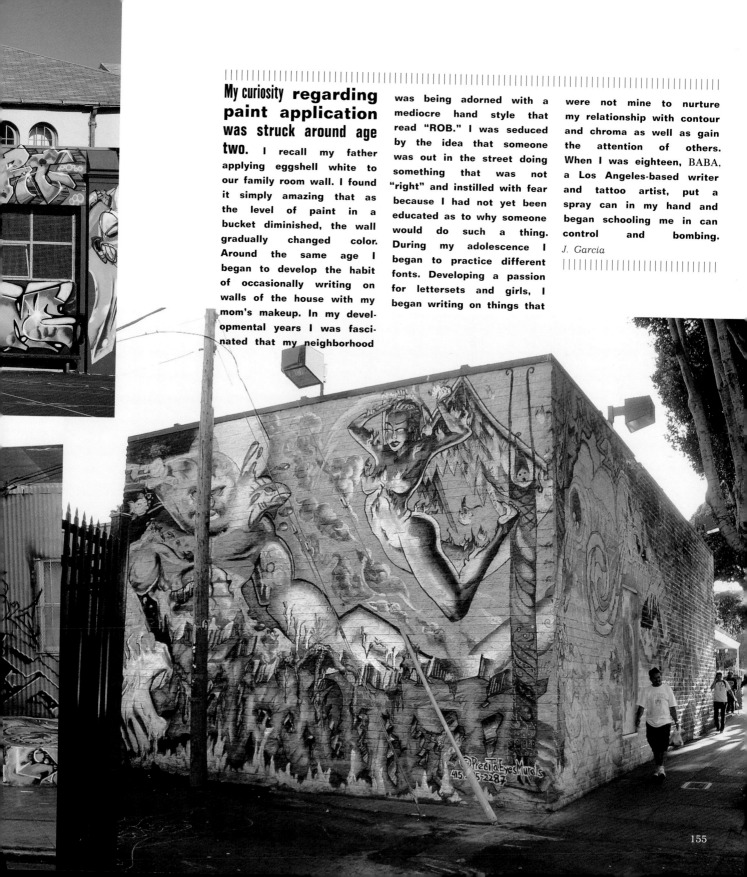

My curiosity regarding paint application was struck around age two. I recall my father applying eggshell white to our family room wall. I found it simply amazing that as the level of paint in a bucket diminished, the wall gradually changed color. Around the same age I began to develop the habit of occasionally writing on walls of the house with my mom's makeup. In my developmental years I was fascinated that my neighborhood was being adorned with a mediocre hand style that read "ROB." I was seduced by the idea that someone was out in the street doing something that was not "right" and instilled with fear because I had not yet been educated as to why someone would do such a thing. During my adolescence I began to practice different fonts. Developing a passion for lettersets and girls, I began writing on things that were not mine to nurture my relationship with contour and chroma as well as gain the attention of others. When I was eighteen, BABA, a Los Angeles-based writer and tattoo artist, put a spray can in my hand and began schooling me in can control and bombing.

J. Garcia

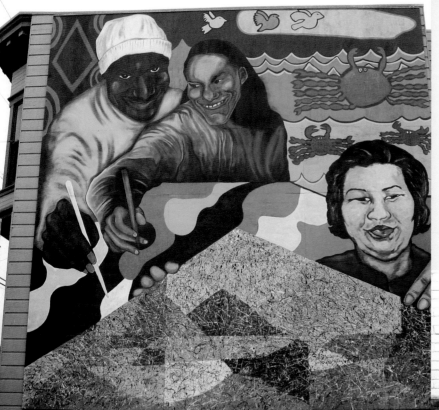

||||||||||||||||||||||||||

Many muralists
HAVE BEEN DEEPLY INVOLVED
WITH **Creativity**
Explored, a Mission-
based art workshop for
adults with developmental
disabilities, on the principle
that creativity is a universal
human capacity. Now sought
by collectors, the remarkable
art produced in the work-
shop breaks stereotypes
about limitations and con-
tributes to the Bay Area art
scene. The 16th Street stu-
dio continues to thrive as a
model of arts engagement,
attracting artists and visi-
tors from around the world.

Annice Jacoby

||||||||||||||||||||||||||

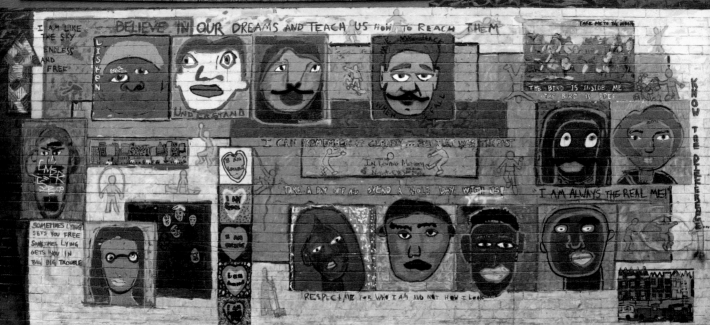

above: **Creativity Explored project with Jane Norling and Eduardo Pineda (Susan Greene, director),**
New Visions, 1987 (restored 2004)
below: **Gary Carlos, Urban Artworks,** *19 Reasons,* 2004
opposite: **San Francisco Boys and Girls Club project (Vicky Riga and Lisa Previs, directors),** *Where Legends Meet,* 1997

IN THE SCHOOLS

RACHEL KAPLAN

HANDS-ON education is a prevalent muralist practice. Bringing the expressive social justice legacy of Mission murals into the schools has been the work of many artists since the late 1960s. The pioneering school mural projects, curriculum-based and integrated with life experience, have been training grounds in the art of collaboration and communication across cultures. Mission mural projects are firmly rooted in a populist, pro-worker, anti-government, political response to a given historical moment—ultimately, they are humane responses to inhumanity. Mural artists offer a means of educating children how to proactively respond to their world.

Ruth Asawa, a Black Mountain–trained modernist sculptor, pioneered community arts education in the Mission. She worked closely with Anne-Marie Thielan, the visionary founder of SCRAP (Scavengers Creative Resource Arts Program) and the Neighborhood Arts Program. In 1975, the National Endowment for the Arts honored Asawa for her Alvarado School Art Workshop, which brought trained artists into the classroom. She said, "Children in schools today would not believe us if we told them that in the 1960s classrooms were painted a gray-green, which the painters called 'San Quentin Gray.'" Today every school in the Mission has not one mural but many murals on the walls.

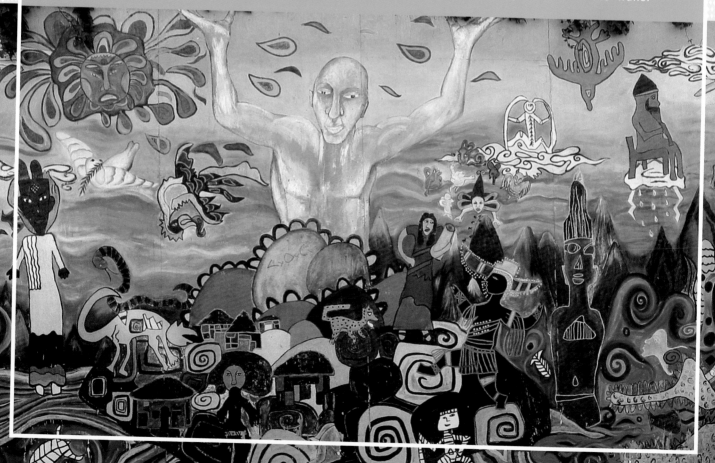

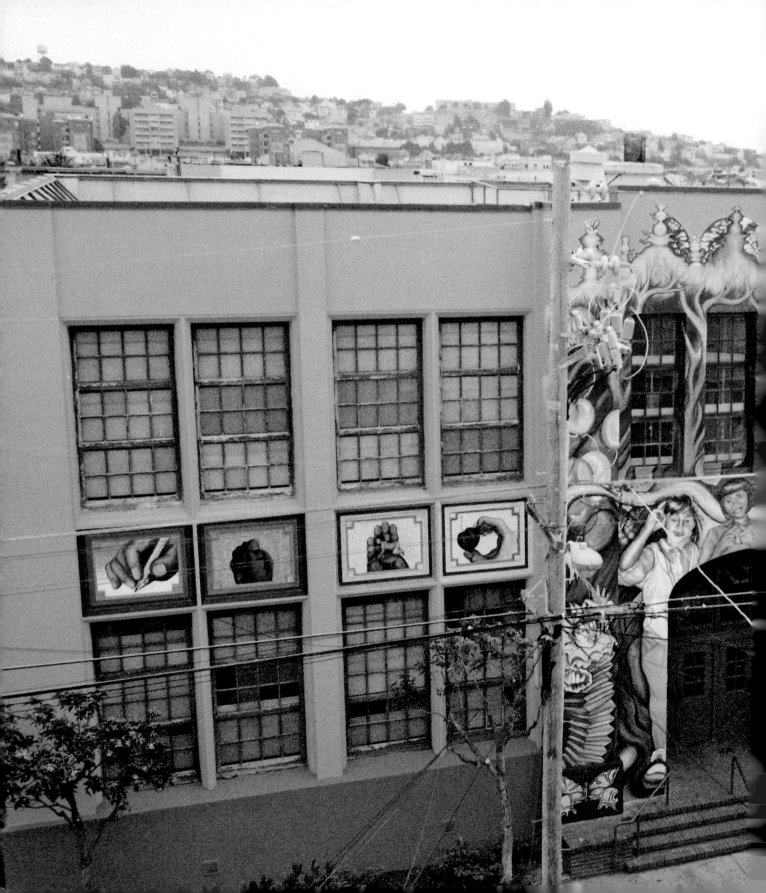

SILENT LANGUAGE OF THE SOUL
KATHERINE GRESSEL

Silent Language of the Soul/El lenguaje mudo del alma, created through a collaborative process that paired artists with the deaf and hearing-impaired program at the Cesar Chavez Elementary School, illuminates the power of language and learning to transcend boundaries. The mural wraps the building as audaciously as Christo uses cloth, in a style reminiscent of the medieval illustrated manuscripts that only priests and the privileged could read—except *Silent Language of the Soul* has a more democratic relationship to its viewers, celebrating the ways in which different cultures communicate.

The mural creates dialogue between the deaf and hearing populations. By acting as an interpreter, the mural illustrates the convergence of all forms of language. Over the main door, Susan Kelk Cervantes and Juana Alicia painted images of four children signing the phrase, "Welcome to the Hawthorne School" (The school was originally named for Nathaniel Hawthorne, and the children's hands had to be repainted when the school's name was changed in 1993). The thirty panels on the school's facade depict hands signing letters of the alphabet, in English and Spanish, and corresponding symbols. The alphabet panels contain Egyptian hieroglyphs, alluding to the beginnings of written language, and interwoven branches reveal the letters of many alphabets, including Japanese, Hebrew, Arabic, and Hopi.

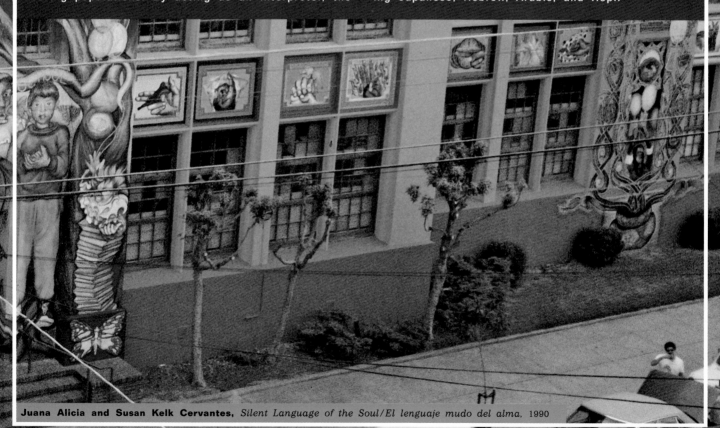

Juana Alicia and Susan Kelk Cervantes, *Silent Language of the Soul/El lenguaje mudo del alma.* 1990

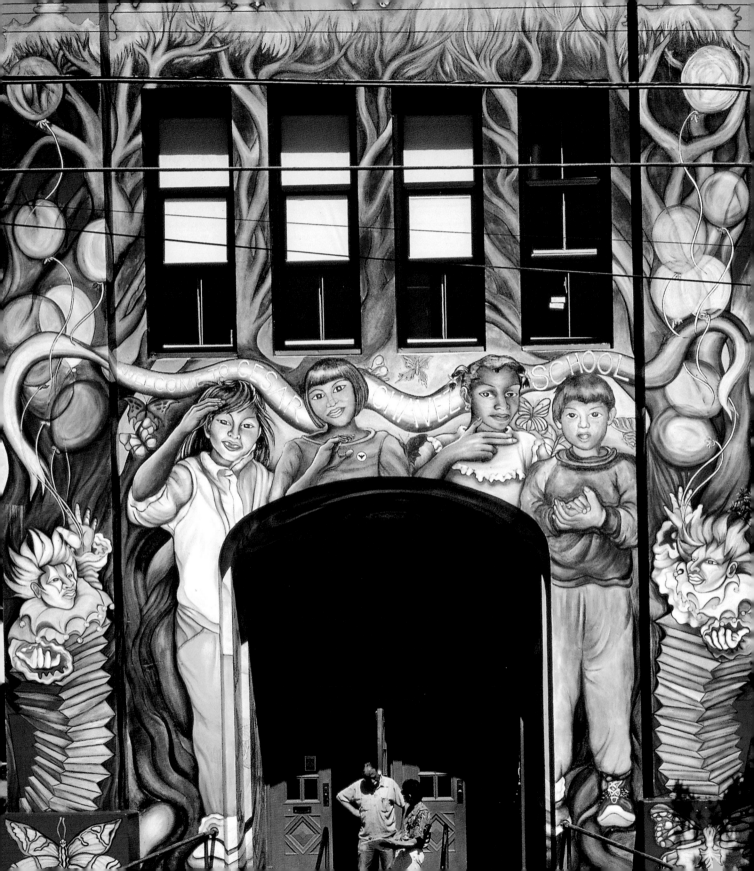

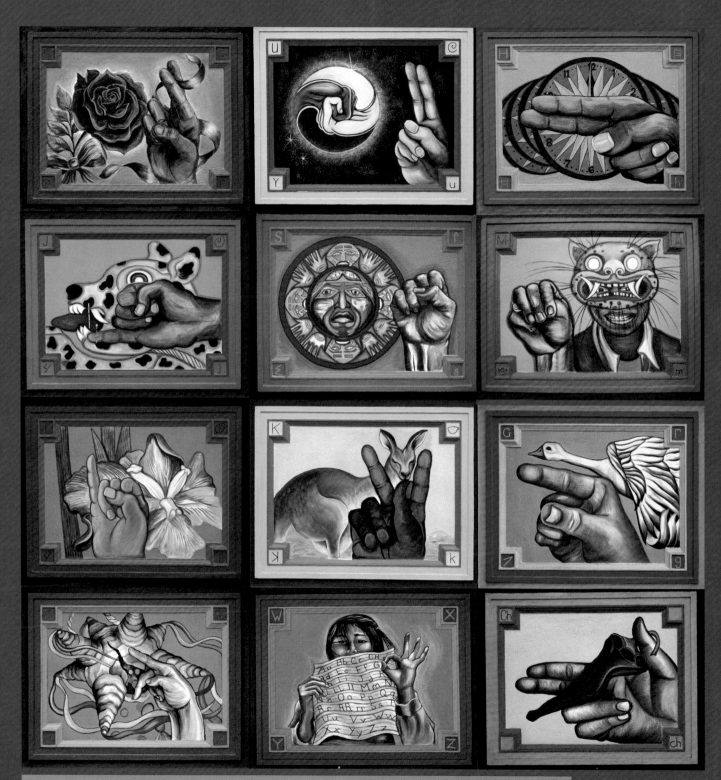

Juana Alicia and Susan Kelk Cervantes, *Silent Language of the Soul/El lenguaje mudo del alma,* 1990

CESAR CHAVEZ ELEMENTARY SCHOOL
PRECITA EYES ARCHIVES

SI SE PUEDE ("Yes, You Can"), the cry of the United Farm Workers (UFW), is painted in sun-drenched colors on Cesar Chavez Elementary School in the heart of the Mission. This *grito* (cry), the image of Chavez, and the black eagle—all icons of the agricultural labor movement—are the foundation for much Chicano art. The three-story scale of the heroic figures is reminiscent of epic church art, with its parallel purpose to inspire and unify. Chavez, surrounded by the fruits of the fields, dominates the mural. Dolores Huerta, the UFW's current leader and another hero often seen in Mission murals, opens a cyclone fence, allowing children access to freedom and education.

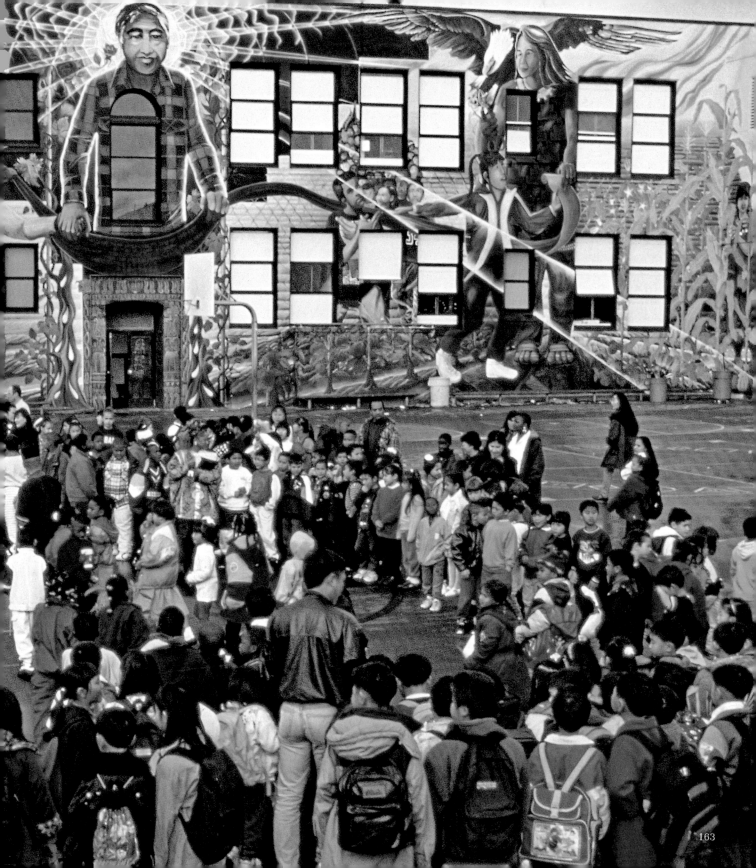

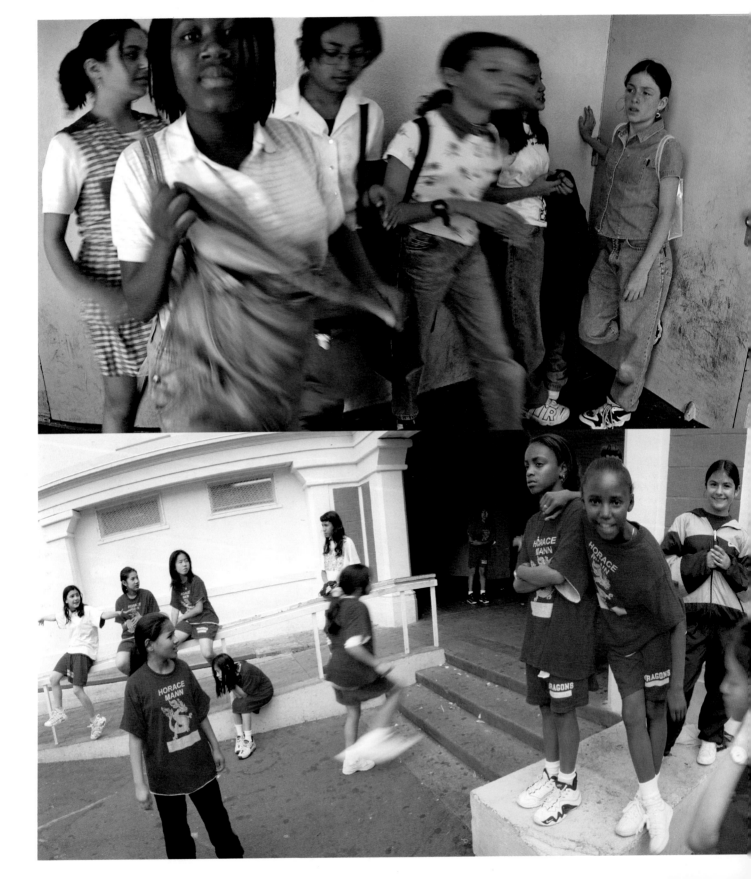

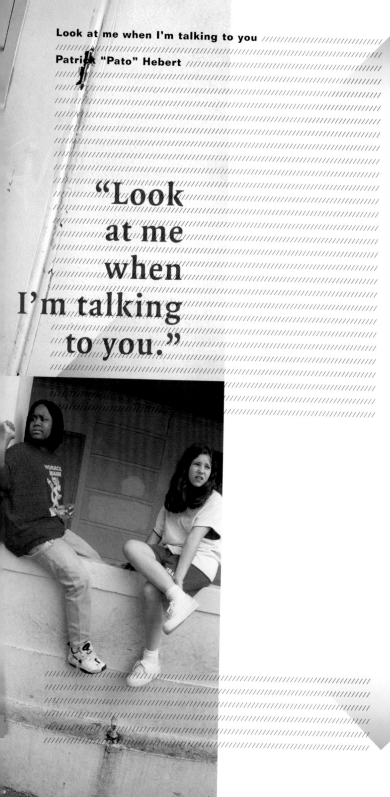

Look at me when I'm talking to you

Patrick "Pato" Hebert

"Look at me when I'm talking to you."

For several years during the mid-1990s, I lived in the Mission and worked as a bi-lingual teacher's aide at Horace Mann Academic **MIDDLE SCHOOL**, located at 23rd and Valencia Streets.

There I established an after-school photography program with support from the Ansel Adams Center for Photography (sadly, now closed) and numerous Horace Mann teachers. Students explored everything from developing and printing their own black-and-white negatives to making Polaroid transfers and digital images. They showed their work annually in the hallways at school and also participated in exhibitions at the Luggage Store Gallery and San Francisco City Hall.

During this time, I also made my own photographic portraits of the students during lunch hour. In 1994 I exhibited a selection of my sixteen-by-twenty-inch color portraits throughout the school hallways. The exhibition was short-term but generated overwhelming enthusiasm that encouraged me to pursue a larger-scale, more permanent project. I proposed using a panoramic camera that would allow for unique optical angles and the presence of multiple narratives within its expansive frame. The resulting images would be enlarged into photomurals and

Patrick "Pato" Hebert, *Look at me when I'm talking to you,* 1998

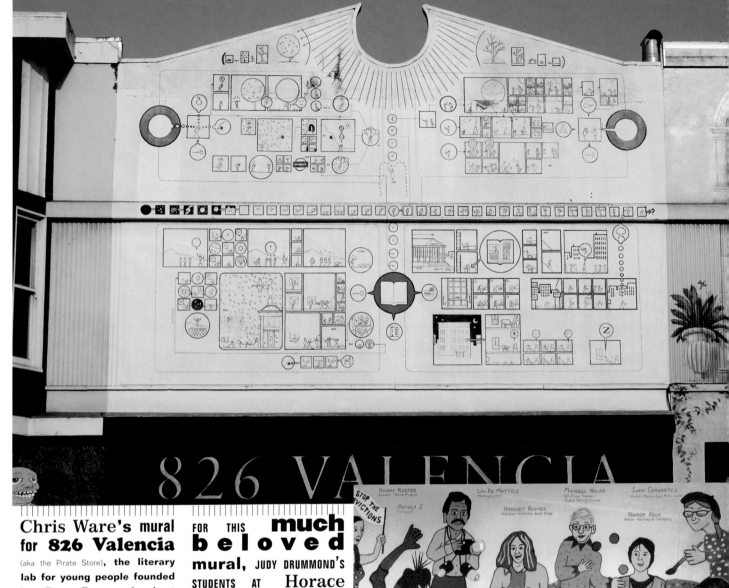

826 VALENCIA

Chris Ware's mural for 826 Valencia

(aka the Pirate Store), the literary lab for young people founded by Dave Eggers, is best viewed by standing in the middle of the street with a telescope. It is a fiendishly intricate diagram depicting the parallel developments of the human race and its efforts at communication.

Annice Jacoby

FOR THIS much beloved mural, JUDY DRUMMOND'S STUDENTS AT Horace Mann Middle School began by interviewing Mission District heroes, a roster of local cultural and social innovators. The award-winning project featured the students' biographies of the heroes and depicted them almost life size in a mural on the outside of their school.

Annice Jacoby

above: **Chris Ware,** 2002

below: **Josef Norris (artist), Judy Drummond (project director), and Horace Mann students,** *People of the Mission District,* 2001

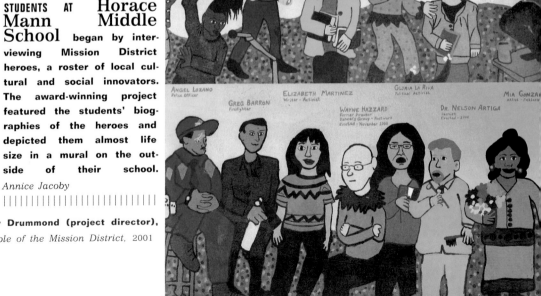

installed in the Horace Mann hallways. Like many Mission mural projects, *Look at me when I'm talking to you* grew through a process of asking people how they wanted to be seen. But how could a mere handful of photomurals represent and engage more than six hundred students? //////////////////////////////////////
//
//
Thanks to the generous support of a grant from the Creative Work Fund, I spent the 1996–1997 school year exploring this question while having the time of my life. I made a series of medium-format panoramic photographs of students during our shared lunch hours. For ten months I met regularly with various members of the school community. I asked two dozen eighth graders to commit to meeting once each month over pizza and soda to give me feedback on the emerging test prints. They gave me a sense of which images were working based on their own unique criteria involving fashion trends, interpersonal relationships, narrative action, and adults' (mis)perceptions about youth. I also met regularly with a team of five teachers who helped guide the project. Over El Farolito burritos, they had vigorous debates about the images: Could the murals represent the school in a positive light without becoming glorified yearbook pictures? Would "bad" behavior be reified if "difficult" students had their portrait blown up and placed on the walls? Or could that be a boost of self-esteem and recognition? Wasn't it important to show kids of color reading, and thereby encourage literacy efforts? Would that feel too much like an old-school mural, of the type that already adorned numerous neighborhood buildings? I also convened meetings with other members of the school staff, the parent group, and neighborhood artists and activists. Each of these groups helped direct the process, along with the hundreds of students who commented on the wallet-size proof images I dispensed weekly: "I hate that picture; my hair's all jacked up!" "Oooh, that was when Sharifa was still going out with Javier." "That's tight, I like how you can see the seagull." /
//
//
The layering of all these insights helped the project slowly develop a sense of direction. Eventually, a rough edit of fifty images was selected from the thousands of negatives made that year. These images were then voted on by members of the various advisory teams and pared down in one last edit. In the spring of 1998, thirteen images were finally enlarged as two-by-five-foot C-prints and placed throughout the school in hallways, stairwells, the library, and the cafeteria. The

billboard-size outdoor photomural, installed on Valencia Street, was printed using then-cutting-edge digital printing technology that has since become the norm for most street advertisements. The outdoor design also incorporated a compelling piece of text: "Look at me when I'm talking to you." The quote became the title for the overall project. //////////////////
//
//
It was common to hear "Look at me when I'm talking to you" at Horace Mann. Teachers might use the phrase while commanding respect or simply asking for attention as students spilled into a busy intersection during a field trip. It could also be heard on the playground as some anxious storyteller struggled to gain the ear of a distracted playmate. The saying appealed to me because of the rich possibilities of the pronouns and the multiplicity of the voice. One of the girls in the picture might be saying to her teachers, peers, or the general viewing public: "Look at me when I'm talking to you." The design also became a reminder to the neighborhood to acknowledge youth and their needs, particularly young women of color who now prominently marked the street corner's visual space. Amid the trend toward school privatization, the mural also acted as an insistent voice for the school itself: "Look at me when I'm talking to you." Finally, as mid-nineties gentrification began to accelerate rapidly throughout the Mission, the mural tag was a shout to newly arrived occupants—"don't ignore us." ///
//
//
The outdoor mural was also a wink toward other visual colleagues in the community: painted murals, graffiti, beer ads, drug abuse PSAs, lettered storefronts, stenciled sidewalks, and the photocopy impasto adorning telephone poles. Photographic histories informed the project as well. The Horace Mann photomurals synthesized the distinct photography and mural traditions that were each a key part of the WPA effort in the 1930s. The images also drew from postwar snapshot and modernist documentary practices, incorporating lessons from the family photo album as well as the canon of street photography. By the 1990s, many artists were combining images and text in an effort to reveal oft-ignored stories in accessible graphic means. Finally, the Horace Mann images were closely aligned with the cherished school dance and studio party pictures that many students eagerly orchestrated with their friends: outfits carefully assembled, hair prepped just so, assertive and playful poses all ready for the professional's camera.

I loved it when the students would share with me these images they had commissioned. I wanted the Horace Mann work to draw from these many dynamic photographic traditions. ///////
///
///

On the Mission streets of the 1990s, painted murals faced fierce competition from an unending stream of photo-based advertisements. *Look at me when I'm talking to you* was designed to bridge the gap between murals and billboards, and to complicate their relationship. It was meant to honor, expand, and reinvigorate the painted mural tradition with dynamic photomurals that appealed to youth. I knew our students' lives were saturated with imagery. This made them media savvy but also fatigued. The public service announcements on billboards and bus shelters often seem to be condescendingly aimed *at* young people, not created in collaboration *with* them. But the participatory presence of our youth gave the Horace Mann work a kind of engaging immediacy rarely achieved in billboards. Photographically, the wide angled and expansive space of the panoramic format enabled multiple narratives to happen simultaneously within a single frame. Intimate portraiture could coexist with the less conventional, ghostlike motion recorded by the panoramic camera's moving lens. These blurred figures could allude to playful fun-house reflections or the passage of time. I hoped this aesthetic complexity, along with the installation of the images at the school site, would help keep the images from feeling decontextualized like so much "documentary" photography. I thought of the work not as documentary but as carefully considered snapshots. Snapshots tend to be images that people cherish. I liked the idea of aligning a photomural project with this vernacular. ///
///
///

Look at me when I'm talking to you was an exercise in visual listening, contextual awareness, and strategic sensitivity. The murals needed to be at once assertive yet vulnerable, purposeful yet playful, tender yet fierce. I wanted them to be full of radical love and critical thinking, without being mired in the tired multicultural pronouncements of the era. The project began as a photographic love letter to my students: "I see you. You matter to me." It became a collective celebration: "We see and share ourselves. In our magic, we make meaning." ///////////
///
// ////
/// ///
///

168

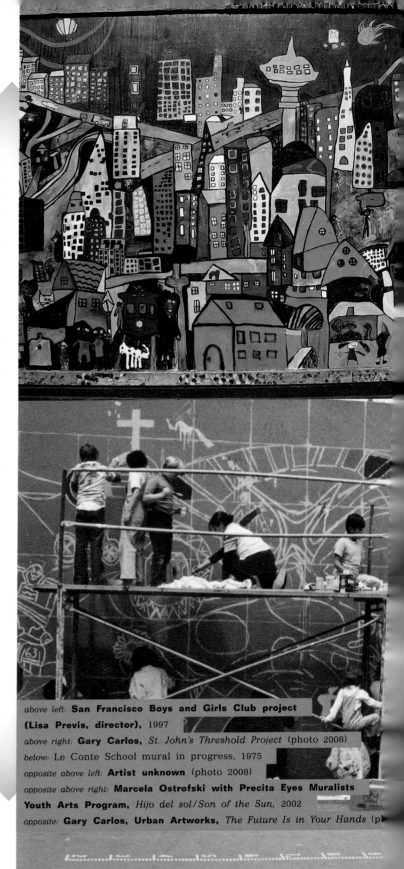

above left: **San Francisco Boys and Girls Club project (Lisa Previs, director),** 1997
above right: **Gary Carlos,** *St. John's Threshold Project* (photo 2008)
below: Le Conte School mural in progress, 1975
opposite above left: **Artist unknown** (photo 2008)
opposite above right: **Marcela Ostrofski with Precita Eyes Muralists Youth Arts Program,** *Hijo del sol/Son of the Sun,* 2002
opposite: **Gary Carlos, Urban Artworks,** *The Future Is in Your Hands* (p

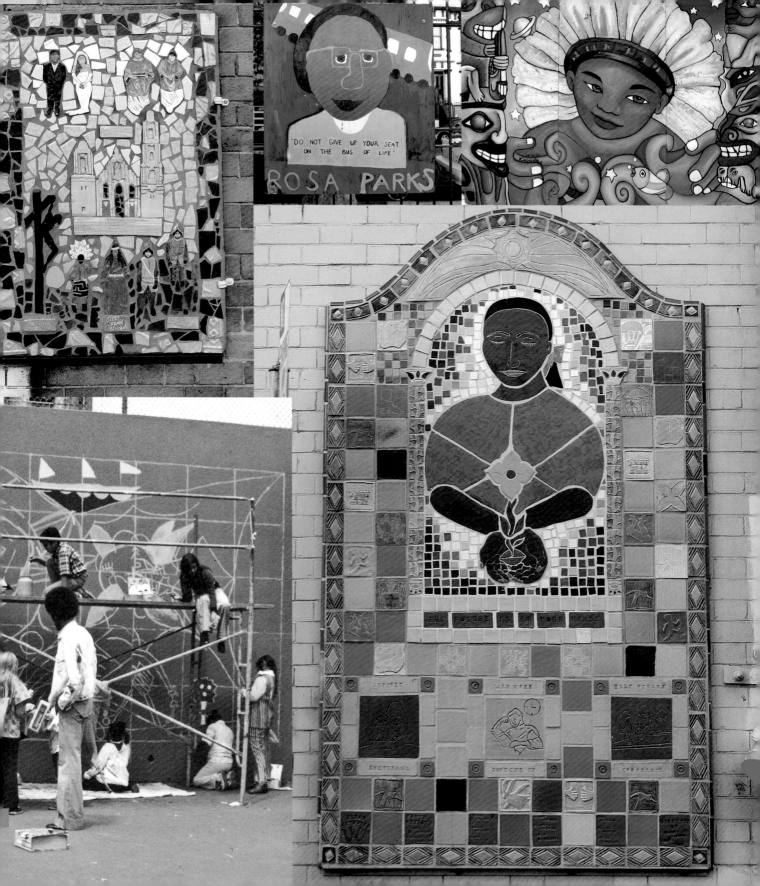

"DO NOT GIVE UP YOUR SEAT ON THE BUS OF LIFE"

ROSA PARKS

THE FUTURE IS IN YOUR HANDS

SAMA-SAMA: MURAL MISSIONARIES

MEGAN WILSON

SAMA-SAMA is an international contemporary art collaboration between the Clarion Alley Mural Project (CAMP) in San Francisco and Apotik Komik ("Comic Pharmacy") in Yogyakarta, Indonesia, sponsored by Intersection for the Arts. Apotik Komik had formed as an underground project at the end of the Suharto dictatorship in 1998 and began experimenting with guerilla public art as the old regime fell. The groundbreaking cultural exchange with the largest Muslim nation was a constructive response to the repercussions of 9/11, including the Bali bombing in October 2002. In the summer of 2003 six CAMP artists (Carolyn Castaño, Carolyn Ryder Cooley, Alicia McCarthy, Aaron Noble, Andrew Schoultz, and Megan Wilson) went to Indonesia. In the fall of 2003 Arie Dyanto, Samuel Indratma, Arya Panjalu, and Nano Warsono traveled from Indonesia to San Francisco. The artists share aesthetics influenced by comics, graffiti, and advertising, and all of them make works in response to social and political conditions.

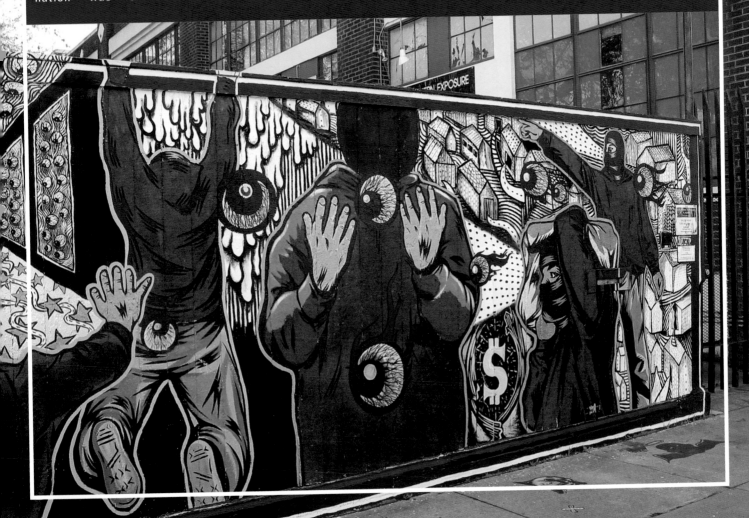

Two prominent Sama-Sama murals **were painted IN THE Mission.** One, *In Dollar We Trust,* **sits aggressively on the back fence of Project Artaud at 17th and Alabama. Youth, high-tops aflame, run through the streets and eyeballs drop like bombs against a background that recalls both the engravers' marks on dollar bills and the textile arts of Indonesia. The group's other effort, on the side of the landmark Rainbow Grocery, uses cutout figures reminiscent of the group's work in Indonesia. It parodies the excesses of food-marketing p r a c t i c e s .**

Aaron Noble

Sama-Sama artists (photo 2008) *opposite:* **Samuel Indratma and Arie Dyanto,** *In Dollars We Trust,* 2003

Yo puedo ver que hay mucho que conocer.
"I can see that there is much to know." The humble utterance serves innocence and cynicism in Joel Bergner's mural *De frontera a frontera,* spanning thirty feet at the entrance to the Mission's artist/activist warehouse CELLspace. In his murals Bergner manipulates a familiar, almost kitschy artistic language and pushes the boundaries of community muralism to create a new

vocabulary that is simultaneously challenging and a c c e s s i b l e .
Bergner came to the Mission District after traveling in Latin America, where he was struck by the "wall" he noticed between American tourists and the locals. *De frontera a frontera* reveals the two sides of this "wall" and the blurred boundaries between them. At first glance, Bergner's murals are similar in their folkloric style

and color scheme to the ubiquitous Mission District signs advertising taquerias, whose palm trees, quaint huts, lush magenta sunsets, and dormant blue volcanoes appeal to escapism or nostalgia for lost homelands. Yet his serene images sometimes dissolve into a haunting Surrealist vocabulary. Shadowy factories interrupt silhouetted tropical hills, the fragmenting landscape of industrialism. Even the color in these murals is slightly off, a little too jarring for tropical sunsets, too black for silhouettes.

Katherine Gressel

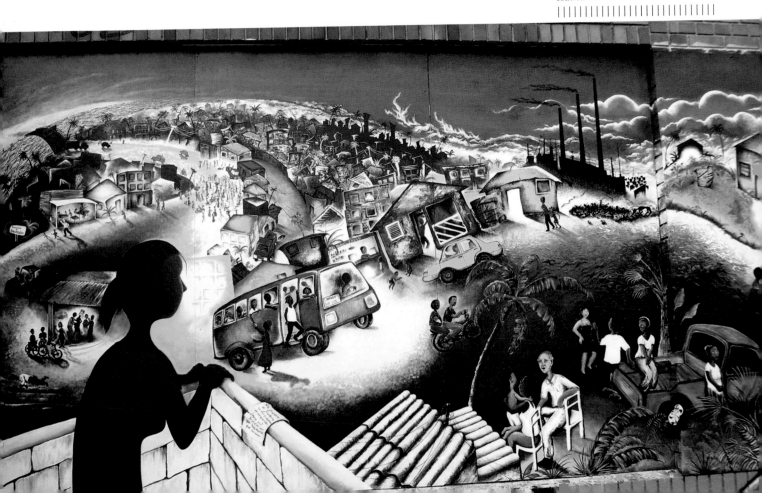

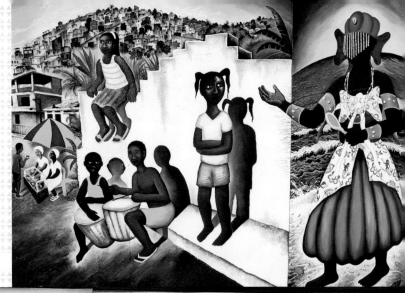

above: **Joel Bergner,** *Sob o sol dos orixas/Under the Sun of the Orishas,* 2006

below: **Joel Bergner,** *El inmigrante/The Immigrant,* 2005

opposite: **Joel Bergner,** *De frontera a frontera/From Border to Border,* 2003

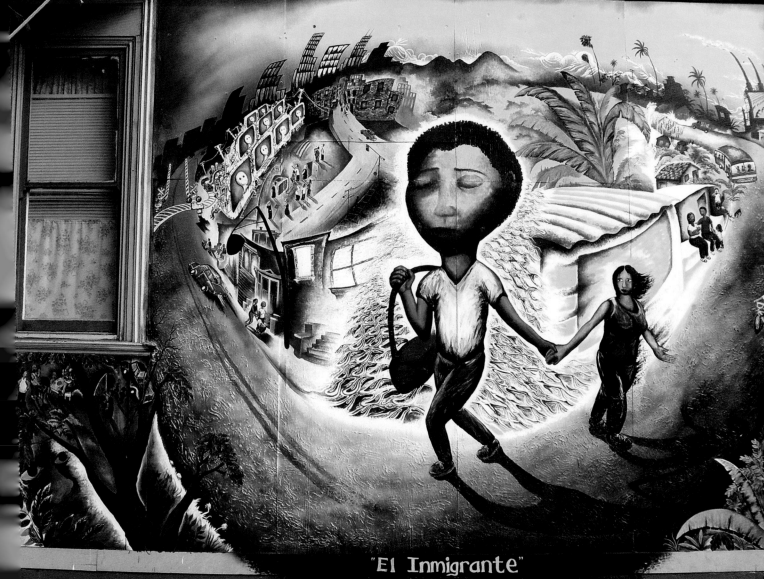

"El Inmigrante"

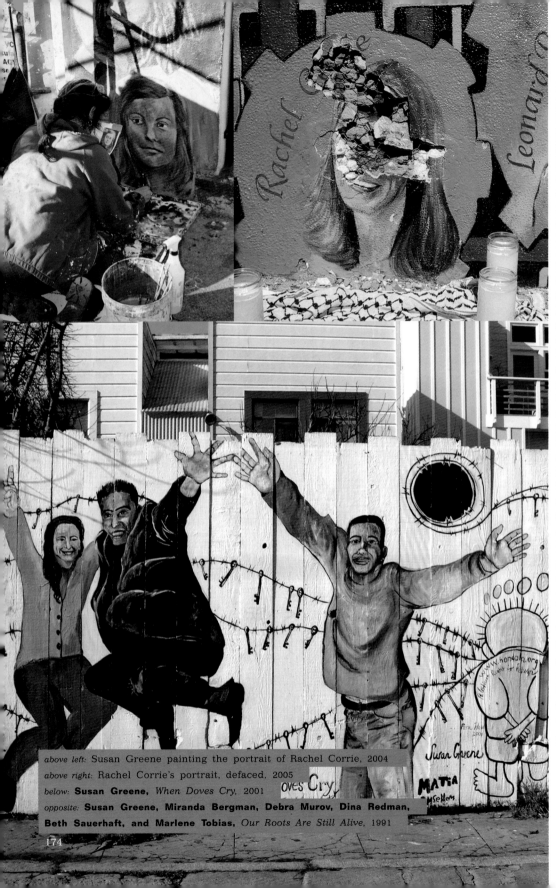

IN MARCH **2003** Rachel Corrie, a young activist with the International Solidarity Movement, **was run over by an Israeli bulldozer.** Around that time I was restoring a mural in the Mission that honored forty political activists. I added Rachel Corrie. One morning I was stunned to see that Corrie's portrait had been smashed with a hammer, leaving large holes. Mumia Abu-Jamal's portrait was also smashed. Six months later, the portraits of Corrie and Abu-Jamal were hammered a second time. This time Bernadette Devlin's face was also smashed, and racist graffiti was written on Nelson Mandela's portrait and what was left of Rachel's face. The police considered the attacks a hate crime, although no suspects were ever apprehended.

Susan Greene

The cartoon figure of Handala, A PALESTINIAN FOLK HERO, **is featured in this mural.** A motif of keys and barbed wire runs throughout, representing the house keys kept by refugees after their expulsion from home.

Susan Greene

above left: Susan Greene painting the portrait of Rachel Corrie, 2004
above right: Rachel Corrie's portrait, defaced, 2005
below: **Susan Greene,** *When Doves Cry,* 2001
opposite: **Susan Greene, Miranda Bergman, Debra Murov, Dina Redman, Beth Sauerhaft, and Marlene Tobias,** *Our Roots Are Still Alive,* 1991

174

BREAK THE SILENCE

SUSAN GREENE

IN 1989, while the first Palestinian intifada (uprising) raged, four Jewish American women artist/activists formed the Break the Silence Mural Project. My own epiphany came in 1988 when I read a newspaper article headlined: "Peace Plan Rejected." Yitzhak Shamir, during an American fundraising tour, said, "All American Jewry stands with us." I could no longer remain silent or ignorant. Miranda Bergman, a highly respected veteran muralist, envisioned a community mural in Palestine. Marlene Tobias, a graphic designer, worked with the Palestine Solidarity Committee. Dina Redman, an illustrator, had been a member of JAAZ, Jewish Americans Against Zionism. We traveled to the West Bank of occupied Palestine and brought San Francisco's community mural tradition to "break the silence" between the United States and Palestine. We lived in a refugee camp for three months and painted six murals.

In 1990 we organized a community mural in the Mission titled *Our Roots Are Still Alive—Palestine Will Be Free.* The mural includes the saber cactus, named for the Arabic word for patience. The roots of saber cacti were not destroyed when five hundred Palestinian villages were razed in 1948, and clusters of cacti that have grown back are evidence of where the villages once were. An Israeli Woman in Black, representing the group that protests the occupation, is a portrait based on a Holocaust survivor who lost her entire family in Auschwitz.

Our Roots Are Still Alive was attacked more than thirty times in twelve years. The assaults on the mural became more virulent in 2000 when the second intifada began. The elderly Israeli Holocaust survivor was defaced regularly. So in June 2001, after unsuccessfully appealing to the city to protect the mural, we decided to board it up. One day we will uncover and rededicate *Our Roots Are Still Alive.*

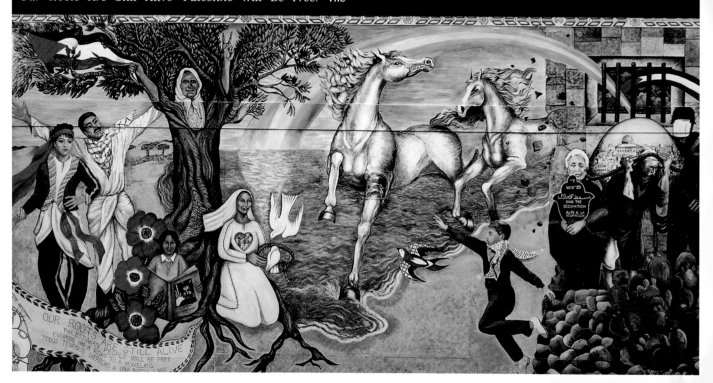

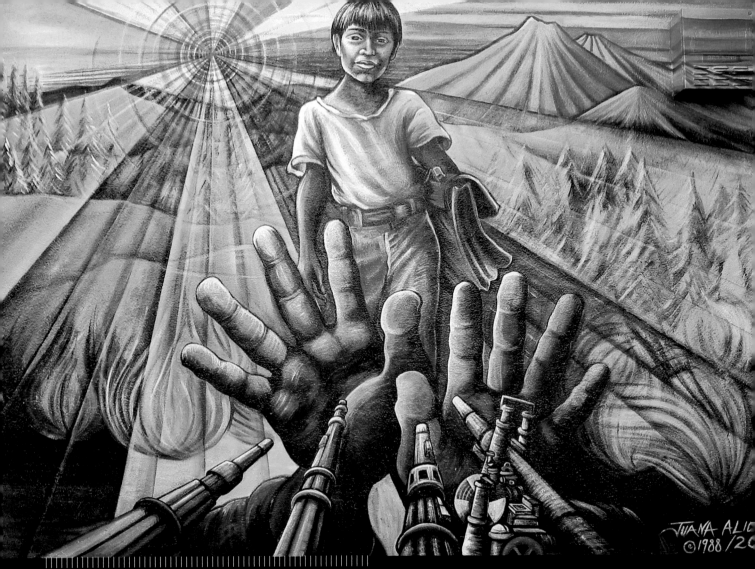

Those who speak OF **collateral dam-age** AND **homeland security** refuse to see the **children** WHOSE LIVES ARE DESTROYED BY WAR. The mural above is simple, compassionate, articulate, and direct. Around the corner on 21st Street is the covered mural (shown on page 175), invisible to those who have never seen it, haunting to those who

remember it. Every time I bike past it, I am taunted by the memory—the white bird, the embroidery on the Palestinian woman's dress. Then I think how easy it is to destroy hope, to end dia-logue, with a few violent g e s t u r e s .

Keith Hennessey

Juana Alicia, *Alto al fuego/Cease Fire,* 1988, restored 2002

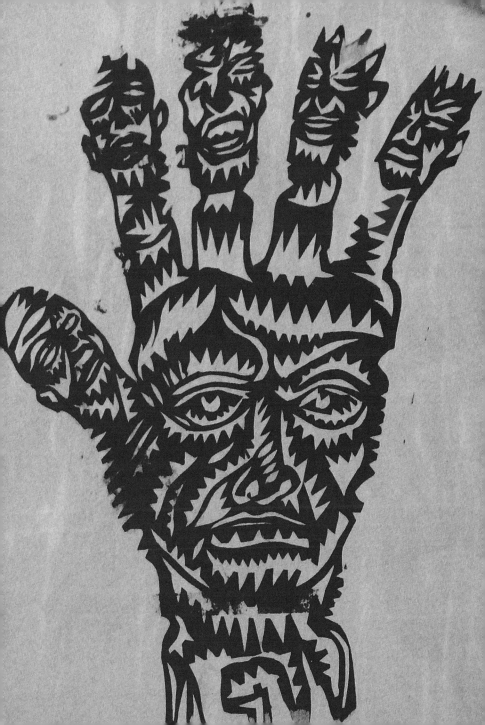

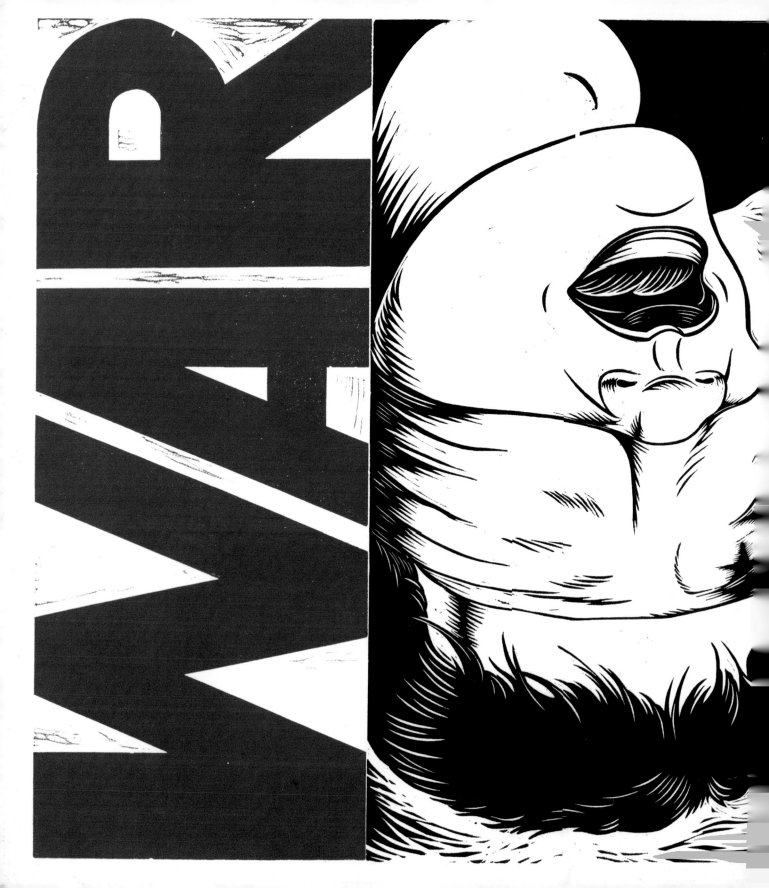

IS A BLIND PATRIOT

JUSTICE

VOTE

Flags
stupid
rags
so
i

Emmanuel Montoya, *War Is a Blind Patriot* (Galería de la Raza billboard), 1991

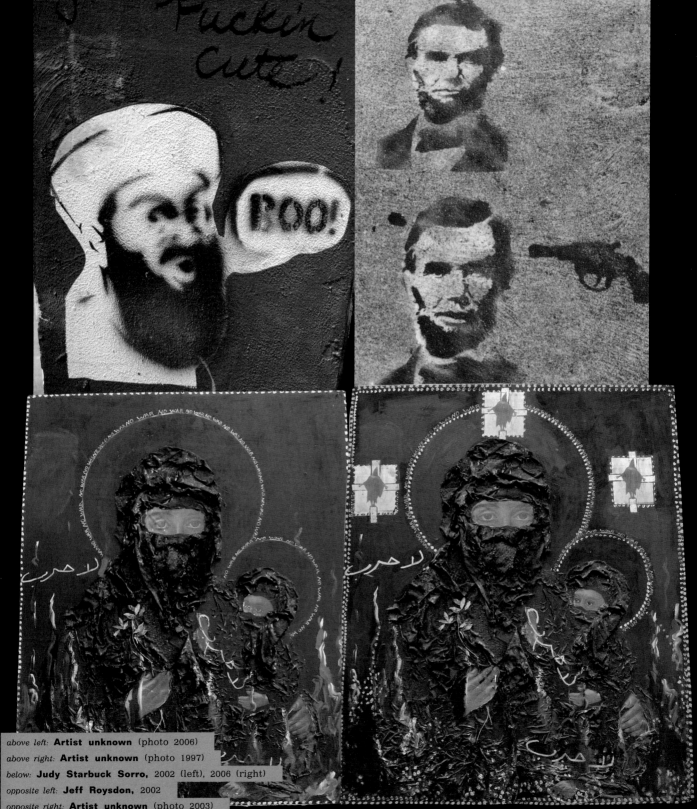

above left: **Artist unknown** (photo 2006)
above right: **Artist unknown** (photo 1997)
below: **Judy Starbuck Sorro,** 2002 (left), 2006 (right)
opposite left: **Jeff Roysdon,** 2002
opposite right: **Artist unknown** (photo 2003)

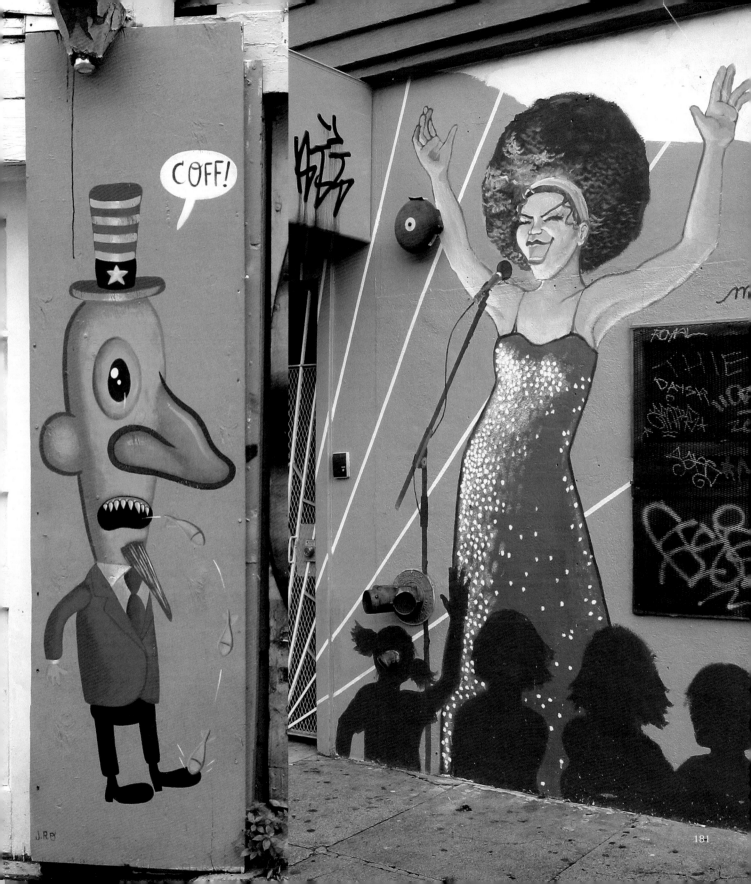

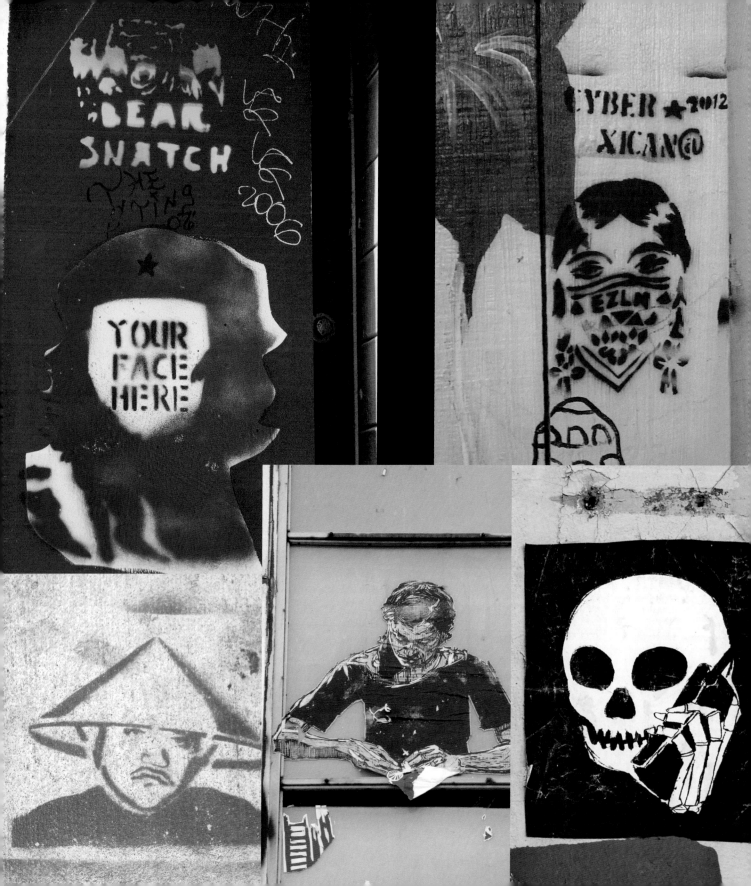

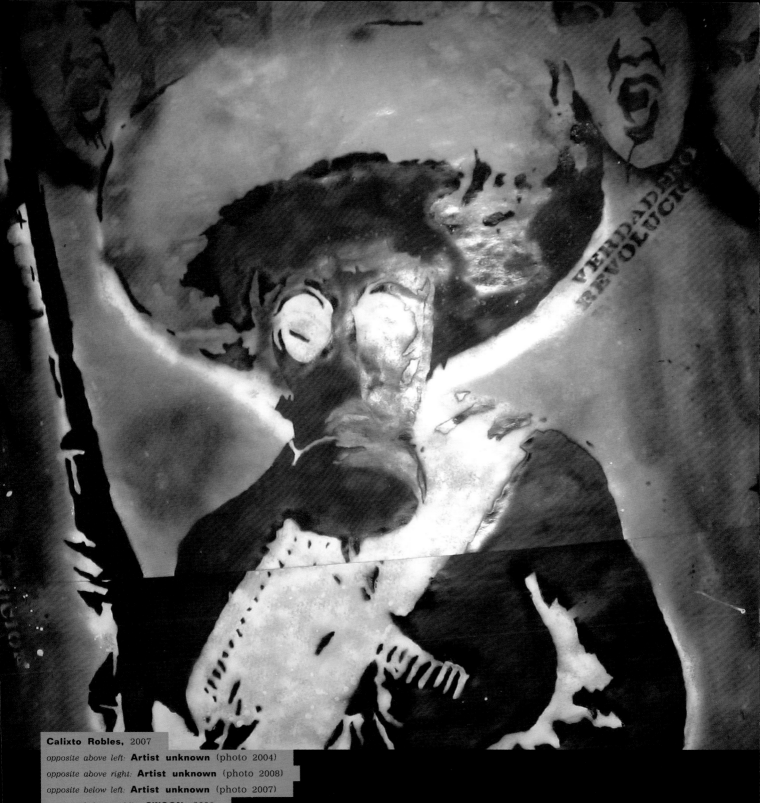

Calixto Robles, 2007

opposite above left: **Artist unknown** (photo 2004)

opposite above right: **Artist unknown** (photo 2008)

opposite below left: **Artist unknown** (photo 2007)

opposite below middle: **SWOON,** 2006

opposite below right: **Skullphone** (photo 2005)

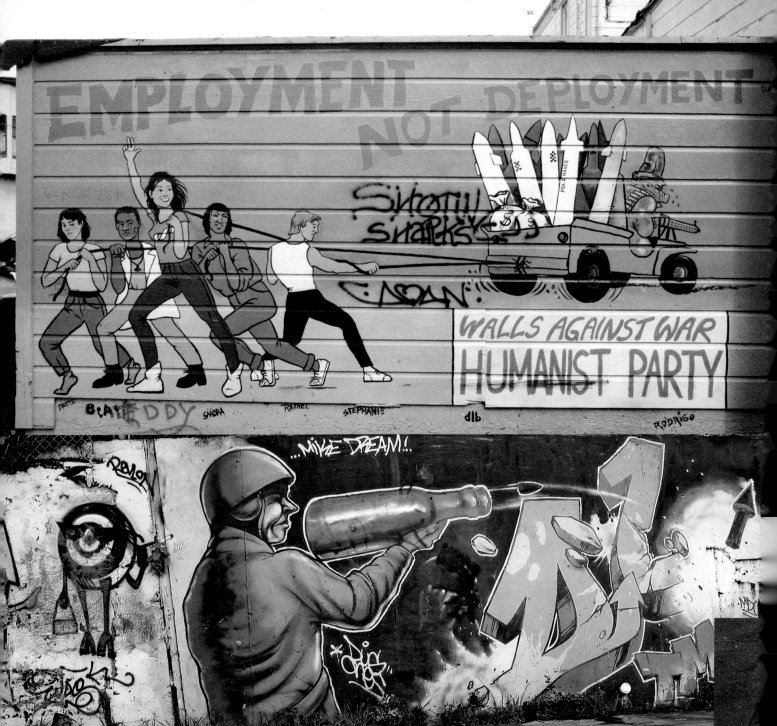

above: **Artist unknown,** 1974
below: **ESPO** (left) **and DUG1** (right), *DREAM Dedication,* 2000
opposite above: **Sebastiana Pastor,** *Children Learn Too,* 1993
opposite below, left and right: **Claude Moller,** left, 2008; right, 2003

184

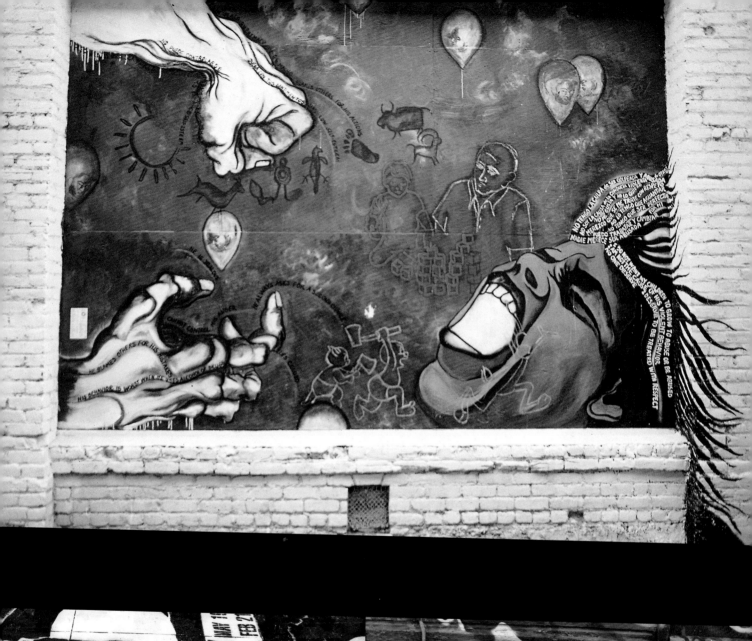
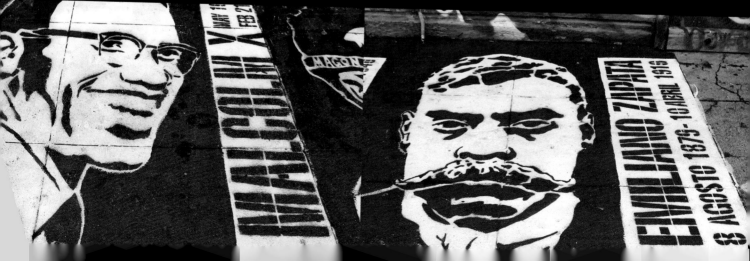

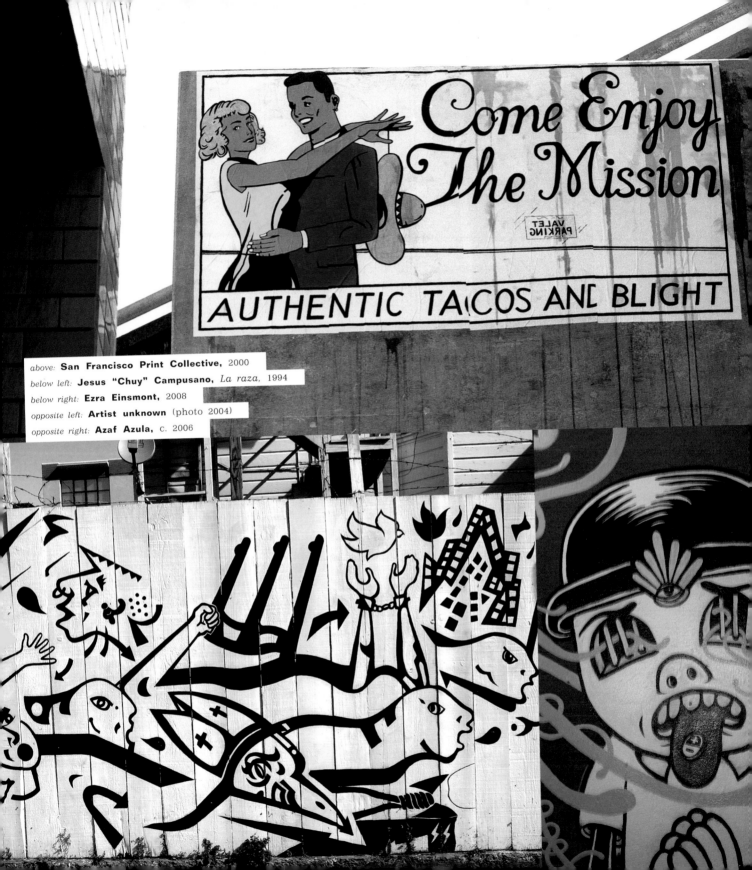

above: **San Francisco Print Collective,** 2000
below left: **Jesus "Chuy" Campusano,** *La raza,* 1994
below right: **Ezra Einsmont,** 2008
opposite left: **Artist unknown** (photo 2004)
opposite right: **Azaf Azula,** c. 2006

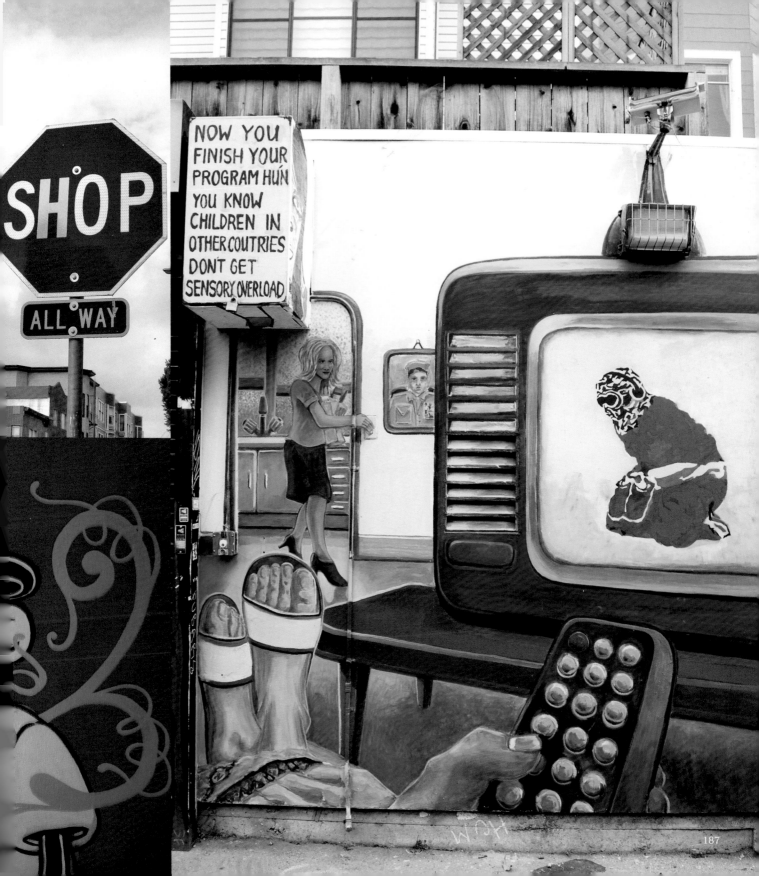

NOW YOU
FINISH YOUR
PROGRAM HUN
YOU KNOW
CHILDREN IN
OTHER COUTRIES
DONT GET
SENSORY OVERLOAD

SHOP

ALL WAY

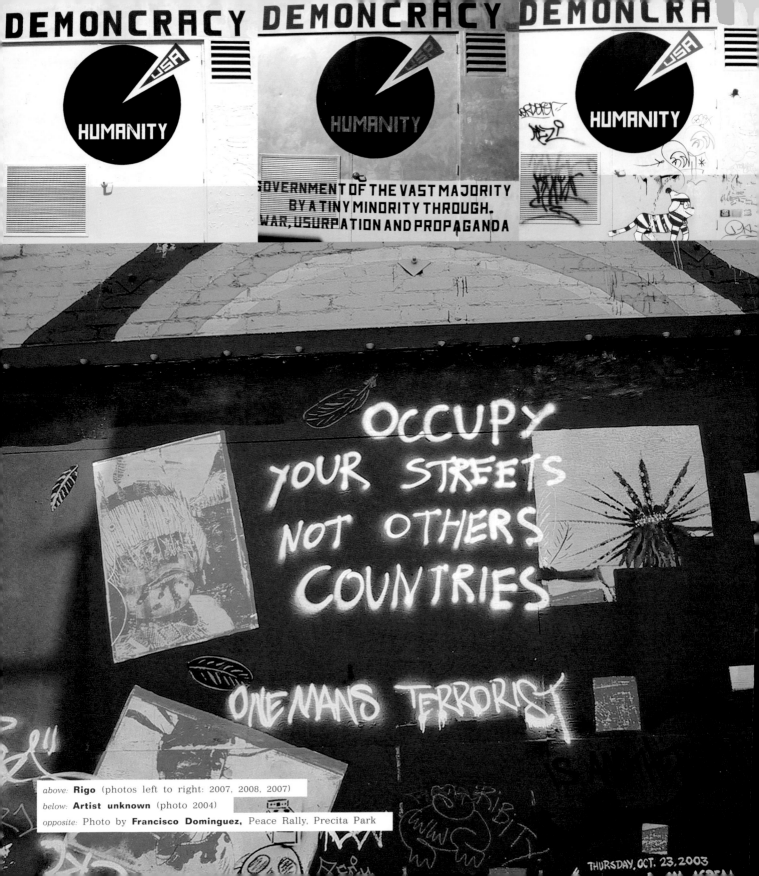

DEMONCRACY DEMONCRACY DEMONCRA

HUMANITY

GOVERNMENT OF THE VAST MAJORITY BY A TINY MINORITY THROUGH. WAR, USURPATION AND PROPAGANDA

OCCUPY
YOUR STREETS
NOT OTHERS
COUNTRIES

ONE MANS TERRORIST

above: **Rigo** (photos left to right: 2007, 2008, 2007)
below: **Artist unknown** (photo 2004)
opposite: Photo by **Francisco Dominguez**, Peace Rally, Precita Park

THURSDAY, OCT. 23, 2003

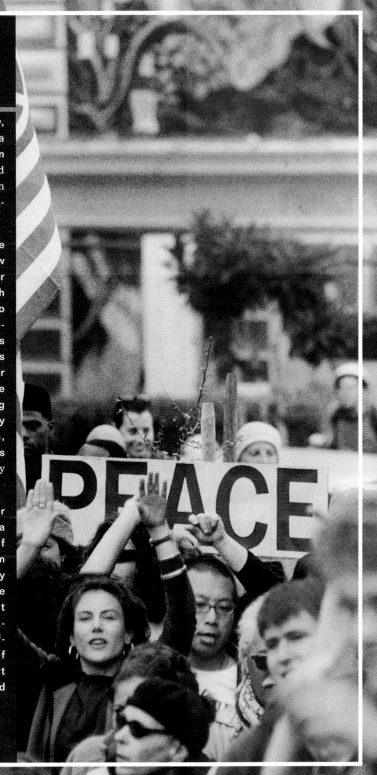

PUBLIC SPEAKING
KATHERINE GRESSEL

THE STREET is where we meet, practice democracy, protest, shop, and stroll. Public art takes part in a dialogue with the space around it. As cultural historian Rosalyn Deutsche observes, "Public space can be defined as a set of institutions where citizens . . . engage in debate." If we apply Deutsche's description, the capacity to provoke debate is what makes a space public.

The usurpation of public space by billboards (the voices of advertisers and large corporations), new housing complexes (the voices of developers), or even new coats of paint (symbolic of a "white" wash by new upper-middle-class residents) threatens to make the messages of once prominent murals obsolete. The people who strive to protect these murals also voice essential questions. Who determines whether a mural's statement is still relevant ten or twenty years after it is first painted? How do we know that the voices of street artworks are being "heard" when, unlike museum pieces, they are usually not accompanied by explanatory labels, audio tours, or docents? How do we measure the impact of murals when we cannot keep track of how many people "pay admission" to "see" them each day?

Street art in the Mission, like public speakers or public protesters, demands that voices be heard in a public arena. San Francisco holds its spot as one of the most desirable cities in the United States. When gentrification issues intensified in the 1990s, they provoked an effective public-art reaction. In the Mission District, there is a particularly discordant symphony of voices—dot-commers, longtime working-class and Latino residents, homeless people, disaffected bohemians, and an amazing concentration of activist artists. The Mission District murals are part of many unresolved arguments, but their continued presence is noisy and insistent.

OUT LOUD AND OUTSPOKEN

KEITH HENNESSEY

THERE are whole schools of art based in the Mission that don't really exist anywhere else. We mix street art and the contemporary dance scene, anti-war movements, the flair for outrage in gender, and sexual liberation politics. Paint and paste artists climb the walls and so do dancers. New College, Contraband at the Roxie Theater, the San Francisco Mime Troupe, Mission Cultural Center, The Lab, Theater Rhinoceros, Dance Brigade, Theater Artaud, Art & Revolution, Global Exchange, Code Pink, Mission Grafica, CELLspace, and Rainbow Grocery, to name just a few, are magnets for Mission activism. Chris

Carlsson and others started the Committee for Full Enjoyment—a troupe ready for protest with drums, stilt walkers, and catchy conceits like Milk of Amnesia and Get-out-of-Debt cards—to speak back to political oppression. In 2000 the Circus of Resistance orchestrated a spectacular street funeral for the Footworks Dancers' Group, complete with acrobats grandstanding off utility poles. The Circus was part of a wave of art actions, such as the Naked Cell Phone March that Lise Swenson choreographed down Valencia for the bemused fascination of patrons at the many fancy dining spots and storefront churches.

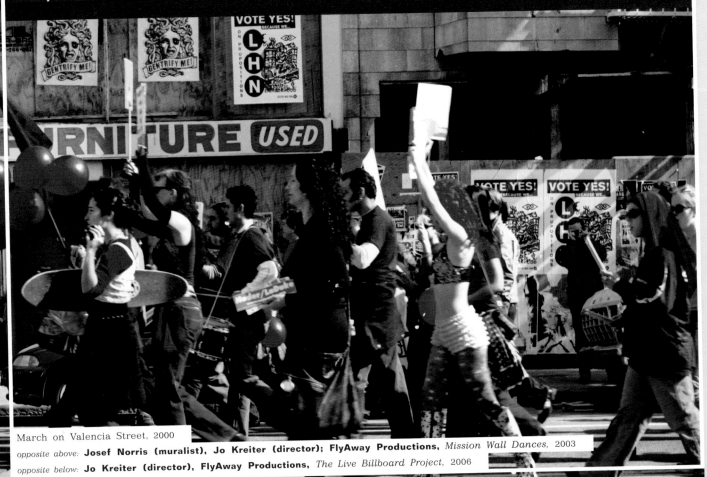

March on Valencia Street, 2000

opposite above: **Josef Norris (muralist), Jo Kreiter (director); FlyAway Productions,** *Mission Wall Dances,* 2003

opposite below: **Jo Kreiter (director), FlyAway Productions,** *The Live Billboard Project,* 2006

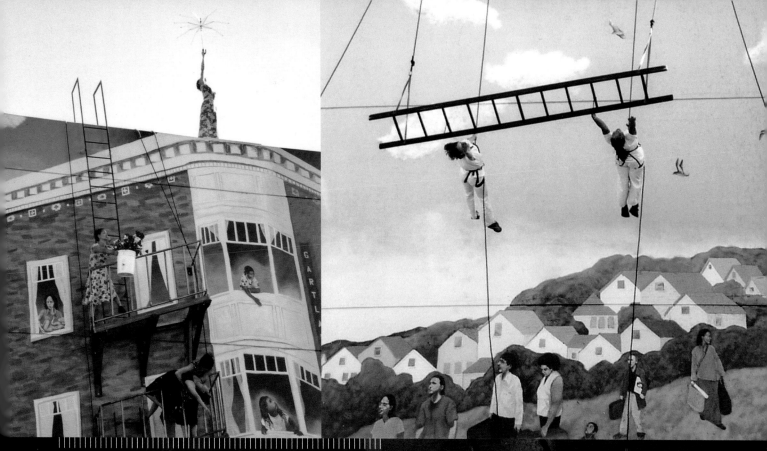

Saturday night. Mission and 24th. Buses full. Club music COMPETES WITH SERENADING **Norteño guitars.** Crowds are staring at the rooftop billboard rigged with flying dancers, framed by streaking city light. My dance troupe, FlyAway Productions, is performing a meditation on beauty, rage, and advertising. I have choreographed dances that require hanging upside down from fire escapes, kicking through the streets, and cartwheeling over the rooftops of the Mission. I hope to counter the drug-based despair and violence that unfolds on a daily basis by having the audience experience dance as a whirlwind of virtuosic daring and an effort to reclaim urban s p a c e .

Jo Kreiter

Does Beauty Ravish You

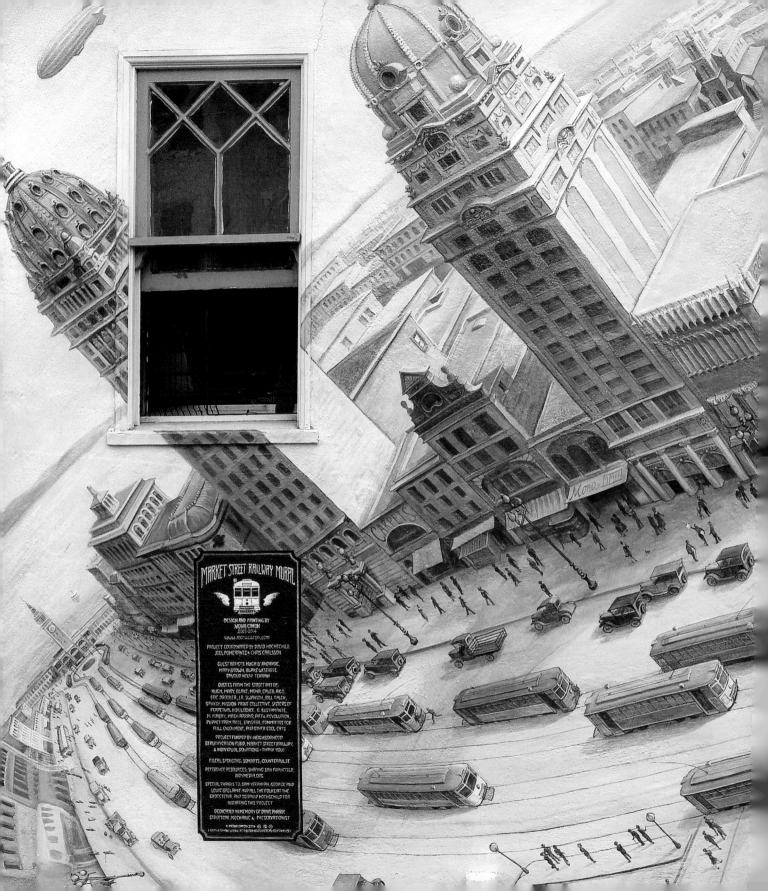

MARKET STREET RAILWAY MURAL

DESIGN AND PAINTING BY
MONA CARON
2003-2004
www.monacaron.com

PROJECT COORDINATED BY DAVID HOCHSCHILD,
JOEL POMERANTZ & CHRIS CARLSSON

GUEST ARTISTS: HUGH D'ANDRADE,
MARY BROWN, BLAKE WARRABLE
DAVOUD HOUSE TEHRANI

QUOTES FROM THE STREET BY:
HUGH, MARY, BLAKE, MONA, CALEB, RIGO,
ERIC DROOKER, J.R. SWANSON, BILL TALEN,
BANKSY, MISSION PRINT COLLECTIVE, SISTERS OF
PERPETUAL INDULGENCE, C. BUSTAMANTE,
M. MABRY, MASK-ARRAY, ARTA REVOLUTION,
PUPPET FARM ARTS, SAMSARA, COMMITTEE FOR
FULL ENJOYMENT, AND OTHER COOL CATS

PROJECT FUNDED BY: NEIGHBORHOOD
BEAUTIFICATION FUND, MARKET STREET RAILWAY,
& INDIVIDUAL DONATIONS - THANK YOU!

FISCAL SPONSORS: SOMARTS, COUNTERPULSE

REFERENCE RESOURCES: SHAPING SAN FRANCISCO,
INDYMEDIA.ORG

SPECIAL THANKS TO: SAM YERAMIAN, GEORGE AND
LOUIE GAZARIAN AND ALL THE FOLKS AT THE
GROCCERIA AND TO DAVID HOCHSCHILD FOR
INITIATING THIS PROJECT

DEDICATED IN MEMORY OF DAVE PHARR
STREETCAR MECHANIC & PRESERVATIONIST

The Mission has a history as a center of international political protest, and its murals voice this messy SPECTRUM of discontents.

One mural of dazzling achievement that sums up this ardent history—from labor strife to the Summer of Love to the closing down of the city when Bush bombed Baghdad—is a 180-degree bird's-eye view of the street as a stage for protest. The mural employs a wry irreverence similar to that which instigated Critical Mass, when bicyclists disrupted Friday rush hour in a gleeful, albeit sometimes nerve-wracking exercise. Who owns the streets? How do we get around? Who is better off? How many protests against how many wars? *Shaping San Francisco,* an historical investigation of place, is a source for the material in Mona Caron's depiction of public space. /////////
///
///
Market Street Railway Mural is a testament to the street as a corridor of protest and change. Embracing the ambitious scope of many San Francisco histories, it has been lauded as an heir to Diego Rivera's sprawling *Pan American Unity,* painted in 1940 for the Golden Gate Exposition. A remarkable window into San Francisco's most prominent street, the mural is a monumental exercise in miniaturization, rich with tiny figures that are embellished with elegant and comic details. It rivals time-lapse photography, with subtle hue variations to note decades shifting and

the changing mass of people. The brilliance of this mural is that it functions in both long and short views. ////////////////////
///
///
The narrative of *Market Street Railway Mural* starts in the 1920s, the previous go-go decade of speculative frenzy and stock-market madness. Fare was five cents a trip. The Big Strike of 1934 enters the picture in the adjacent panel with an homage to the then-controversial frescoes in Coit Tower, which were hidden from the public until months after the strike was over. Labor wins respectability on the third panel, which features a large 1940s Labor Day parade. In the center of the mural, representing the mid-century period, buses join cars in a traffic jam, and Market Street lives up to its name with thriving retail. Gay pride takes over the street by the late 1970s. The iconic Sisters of Perpetual Indulgence join thousands to dance out of the closet, while one couple commemorates murdered political leader Harvey Milk. ///////////////////////
///
///
Closer to the present, the wider panel includes a gritty view of the Grant Building at 7th and Market, next to a rooftop featuring the Billboard Liberation Front in action. Bicyclists emerge from the building—the Committee for Full Enjoyment is departing for Critical Mass. Two trucks deliver messages. Globalization, Inc., has been zapped with anti–World Trade Organization graffiti; and a van for Workathon.com promises to include food pills with deliveries and offers to take payment in stock options. An empty storefront facing the traffic was once home to Megabubble.com but is a graffiti gallery now.
///
///
The Grant Building is the staging area for the many participants in the big February 15, 2003, protest against the Iraq War. Puppets, drumming, and humorous signs capture the fierce jubilation with which people refused consent to the unconscionable war. Today's marginal, unheralded, but often visionary efforts are projected into an ecotopian future San Francisco in the right-most panel. On the roof of CELLspace no.13, today's Odd Fellows Hall, the artist depicts herself, painting the skyline and roof gardens that fill her view. Blimps, elephants, and plug-in solar carts join bicyclists, streetcars, and pedestrians in an apparently stress-free transit paradise. Rigo's *Innercity Home* is portrayed, as is the tag of graffiti artist SATYR. Foliage drapes buildings while windmills gather kinetic energy. A semi-permanent Burning Man looks over it all, contentedly. ///////////////////////////

opposite and overleaf: **Mona Caron,** *The Market Street Railway Mural,* 2004

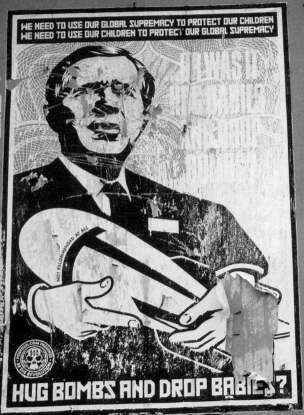

WE NEED TO USE OUR GLOBAL SUPREMACY TO PROTECT OUR CHILDREN
WE NEED TO USE OUR CHILDREN TO PROTECT OUR GLOBAL SUPREMACY

HUG BOMBS AND DROP BABIES?

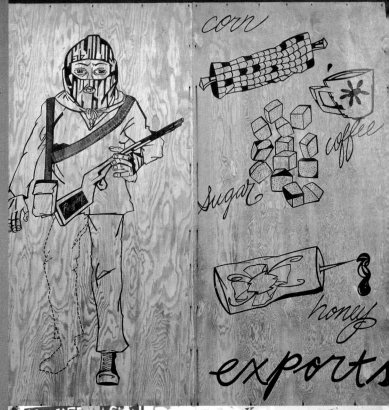

corn

sugar

coffee

honey

exports

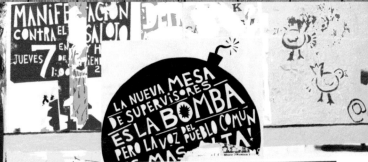

MANIFESTACIÓN
CONTRA EL SALON
7 JUEVES DE

LA NUEVA MESA
DE SUPERVISORES
ES LA BOMBA
PERO LA VOZ DEL PUEBLO COMÚN
ES MÁS ALTA!

Los siete animales
que le cuesta al viejo
residente de la
Misión

YOU WERE PUT HERE
TO PROTECT US
BUT WHO PROTECT
US FROM YOU.

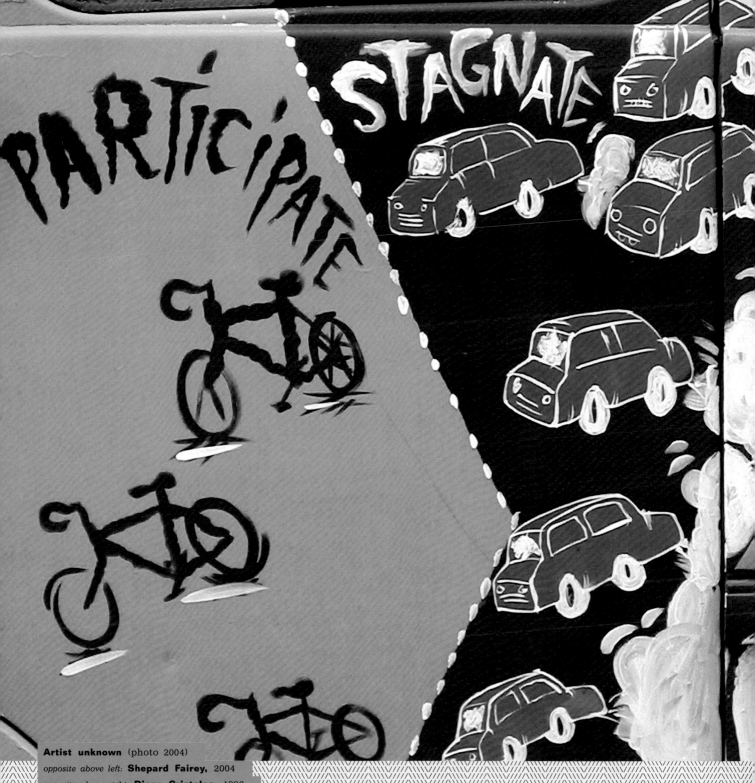

PARTICIPATE

STAGNATE

Artist unknown (photo 2004)
opposite above left: **Shepard Fairey,** 2004
opposite above right: **Diana Cristales,** 1996
opposite below left: **Artist unknown** (photo 2003)
opposite below right: **San Francisco Print Collective,** 2000

Whose Art Is This Anyway? //
//

Will Shank ///
//
//

As a conservator of modern ART, my job is to understand and preserve precious museum objects.

But I am also a former Mission resident who has biked and jogged up and down every street and alley in order to seek out the neighborhood's mural treasury. The layers of art in the Mission are an invitation for exploration to a conservator. As the cofounder, with mural historian Tim Drescher, of an initiative called Rescue Public Murals, I am hoping to accomplish something that contemporary public art frequently does not do well. Thanks to the Getty Foundation and other supporters, we are able to examine what is enduring in a temporal medium. While stone sculptures and ceiling frescoes were designed to address eternity, outdoor murals are subject to the tyranny of time, street life, politics, and fashion. //////////////
//
//

Consider this contentious mural. An innocent-looking, almost-white wall sits quietly on a sun-blasted, south-facing building in a warehouse neighborhood where San Francisco's largely Latino Mission District creeps toward the foot of Potrero Hill. There is nothing remarkable about the southern wall of the windowless building except for its massive sixty-by-sixty stance at the intersection of several narrow industrial streets that get lots of cars but little foot traffic. But, if you look closely, you will notice a rectangle of faded color here, and some splotches of dripped

above: **Jesus "Chuy" Campusano,** *Lilli Ann,* 1986
below: Lilli Ann Building after mural was whitewashed, 1998

colors there, apparently made by someone hurling a paint-filled balloon at the white wall. The Lilli Ann building, built as a garment factory and currently housing offices, holds a secret. ///
//

Until 1998, a brightly hued, abstract, geometric mural by Chicano artist Chuy Campusano filled this wall. Then suddenly it was gone. The building had changed hands, and the owners took steps to seal out moisture that was creeping into the interior through the painted wall. They used an opaque layer of sealant, which turned the once-colorful wall white. /
//

Hysteria ensued. Death threats were made against the building's owners. The family of the deceased artist sued the owners of the building but encouraged local supporters to cease the vandalism, which had begun when the mural was covered over. The option was explored of transferring the aged paint film, in a variation of the traditional Italian fresco technique known as *strappo,* from a wall that consisted of hundreds of cinderblocks, mortar, and cement patches. The family eventually settled for monetary compensation, and the wall remains blank. ///
//
//

The principles of conservation treatments for contemporary murals are among the few areas whose ethics are not specifically addressed by my profession. When called upon to address the condition problems of a deteriorating outdoor mural, the average conservator will apply the standard principles of conservation to his or her task: documentation, reversibility, and design compensation restricted to areas of loss. But is this approach always, or even usually, appropriate? ////
//

I have questioned several managers of public art collections about the special case of outdoor murals. From their point of view, painted walls should by-and-large be considered temporary artworks. Some city collections have quantified the number of years that a mural should be expected to last: ten years, say, or fifteen. In spite of this hard line about the limited life span of outdoor murals, there is almost universal hesitation when the time comes to state that all murals should fall into this somewhat disposable category. ///////////////////////
//
//

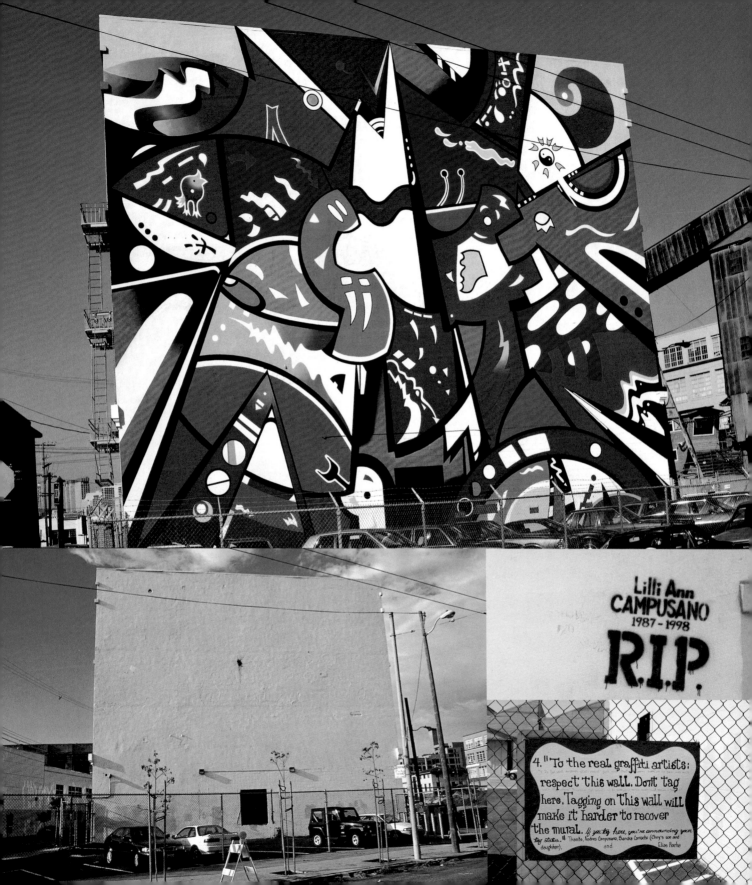

Lilli Ann
CAMPUSANO
1987 - 1998
R.I.P.

4. "To the real graffiti artists:
respect this wall. Don't tag
here. Tagging on this wall will
make it harder to recover
the mural. If you tag here, you're announcing your
tag status." Thanks, Andres Campusano, Sandra Corracho (Chuy's son and
daughter), and Elias Rocha

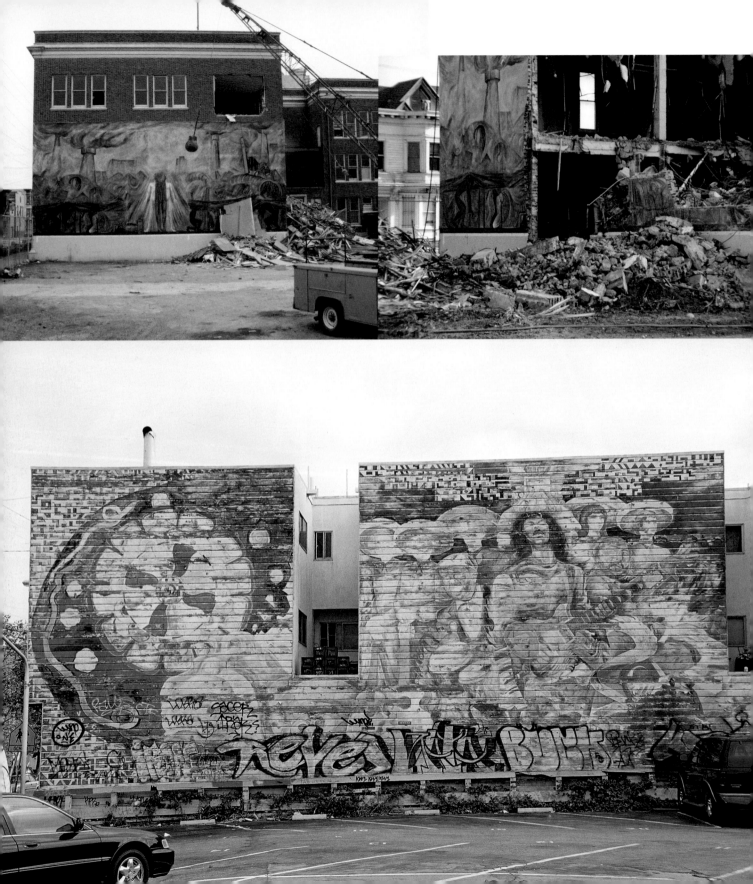

The tricky sociological matter is that a highly visible work of art on constant public display develops a life, and sometimes a cult, of its own—even if an authoritative body, or the community that created it, decides that it is time to do away with a mural. Even if adequate notice is posted, as is required by law, the destruction of any sort of art in the public eye can have violent repercussions when the artist, or the community, objects. The Visual Artists Rights Act grants to artists certain "moral" or "aesthetic" rights in the integrity of their work. /// ///

As the matter was resolved, the Lilli Ann mural itself was the loser. This sort of highly publicized conflict certainly discourages other building owners from welcoming such public works of art on their walls or arbitrarily destroying the ones that already exist. Happily, in test cases elsewhere, those who would eliminate a mural without the approval of the artist(s) who created it have paid a high price. ///////////////////////////// /// ///

Rescue Public Murals has begun to bring together the communities that create murals, the owners of buildings whose walls they grace, the caretakers of these powerful visual statements, and the professionals whose job it is to save works of art in order to come to some consensus about how best to proceed. The Mission was the breeding ground of this initiative. ///////// /// /// /// /// /// /// /// /// /// /// /// /// /// /// /// /// ///

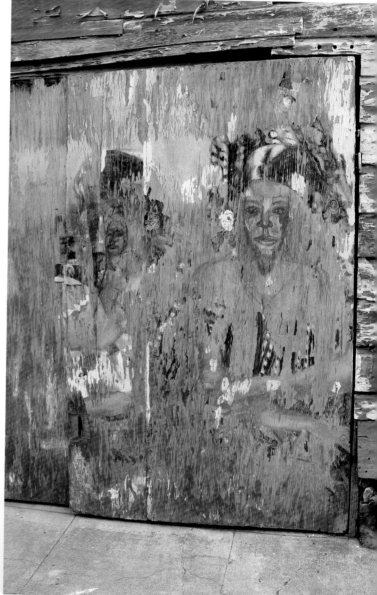

Brooke Fancher, *My Child Has Never Seen His Father.* ///////// *Volan lejos los sentimentos cuando los amados han muertos* // *todos,* 1984 (photo 2003) ///

opposite above: Mural by **Gilberto Ramirez,** 1975; destroyed in 1984
opposite below: **Michael Rios,** *Inspire to Aspire,* 1987 (photo 2006)

HUMAQUINA: MANIFEST TECH-DESTINY

If YOUR MIND IS ON YOUR computers, WHO'S MINDING YOUR body?

HISTORICAL AMNESIA
HISTORICAL AMNESIA
HISTORICAL AMNESIA
HISTORICAL AMNESIA
HISTORICAL AMNESIA
HISTORICAL AMNESIA
HISTORICAL AMNESIA
HISTORICAL AMNESIA
HISTORICAL AMNESIA
HISTORICAL AMNESIA
HISTORICAL AMNESIA
HISTORICAL AMNESIA
HISTORICAL AMNESIA

opposition
survival
dislocation
struggle
representation

Los restos coloniales se manifiestan en el olvido

The (Postcolonial) Rules of Engagement: Advertising Zones, Cultural Activism, and Xicana/o Digital Muralism

John Jota Leaños

Advertising zones are panoptic, penetrating, and b o r d e r l e s s. Programmed with complex ideological code, corporate advertising has placed itself at the forefront of a new architectural LANDSCAPE.

This did not happen by accident, nor is it a natural sequence of events. Within the last thirty years, urban centers have undemocratically opened their gates to corporate branding, capitalist whims, and advertising experimentation, often mimicking the trends of street art.

This postindustrial version of excessive marketeering has occurred at the same time as other forms of public visual expression, such as graffiti, postering, tagging, and murals have become increasingly criminalized by cities and states across the nation. In his book *City of Quartz*, Mike Davis shows that throughout the 1990s an increased effort by police and urban planners has successfully privatized and controlled public spaces using an assortment of architectural, urban design, and technological tactics. These efforts serve to fortify race and class segregations as well as protect private property, ensure corporate investment, and maintain the status quo.

As the cost of living in San Francisco skyrocketed in the 1990s, advertising space became as competitive and pricey as living space. The rapid influx of capital into San Francisco due to Internet speculation and dot.com start-up mania spawned the appearance of hyper-real ads in the cityscape. Enormous, twenty-story-high advertisements for Levi's and SUVs glued themselves to buildings all over the city. These steroid-induced billboards were not only selling products but celebrating the inevitable victory of capitalism, as was seen on a billboard that gloated, "Capitalism Served Fresh Daily."

Simultaneously, California was busy passing Proposition 21, the Gang Violence and Juvenile Crime Prevention Act of 1998, which streamlines youth into the adult prison system and makes graffiti and poster vandalism punishable as a felony with up to three years in prison. The City of San Francisco, following the lead of the rest of the country, also established a graffiti abatement program, juvenile curfew laws, and anti-cruising ordinances that set out special task forces to criminalize youth armed with spray cans, posters, wheat paste, and ideas. Today, San Francisco spends well over $20 million in graffiti abatement, not counting the costs of prosecuting, charging, and retaining young writers.

above: **Los Cybrids (John Jota Leaños, René Garcia, and Monica Praba Pilar),** *Humaquina: Manifest Tech-Destiny* (Galería de la Raza digital billboard), 2001

middle: **Los Cybrids (John Jota Leaños, René Garcia, and Monica Praba Pilar),** *Somos digital* (Galería de la Raza digital billboard), 2004

below: **John Jota Leaños,** *Los restos coloniales se manifiestan en el olvido/Colonial Remnants Manifested in Amnesia* (Galería de la Raza digital billboard), 1998

Appropriating advertising BECAME A SHARP TACTIC FOR **San Francisco's** Xicana/o digital mural movement. Al Lujan installed his digital mural *Resist the Dot Con* as he was in the midst of being evicted from his apartment in the Mission. The mural became the face of the anti-gentrification movement in San Francisco.

John Jota Leaños

Photo by Greg Roden

Corporate Jerk Award: Levi's

While community concern continues to run high about gang violence, the greedy people at Levi's evidently decided if you can't beat 'em, join and if you can't join 'em, sell 'em pants. Several of these pro-gang billboards are up in the Mission, designed no doubt, to appeal to the drive-by shooter market now dominated by baggy Lee's. Billboard Liberation Front: where are you when we need you?

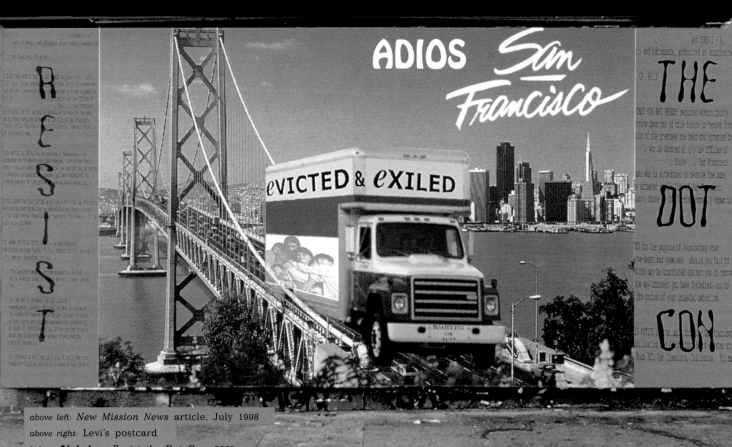

above left: New Mission News article, July 1998

above right: Levi's postcard

below: **Al Lujan,** *Resist the Dot Con,* 2000

The burly presence of corporate advertising in privatized public space and the policing of cultural activity done "without permission" have led to a street war of symbols and icons. Artists and activists have taken on a David-and-Goliath battle over cultural codes with the belief that social change and political transformation occur by inserting alternative messages within the public arena. //
//
//
In 1998 I approached the then-director of Galería de la Raza, Gloria Jaramillo, with a proposal for the first computer-generated billboard mural on the side of the gallery's building, which had been reclaimed by local painters for decades. I was interested in creating a digital mural that merged photography, Xicana/o mural tactics, and contemporary advertising. *Los restos coloniales se manifiestan en el olvido (Colonial Remnants Manifested in Amnesia)* was a triptych about how colonialism—past and present—promotes cultural amnesia through a strategic masking of language, space, and image. The mural hit the street during the tense climate just before California passed Proposition 227, an anti–bilingual education ballot initiative. ///
//
//
A year later, I collaborated with Carolina Ponce de León to establish the Digital Mural Project at Galería de la Raza. By curating artists who make witty, sharp critiques of hot-button issues such as racial profiling, surveillance, sexual equality, and post-humanism, we were able to not only break with the traditional mural aesthetic but also form a new vision steeped in advertising, Mexican muralism, and new media. The display of intelligence was raw, and the community reaction a roar—of attention, attack, and appreciation. During this time, Latinos in the United States were being deemed as the furthest behind in the race to become connected to the Internet. Although the rhetoric of the so-called digital divide told us that we were electronically deficient, we strove to forge a fresh, radical, informed, and dissenting digital muralism. /////////////////////////
//
//
On the surface, the advertising industry and political artists are diametrically opposed. However, a closer look reveals that advertisers and Xicana/o digital muralists may share some common strategies. Advertisers, like muralists, have a goal of communicating ideas using a wide range of psychological, aesthetic, emotional, and narrative approaches. The idea of transformation, so important for the political artist, is present

in advertising, which seeks to connect with its audience (consumers) through narrative, fantasy, and style. Its tactics include countless repetition, the high-tech "wow" effect, humor, sexual enticement, the marketing of "cool," and other means. Mural production shares the need to "advertise" an ideological position, whether a political statement or an aesthetic one. //
//
//
The tactic among artists and cultural activists to "take over public space" or "reclaim the streets" is not only a creative act of irreverent civil disobedience; it is an aesthetic practice of engaging in specifically non-art-related sites or communities. From laser graffiti writers and theater for surveillance cameras to billboard fiddling and Flash Mobs, contemporary interventionist art practice assails unexpected public spaces with often witty, subversive, and disruptive artwork. The oppositional politics of these art tactics often serve as lucid critiques that respond to several trends, including the corporate control of public discourse, where access is bought and sold; the surveillance, policing, and disappearance of most public space; and the dominance of the ideology of private and individual rights. //
//
//
The colonialist metaphors of space and land occupation seem to engender an endless game of territorial rights. In the search for postcolonial rules of engagement, Xicana/o Muralismo is a proactive tactic of subversive cultural coding. Steeped in the tradition of cultural activism of the Mexican muralists, this movement is a community-based public art form founded in hybrid Mexican-American working-class aesthetics, culture, and politics. //
//
//
//
//
//
//
//
//
//
//
//
//
//
//
//

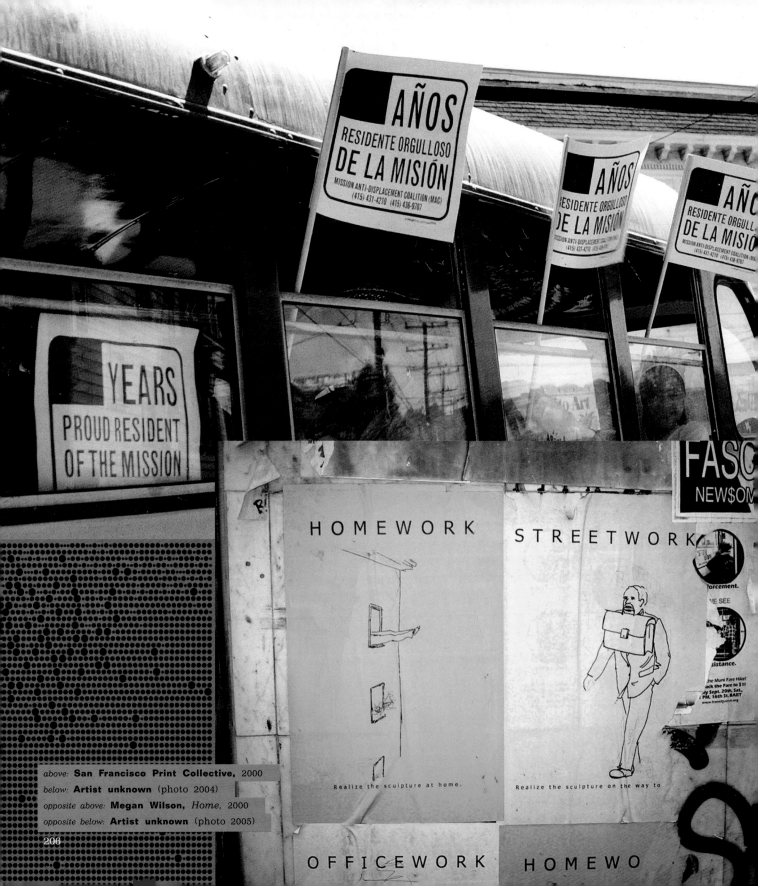

AÑOS
RESIDENTE ORGULLOSO
DE LA MISIÓN
MISSION ANTI-DISPLACEMENT COALITION (MAC)
(415) 431-4210 (415) 436-9707

AÑOS
RESIDENTE ORGULLOSO
DE LA MISIÓN
MISSION ANTI-DISPLACEMENT COALITION (MAC)
(415) 431-4210 (415) 436-9707

AÑOS
RESIDENTE ORGULLOSO
DE LA MISIÓN
MISSION ANTI-DISPLACEMENT COALITION (MAC)
(415) 431-4210 (415) 436-9707

YEARS
PROUD RESIDENT
OF THE MISSION

FAS©
NEW$OM

HOMEWORK

Realize the sculpture at home.

STREETWORK

Realize the sculpture on the way to

OFFICEWORK HOMEWO

above: **San Francisco Print Collective,** 2000
below: **Artist unknown** (photo 2004)
opposite above: **Megan Wilson,** *Home,* 2000
opposite below: **Artist unknown** (photo 2005)

At the turn of the twenty-first century the Bay Area was the epicenter of a massive trans-formation brought about by the dot-com boom and the new economy. The Mission District felt like a big kegger; loud and drunk hordes poured out onto the streets nightly from the trendy venues that popped up all along Valencia Street. The arts community witnessed the departure of artists and arts spaces. I was inspired to respond to the changes when my land-lord sued me for eviction. To draw attention to the dis-placement occurring in the neighborhood, in August 2000 I started painting signs that read *Home* and gave them to people to display in their windows or carts (if they were homeless). I called the project *Better Homes and Gardens.* The idea was inspired by an incident that happened in my hometown of Billings, Montana. During Hanukkah, a right-wing group threw bricks at the windows of Jewish homes. In response, Christian homes and busi-nesses placed menorahs in their windows. The violence stopped. Could I capture this sense that violence against one strikes us all?

Megan Wilson

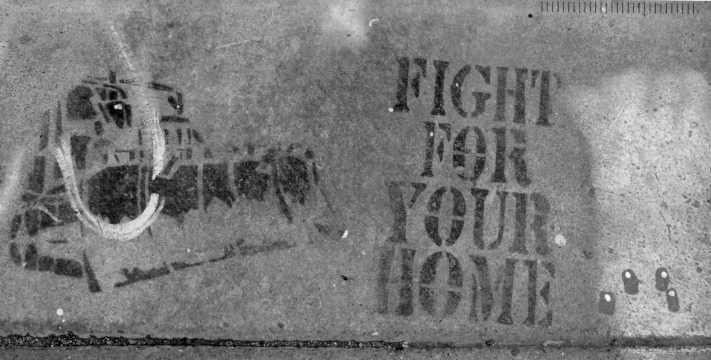

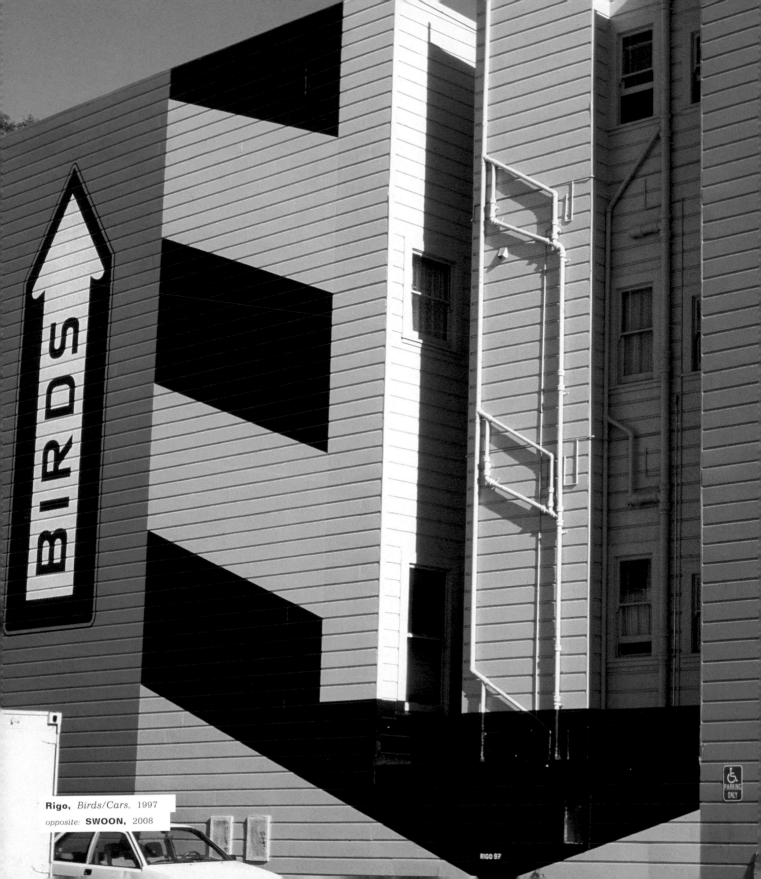

Rigo, *Birds/Cars,* 1997
opposite: **SWOON,** 2008

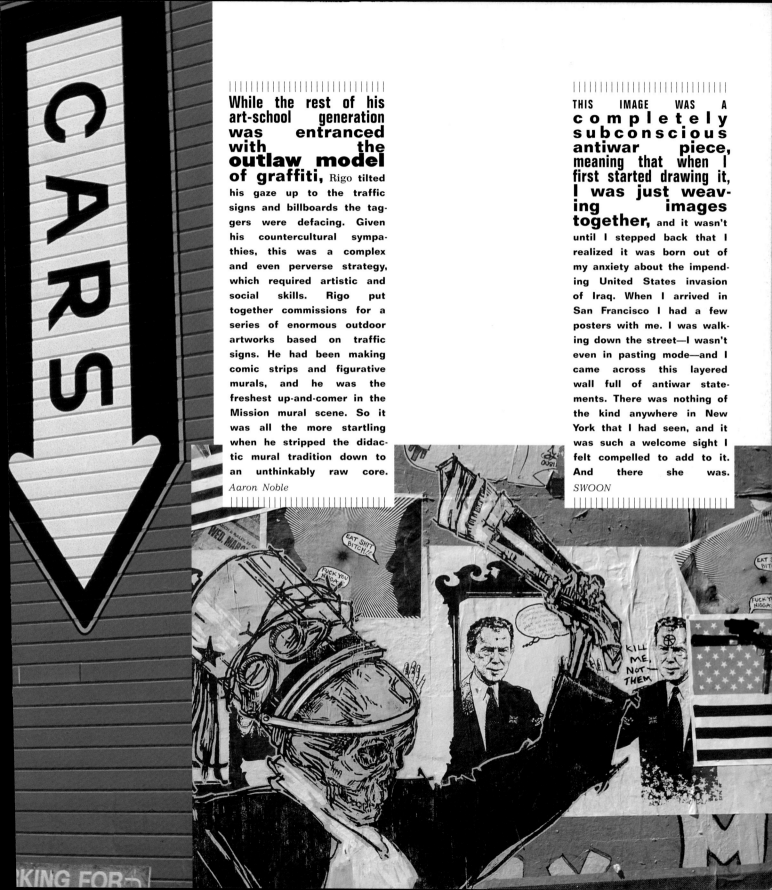

While the rest of his art-school generation was entranced with the **outlaw model of graffiti,** Rigo tilted his gaze up to the traffic signs and billboards the taggers were defacing. Given his countercultural sympathies, this was a complex and even perverse strategy, which required artistic and social skills. Rigo put together commissions for a series of enormous outdoor artworks based on traffic signs. He had been making comic strips and figurative murals, and he was the freshest up-and-comer in the Mission mural scene. So it was all the more startling when he stripped the didactic mural tradition down to an unthinkably raw core.

Aaron Noble

THIS IMAGE WAS A **completely subconscious antiwar piece,** meaning that when I first started drawing it, I was just weaving images together, and it wasn't until I stepped back that I realized it was born out of my anxiety about the impending United States invasion of Iraq. When I arrived in San Francisco I had a few posters with me. I was walking down the street—I wasn't even in pasting mode—and I came across this layered wall full of antiwar statements. There was nothing of the kind anywhere in New York that I had seen, and it was such a welcome sight I felt compelled to add to it. And there she was.

SWOON

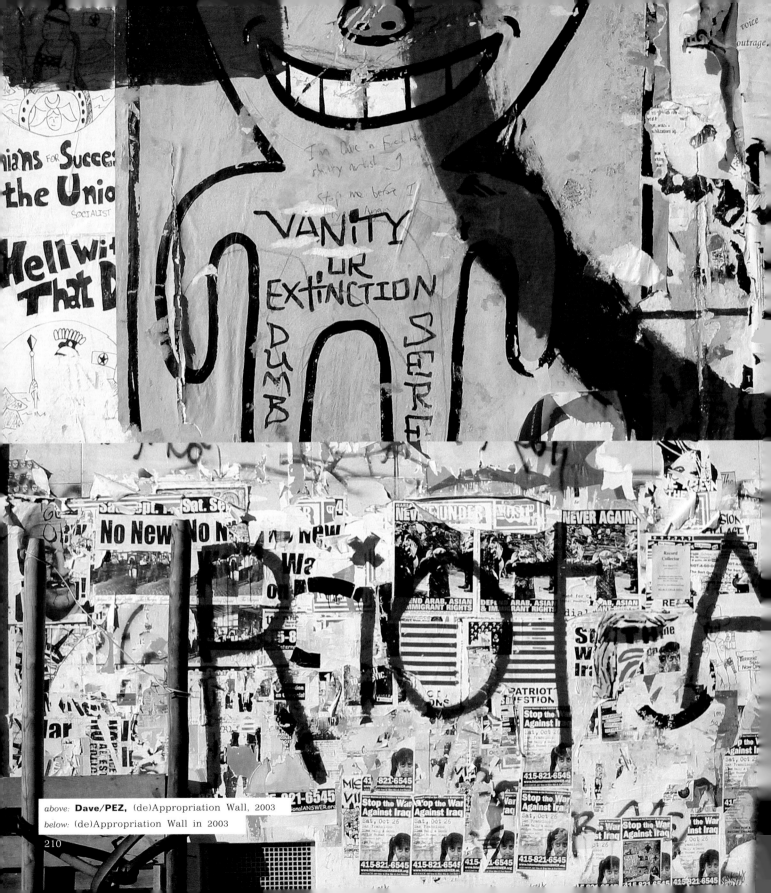

above: **Dave/PEZ,** (de)Appropriation Wall, 2003
below: (de)Appropriation Wall in 2003

(de)Appropriation Project //

Bruce Tomb //
//
//

This project began as maintenance on the FACADE of my home and workplace.

Sometimes I call it an archeographic collage. The local alternative paper calls it the "democracy" wall because it rallies against the slew of wars and injustices. It is a public art platform that has a life of its own. ////////////////////////////
//
//

The building, constructed as the Mission Police Station in 1950, was sold through public auction in 1996 after it had been sitting empty for a number of years. The old precinct was known for civil-rights abuses. A new station was built six blocks away to replace it. While empty, the austere modern institutional building sustained a fair amount of vandalism and was further stigmatized. After moving in, I was preoccupied by daily maintenance on the Valencia Street facade, removing the endemic graffiti with chemicals. Inside, the holding cells are still intact, and are also covered with graffiti on every possible surface, including the bars. Most of the writings are monikers from the neighborhood gangs. ////////////////////////
//
//

The Sisyphean nature of the endeavor to maintain the Valencia Street facade became apparent with nightly tagging. I have a high regard for graffiti as it has evolved over the recent decades, but this graffiti remained "dog piss." About a year into my maintenance attempts, the City of San Francisco asked me to participate in their Graffiti Abatement Program, which was just as ineffective. After I opted out of this service upon the city's request to be paid (the work had been free up to this point), the city threatened a lien against the property based on complaints from the neighbors. Faced with a long-term maintenance issue, I knew I needed to find a way to deal with the wall in a manner in which I could find some satisfaction in both the process and the outcome. An experiment began. //
//

The first "action" I contributed to the wall, in late 1998, was a sky-blue checkerboard pattern corresponding to the glazed ceramic tiles of the original facade. This cut up the existing tagging into calligraphic fragments. Of course, the surface was quickly overwritten, and soon the layering evolved. None of these early actions were documented. //////////////////////
//

When the postering shifted to wheat paste, it became evident that something interesting was emerging. I began taking pictures in early 2001. The spectrum and content of the work on the wall began to broaden, including territorial tagging, artistic doodles, political posters, community-based flyers, screenprinted posters, stencils, and unique hand-painted artist posters. There were episodes of intense political material and then remarkable purely artistic work. Often the collage would be a complete jumble, and then someone might make a large or bold work that tied everything together. Some work I loved and some work I didn't. Nothing lasted very long in either case. "Fuck the Homeless! Save the Tourists!" posters with the mayor's picture were particularly inflammatory. I told the city that I now considered the wall a public art project and that regardless of content it must be protected under the First Amendment. This must have been a compelling argument. The following night three new posters were placed that remained there for well over a year. ////////////////
//

At this point, I see my role as somewhere between custodian and curator of a public collage authored by many. The political nature of the monumental collage produced on this facade has a graphic impact that resonates with the media-intensive origins of some modernist architecture. Works by Constructivist architects, such as the Vesnin brothers' design for the Moscow headquarters of the *Leningrad Pravda* newspaper (1924) or Aleksandr Rodchenko's designs for kiosks and radio towers, as well as agitprop are precedents for the wall's style and intention. What some regard as a gesture of defacement, others see as a protest against contemporary models of urbanism and notions of public and private space. ////////////////////////////

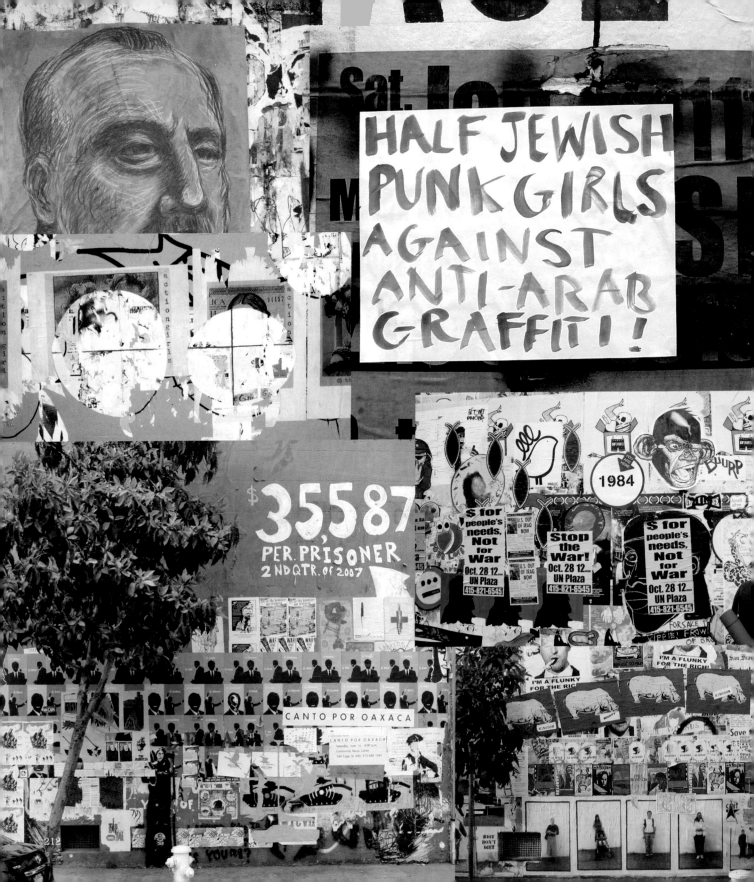

HALF JEWISH PUNK GIRLS AGAINST ANTI-ARAB GRAFFITI!

$35,587 PER PRISONER 2ND QTR. of 2007

1984

DUURP

$ for people's needs, Not for War Oct. 28 12 UN Plaza 415-821-6545

Stop the War! Oct. 28 12 UN Plaza 415-821-6545

$ for people's needs, Not for War Oct. 28 12 UN Plaza 415-821-6545

I'M A FLUNKY FOR THE RICH!

I'M A FLUNKY FOR THE RICH!

CANTO POR OAXACA

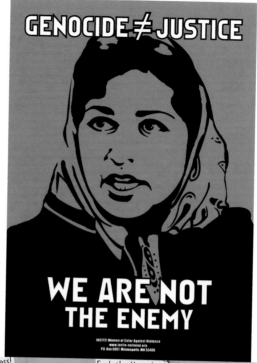

GENOCIDE ≠ JUSTICE

WE ARE NOT
THE ENEMY

INCITE! Women of Color Against Violence
www.incite-national.org
P.O. Box 6861 Minneapolis, MN 55406

above: **Faviana Rodriguez**, *We Are Not the Enemy,*
2001
below: (de)Appropriation Wall in 2002
opposite: Clockwise from top left:
(de)Appropriation Wall in 2008, 2003, 2001,
2003, 2001, 2006

**I saw her
face on 9/11.
Bush was promising
revenge.** Afghan women
became a symbol against
war. This poster circulated
the world as the threats
swelled. I want my art in
liquor stores. I am inspired
by the earlier generation of
artists working in the
Mission, such as Yolanda
Lopez, Juan Fuentes, **and**
Malaquiz Montoya, **as well
as the seminal black-and-
white organizing posters of
Rini Templeton. My book**
Reproduce & Revolt **is a col-
lection of copyright-free
imagery for artists and
a c t i v i s t s .**
Favianna Rodriguez

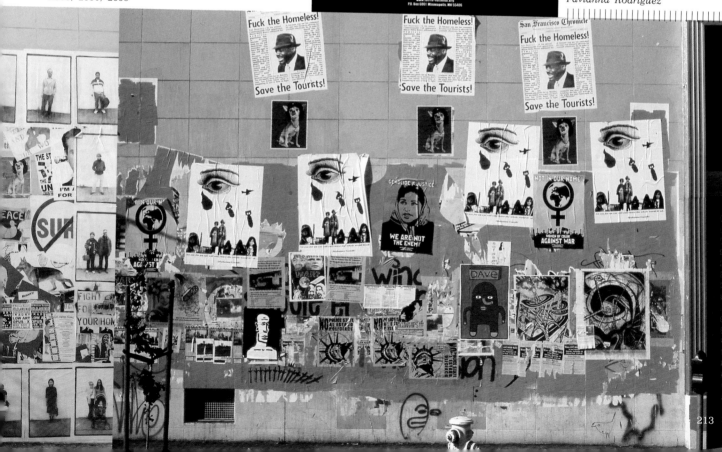

213

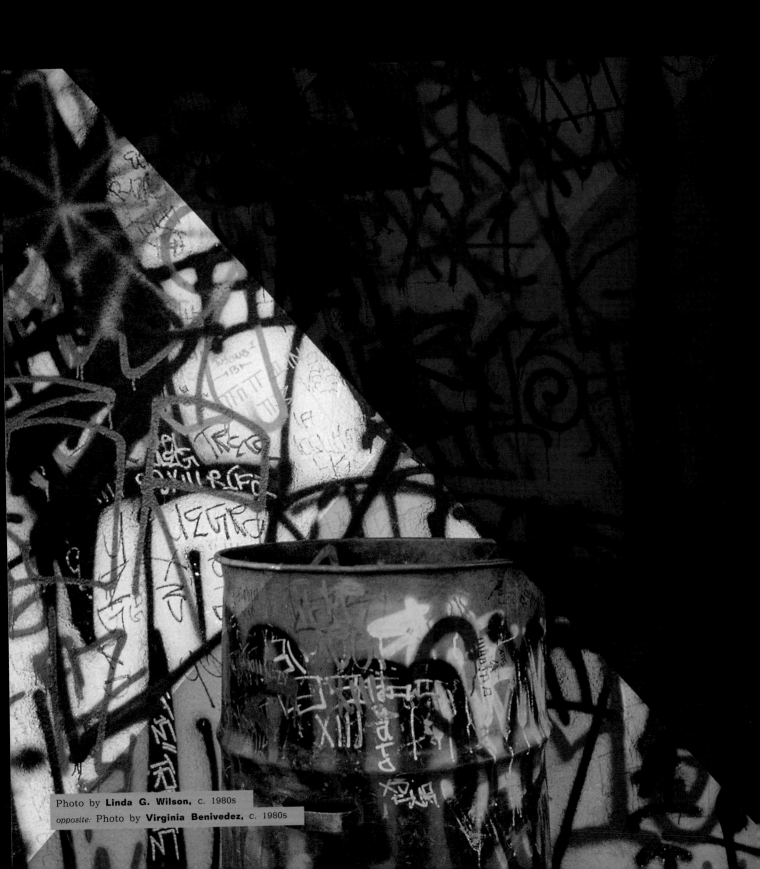

Photo by **Linda G. Wilson**, c. 1980s

opposite: Photo by **Virginia Benivedez**, c. 1980s

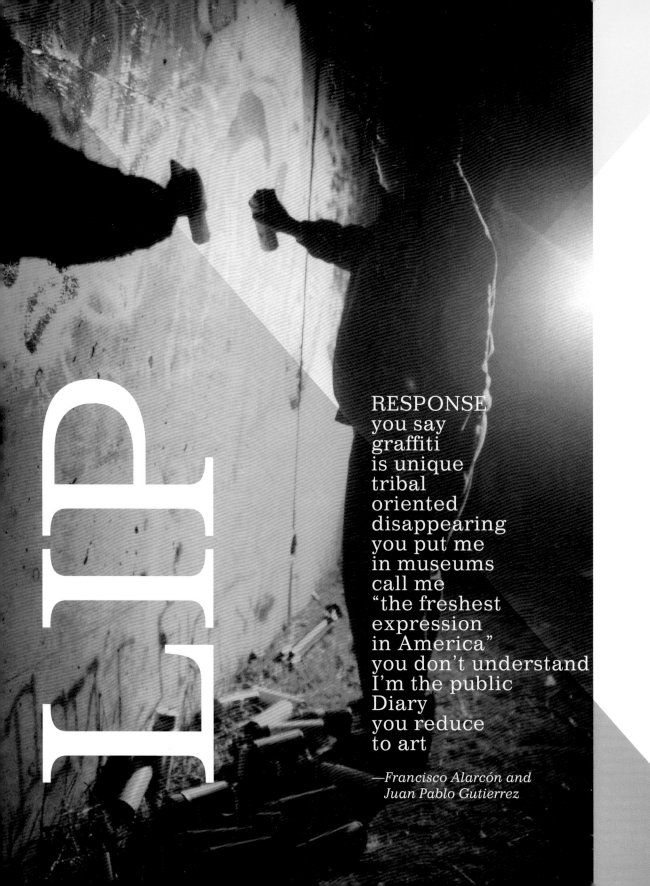

LIP

RESPONSE
you say
graffiti
is unique
tribal
oriented
disappearing
you put me
in museums
call me
"the freshest
expression
in America"
you don't understand
I'm the public
Diary
you reduce
to art

—*Francisco Alarcón and
Juan Pablo Gutierrez*

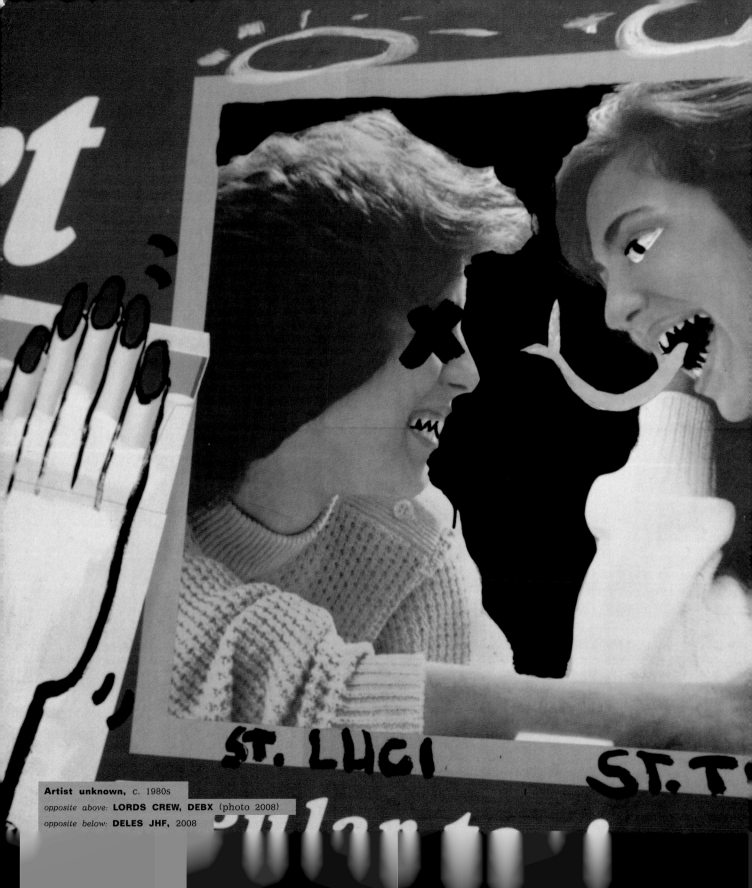

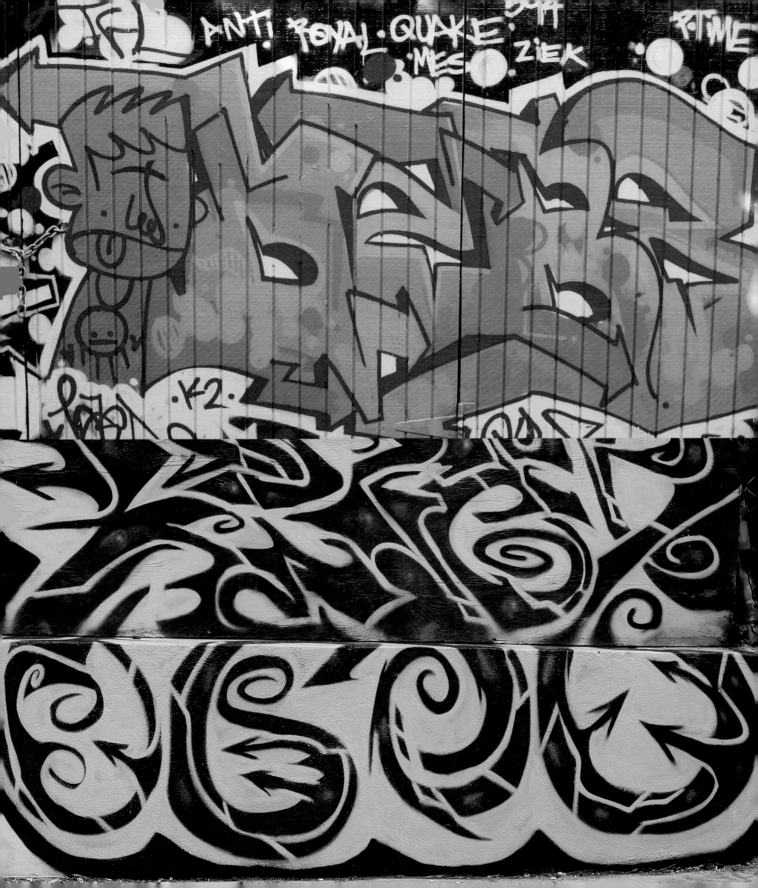

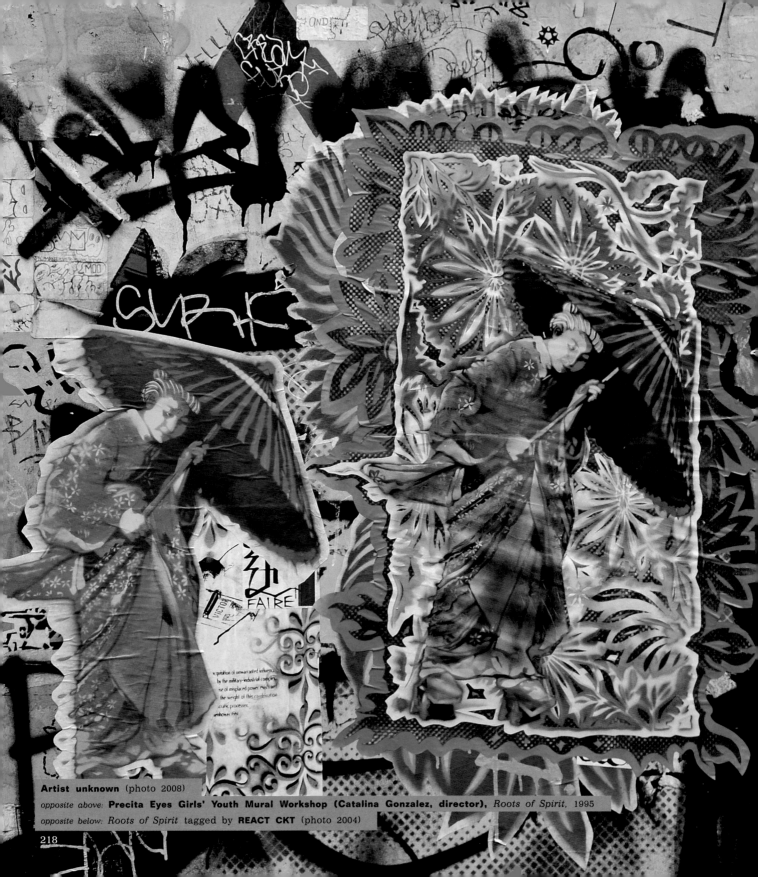

Artist unknown (photo 2008)

opposite above: **Precita Eyes Girls' Youth Mural Workshop (Catalina Gonzalez, director),** *Roots of Spirit,* 1995

opposite below: *Roots of Spirit* tagged by **REACT CKT** (photo 2004)

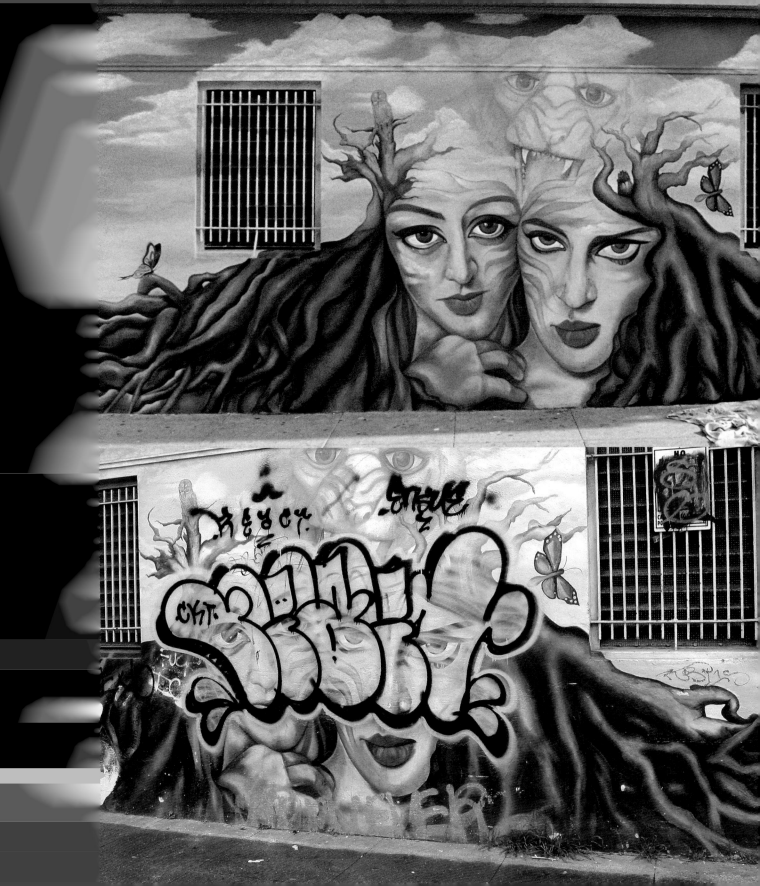

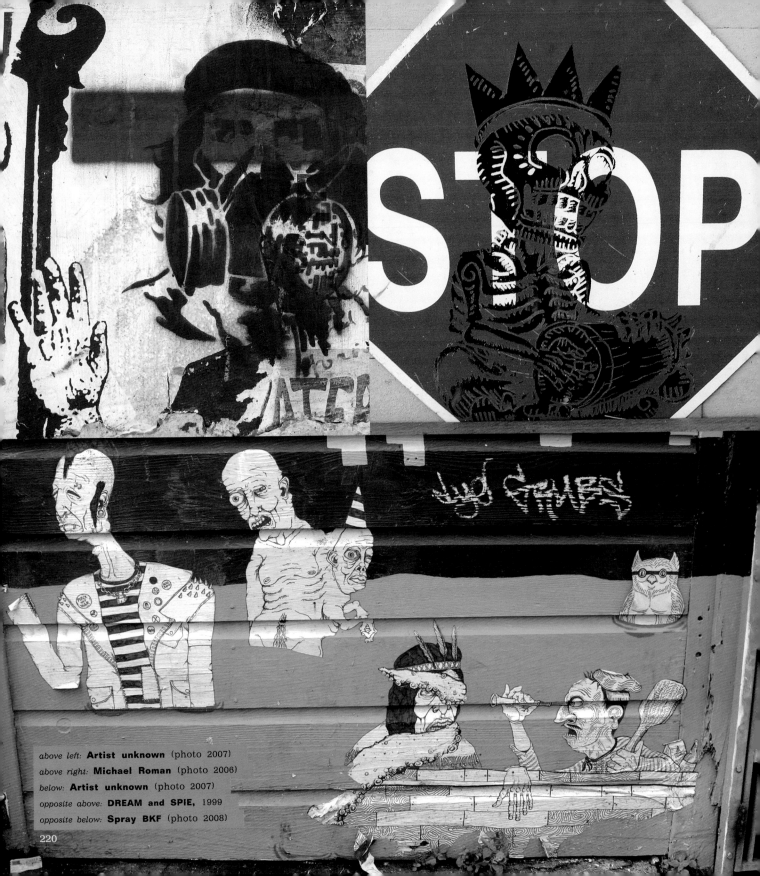

above left: **Artist unknown** (photo 2007)
above right: **Michael Roman** (photo 2006)
below: **Artist unknown** (photo 2007)
opposite above: **DREAM and SPIE,** 1999
opposite below: **Spray BKF** (photo 2008)

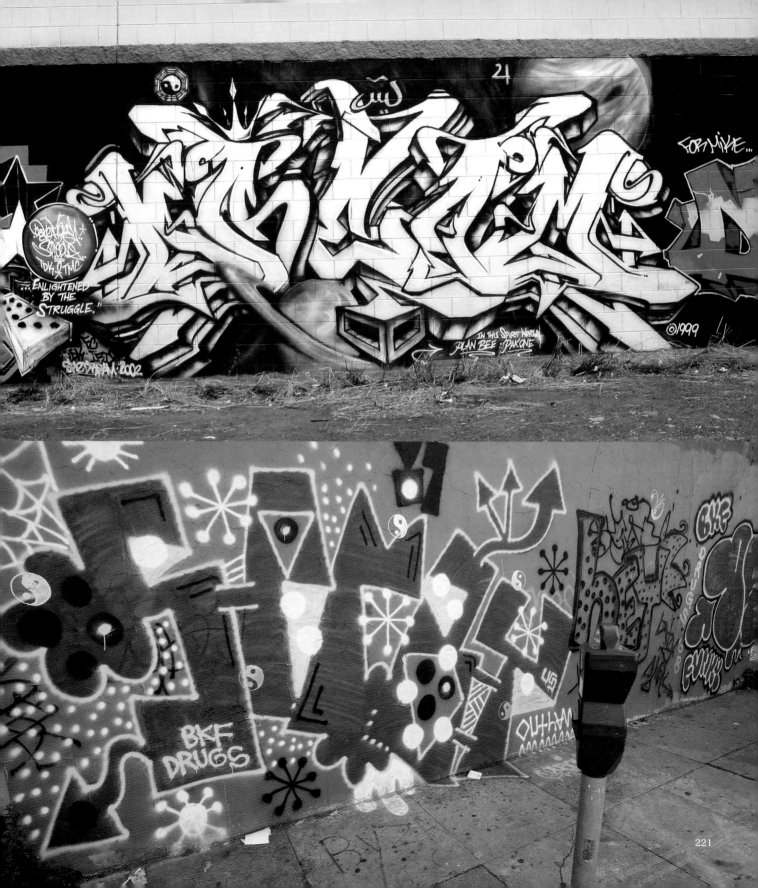

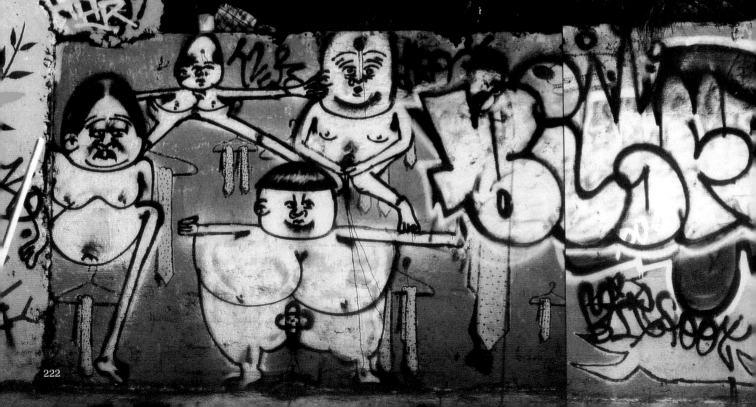

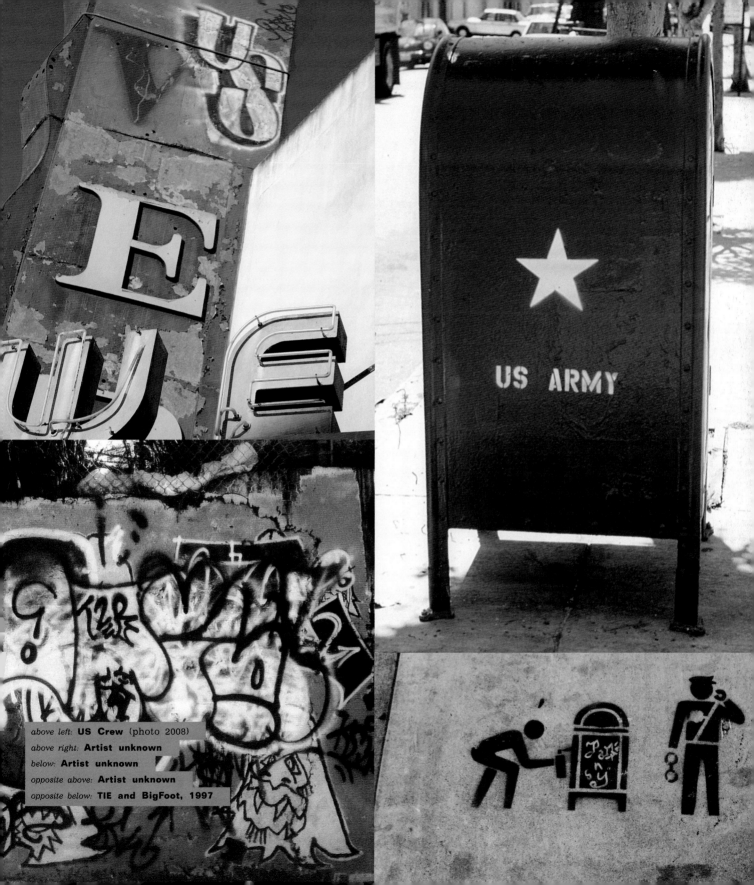

above left: **US Crew** (photo 2008)
above right: **Artist unknown**
below: **Artist unknown**
opposite above: **Artist unknown**
opposite below: **TIE and BigFoot, 1997**

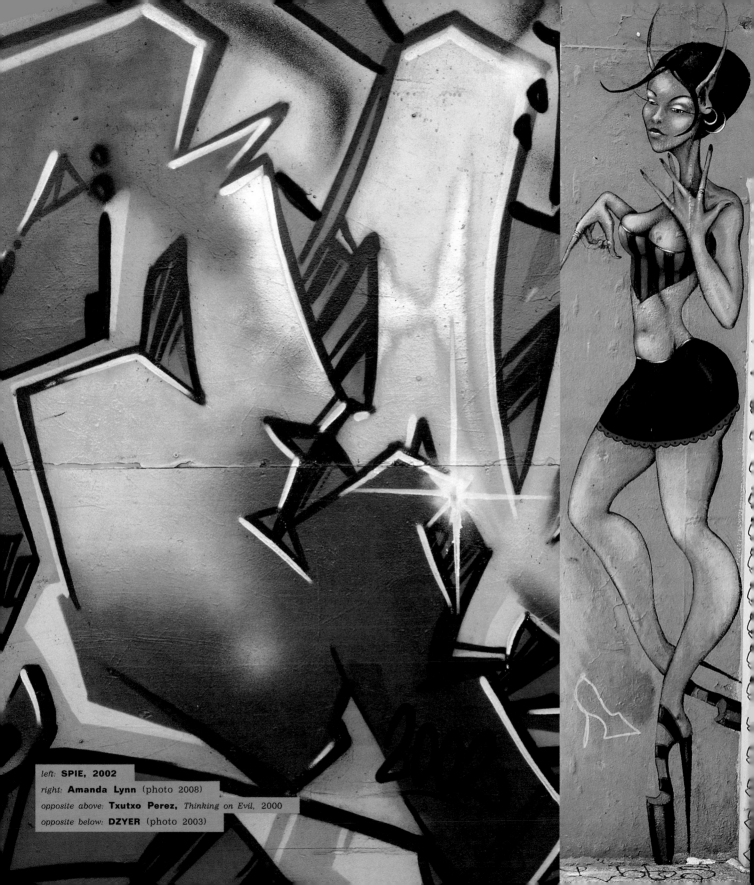

left: **SPIE, 2002**

right: **Amanda Lynn** (photo 2008)

opposite above: **Txutxo Perez,** *Thinking on Evil,* 2000

opposite below: **DZYER** (photo 2003)

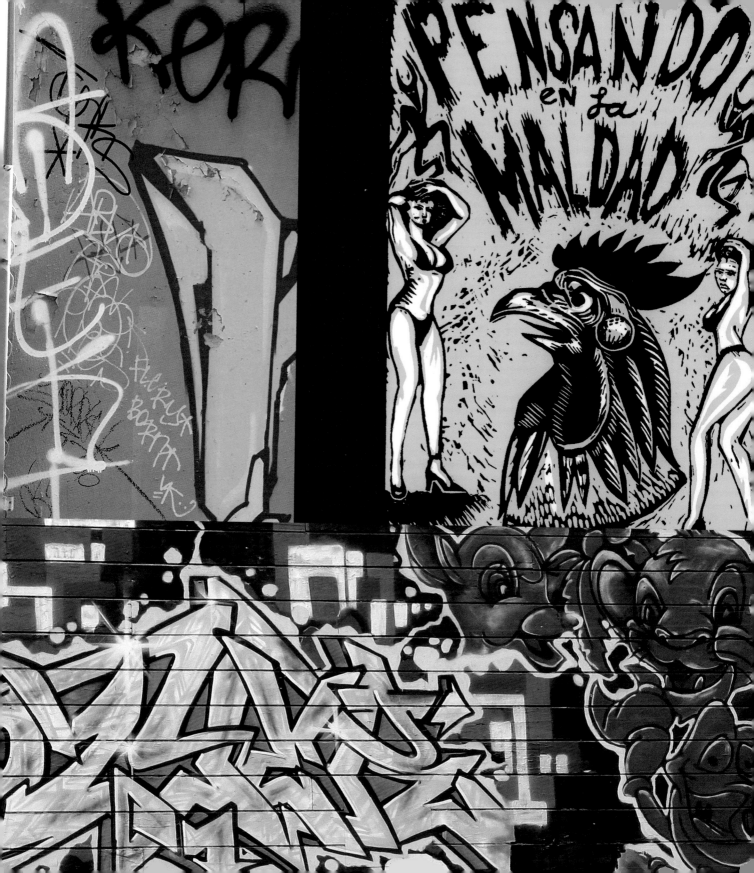

Tyranny and Counter-Tyranny: Visual Situations in the Mission ///
///
David Goldberg ///
///
///

The Mission is a LABORATORY for developing new ways of seeing. To see things differently is the first step to change.

Muralism, broadly defined, is a strategy of counter-tyranny that redefines the visual environment to reflect priorities that are more cultural than commercial, more activist than hypnotic, more stimulating than seductive. The counter-tyranny of muralism in San Francisco's Mission District urges the viewer to reclaim agency, to recognize that what (s)he wants to see has been hijacked by those (on all sides of the political spectrum) who have (lost or found?) faith in an individual's diminishing ability to make meaning in the world. ///
///
///

Sanctioned billboards are dense here. Advertising competes with buildings robed in murals celebrating the history of women, and survives those mavericks who brave the billboard jungle gym to sabotage another odious commercial message. In the Mission no bus shelter advertisement is safe, as poets scrawl across the glass with Sharpies, teenagers practice their alter-ego signatures with inch-thick markers, and the truly subversive obtain the keys to unlock the Plexiglas cabinets and *replace* the official advertisement with an *improvement*. /////////////////
///
///

Day and nighttime muralists manufacture a steady stream of powerhouse iconography from mythology, ecology, history,

magic, and politics, in a sustained ecosystem of aerosol graffiti, lattices of tags, and brushwork. Meanwhile, gang-bangers use the broad surfaces and back sides of Mission District liquor stores to claim turf and honor their fallen soldiers with hand-applied gothic lettering. An ever-changing collage of graffiti throw-ups anchors aging theater-cum-church marquees. Tijuana-style lines of aerosol letters follow the edges of rooftops like typewriter output. But even they have to compete with sanctioned aerosol graffiti "productions" (large-scale multi-artist collaborations) and alliances between the illegal and legal wall-painting traditions. Further into the mix, the semi-legal advertising poster gangs meet the political wheat-paste crews at plywood-enclosed sites of decay, de- and con-struction. iPod silhouettes confront raw anti-war graphics and caricatures of local politicians. Meanwhile, at the relatively microscopic scale, the tags and stickers proliferate, while the time-honored traditions of blacking out the teeth in dazzling smiles, adding the handlebar mustache, and using liquid paper to undermine the commercial gaze all continue to thrive. ///////////////////////
///
///

The gang-banger who tags for the supremacy of one compass vector over another has little concern for how such markings affect those outside of her or his community. Neither do graffiti artists or wheat-paste brigades. The advantages that the official advertisers have over anyone else cultivating and competing for attention are legal protections, demographic research, and market incentive. Everyone is targeting somebody. Visual counter-tyranny, whether practiced by spray artists, printmakers, Kinko's commandos, or traditional muralists, is the opposite of advertising. ////////////////////////////////
///
///
///
///
///
///
///
///
///
///
///
///

above left: **Nome Edonna** (photo 2004)
above right: **HEART/Sara Thustra,** 2005
below left: Shepard Fairey homage (photo 2008)
below right: **Artist unknown** (photo 2006)

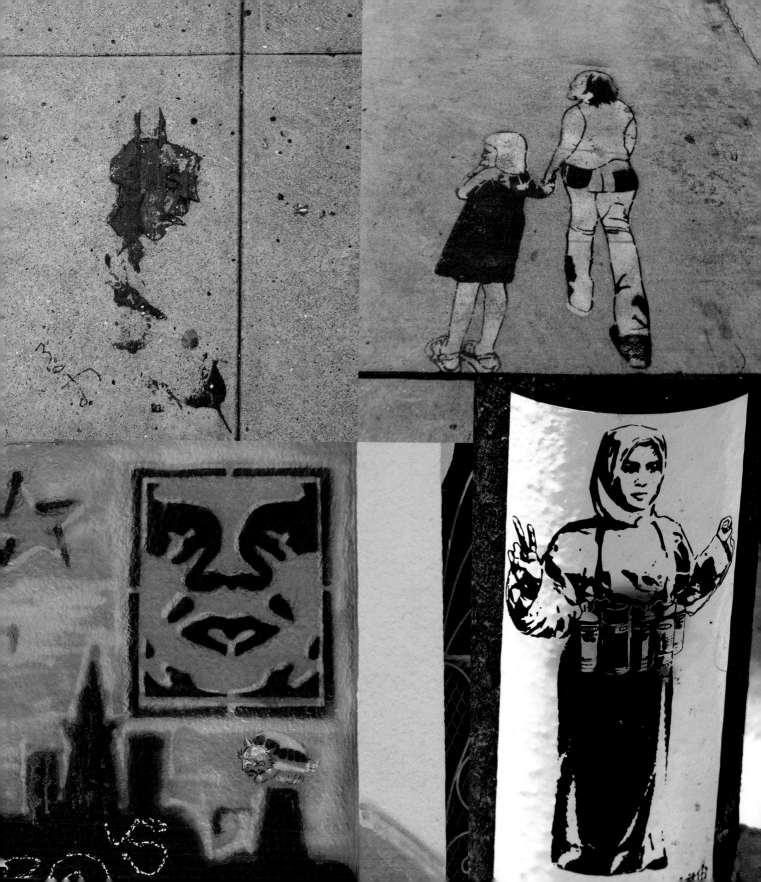

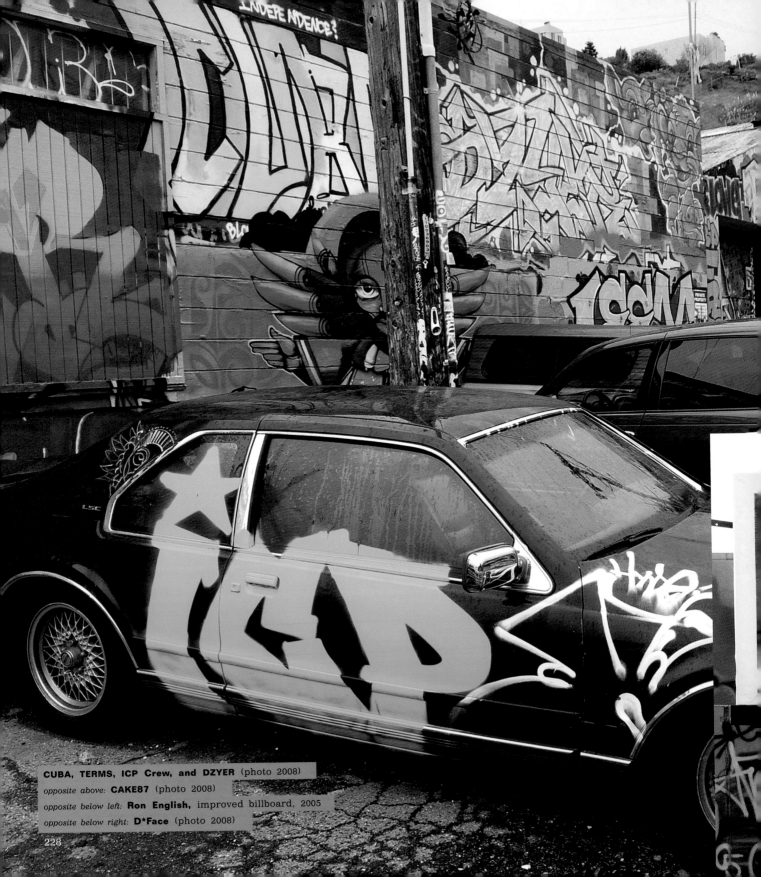

CUBA, TERMS, ICP Crew, and DZYER (photo 2008)

opposite above: CAKE87 (photo 2008)

opposite below left: Ron English, improved billboard, 2005

opposite below right: D*Face (photo 2008)

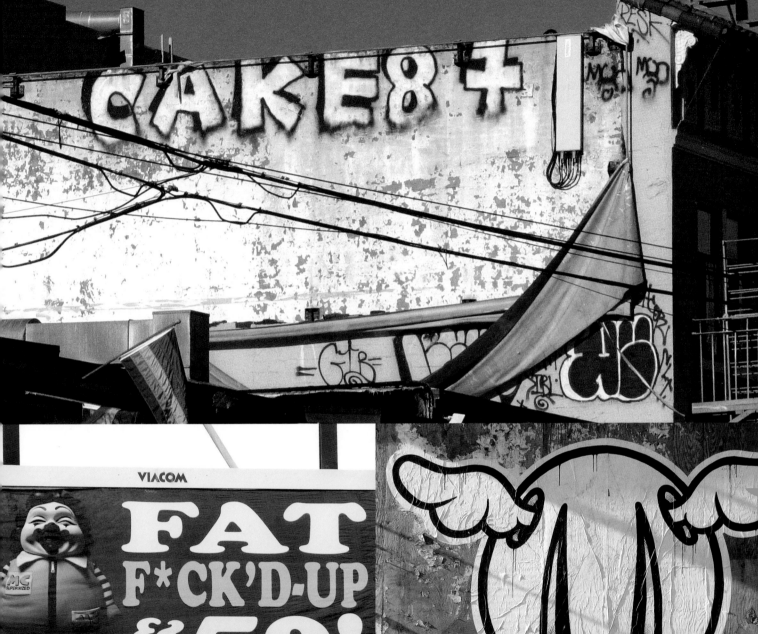

DEAD YET?

SURGE ... NING: PREGNANT WOMEN WHO SMOKE RISK FETAL INJURY AND PREMATU...

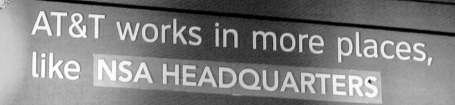

AT&T works in more places,
like NSA HEADQUARTERS

The new at&t

#951545

CBS

14'h x 48'w

Improved billboards, (top) 1996 and (bottom) 2008
opposite: Improved billboard, 1990

230

MOTORS, Inc.
415-626-6363
www.ecitymotors.com

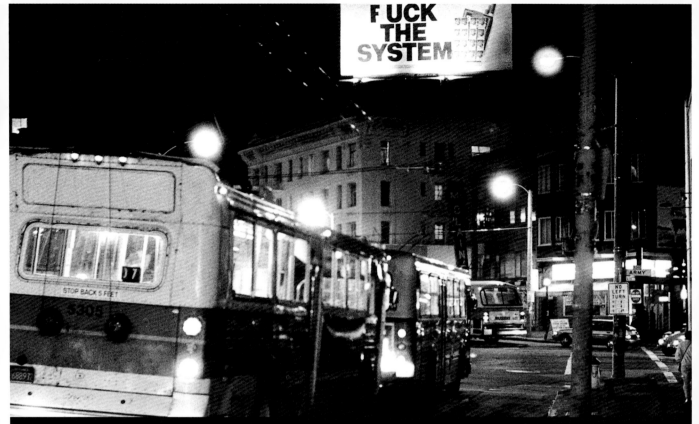

DRIVE-BY THEATER
ANNICE JACOBY

THE CORNER of Mission and Army, now renamed Cesar Chavez Street, is one of the ugliest in San Francisco. Worlds cross at the intersection. A flow of traffic from freeways to coveted neighborhoods ignores the visual blight. The street is broad and bald as it heads toward Dolores, the boulevard of backlit palms rising from the tail of the Mission. Perhaps you are driving to Cesar's Latin Palace (later Roccapulco), where on any night young Latino men are available for salsas, no introduction necessary. Some of these same young men spend their days on the corner in front of the paint store, in the roulette of traffic hoping for pick-up jobs. Day labor by light, dancers at night.

This intersection is rich in super-scale billboards like "Got Milk" or "Buck the System." The latter was cleverly altered to "Fuck the System" around the time a loaded roof-tarring truck drove into the glass window of a flower shop, killing the owner's wife, who had just arrived without legal documentation. For a few days, the altered sign defiantly remained, amusing all who drove by. But it was especially poignant to the day laborers, before it was replaced with a two-story-tall beer can. The community has been fighting alcohol and cigarette advertising for decades.

R. O. Thornhill, BLF Education Officer, and Blank De Coverly, BLF Minister of Propaganda

It is now clear that the **AD** holds the most esteemed position in our cosmology.

Old-fashioned notions about art, science, and spirituality—the noblest goals—have been dashed on the crystalline shores of Acquisition. Artists are judged and rewarded by bowing to fashion and the vagaries of gallery culture. It is clear that He who controls the Ad speaks with the voice of our age. Of all the types of media used to disseminate the Ad there is only one that is entirely inescapable to all but the bedridden shut-in or the Thoreauian misanthrope. We speak of the Billboard. Our ultimate goal is nothing short of a personal and singular Billboard for each citizen. Until that glorious day for global communications, we will continue to do all in our power to encourage the masses to use any means possible to commandeer the existing media and to alter it to their own design. /

The Art & Science of Billboard Improvement: Helpful Hints for Alteration of Outdoor Advertising

Look up! Billboards have become as ubiquitous as human suffering, as difficult to ignore as a beggar's outstretched fist. Every time you leave your couch or cubicle, momentarily severing the electronic umbilicus, you enter the realm of their impressions. Larger than life, subtle as war, they assault your senses with a complex coda of commercial instructions, the messenger RNA of capitalism.

There are a million stories in the Big City, and as many reasons to want to hack a billboard. We have our reasons, and we don't presume to judge yours. In our manual, we have made a conscious effort to steer clear of ideology and stick to methodology. The procedures are based on our twenty-plus years of experience executing billboard improvements professionally, safely, and (knock on wood) without injury or arrest. In most cases, it should not be necessary to follow the elaborate, even obsessive, precautions we outline. A can of spray paint, a blithe spirit, and a balmy night are all you really need. /////

In choosing a sign, keep in mind that the most effective alterations are often the simplest. You can totally change the meaning of an advertisement by changing one or two letters. Signs featuring large, illuminated text can often be improved simply by turning off a few letters, converting "HILLSDALE" to "LSD," or "HOTEL ESSEX" to "HOT SEX." Although the sudden urge to just climb right up a sign and start hacking can occasionally be overwhelming, in our experience this type of "impulse improvement" tends to deliver unsatisfactory results, at unnecessary personal risk. /////////////////////

After choosing your board, be sure to inspect it, both during the day and at night. Take note of all activities in the area. Who is about at 2:00 A.M.? How visible will you be while scaling the support structure? What is the patrol pattern in the area? We've been spotted at work a number of times, and many people were amused. You'll find that most people, including officials, don't look up unless given a reason to do so. Go up on the board prior to your hit. Check your escape routes. If you do choose to work in daylight, wear coveralls (company name on the back?) and a painter's hat, and work quickly. /////////////

Have one or two cars positioned at crucial intersections within sight of the board. It's crucial that the ground crew doesn't lounge around the vehicle(s). We've found that lookouts dressed as winos, or as homeless couples, are virtually invisible additions to the urban landscape. The risk of apprehension on a board pales in comparison to the risk of falling. Even if you are an experienced climber, we don't recommend solo actions.

Improved billboards: top to bottom, 1977, 1977, c. 1980s, 1992, 1989

Billboard structures are notorious trash magnets. The responsible billboard liberator leaves nothing of his own behind (not even fingerprints), though he may on occasion leave a cold six-pack (or an expensive bottle of single malt if he's real classy) for the benefit of those hard-working sign men assigned to the unglamorous task of unaltering his alteration. //////////////////////////////////

Like the advertisements they improve, your actions should aim for the greatest possible reach. Actions executed at the beginning of a holiday weekend tend to stay up longest, since repair crews are less readily available. Be sure to get a good "before" picture of the board to be altered. Press releases may be serious or surreal, according to your motives and whim. Record your manifesto on CD, and call in your "anonymous tip." //

And remember: "If you're not having fun, they win!"

w w w . b i l l b o a r d l i b e r a t i o n . c o m

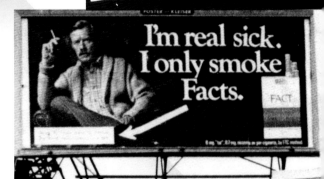

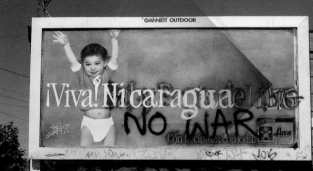

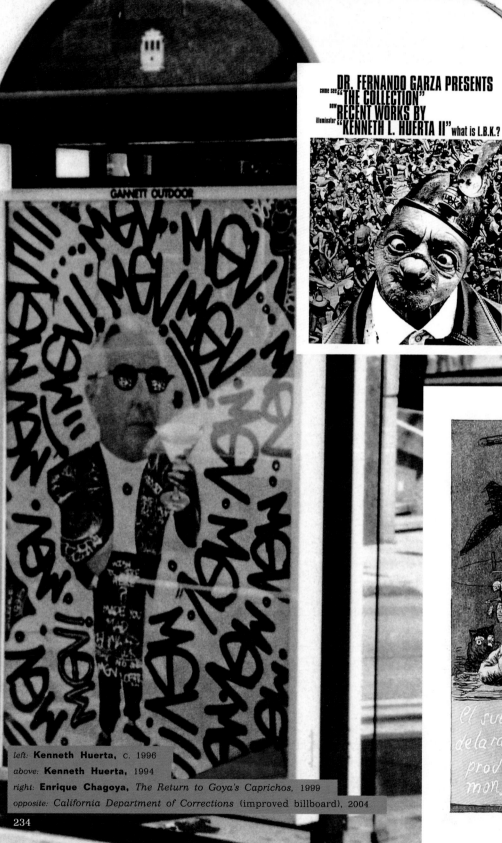

Kenneth Huerta was a **BURNING STAR** IN THE MID-NINETIES. His tags and posters flooded the city walls. To go anywhere with him was to be accomplice to a dozen acts of vandalism. At that time he, along with a few other artists, had obtained the method of opening the illuminated bus-shelter advertising boxes and were making regular interventions in the stream of corporate discourse. It's easy: you just take a poster home, correct it, and put it back. These ideas are in everybody's heads, as the Situationist International used to say.

Aaron Noble

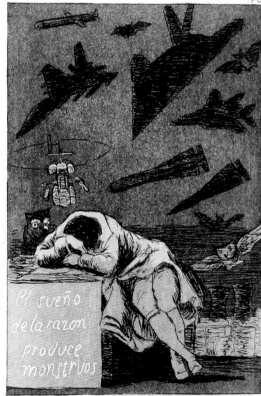

left: **Kenneth Huerta,** c. 1996
above: **Kenneth Huerta,** 1994
right: **Enrique Chagoya,** *The Return to Goya's Caprichos,* 1999
opposite: *California Department of Corrections* (improved billboard), 2004

THE SLEEP OF REASON

ANNICE JACOBY

WE HAVE all seen it. The man putting his head down on the desk, too weary to attend to business, while bats and owls storm the sky. Goya was drawing his nightmares on copperplate 43 of *Los Caprichos*. His inscription, *El sueño de la razon produce monstrous*, translates to "The sleep of reason produces monsters." Goya's contempt was fed by the suppression of the Enlightenment, the greed in society, and the ravage of ongoing wars.

Two centuries after Goya, the Sleep of Reason snoozes on. Enrique Chagoya, known for his appealing paintings steeped in pungent mockery of American icons, sees Goya as "someone who's very frustrated with his times, someone who's very angry with his society. I just wish I could have met him." Chagoya's *The Return to*

Goya's Los Caprichos exploits the painfully easy historical sweep, morphing the birds into tomahawk jets. "Imagine Baghdad under fire," Chagoya says, "and you don't know where to hide for a whole night, weeks, months, years. That's worse than any bat or devil. We're worse than any devil cheating you to get your soul to Hell. That's Hell. That's the sleep of reason today."

False security can be added to the list of transgressions. Credit cannot be established for the crew that improved the mattress billboard campaign on Valencia to protect the brave from special Homeland Security attention. The homage to Goya, stamped with the Homeland Security Seal, reminds those awake that monsters metastasize while we take a cozy nap in the sky.

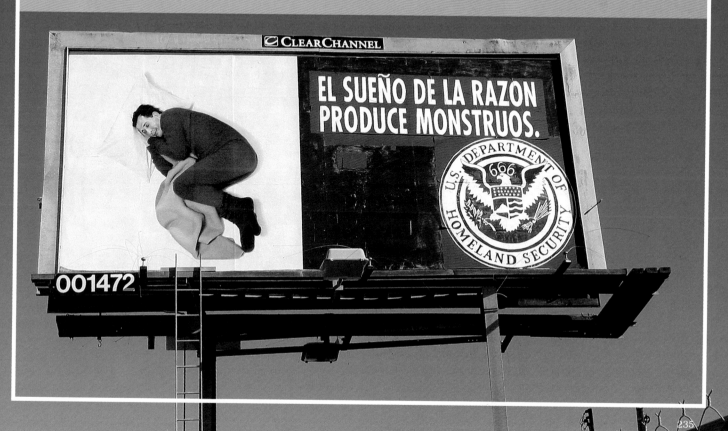

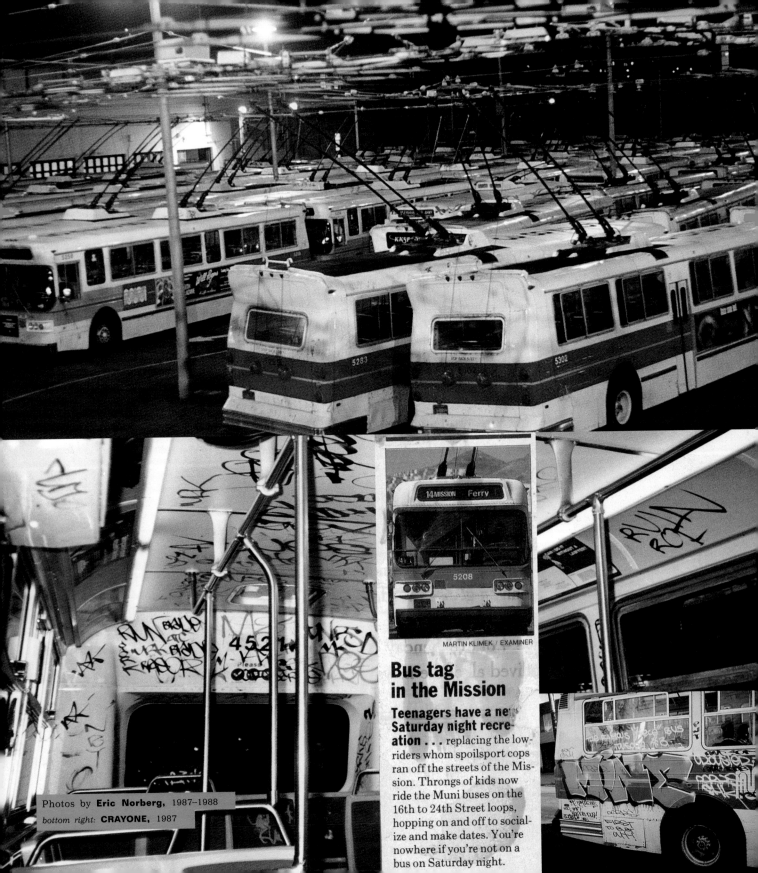

MARTIN KLIMEK / EXAMINER

Bus tag in the Mission

Teenagers have a new Saturday night recreation . . . replacing the lowriders whom spoilsport cops ran off the streets of the Mission. Throngs of kids now ride the Muni buses on the 16th to 24th Street loops, hopping on and off to socialize and make dates. You're nowhere if you're not on a bus on Saturday night.

Photos by **Eric Norberg,** 1987–1988
bottom right: **CRAYONE,** 1987

Build and Destroy (BAD)

Eric Norberg

Graffiti is scribbling on a wall. I don't scribble.
TRUE 222
Graffiti is not an international crime, it is worldwide gathering.
DREAM TDK

Translating graffiti culture and idioms can be DANGEROUS business.

A teacher overhears two students talking about *bombing* the bridge downtown. It turns out to be code talk for a popular graff spot, but not before ringing alarm in the teacher's mind. The language of the graff *writer* is confusing. *Bomb, destroy,* and *piece* take on potent insider meanings. In the era of fear propped up by the War on Terror, this twisting of language is increasingly threatening to the status quo. *Aerosol artist, spray-can artist, alphabet stylist, subterranean guerrilla,* or even *abstract social realist*—the writer is self-defined.

A *hit-up,* a visual takeover, is rooted in rebellion. Why do people *hit up*? Most writers tell you their motive is to gain respect from their peers and the appeal of being an outlaw on the streets. They gravitate to graff for fame or going against the grain. Most enjoy disturbing a power structure that is rotten to the core. The history of colonialism (physical, mental, cultural, and economic) has always met creative resistance. Graffiti is part of a healthy continuum of natural, raw expression, a useful social antidote.

Graff writers flex a power of self-determination through language. Graff writing is a signifier of the urban non-white vernacular: Spanglish, Chinglish, pidgin, patois, Ebonics, and other intentional "substandard" English. It is purposefully raw, unchained, and unapologetic. Standard English is jolted around by graffiti's audacity to reconstruct its pillars: the letters that form words. Add the writer's signification and inflection and you have a metaphysical phenomenon that transcends race and class. A liberating state of being is achieved because the *getting-up* lifestyle exists outside of deadening convention. Graff writing is a violation of private property and directly attacks the power elite of society. This is dangerous to the system because graff breeds graff.

As for me, writing was (and still is) a strong alternative to gangs, violence, drugs, and other unproductive activity. Graff writing saved my life. My love for it has also almost taken my life. Graff was my vehicle to channel energy and ideas, deal with frustrations, create community, and build my own strengths. How can I possibly explain what it is to those who have never done it? The feeling after hitting up on a city wall in the middle of the night and evading the cops is thrilling.

As a kid, I was fascinated by the superhuman qualities of the animated Letterman character on PBS's Electric Company. Sesame Street also featured a man who would go around the city with a paint bucket and a brush, putting a single letter character on surfaces to teach the letter of the day. The act of joining letters to make the word and apply it to a public surface can be liberating as well as forcefully intrusive. Cursive penmanship studies in third grade provided me with structural letter foundations, and *cholo placas* hit up around the neighborhood gave me another way to construct the pillars of the written word. So when North Philly/New York hip-hop writing and culture planted its seed in the Bay Area (1983–1984), via the film *Style Wars* and the book *Subway Art,* I already had an introduction to letter, line, and form.

In barrios like the Mission District, distinctive Chicano *cholo* writing, called *placas,* spoke the names of local kids and teens, and asserted the existence and experience of a people surviving in Amerika, in occupied Aztlán (the ancestral Aztec territory of Northern Mexico, which was stolen by the United States). *Cholo* writing implies *La Raza.* The heritage of style in these hand scripts, some of which go back to the 1930s, very much influence the hard-edged rigidity of today's West Coast graff writing. With derivations of Old English script, *cholo* writing is squarish, sometimes with triangle letterforms that can have either a

237

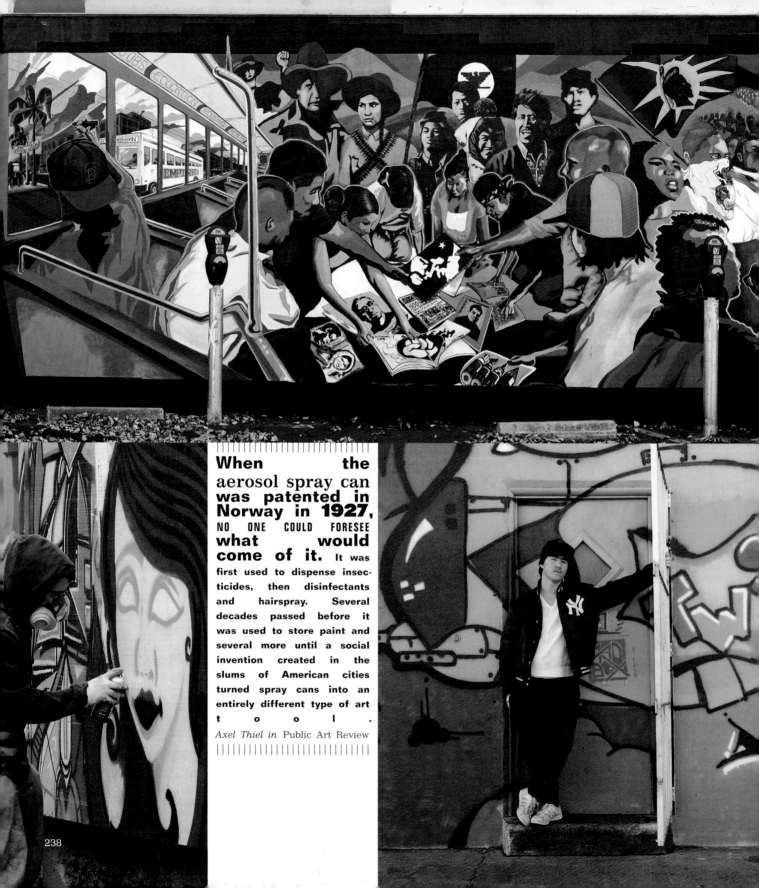

When the aerosol spray can was patented in Norway in **1927**, NO ONE COULD FORESEE what would come of it. It was first used to dispense insecticides, then disinfectants and hairspray. Several decades passed before it was used to store paint and several more until a social invention created in the slums of American cities turned spray cans into an entirely different type of art t o o l .

Axel Thiel in Public Art Review

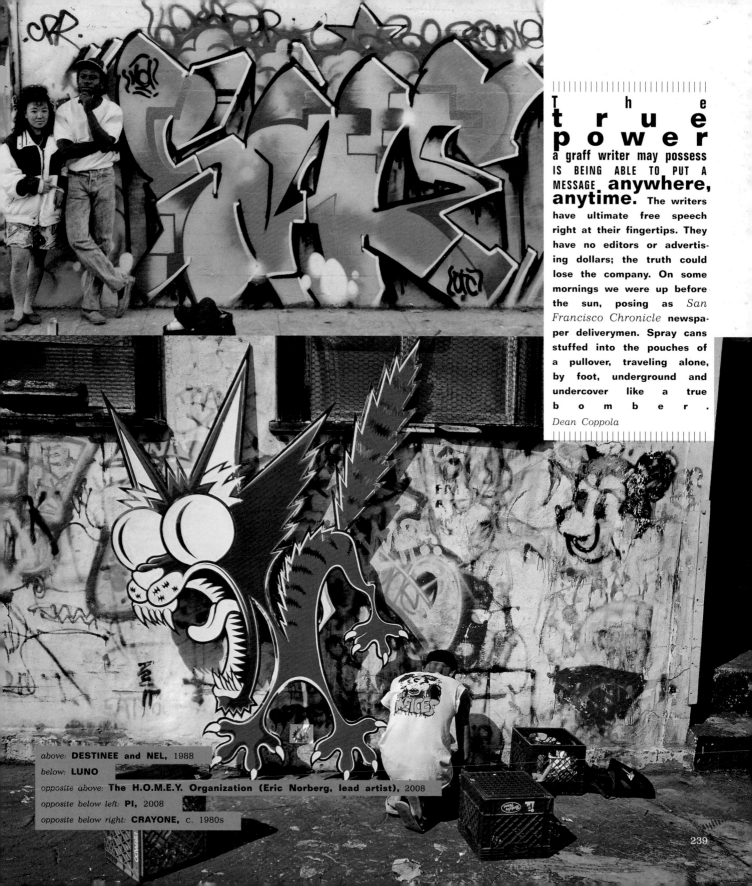

The **true power** a graff writer may possess IS BEING ABLE TO PUT A MESSAGE **anywhere, anytime.** The writers have ultimate free speech right at their fingertips. They have no editors or advertising dollars; the truth could lose the company. On some mornings we were up before the sun, posing as *San Francisco Chronicle* newspaper deliverymen. Spray cans stuffed into the pouches of a pullover, traveling alone, by foot, underground and undercover like a true **b o m b e r .**

Dean Coppola

above: **DESTINEE and NEL,** 1988
below: **LUNO**
opposite above: **The H.O.M.E.Y. Organization (Eric Norberg, lead artist),** 2008
opposite below left: **PI,** 2008
opposite below right: **CRAYONE,** c. 1980s

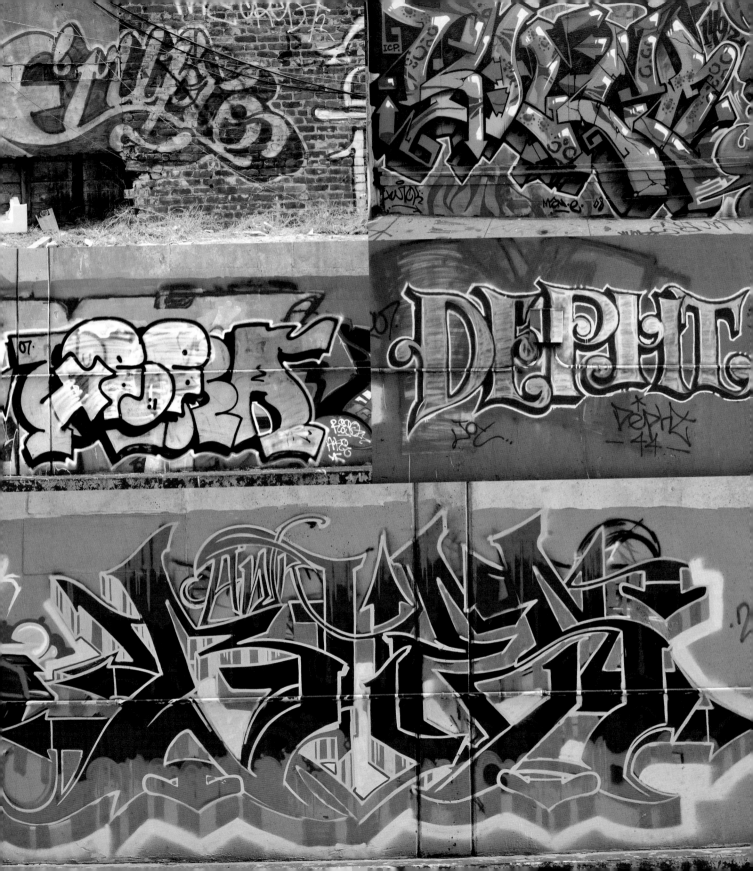

structured lean or a straight and blocky stance. The territorial gang fonts are unique to each area and may mix numbers, backward letters, and vertical, left-to-right combinations. *Cholo* script forms are instantly recognizable—like Egyptian hiero-glyphs, Chinese characters, Celtic scrolls, and medieval illumi-nated manuscripts—and can exhibit a direct lineage to Aztec glyphs and symbolism. // //

By the time I was in middle school, the hip-hop movement was commanding my generation to bust out and get loose. Defining one's own identity was where it was at. Legendary RIF RW (Reckless Writers) is credited with jumpstarting elaborate signature hit-ups all around San Francisco and Daly City in 1983. The next year CUBA did the first *piece* (colorful, filled-in stylized letters) in San Francisco. By 1985 PENGO, NED 2PM (2 Piece Makers), WOD (Writers of Doom), DAZEL, ZINC, QUEST, TINY, ZEST, and FURY DA (Def Artists) had work all around the Mission. Hit-ups were seen on back alleys, underpasses, rooftops, and numerous "secret spots." Spray-painted signatures turned to elaborate multicolored pieces with interweaving bars, and bigger and big-ger *burner* productions developed. Competitive battles between writers brought out unique letter styles and inventive painting techniques. Crews TWS (Together with Style) and TMF (Too Much Funk) were the most famous. // //

San Francisco Transit experienced its share of signature tags and multicolored pieces. ENUF BVD (Black Vandals Destroy) had two color *throw-ups* (quick piecing style) on numerous metro trains. SPECKS smacked the first full-color piece on a metro car. DARKS, MOST, VERSE, and many others were bombing buses with throw-ups. CRAYONE and STYLS TWS had full-color pieces on articulated buses. MAN 45, NORM, RISQUE, DREAM, and QUEST did too. Graff writers crept into the bus yards at night and gathered fame by day. The fourteen Mission lines were home to hundreds of them. //////////////////// //

The dynamics of the crew filled the void that school failed to fill—sharing passions, ideas, camaraderie, and trust. Multimember, multiethnic, multitalented crews with acronyms like KGB (Krylon Graffiti Bombers), WOD (Writers of Doom), GF (Graffiti Funk), KSUN (Kan't Stop Us Now), OTC (Out to Crush), ROT (Reign of Terror), and HNR (Hit-n-Run) bus-hopped around the city testing out newly acquired markers. In the process, they broke down territorial gang boundaries. // // //

We *racked* (appropriated without asking) paint until spray was under lock and key by law. We made markers out of blackboard eras-ers or felt stuffed inside an empty deodorant container. We put food coloring into bottled liquid white shoe polish to create opaque, pastel-colored, foamy "mop" hit-ups on the bus win-dows. Writers created two-tone Streaker pens by razor-cutting the length of colored sticks and sandwiching the new combina-tion back into the plastic housing—turquoise with black, peach with brown, blue with orange combinations. Kids invented their own color and design theory in the back of the bus. /////////// // //

This art form, created by inner-city youth, developed into a whole culture. The break beat of the DJ's turntables supported the uprockin', lockin', poppin' break dancer, and the rappin' acro-batics of the MC's rhymes took visual form in the style of the graffiti writer. A common thread of youth expression, from the punk rocker to the skateboarder, is embodied within a can of spray or a fat marker. //

above left: **ERUPTO** (photo 2008)
above right: **TWICK** (photo 2008)
middle left: **Artist unknown** (photo 2008)
middle right: **DEPHT,** 2007
below: **BLES AWR** (photo 2008)

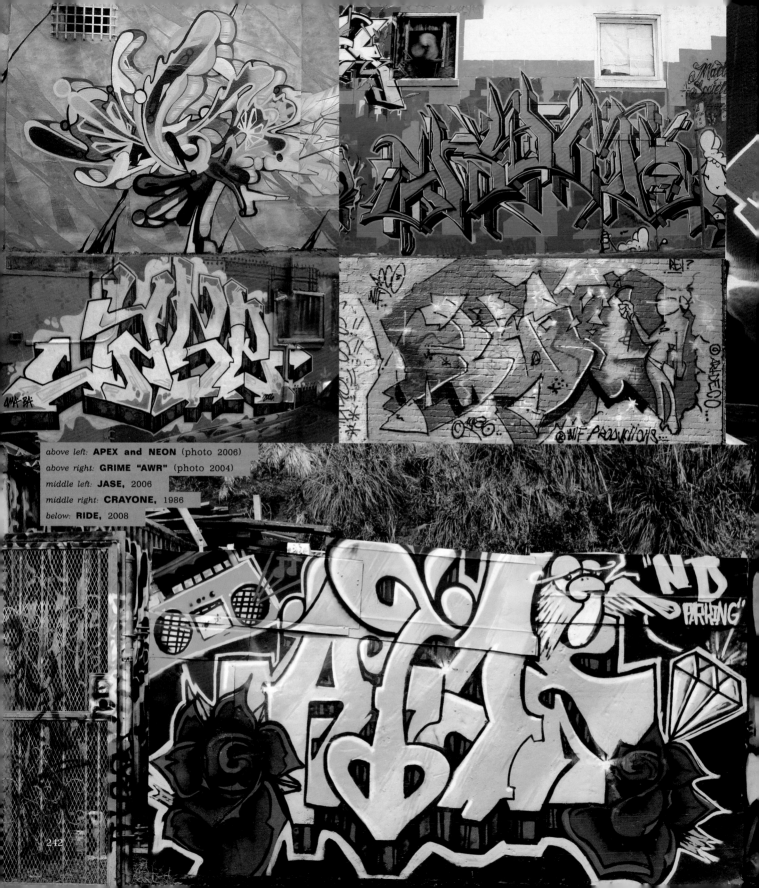

above left: **APEX and NEON** (photo 2006)

above right: **GRIME "AWR"** (photo 2004)

middle left: **JASE,** 2006

middle right: **CRAYONE,** 1986

below: **RIDE,** 2008

242

GRAFFITI WRITING
APEX

GRAFFITI writing was never meant to be understood by the outside world. This art form was created for the sole purpose of self. A selfish act that included other selfish people, that resulted in a community. This community started its own rules for letters, and all letters had to be original. They generally speaking did not copy a typeface (font) to do their work. Since writing started with writing your name, much like a signature, each piece was unique. Within the community there were standouts, and people started to copy what they were doing. In this process, different letter families formed a street font. Studying the street fonts is the groundwork for understanding many of the works of art. This knowledge has been passed to younger generations through a master/teacher format, allowing for the details of the writing to be understood only by other writers and not outsiders. Now that this community has grown older, some artists are changing their selfish view. They would like outsiders to understand their work, resulting in a bloom of interest in street art that some say is killing it. Can something good stay underground forever?

Eye candy.
Creative destruction. The name of the game is to put your name on something.
APEX

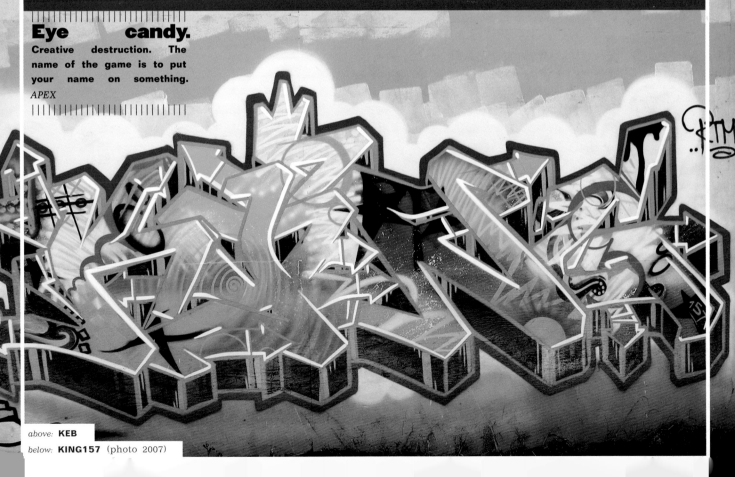

above: **KEB**
below: **KING157** (photo 2007)

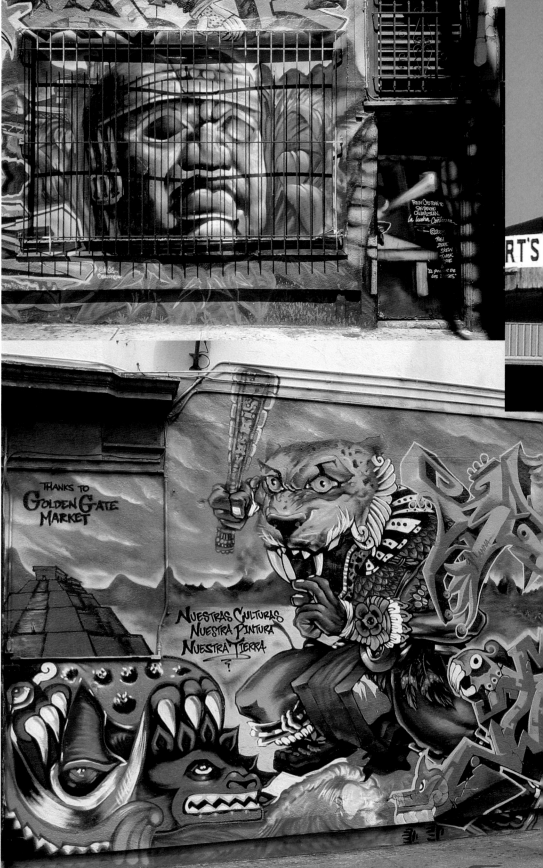

IN A WEEK'S TIME, IN **July 2003, a remarkable aero-sol piece** WAS PAINTED AT THE **Golden Gate Market.** Five urban artists (RAFA, ZORE, SKEW, TWICK, SPIE) and a traditional painter of Mission storefronts (dubbed EL PINTOR DE LOS DIOSES by the other artists) blended styles and histories. Their title, *Nuestras culturas, nuestra pintura, nuestra tierra,* was chosen to respect the existing mural, by Ernesto "Cruising Coyote" Paul, his son, and other area youth. SPIE estimates that 80 percent of the 2003 mural was "done freestyle" in a "spontaneous creative outpouring" and interplay with traditional Mesoamerican art. EL PINTOR DE LOS DIOSES was watching the graff writers at work and was invited to join. It was his first time with aerosol. He contributed the montage of pre-Columbian elements in the lower left corner: a reptile eye glyph, water symbols, a jaguar paw, and a stylized version of the head of the feathered serpent from Teotihuacán.

Ruben C. Cordova

RAFA, ZORE, SKEW, TWICK, SPIE, and El Pintor de los Dioses, *Nuestras culturas, nuestra pintura, nuestra tierra,* 2003

opposite above: **HEART 101,** *No More Prisons,* 1999

opposite below: **TWIST (Barry McGee)** (photo 1991)

Go up
huge.

"How the fuck did they do that?" That's the approach I'm going for.

NORM

In **1999** GRAFFITI WRITERS NATIONWIDE **spray painted the message "No more Prisons"** in bold letters on sidewalks, mall walls, and industrial buildings. "This is the first ever nationwide political graffiti campaign," said one writer from New York City who wished to remain anonymous. "The prison system is making a profit by locking up our people for nonviolent offenses. We're going to send the message that this madness needs to stop. Our generation is going to stop the prison industry the way the hippies stopped the Vietnam War."

Anonymous graffiti artist

I started in 1984. I was severely into riding scooters and stuff. I was loosely a mod. There's this guy we'd go riding around with, and he would stop at all the stoplights and do this dead design and write "Zotz." I thought, What are you doing? He introduced me. My drawings come from things I see on the streets, like a man passed out. I saw this guy drawing on his face with a ballpoint pen, and he was doing it for hours. It's the kind of thing that inspires me. It's extreme, super sad, but humorous. You want to look but you don't want to l o o k .

TWIST

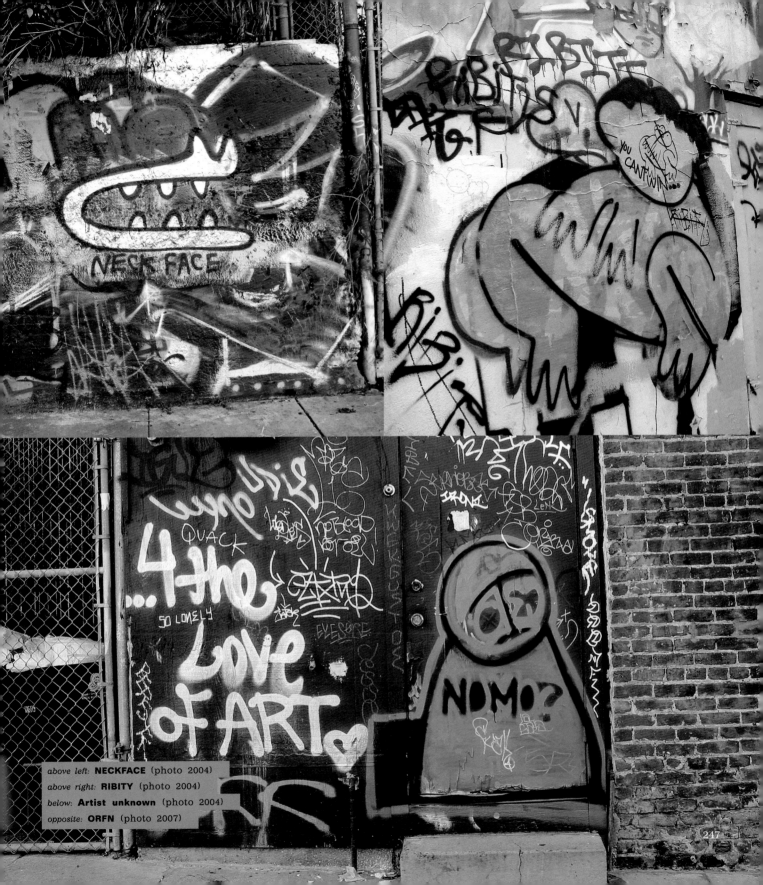

above left: **NECKFACE** (photo 2004)

above right: **RIBITY** (photo 2004)

below: **Artist unknown** (photo 2004)

opposite: **ORFN** (photo 2007)

247

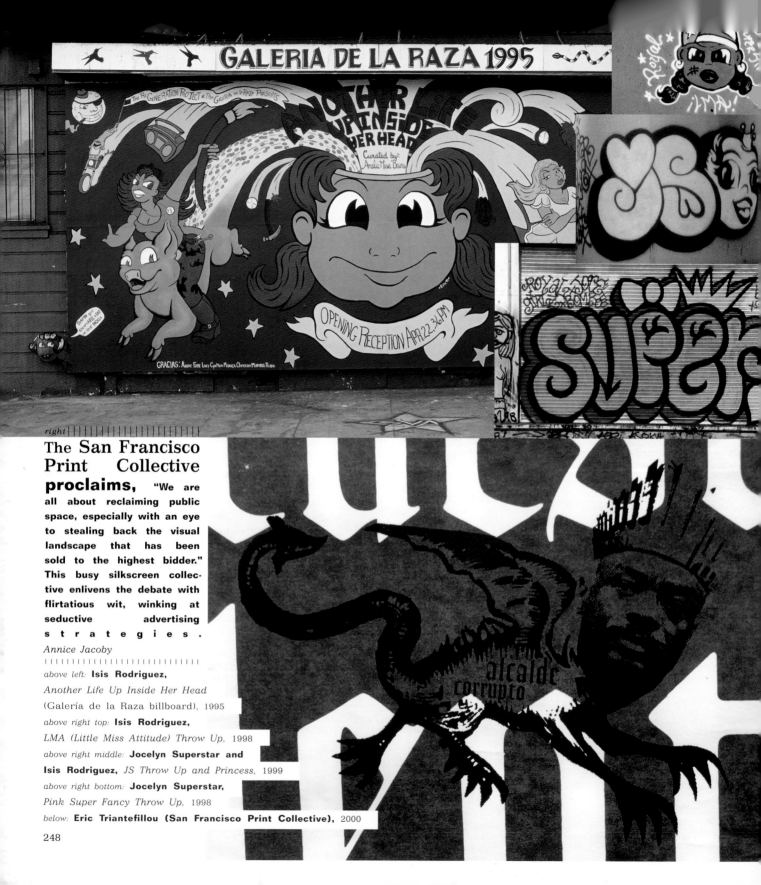

GALERIA DE LA RAZA 1995

The San Francisco Print Collective proclaims, "We are all about reclaiming public space, especially with an eye to stealing back the visual landscape that has been sold to the highest bidder." This busy silkscreen collective enlivens the debate with flirtatious wit, winking at seductive advertising strategies.

Annice Jacoby

above left: **Isis Rodriguez,**
Another Life Up Inside Her Head
(Galería de la Raza billboard), 1995
above right top: **Isis Rodriguez,**
LMA (Little Miss Attitude) Throw Up, 1998
above right middle: **Jocelyn Superstar and**
Isis Rodriguez, *JS Throw Up and Princess,* 1999
above right bottom: **Jocelyn Superstar,**
Pink Super Fancy Throw Up, 1998
below: **Eric Triantefillou (San Francisco Print Collective),** 2000

248

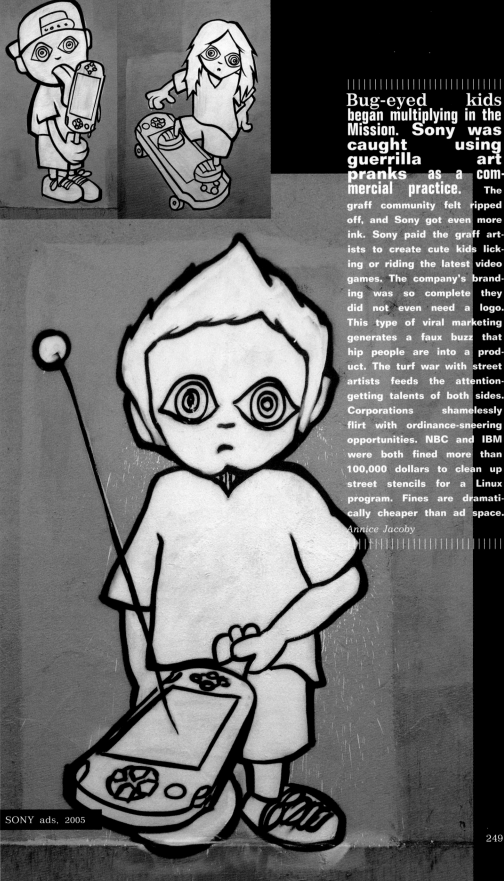

MY MOMENTS WITH GRAFFITI **have been spon-taneous** and COSMIC. I met graffiti artist Nicole Repack, also known as Jocelyn Superstar, **in 1997 at a famous tagging spot called the "Florida Walls" in the Mission District. I had done a throw-up of a mean kitty with my tag name LMA** (Little Miss Attitude)**, and Nicole** side-busted me with the words, "Yo! Isis, we need to get together. PS I love you." That might sound a little cheesy to you, but at that time Jocelyn Superstar was making waves in the graff community with her side-busting technique, which questioned public space and challenged graffiti's mostly male-dominated rules. From my perspective, saying cheesy, sentimental things to people was a brilliant, dis-ruptive bug repellent for the boys' club. I was eager to meet this irreverent bomber. During our first time together, we didn't waste time bomb-ing and practicing our can technique. Instead, we went to an abandoned parking lot in Potrero Hill and embarked on an all-nighter, working on a piece called *Super Attitude,* seven feet high and fifty feet wide. That night was so magical. We began at mid-night with a full moon that kept our wall lit as we qui-etly worked to the sound of spray cans. As the sun was coming up, we finished our purple piece without any hassles from the cops.

Isis Rodriguez

SONY ads, 2005

Bug-eyed kids began multiplying in the Mission. Sony was caught using guerrilla art pranks as a com-mercial practice. The graff community felt ripped off, and Sony got even more ink. Sony paid the graff art-ists to create cute kids lick-ing or riding the latest video games. The company's brand-ing was so complete they did not even need a logo. This type of viral marketing generates a faux buzz that hip people are into a prod-uct. The turf war with street artists feeds the attention-getting talents of both sides. Corporations shamelessly flirt with ordinance-sneering opportunities. NBC and IBM were both fined more than 100,000 dollars to clean up street stencils for a Linux program. Fines are dramati-cally cheaper than ad space.

Annice Jacoby

THE STENCIL GODFATHER OF THE MISSION

AARON NOBLE

THE DIFFICULTY in evaluating Scott Williams's painting lies in penetrating the overgrown tangle of signs with which he has attempted to cover as many fragments of the world as possible. I say *painting* rather than *paintings* because Scott is as unmoved by the presence of an edge as he is indifferent to the material of the support. He has covered cars, furniture, restaurants, his entire apartment, and a good chunk of the Mission with stencils. One work flows into another, driven by Scott's *horror vacui.* Each work is a reorganization of images from a common, ever-expanding pool.

For more than two decades, Williams has been accumulating an encyclopedic image file organized by simple types: monkeys, cowboys, buildings, machines, etc. From this image bank he has cut thousands of lacy, intricate stencils, which have been exhibited as works of art in their own right. The stencil/spray-can combination is normally valued as a guerilla technique of speed and graphic economy. Williams instead builds up complex, painterly layers, shifting stencils off register and respraying in a different shade, employing optically disorienting patterns and color combinations while

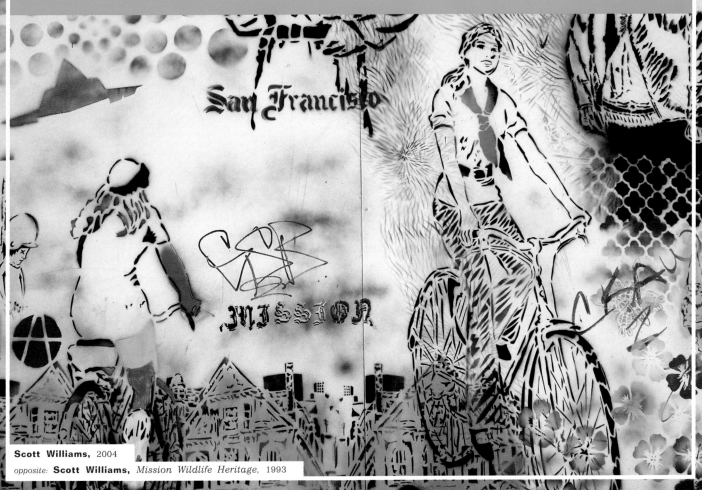

maintaining an ambiguous authorial tone poised somewhere between pop and paranoia.

This black, satirical, dislocated tone is characteristic of a generation of San Francisco artists who came of age in the eighties using collage as a privileged technique for challenging the solidity of consensus reality. Craig Baldwin, Winston Smith, Julie Murray, Negativland, Survival Research Laboratories, and many others created punk-inflected works that carried the subversive influences of William Burroughs, Philip K. Dick, Bruce Conner, and Jess. Scott deflects questions about his intentions with the most mundane comments imaginable: "Oh, that was just lying around, but Carla said, 'Are you going to cut that?' so I did." He quotes Rauschenberg: "My paintings are about the world, not about me." And the world is not as it seems.

Scott Williams, 2004
opposite: **Scott Williams,** *Mission Wildlife Heritage,* 1993

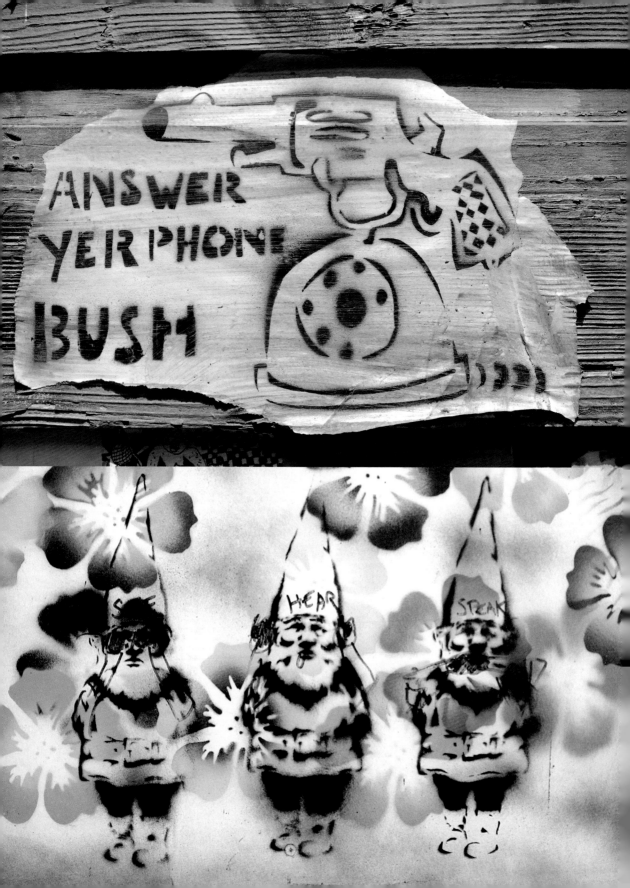

THE ART OF NEGATIVE SPACES

RUSSELL HOWZE

A NEWLY discovered country exists without borders, leaders, and ironclad laws. Its citizens carry no official identification except possibly the paint stains on clothes and hands or a camera stand as informal documents of citizenship. To become a member of this nation, one only has to think up an idea, put it on a piece of paper, cut it out, and paint it somewhere.

Finding modern stencil art peppered throughout the Mission wouldn't surprise a Tehuelches tribesman from 1000 B.C. South America. One could argue that the use of negative space to create an image in a public location may be as old as making fire and knocking bones together to make music. San Francisco's Mission District has been home to stencil art since at least the 1980s. When I arrived here in 1997, I found many stencils in various states of fading away. This impermanence compelled me to create historical documents of the public stencil work. So today, thousands of photographs later, the cave stencil's urban ancestor holds its own as a testament to creating a language that may one day perplex future observers much like the hand stencils from another era perplex us.

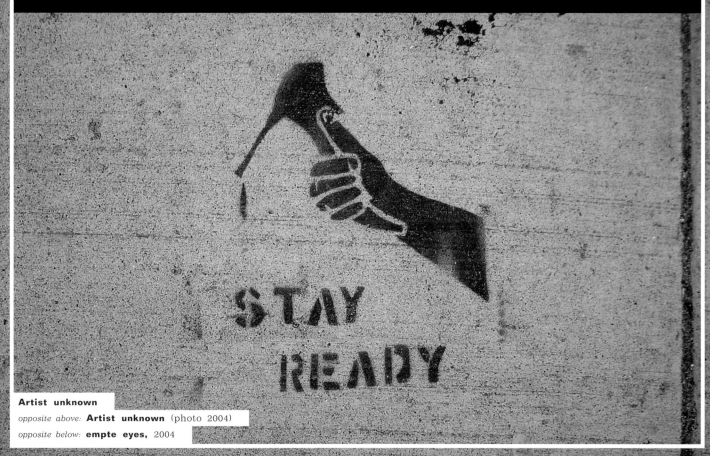

Artist unknown

opposite above: **Artist unknown** (photo 2004)

opposite below: **empte eyes,** 2004

HELL IN PLAYLAND

CLAIRE BAIN

AS INVENTIVE and sarcastic as Saul Steinberg, as politically lacerating as Daumier—Andrew Schoultz, Sirron Norris, and Aaron Noble use cartoon techniques to frame apocalyptic visions. By exploiting cuteness and humor to communicate pathos, they depict hell in playland. In Noble's case, the defeated invincible is a thumb-sucking Batman. Their sleek, stylized imagery coyly conveys dark, underlying meaning, like Dalí's stretched objects and the Surrealists' hybrid creatures that combine humans, animals, buildings, and machines. The murals at Norm's Market and Lexington Street portray corrupt society in the manner of Flemish painters Pieter Bruegel the Elder and Hieronymus Bosch. Like the work of the Surrealists, Bosch, and Dr. Seuss, they warp space and species. Seussian elements—the character of the line work, the depiction of buildings, and the precarious feeling of movement—are affectionately quoted.

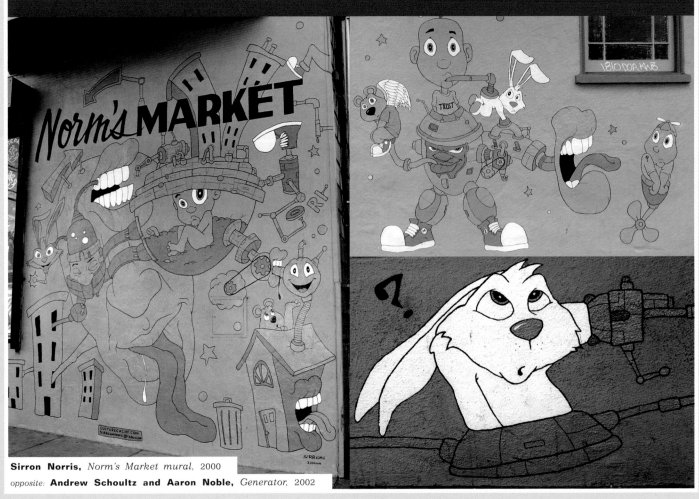

Sirron Norris, *Norm's Market mural,* 2000

opposite: **Andrew Schoultz and Aaron Noble,** *Generator,* 2002

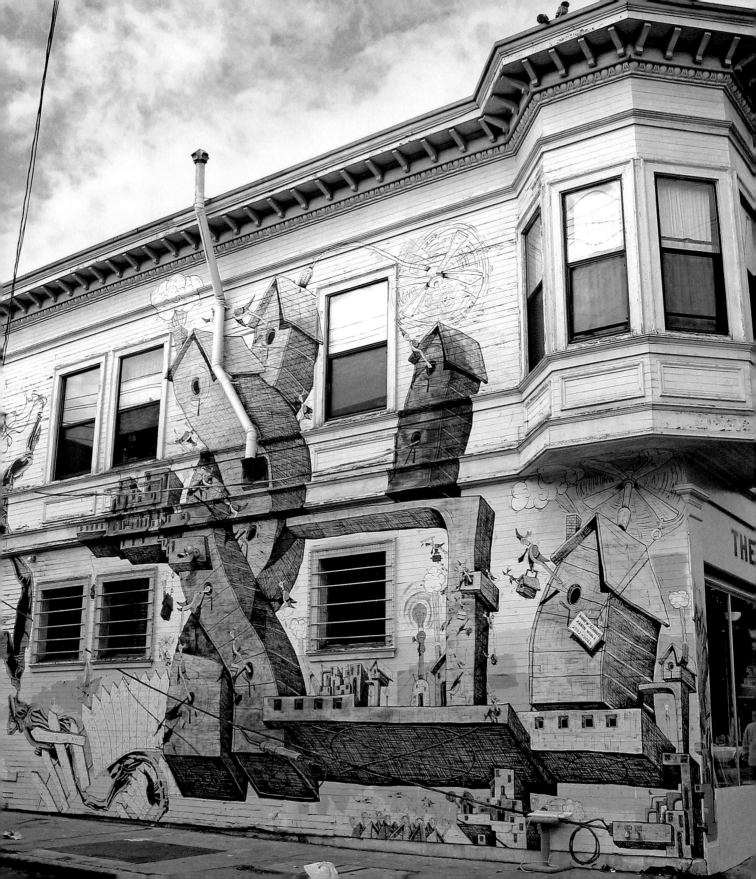

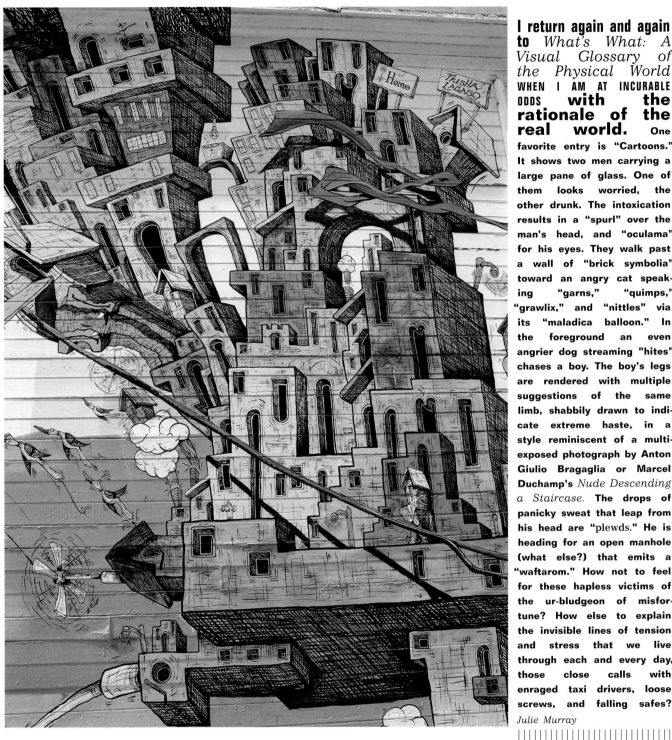

I return again and again to *What's What: A Visual Glossary of the Physical World* WHEN I AM AT INCURABLE ODDS **with the rationale of the real world.** One favorite entry is "Cartoons." It shows two men carrying a large pane of glass. One of them looks worried, the other drunk. The intoxication results in a "spurl" over the man's head, and "oculama" for his eyes. They walk past a wall of "brick symbolia" toward an angry cat speaking "garns," "quimps," "grawlix," and "nittles" via its "maladica balloon." In the foreground an even angrier dog streaming "hites" chases a boy. The boy's legs are rendered with multiple suggestions of the same limb, shabbily drawn to indicate extreme haste, in a style reminiscent of a multi-exposed photograph by Anton Giulio Bragaglia or Marcel Duchamp's *Nude Descending a Staircase.* The drops of panicky sweat that leap from his head are "plewds." He is heading for an open manhole (what else?) that emits a "waftarom." How not to feel for these hapless victims of the ur-bludgeon of misfortune? How else to explain the invisible lines of tension and stress that we live through each and every day, those close calls with enraged taxi drivers, loose screws, and falling safes?

Julie Murray

above: **Andrew Schoultz and Aaron Noble,** *Generator,* 2002
below: **Andrew Schoultz,** 2001
opposite: **Andrew Schoultz and Aaron Noble,** *Generator,* 2002

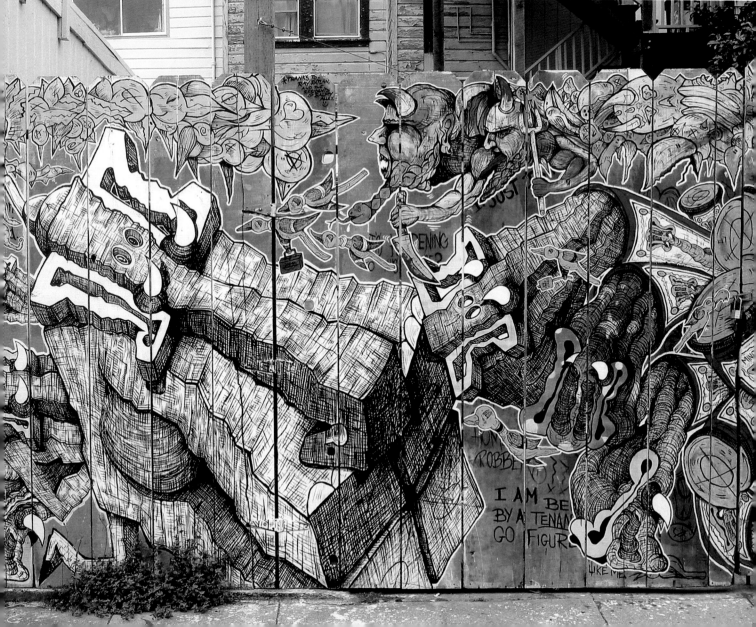

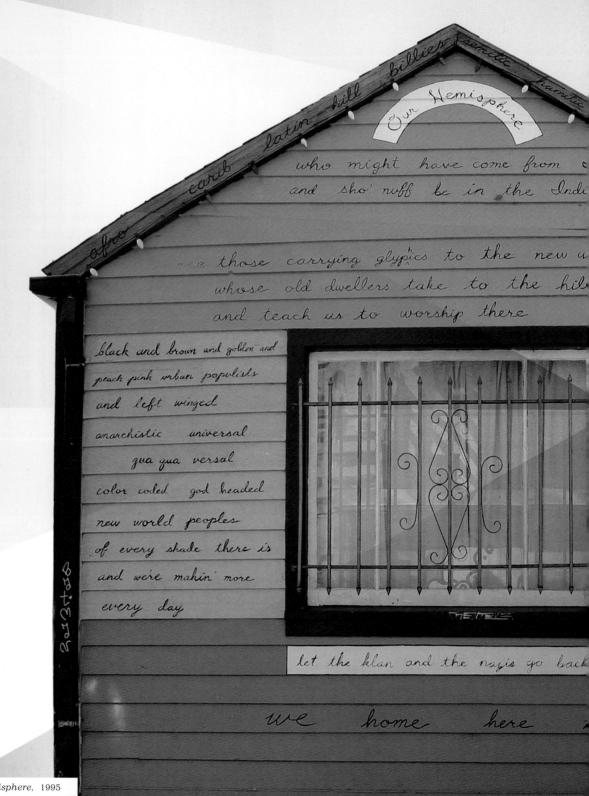

Our Hemisphere

semitic
billies
hamitic
hill
latin
carib
afoo

who might have come from
and sho' nuff be in the Indi

those carrying glyphics to the new u
whose old dwellers take to the hil
and teach us to worship there

black and brown and golden and
peach pink urban populists
and left winged
anarchistic universal
qua qua versal
color coded god headed
new world peoples
of every shade there is
and we're makin' more
every day

let the klan and the nazis go back

we home here

Aaron Noble, *Our Hemisphere,* 1995

258

Our Hemisphere

afro carib latin hill billies

semitic hamitic semi Dravidian natives

who might have come from India
and sho' nuff be in the Indies here

those carrying glyphics to the new world
whose old dwellers take to the hills still
and teach us to worship there

black and brown and golden and
peach pink urban populists
and left winged
anarchistic universal
 qua qua versal
color coded god headed
new world peoples
of every shade there is
and we're makin' more
every day

a class containing classes
the x's and y's
of manifesting humanities
 be coming
the music of the world

containing all

excluding none

let the klan and the Nazis go back

we home here now

—Q. R. Hand

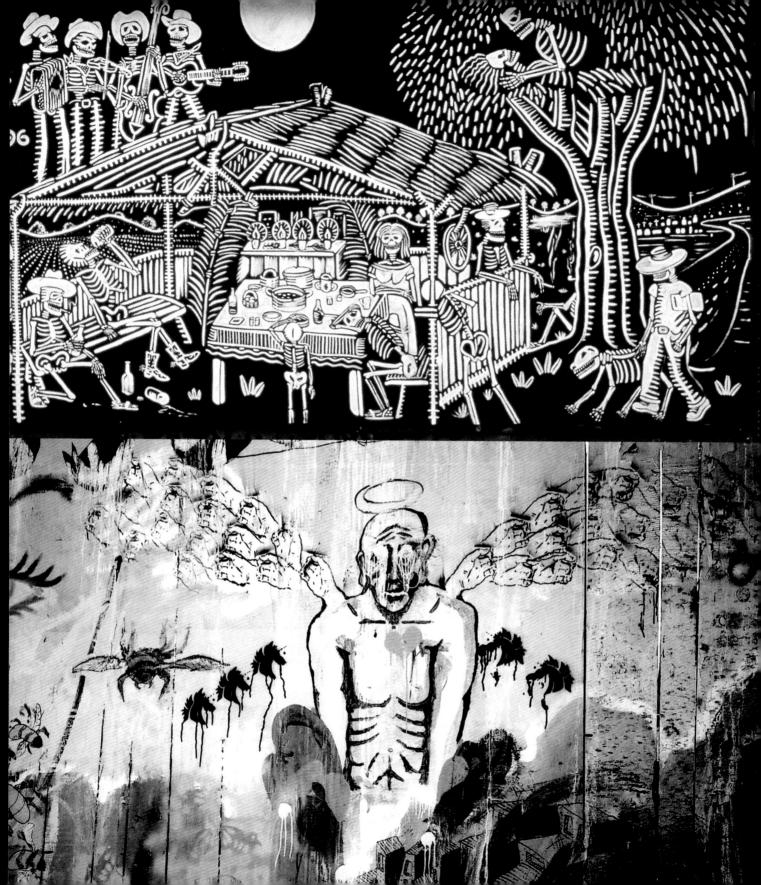

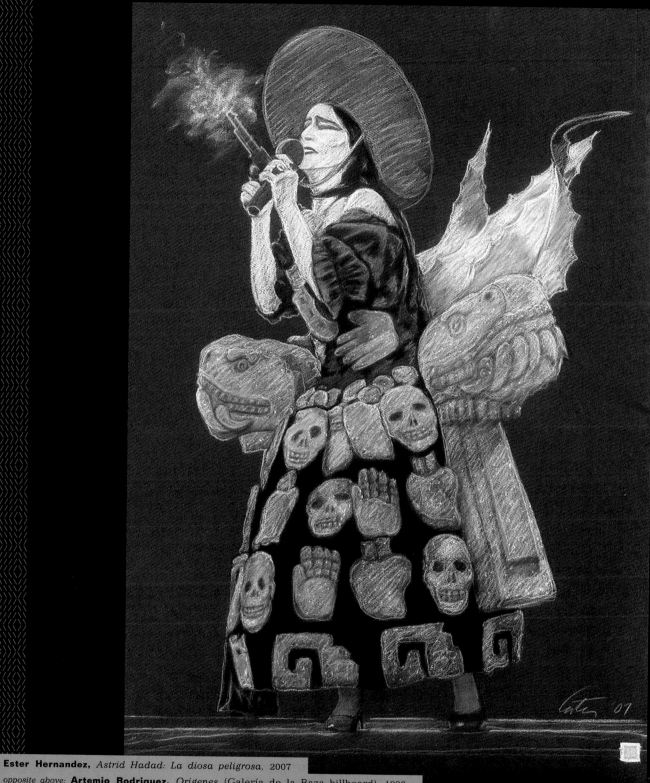

Ester Hernandez, *Astrid Hadad: La diosa peligrosa,* 2007
opposite above: **Artemio Rodriguez,** *Origenes* (Galería de la Raza billboard), 1996
opposite below: **Artist unknown** (photo 2007)

left: **Josue Rojas,** 2008 (in progress)
right: **Artist unknown**
opposite: Photo by **Keith Holmes,** c. 1980s

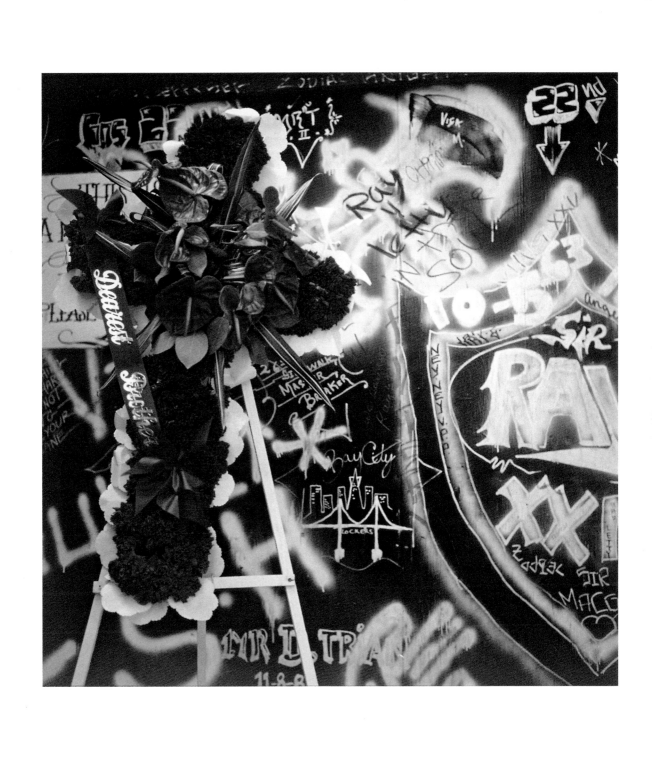

Photo by **Linda G. Wilson**, *Urban Messages: Flowers for Sir Ray*, 1982
opposite: **Susan Kelk Cervantes, Juana Alicia, and Raul Martinez**, *New World Tree*
(detail by Susan Kelk Cervantes), 1987

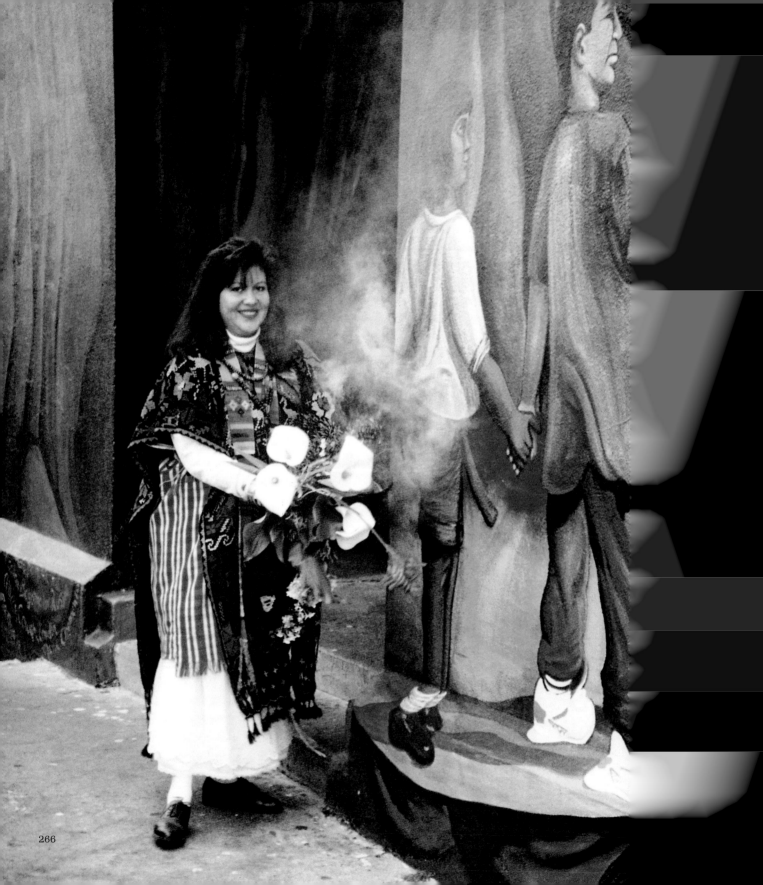

Altaring / Altering

Annice Jacoby

Without SPIRIT, the heart, the hands, eyes, voice, and lips cannot function. Without spirit the heart merely functions as a muscle.

Many in the Mission mural movement are passionately fixing and invigorating that common purpose. Spirit is what ensures that we are not simply going through the motions of day-to-day life, but are living life with meaning and a consciousness of others and the space around us.

The Mission is full of altars, both intimate and monumental. A painted rock, a candle cove, carnations, and deflated Mylar balloons are all signs of loss and love. Many Mission murals are like altars, providing spiritual guidance and illuminating denied histories and ancient legends.

Public art in the Mission primes cultural mythmaking or reverses debilitating stereotypes contained in traditional stories, such as those that portray women and the poor as weak, jealous, or vengeful. Monuments honor Rigoberta Menchú as they trounce Christopher Columbus. Presenting common characters in new ways can change individual and community perceptions. Muralists like Juana Alicia and Isaías Mata constantly reshape cultural consciousness as they reshape public space. They allow women, working people, minorities, and others who have experienced suffering to reenvision themselves as a newer, stronger, more connected, and empathetic cast of characters. The Women's Building mural *Maestrapeace* has attracted a steady feminist pilgrimage from around the world. An extreme example of the mural's potency may be Jaime Cortez's cartoon-punk-lesbian-Latina heroine at the mercy of *Maestrapeace* figures come to life.

The handbook for many in the mural movement in the seventies and eighties was *Toward a People's Art: The Contemporary Mural Movement* by James D. and Eva S. Cockcroft. The book championed a shift in the control of the manufacture of culture. Women were encouraged to participate in the arts and in activities they had previously occupied only in times of need. Creative and social prescriptions were tested famously by women painters in the Mission. The women artists recall the taunts—"It takes strength to wield a paintbrush on a scaffold." Las Mujeres Muralistas co-opted Rosie the Riveter gender-bending propaganda, adding to the upheaval in male dominance in the arts, not just in recognition but also in matters of process, subject, and community involvement. The Cockcrofts and other critics saw the power of the Muralistas' work derived from identification—people recognized themselves, their dreams, or their histories in the paintings. The Cockcrofts write, "The figures in *Latinoamerica* by the Mujeres Muralistas are taken from cultures throughout Latin America shown in traditional clothing; the Muralistas attempt to break down a narrow nationalism which sometimes exists in the multinational Mission District."

These artists have collectively enlivened the notions of pilgrimage, talisman, tapestry, and transformation. They bring issues from the kitchen table to the street. People from around the world arrive at the Women's Building on 18th Street in San Francisco with a devotion of faith, ready to receive the beatific radiance of a three-story high Quiche Mayan peasant woman who won the Nobel Prize. Like women in many cultures these artists create and attend our altars, work from a collaborative model, live and die without much recognition, and provide uplift and evanescent beauty, but carry the violent responsibility of birthing life while calling for peace.

Marta Ayala blessing a new mural, *Keep Our Ancient Roots Alive,* 1993

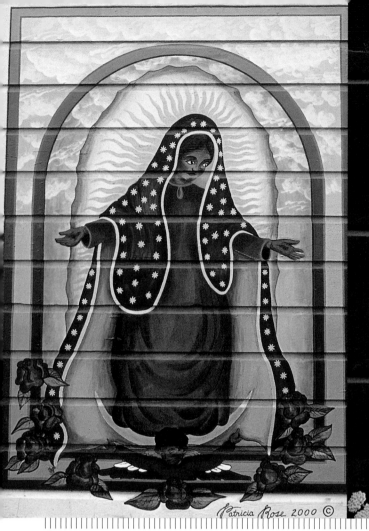

Patricia Rose 2000 ©

Our Lady of Guadalupe IS A **very important figure** in Mexico and throughout Latin America; it was an honor to be asked to paint her in Balmy Alley. In creating her image, I made two design considerations that are not completely traditional. Usually Our Lady of Guadalupe is shown with her hands folded together in prayer and her eyes downcast or closed. I painted her with open eyes looking out over the neighborhood, not missing a thing. I also painted her arms extended in welcome, blessing the community. I took a lot of care painting her hands, to make them as beautiful, strong, and capable as I could. Her loving hands reach out to comfort all, gracing those who have lived here for generations and welcoming newcomers, especially those whose journey to California has been a lengthy odyssey, much more than a simple plane trip.
Patricia Rose

left: **Patricia Rose,** *La Virgencita,* 2000
right: Sidewalk altar, 2008
opposite: **Marta Ayala,** *Manjushri,* 2001

268

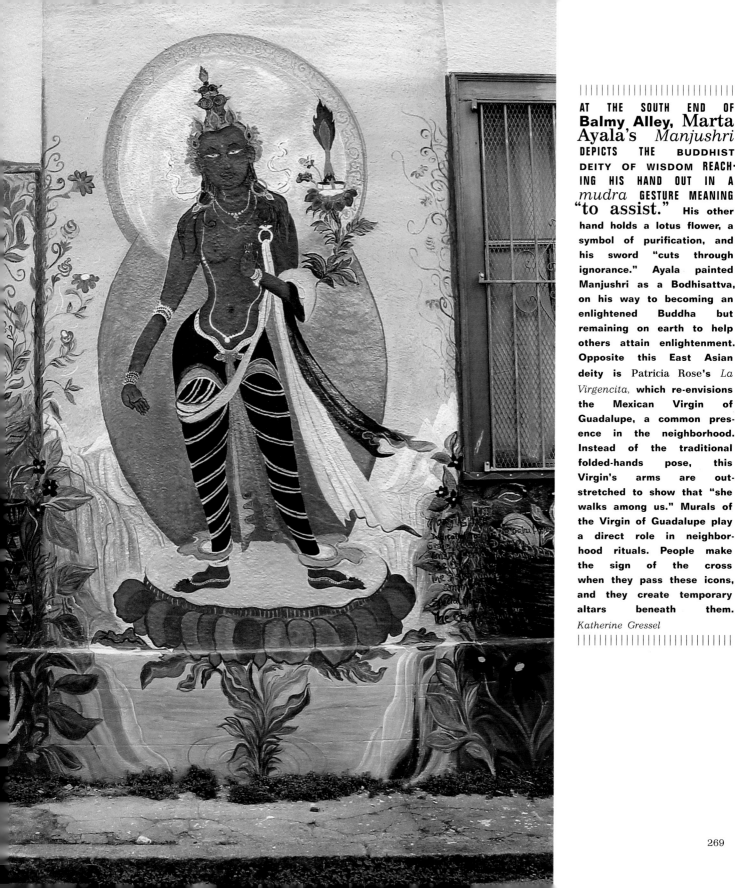

AT THE SOUTH END OF **Balmy Alley,** Marta Ayala's *Manjushri* DEPICTS THE BUDDHIST DEITY OF WISDOM REACHING HIS HAND OUT IN A *mudra* GESTURE MEANING "to assist." His other hand holds a lotus flower, a symbol of purification, and his sword "cuts through ignorance." Ayala painted Manjushri as a Bodhisattva, on his way to becoming an enlightened Buddha but remaining on earth to help others attain enlightenment. Opposite this East Asian deity is Patricia Rose's *La Virgencita,* which re-envisions the Mexican Virgin of Guadalupe, a common presence in the neighborhood. Instead of the traditional folded-hands pose, this Virgin's arms are outstretched to show that "she walks among us." Murals of the Virgin of Guadalupe play a direct role in neighborhood rituals. People make the sign of the cross when they pass these icons, and they create temporary altars beneath them.

Katherine Gressel

269

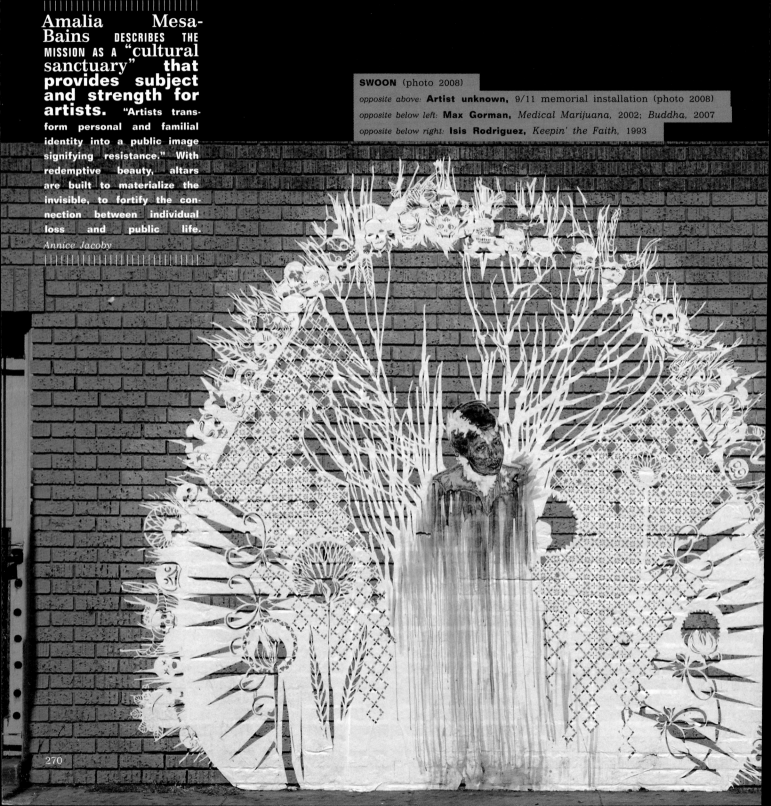

Amalia Mesa-Bains DESCRIBES THE MISSION AS A "cultural sanctuary" that provides subject and strength for artists. "Artists transform personal and familial identity into a public image signifying resistance." With redemptive beauty, altars are built to materialize the invisible, to fortify the connection between individual loss and public life.

Annice Jacoby

SWOON (photo 2008)

opposite above: **Artist unknown,** 9/11 memorial installation (photo 2008)

opposite below left: **Max Gorman,** *Medical Marijuana,* 2002; *Buddha,* 2007

opposite below right: **Isis Rodriguez,** *Keepin' the Faith,* 1993

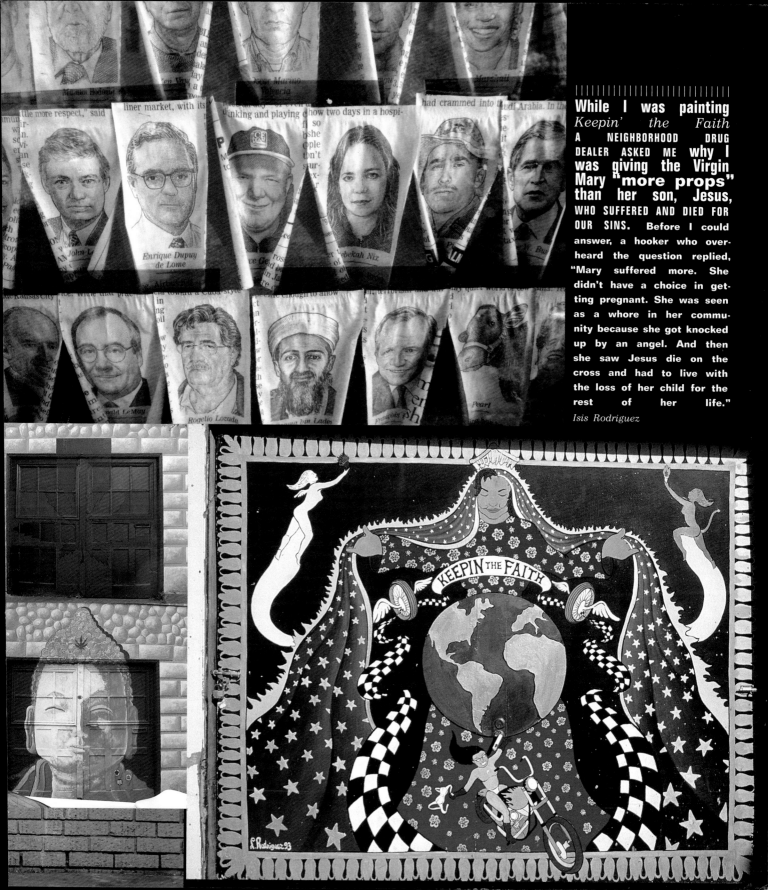

While I was painting *Keepin' the Faith* A NEIGHBORHOOD DRUG DEALER ASKED ME why I was giving the Virgin Mary "more props" than her son, Jesus, WHO SUFFERED AND DIED FOR OUR SINS. Before I could answer, a hooker who overheard the question replied, "Mary suffered more. She didn't have a choice in getting pregnant. She was seen as a whore in her community because she got knocked up by an angel. And then she saw Jesus die on the cross and had to live with the loss of her child for the rest of her life."

Isis Rodriguez

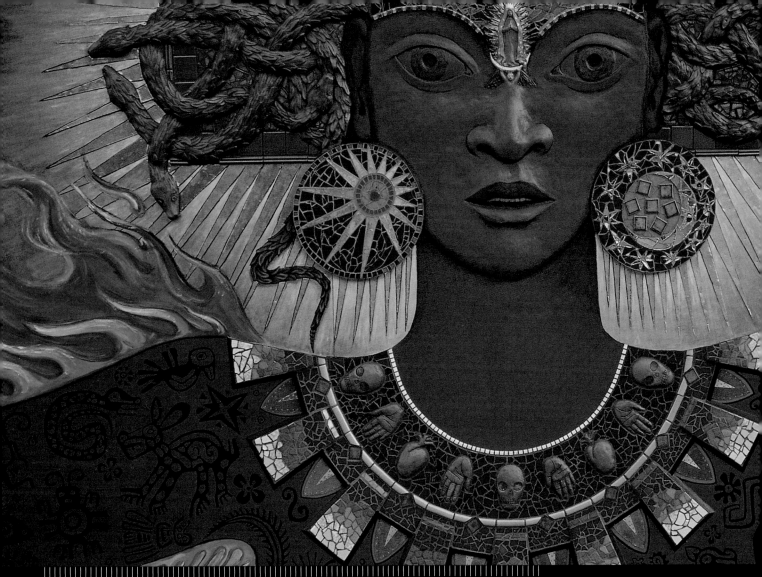

In 1990 I painted a mural ON MY NEIGHBOR'S GARDEN FENCE. The Gaffneys' home is the headquarters of Instituto Pro Musica and Coro Hispano. I wanted to communicate the joy I have experienced while singing the elegiac repertoire of Spanish and Latin American music with these choirs since 1979. "Dios Tonantzin" is a hymn to the Virgin Mary, written in Nahuatl, the language of the Aztecs. My first version of the mural, *La Madre Tonantzin,* did not weather well. As the paint started to flake off and the boards began to rot, Precita Eyes secured funding and brought in Allison Folland to assist in creating a new mural. The 1998 version is very mixed media: the mask and snake headdress are cast resin, the jewelry is glass and tile mosaic, and the rays around the head are sheet copper and brass. Offerings of fruit, flowers, sage, and incense are often placed in front of the wall. On foggy days moisture collects on her face and tears appear to run from her eyes.
Colette Crutcher

Colette Crutcher, *La Madre Tonantzin,* 1998
opposite: **Juana Alicia, Susan Kelk Cervantes,** and **Raul Martinez,** *New World Tree,* 1987

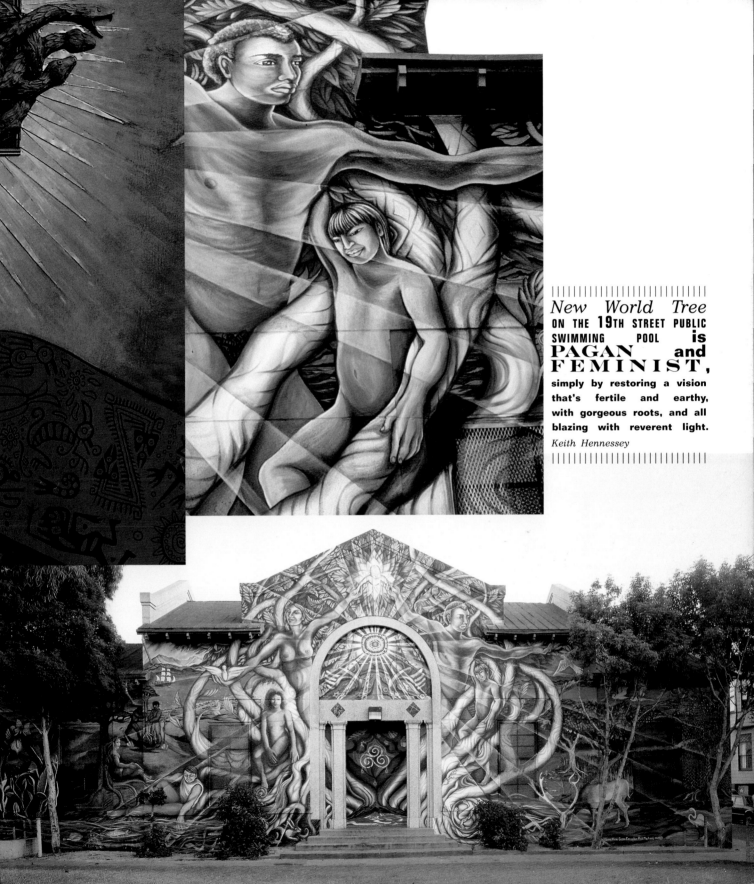

New World Tree ON THE **19**TH STREET PUBLIC SWIMMING POOL **is** PAGAN **and** FEMINIST, simply by restoring a vision that's fertile and earthy, with gorgeous roots, and all blazing with reverent light.

Keith Hennessey

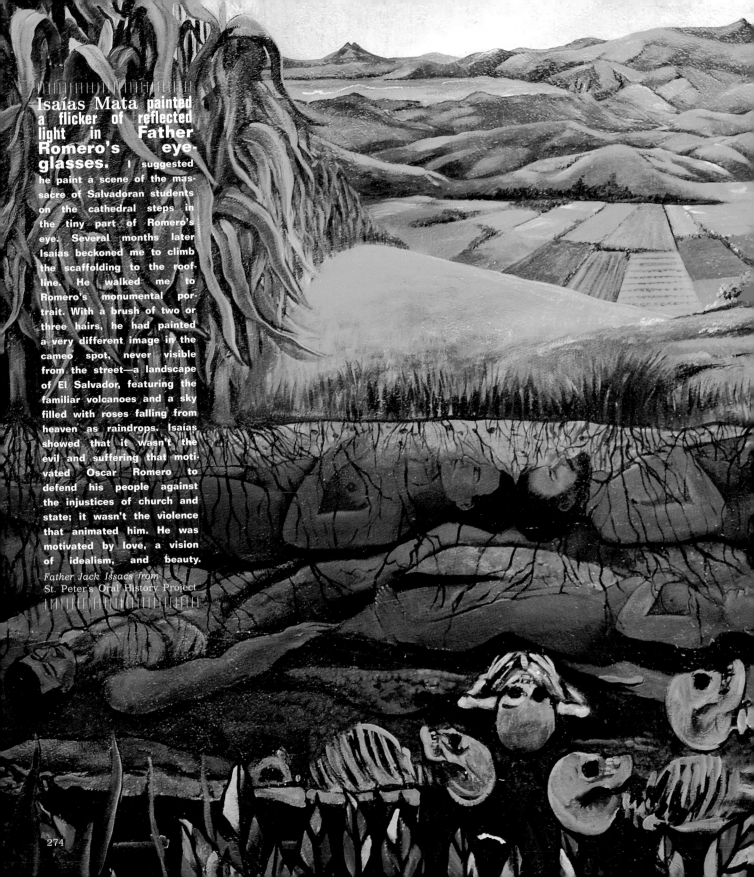

Isaías Mata painted a flicker of reflected light in **Father Romero's eyeglasses.** I suggested he paint a scene of the massacre of Salvadoran students on the cathedral steps in the tiny part of Romero's eye. Several months later Isaías beckoned me to climb the scaffolding to the roofline. He walked me to Romero's monumental portrait. With a brush of two or three hairs, he had painted a very different image in the cameo spot, never visible from the street—a landscape of El Salvador, featuring the familiar volcanoes and a sky filled with roses falling from heaven as raindrops. Isaías showed that it wasn't the evil and suffering that motivated Oscar Romero to defend his people against the injustices of church and state; it wasn't the violence that animated him. He was motivated by love, a vision of idealism, and beauty.

Father Jack Issacs from
St. Peter's Oral History Project

274

500 YEARS OF RESISTANCE

JUDITH THORN

THE EXTERIOR walls of St. Peter's parish function as a triptych, an outdoor altarpiece reflecting the struggle of indigenous people of the Americas. Painted in 1992 by Isaías Mata, *500 Years of Resistance* was commissioned by Father Jack Isaacs, a liberation theologian and a priest at St. Peter's. The church and the mural offer an alternative theology of social justice, a different view of the five hundred years since Spain invaded the Americas. Priest and artist together created an epic narrative, answering the question, "How can the disenfranchised appear in history?"

Isaías Mata was a political refugee from El Salvador. The Mission was teeming with families and individuals who had fled from the wars in Nicaragua, Guatemala, and El Salvador. Men, fleeing the military crackdown on the poor, forced conscription, or their own politics of indigenous self-determination, often arrived alone. St. Peter's served as a sanctuary for all of them and a canvas for Mata.

The promenade features a conch shell, used in indigenous religions to salute the four cardinal points of the universe. Hands with broken shackles frame the conch. Below are the bodies of the dead whose rhizomes of race and identity feed the future. The dead in the St. Peter's mural are reminiscent of those in Diego Rivera's mural in the Chapel at Chapingo. Rivera wrapped the bodies of revolutionary leaders in red cocoons, and these people are shown as nourishment for the corn growing above them. In the centerpiece, rising above the indigenous iconography, is a huge, hovering figure, the image of liberation, the syncretic figure of Christ: Quetzalcoatl. Images of fertility and new life, symbolized by the sacred corn, are at the corner. Turning the corner to the third panel, the question, "Do the oppressed have agency?" is resolved. Watched over by saints, humanity supports the struggle and triumph of social justice.

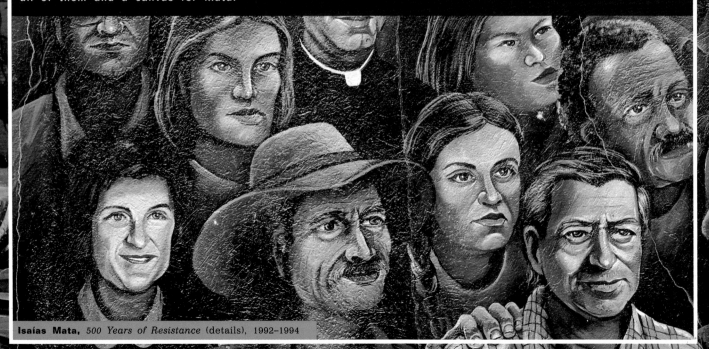

Isaías Mata, *500 Years of Resistance* (details), 1992–1994

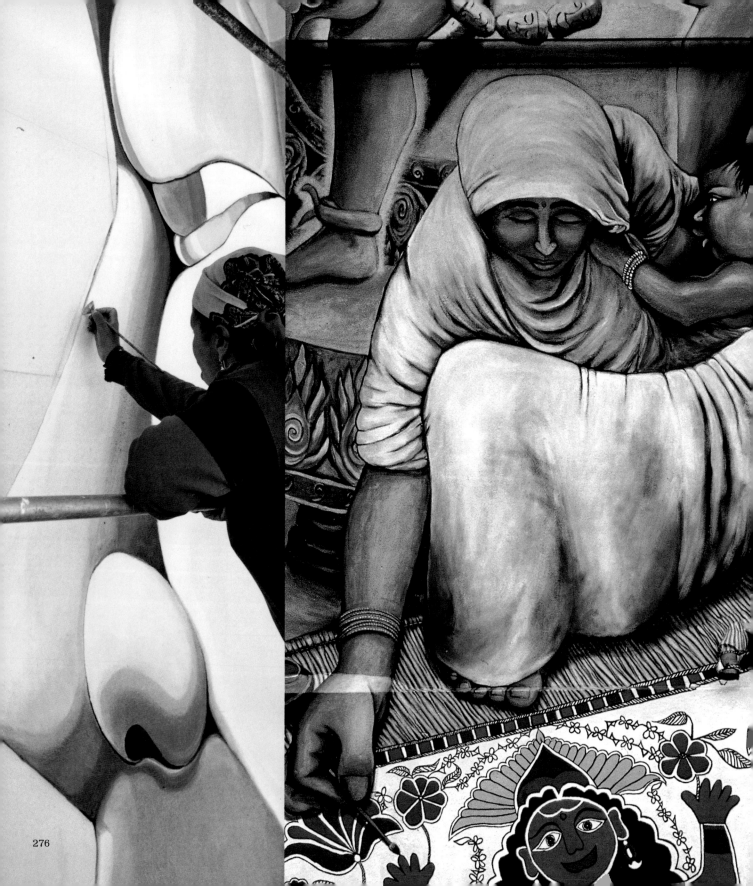

THE WOMEN'S BUILDING, *MAESTRAPEACE*
GENNY LIM

YVONNE LITTLETON had a vivid dream of a woman reaching across a building to another woman. The two touched each other gently on the chin. She jumped out of bed and drew it. This image was later painted on four corners of the Women's Building. Juana Alicia painted Yemayah, rising up out of waves from an outstretched hand. Irene Perez painted the Aztec goddess Coyolxauhqui bursting out of the other hand. Susan Kelk Cervantes's hands provided the model.

Maestrapeace began in October 1993 as a labor of love, fueled by a community mandate to express the historic significance of the San Francisco Women's Building. Susan Kelk Cervantes, Miranda Bergman, Juana Alicia, Irene Perez, Edythe Boone, Meera Desai, and Yvonne Littleton answered the call. Juana and Irene perched above the first three floors, where high winds and inclement weather tested raw nerves. Susan, never afraid of heights, painted the uppermost Venus and Pleiades. Meera oversaw the symbolic fabrics: Samoan tapa cloth, Cherokee silk, Russian lace, Mayan weave, and Hmong appliqué, honoring the women who wove, pounded, stitched,

and dyed the natural cloths. The mural is tied together by the visual mantra of the names of five hundred women, living and dead, in elegant calligraphy by Olivia Quevedo.

The sight of the muralists and their seventy-plus volunteers hanging from ten stories of scaffolding, with paintbrushes and buckets in hand, was a liberating tableau. Because of bare-bones finances, the artists wore no protective gear or harnesses. The project was also stalled for months during prime weather conditions to fight the city's sudden claim that the mural would violate the building's Historic Landmark status. Nonetheless, the project took on a festive air. *Maestrapeace*'s emerging identity was a compelling visual opera, created by the countless hands of women.

The artists struggled for a title until they received a letter from Rigoberta Menchú, winner of the Nobel Peace Prize that year, saying, "This masterpiece deserved a blessing." The artists were inspired to feminize the conventional sense of mastery into *Maestrapeace*, invoking their mission as "teachers of peace."

pages 276–281: **Juana Alicia, Miranda Bergman, Edythe Boone, Susan Kelk Cervantes, Meera Desai, Yvonne Littleton, and Irene Perez,** *Maestrapeace,* San Francisco Women's Building, 1994

opposite left: Yvonne Littleton painting *Maestrapeace,* 1994

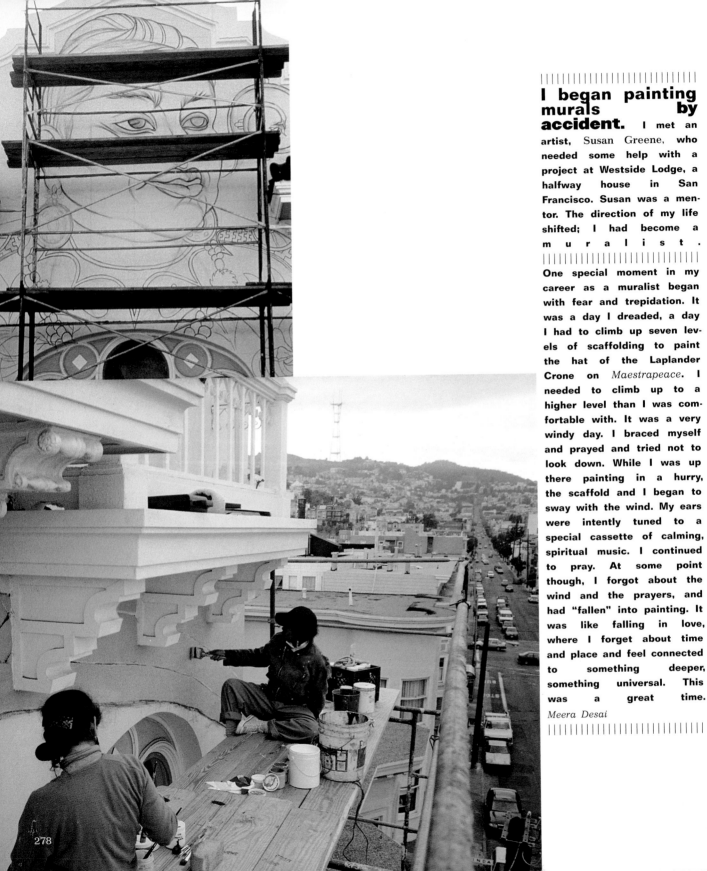

I began painting murals by accident. I met an artist, Susan Greene, who needed some help with a project at Westside Lodge, a halfway house in San Francisco. Susan was a mentor. The direction of my life shifted; I had become a m u r a l i s t .

One special moment in my career as a muralist began with fear and trepidation. It was a day I dreaded, a day I had to climb up seven levels of scaffolding to paint the hat of the Laplander Crone on *Maestrapeace*. I needed to climb up to a higher level than I was comfortable with. It was a very windy day. I braced myself and prayed and tried not to look down. While I was up there painting in a hurry, the scaffold and I began to sway with the wind. My ears were intently tuned to a special cassette of calming, spiritual music. I continued to pray. At some point though, I forgot about the wind and the prayers, and had "fallen" into painting. It was like falling in love, where I forget about time and place and feel connected to something deeper, something universal. This was a great time.
Meera Desai

EACH OF THE ARTISTS INVOLVED IN *Maestrapeace* **contributed formally and conceptually** TO THE DESIGN AND ITS EXECUTION, drawing upon community input from thousands of surveys. The mural is a compendium of ideas, knowledge, and visual fireworks. A paean to the enormity of women's contributions, the *Maestrapeace* mural is a public national art monument, on par with contemporary pieces such as Judy Chicago's *Dinner Party* and the *AIDS Quilt,* as well as a lasting tribute to the human spirit of important religious and political art.

Laura E. Pérez

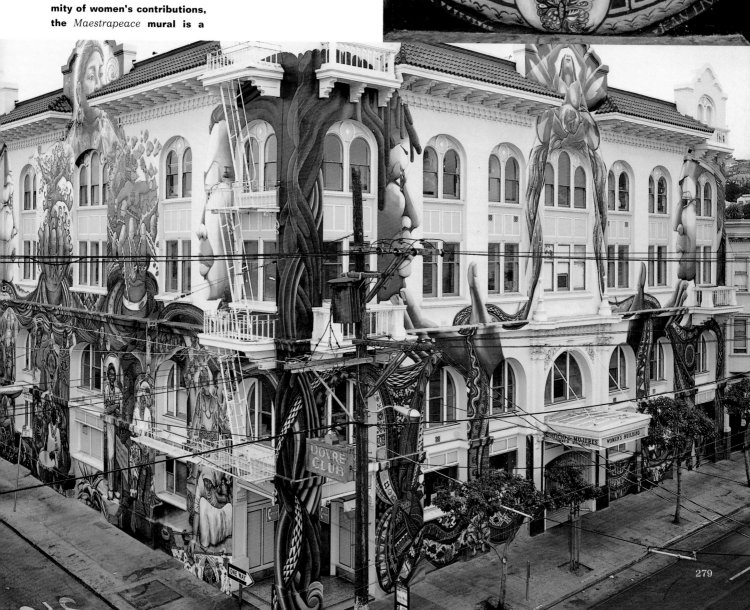

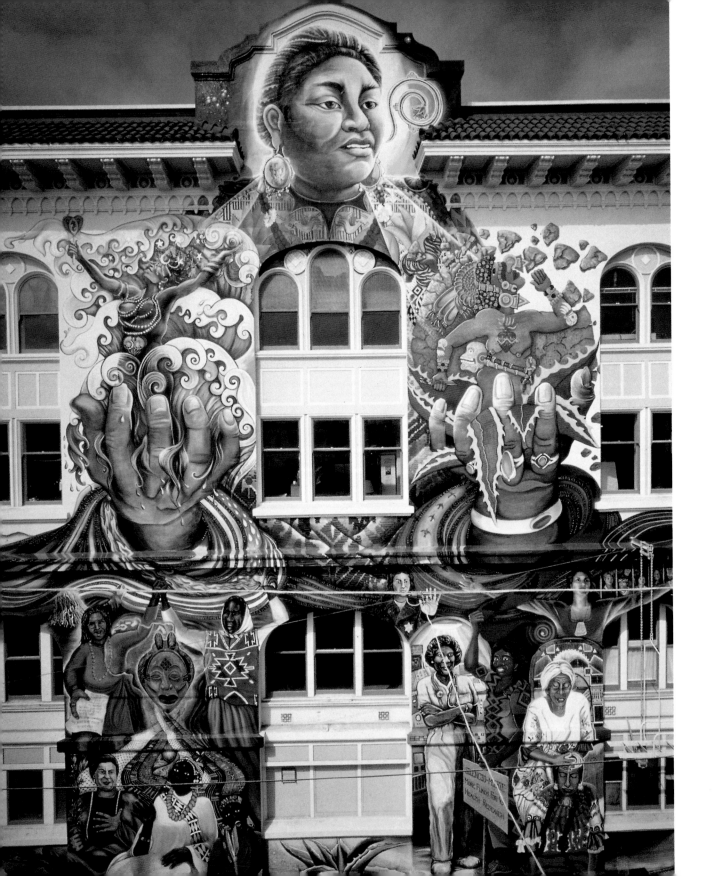

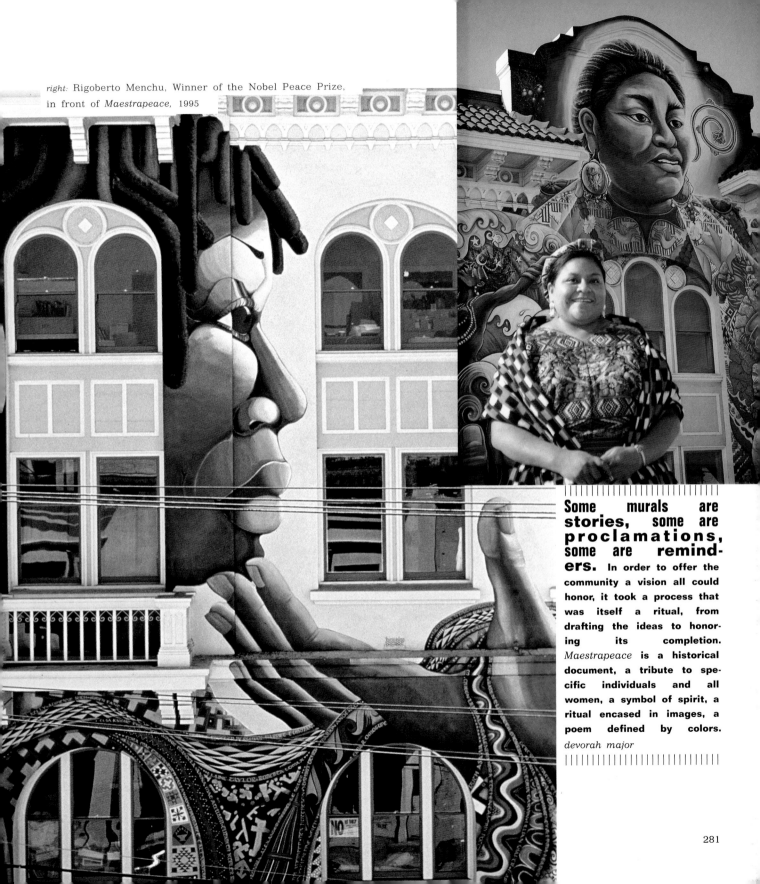

right: Rigoberto Menchu, Winner of the Nobel Peace Prize, in front of *Maestrapeace*, 1995

Some murals are stories, some are proclamations, some are reminders. In order to offer the community a vision all could honor, it took a process that was itself a ritual, from drafting the ideas to honoring its completion. *Maestrapeace* is a historical document, a tribute to specific individuals and all women, a symbol of spirit, a ritual encased in images, a poem defined by colors.
devorah major

281

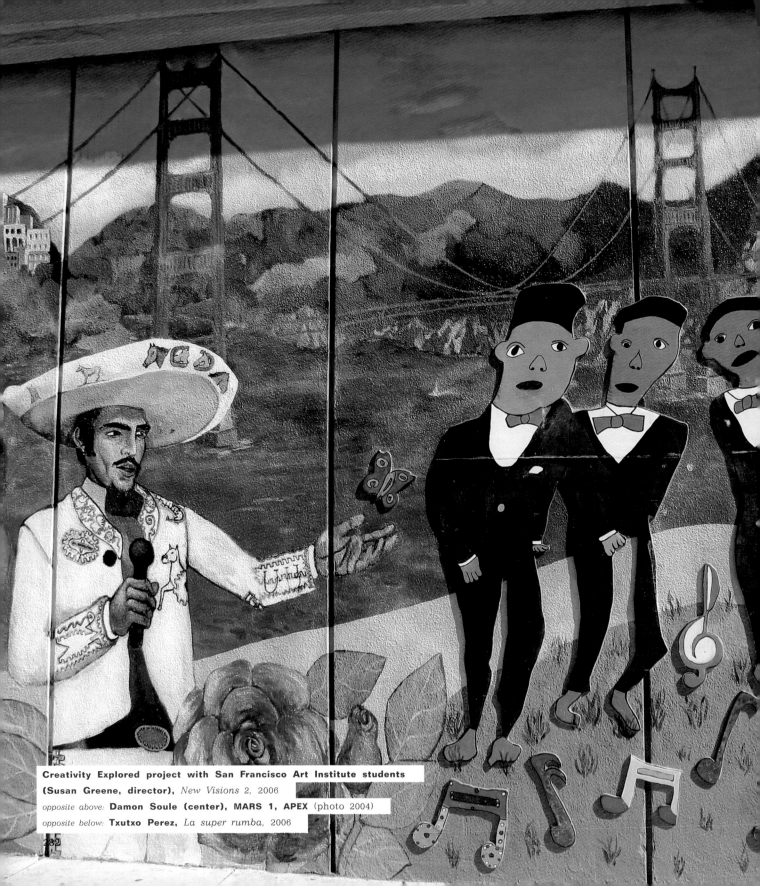

Creativity Explored project with San Francisco Art Institute students
(Susan Greene, director), *New Visions 2*, 2006
opposite above: Damon Soule (center), MARS 1, APEX (photo 2004)
opposite below: Txutxo Perez, *La super rumba*, 2006

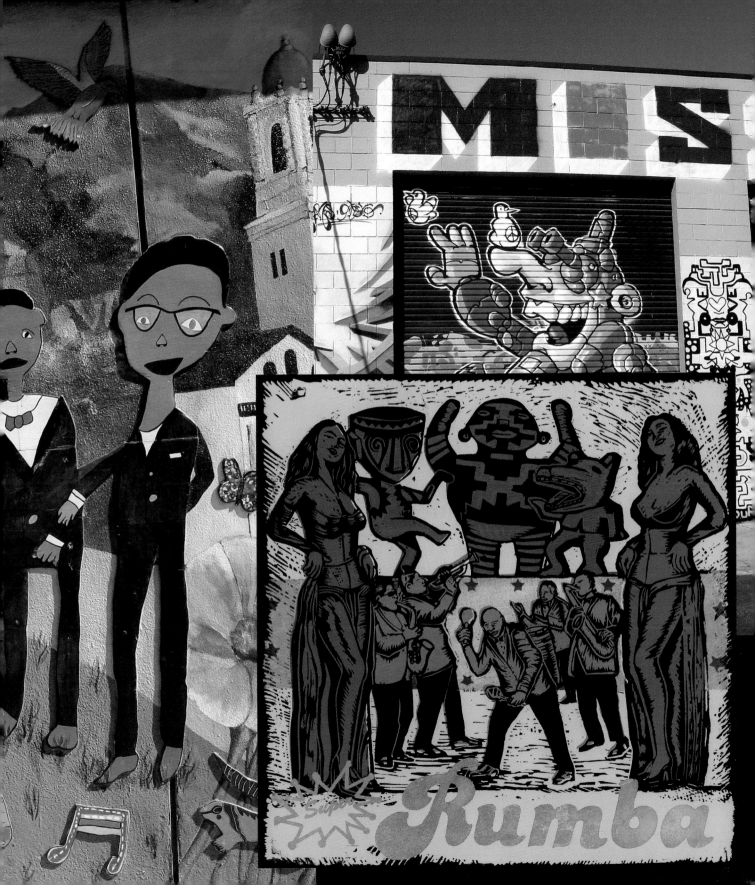

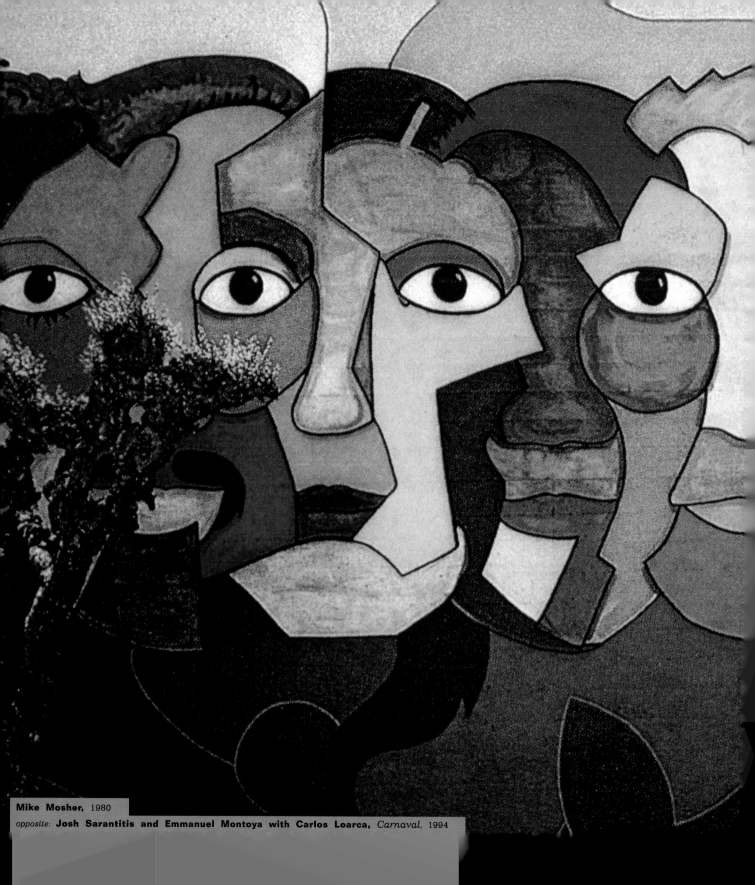

Mike Mosher, 1980

opposite: **Josh Sarantitis and Emmanuel Montoya with Carlos Loarca,** *Carnaval,* 1994

¡CARNAVAL!
ARTURO ARIAS

CARNAVAL, the popular days of dancing in the street, began in San Francisco around Precita Park in 1979. There are three important murals that capture the days of fantasy and rapture year round. Carnaval offers a brief entry into a symbolic sphere of utopian freedom. Its modes include parody and grotesque realism. The rites imply a valorization of Eros and a subversion of established power.

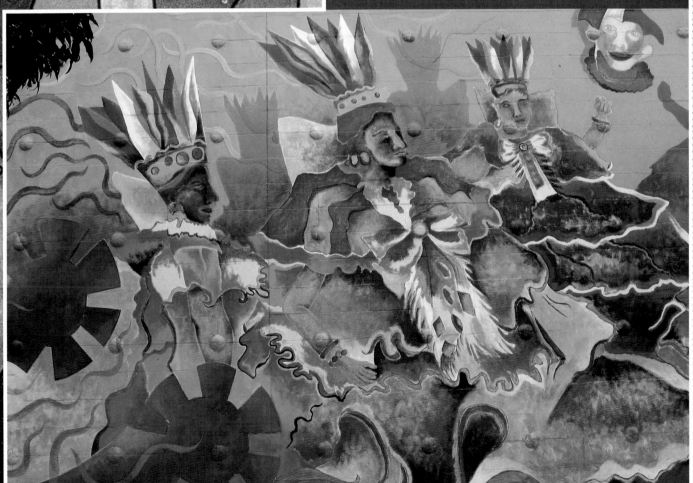

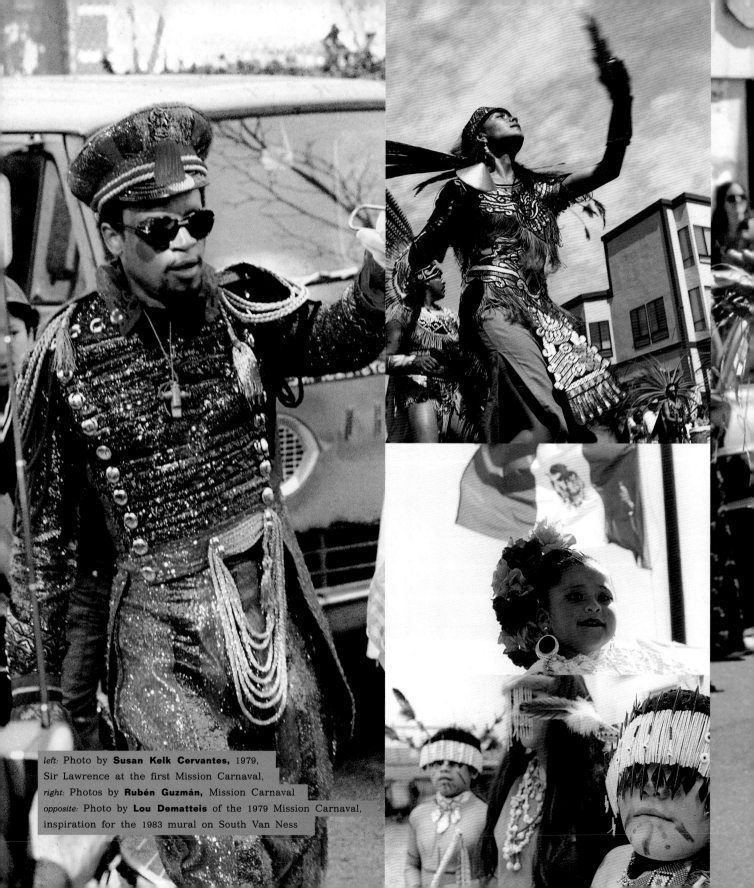

left: Photo by **Susan Kelk Cervantes,** 1979,
Sir Lawrence at the first Mission Carnaval,
right: Photos by **Rubén Guzmán,** Mission Carnaval
opposite: Photo by **Lou Dematteis** of the 1979 Mission Carnaval,
inspiration for the 1983 mural on South Van Ness

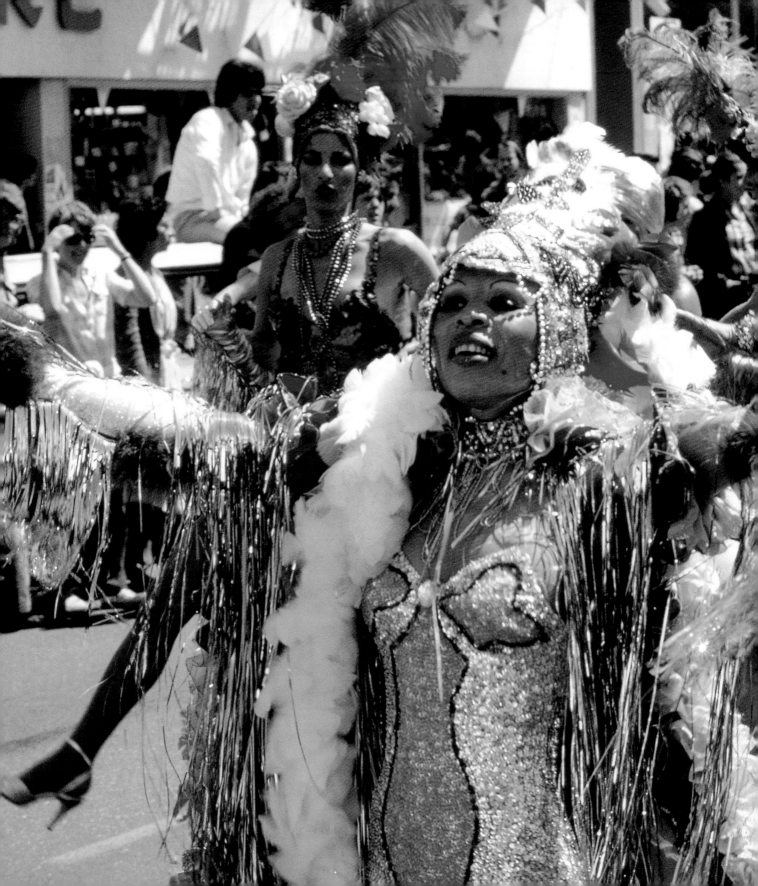

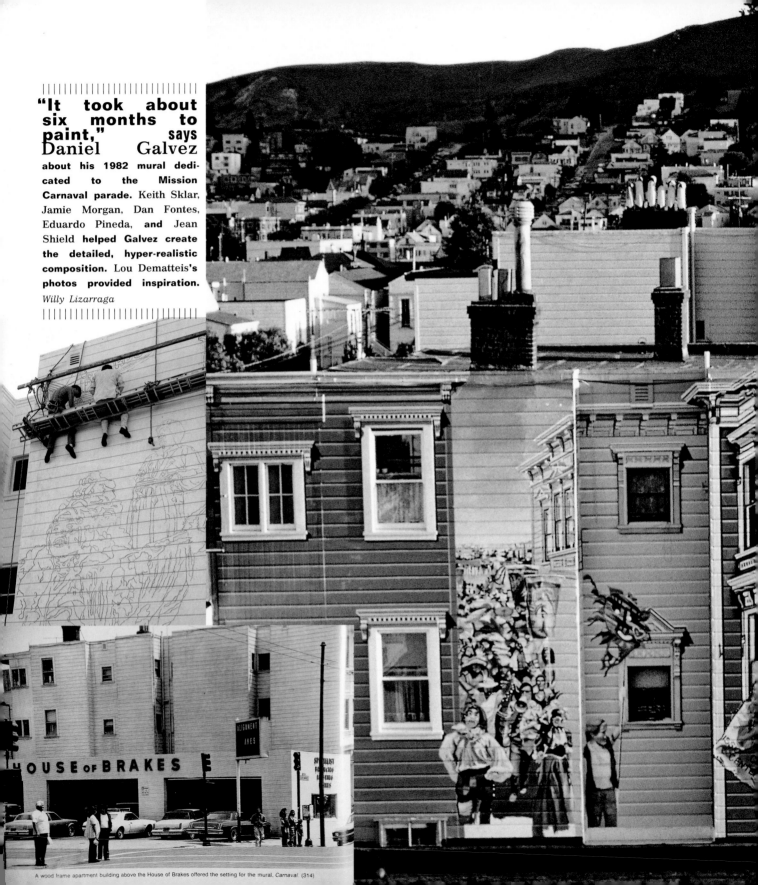

"It took about six months to paint," says Daniel Galvez about his 1982 mural dedicated to the Mission Carnaval parade. Keith Sklar, Jamie Morgan, Dan Fontes, Eduardo Pineda, **and** Jean Shield **helped Galvez create the detailed, hyper-realistic composition.** Lou Dematteis's photos provided inspiration.

Willy Lizarraga

A wood frame apartment building above the House of Brakes offered the setting for the mural, *Carnaval*. (314)

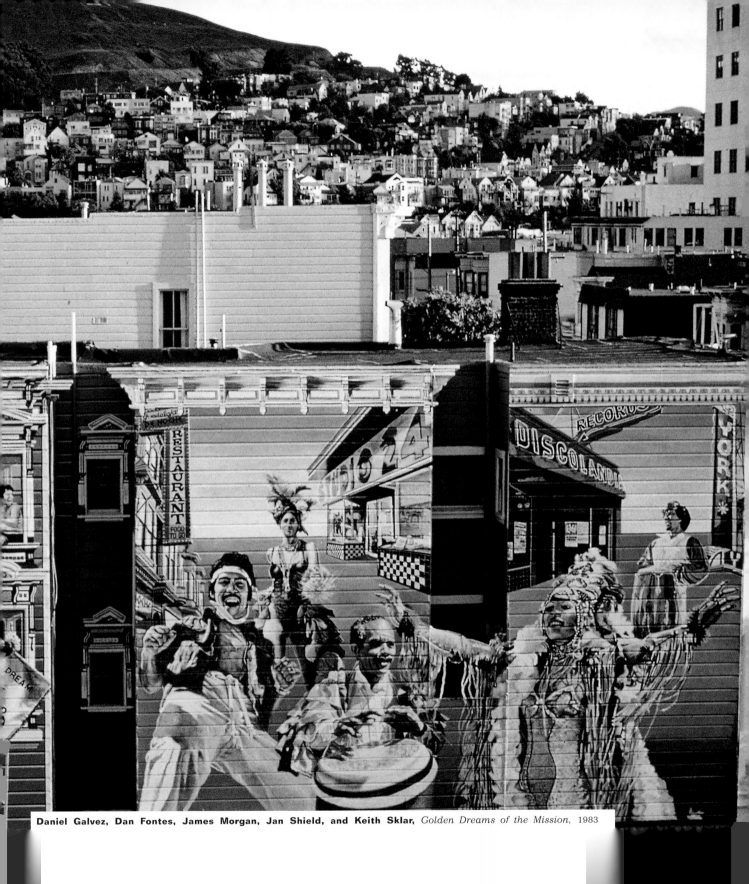

Daniel Galvez, Dan Fontes, James Morgan, Jan Shield, and Keith Sklar, *Golden Dreams of the Mission,* 1983

THE DAY OF THE DEAD

ALEJANDRO MURGUIA

EL DIA de los Muertos in La Misión is nothing like the one in Mexico, where children spread carpets of marigold petals. The skeletons in the Mission could be anyone in the barrio. Dozens of emerald and ruby candles of La Virgen del Tepeyac project shadows of dancing *calaveras* on the walls. Clouds of scented copal smoke waft toward the twelve-foot ceiling, which is crisscrossed with festive yellow and orange *papel picado* streams.

An altar stands in the center of the fiesta, a four-tiered pyramid tall as me, draped with a crocheted white tablecloth. Every level of the altar is covered with *ofrendas*, offerings to a glorious life and a happy death. On the bottom level, a dozen full-size candy skulls sit between red votive candles and yellow taper candles. The next level has bundles of

cempazúchil flowers tied with purple yarn, a cross of woven straw, a punched-tin heart with a dent, a twisty serpent made of red and black beans, a calendar of a big-breasted Aztec princess from Taqueria Pancho Villa, a can of Café Bustelo, and a rubber mermaid. On the next level there's a glow-in-the-dark Virgin of Fátima, *ristras* of dried red chilies, clay dishes filled with cracked corn, a pack of Zig-Zag papers, an aloe vera plant, a miniature diorama of a *calavera* family being evicted by a *calavera* landlord, and some photos in gilt-edged frames. At the top of the altar a stone censer releases gray clouds of copal. A hundred years from now who knows if there'll even be a barrio La Mísion, so these artifacts will speak volumes to those who reconstruct the past.

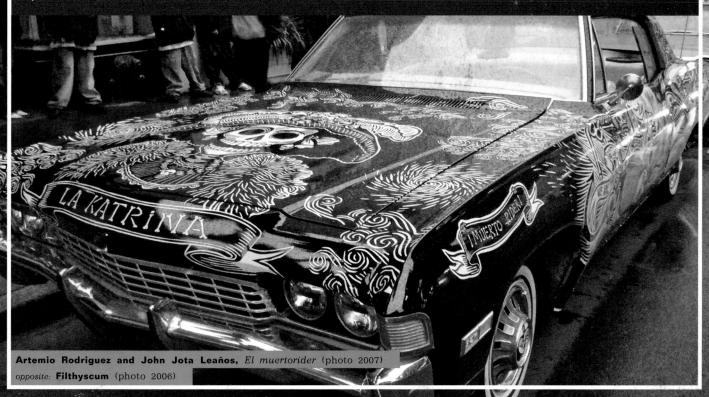

Artemio Rodriguez and John Jota Leaños, *El muertorider* (photo 2007)
opposite: **Filthyscum** (photo 2006)

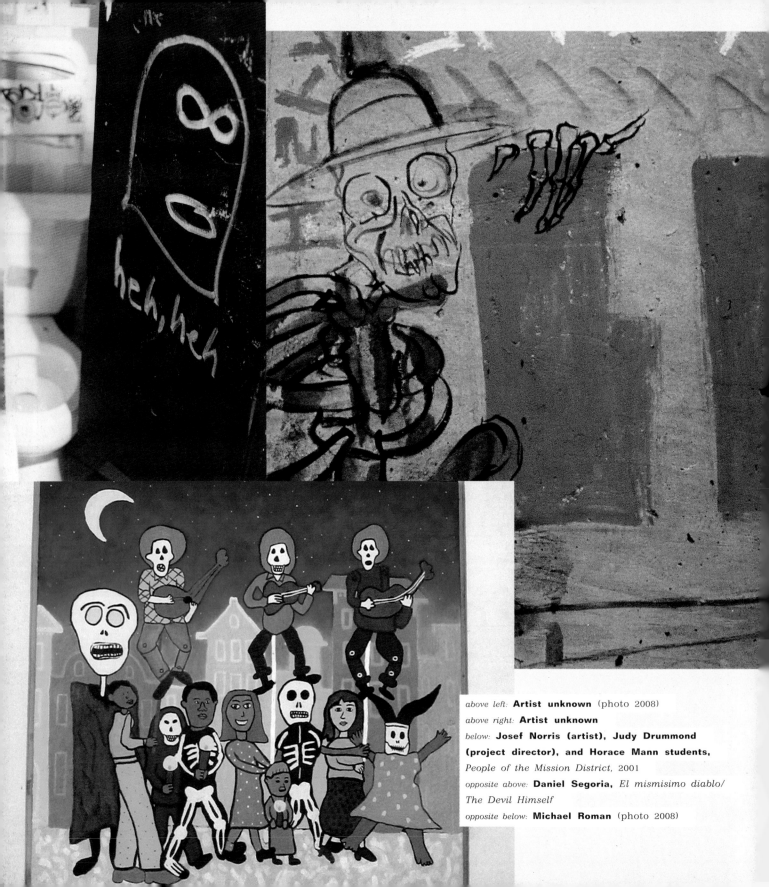

above left: **Artist unknown** (photo 2008)

above right: **Artist unknown**

below: **Josef Norris (artist), Judy Drummond (project director), and Horace Mann students,** *People of the Mission District,* 2001

opposite above: **Daniel Segoria,** *El mismisimo diablo/ The Devil Himself*

opposite below: **Michael Roman** (photo 2008)

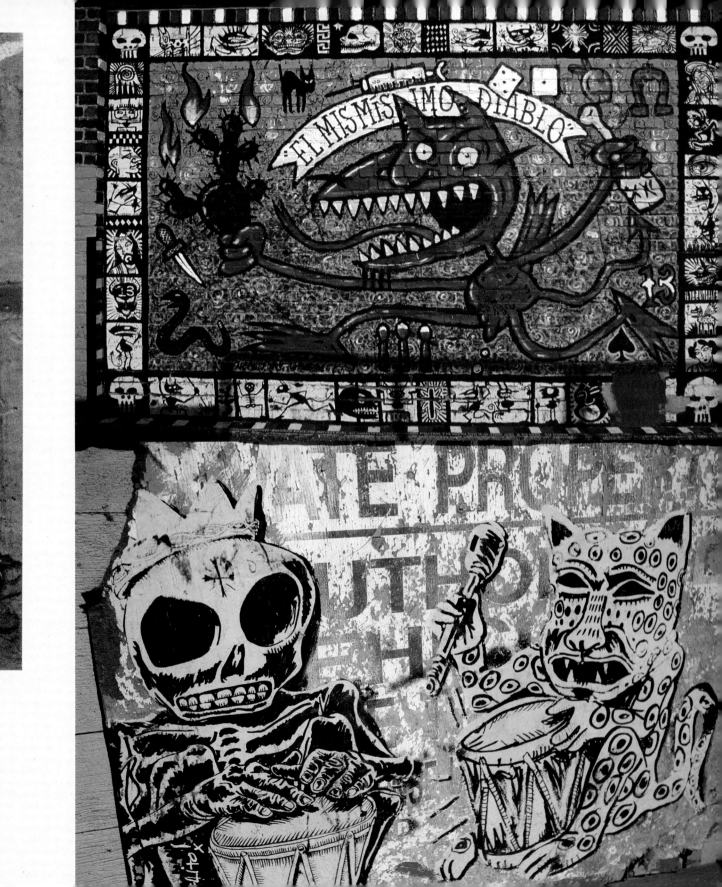

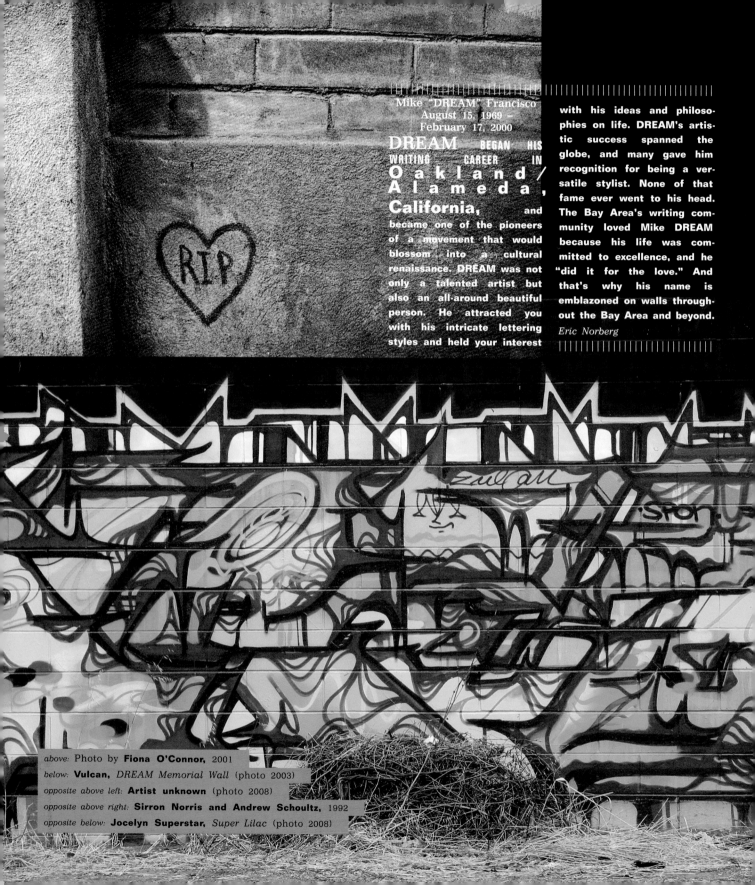

Mike "DREAM" Francisco
August 15, 1969 –
February 17, 2000

DREAM BEGAN HIS WRITING CAREER IN **Oakland/ Alameda, California,** and became one of the pioneers of a movement that would blossom into a cultural renaissance. DREAM was not only a talented artist but also an all-around beautiful person. He attracted you with his intricate lettering styles and held your interest with his ideas and philosophies on life. DREAM's artistic success spanned the globe, and many gave him recognition for being a versatile stylist. None of that fame ever went to his head. The Bay Area's writing community loved Mike DREAM because his life was committed to excellence, and he "did it for the love." And that's why his name is emblazoned on walls throughout the Bay Area and beyond.

Eric Norberg

above: Photo by **Fiona O'Connor,** 2001
below: **Vulcan,** *DREAM Memorial Wall* (photo 2003)
opposite above left: **Artist unknown** (photo 2008)
opposite above right: **Sirron Norris and Andrew Schoultz,** 1992
opposite below: **Jocelyn Superstar,** *Super Lilac* (photo 2008)

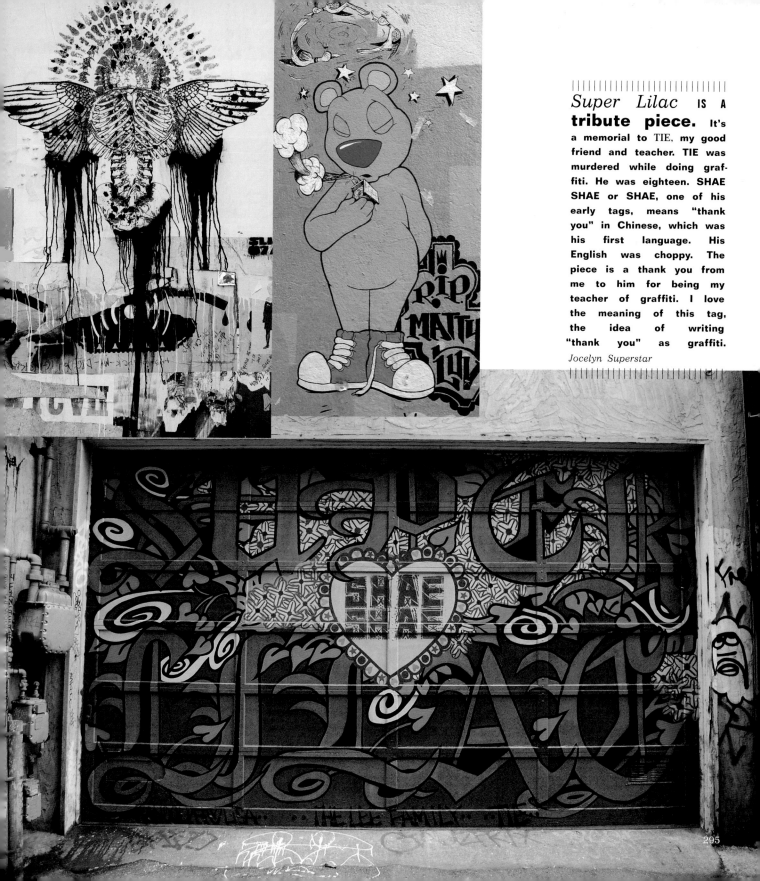

Super Lilac IS A **tribute piece.** It's a memorial to TIE, my good friend and teacher. TIE was murdered while doing graffiti. He was eighteen. SHAE SHAE or SHAE, one of his early tags, means "thank you" in Chinese, which was his first language. His English was choppy. The piece is a thank you from me to him for being my teacher of graffiti. I love the meaning of this tag, the idea of writing "thank you" as graffiti.

Jocelyn Superstar

GERMS, 2008

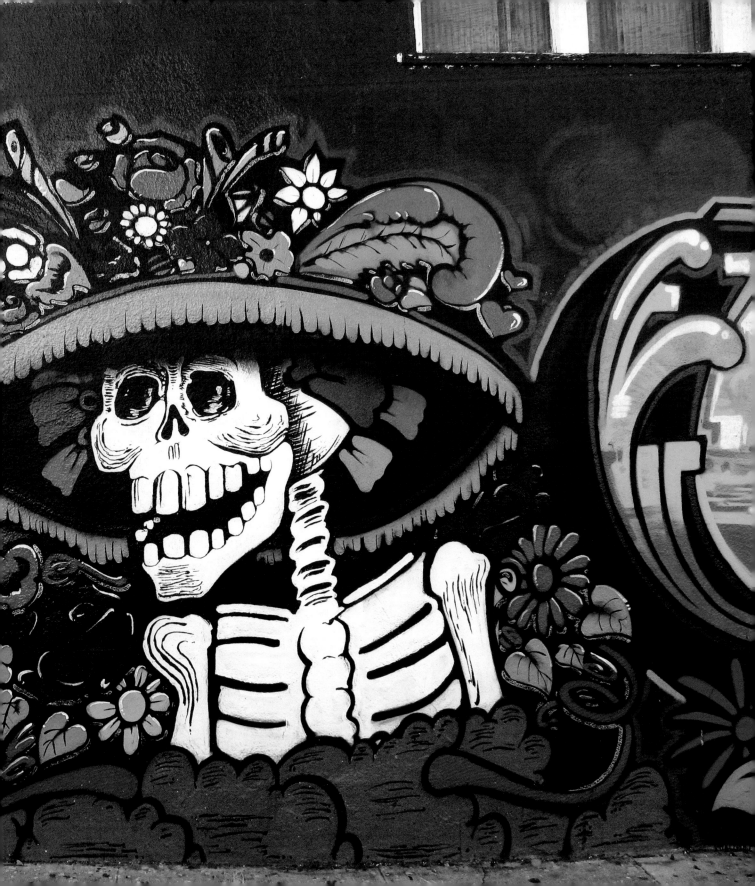

By the way, *con permiso.*

We couldn't squeeze a whole neighborhood into a book, especially one like the Mission, which spills like a freshly whacked piñata onto the sidewalks and sprawls up the walls in daily mega doses. For more background, foreground, and personal rumblings on Mission murals, with and without permission; further ramblings down the alleys; and histories, poems, and pictures galore, here's a list of writers, artists, photographers, friends, and fans who made contributions along the way. Many can be found online. *¡Gracias a todos!*

//

Books //

Barnett, Alan W. *Community Murals: The People's Art.* Associated University Presses, 1984.

Barthelmeh, Volker. *Street Murals: The Most Exciting Art of the Cities of America, Britain, and Western Europe.* Alfred A. Knopf, 1982.

Bou, Louis. *Street Art: The Spray Files.* Collins Design, 2005.

Chalfant, Henry, and James Prigoff, *Spraycan Art.* Thames & Hudson, 1987.

Cockcroft, Eva, and Holly Barnet-Sanchez. *Signs from the Heart: California Chicano Murals.* Social and Public Art Resource Center, 1990.

_____, James Cockcroft, and John Weber. *Towards a People's Art: The Contemporary Mural Movement.* E. P. Dutton, 1977.

Cooper, Martha, and Joseph Sciorra. *R.I.P.: Memorial Wall Art.* Thames & Hudson, 2002.

Ganz, Nicholas. *Graffiti World: Street Art from Five Continents.* Abrams, 2004.

Gaspar de Alba, Alicia, and Tomas Ybarra Frausto. *Velvet Barrios: Popular Culture and Chicana/o Sexualites.* Palgrave Macmillan, 2002.

Grody, Steve. *Graffiti L.A.: Street Styles and Art.* Abrams, 2007.

Drescher, Timothy W. *San Francisco Bay Area Murals: Communities Create Their Muses, 1904–1997.* Pogo Press, 1998.

_____, Rupert Garcia, and Carmen Lomas Garza. "Murals: 'People's Art and Social Change' and 'Recent Raza Murals in the U.S.'" *Radical America* 12, no. 2 (March–April 1978).

Dunitz, Robin, and James Prigoff. *Painting the Towns: Murals of California.* RJD Enterprises, 1997.

Finkelpearl, Tom. *Dialogues in Public Art.* MIT Press, 2001.

Howze, Russell. *Stencil Nation: Graffiti, Community, and Art.* Manic D Press, 2008.

Johanson, Chris, and Aaron Rose. *Chris Johanson.* Deitch Projects, 2004.

MacPhee, Josh, and Favianna Rodriguez. *Reproduce y rebélate/ Reproduce and Revolt,* Soft Skull Press, 2008.

McQuiston, Liz. *Graphic Agitation.* Phaidon, 1996.

Mr. Fly. *Mexican Stencils Propa.* Editorial RM, 2008.

Noriega, Chon. *Just Another Poster?: Chicano Graphic Arts in California.* University of Washington Press, 2001.

Partch, Elizabeth. *Body/Culture: Chicano Figuration.* University Art Gallery, Sonoma State University, 1990.

Rose, Aaron, et al. *Beautiful Losers: Contemporary Art and Street Culture.* D.A.P., 2005.

Rotman, Steve. *Bay Area Graffiti.* Mark Batty Publisher, 2009.

_____. *San Francisco Street Art.* Prestel, 2009.

Selz, Peter. *The Art of Engagement.* University of California Press, 2006.

Smith, Keri. *The Guerilla Art Kit.* Princeton Architectural Press, 2007.

Strauss, Steve. *Moving Images: The Transportation Poster in America.* Fullcourt Press, 1984.

Walsh, Michael. *Graffito.* North Atlantic Books, 1996.

///

Films //

Nic Hill, *Piece by Piece,* 2004

Veronica Majano, *Calle Chula,* 1998

Benjamin Morgan, *Quality of Life,* 2006

Aaron Rose, *Beautiful Losers,* 2007

Tony Silver and Henry Chalfant, *Style Wars,* 1983

Lise Swenson, *Mission Movie,* 2004

Whisper Media, *Boom: The Sound of Eviction,* 2000

///

Websites ///

www.artcrimes.com
www.bayareagraffiti.com
www.billboardliberation.com
www.bombingscience.com
www.breakingthesilence.org
www.deappropriationproject.net
www.fecalface.com/SF
www.funkandjazz.com
www.justseeds.org
www.juxtapoz.com

www.knowngallery.com
www.obeygiant.com
www.otherthings.com/grafarc
www.precitaeyes.org
www.sfgraf.com
www.shapingsanfrancisco.org
www.startmobile.net
www.stencilarchive.org
www.woostercollective.com
www.3580.com/transit

///
///
///
///
///

Contributors

Francisco X. Alarcón is an award-winning poet who leads the processional for the Day of the Dead down Balmy Alley. He teaches at the University of California, Davis.

Arturo Arias is the author of *El Norte, After the Bombs,* and other prized fiction and literary criticism. He is the recipient of the Casa de Las Americas Award.

Lori B (Bloustein) is a performer and photographer based in San Francisco. Her writing, recordings (including *Hurricane Child* and *Shadows of Love*), and private healing practice explore the meaning of Homecoming (www.lorib.net).

Claire Bain, a painter and video/performance artist, was president of Canyon Cinema and a director of the Precita Eyes education programs.

Billboard Liberation Front has been improving outdoor advertising since 1977.

Chris Carlsson, a writer, historian, bicyclist, and organizer/activist, lives in San Francisco. His latest book is *Nowtopia: How Pirate Programmers, Outlaw Bicyclists, and Vacant-Lot Gardeners Are Inventing the Future Today!* (AK Press).

Susan Kelk Cervantes is the founding director of Precita Eyes Muralists Association, Inc., and the recipient of many honors as an artist and community organizer.

Marvin Collins is a Bay Area photographer and historian who covered the war in Central America and the Mission artists who chronicled the struggles there and at home. He currently devotes much of his energy to the California wine industry and its history.

Ruben C. Cordova is an art historian focusing on contemporary Latino culture. He teaches at the University of Texas, San Antonio.

Jaime Cortez, a writer, visual artist, and cultural worker, has a new short-story collection to be published by Suspect Thoughts Press in 2009.

Lou Dematteis, a former staff photographer for Reuters, is an internationally known photojournalist who lives in the Mission. His most recent book is *Crude Reflections: Oil, Ruin and Resistance in the Amazon Rainforest.*

Timothy W. Drescher, the author of *San Francisco Bay Area Murals: Communities Create Their Muses, 1904–1997* and coauthor of *Agitate! Educate! Organize! American Labor Posters,* is currently a codirector of Rescue Public Murals (Heritage Preservation).

Guillermo Gómez-Peña is a writer, performance artist, and activist living in the Mission.

David A. M. Goldberg is a writer, cultural critic, and visual artist raised in the master traditions of hip-hop, graffiti, and Mission Muralismo.

Susan Greene is an artist, educator, and clinical psychologist whose practice focuses on borders, migrations, decolonization, and memory. She is on the faculty of Goddard College and directs the Learning Center at the San Francisco Art Institute.

Katherine Gressel is an artist, arts educator, and writer. She has worked with Groundswell, Creative Time, and the Lower Manhattan Cultural Council. A former Mission resident, she organized and painted murals with Precita Eyes Muralists.

Juan Pablo Gutierrez is a Mission poet and the past director of the Mission Cultural Center.

Rubén Guzmán is a photographer, journalist, educator, and former curator at Galería de la Raza.

Q. R. Hand is a Mission poet and a prominent member of the Black Panther party. He is the author of *How Sweet It Is* and *Whose Really Blues,* and the coauthor, with John Ross, of *We Came to Play: Writings on Basketball.*

Brock Foxworthy Hanson is a Getty Images photographer, multimedia artist, and freelance writer living in San Francisco and Seattle (www.daresay.com).

Patrick "Pato" Hebert is an artist and educator. Recent projects include a text-based installation for the California Biennial, a participatory project commissioned by the Los Angeles County Museum of Art, and a solo exhibition at Haverford College.

Keith Hennessy, a performance artist and teacher, lives in the Mission and tours internationally with his company Circo Zero.

Leticia Hernandez-Linares is a writer, educator, and performance poet living and working in the Mission community.

Russell Howze curates the Stencil Archive (stencilarchive.org), a San Francisco–based international stencil art gallery. He is the author of *Stencil Nation: Graffiti, Community, and Art.*

Annice Jacoby (Editor) is a writer and artist. Her public performance work includes *City of Poets* with Lisa Citron, *The Roof Is on Fire* with Suzanne Lacy, *gossipgospel* for Beijing 95, and the Fort Point Project for the Hague Appeal for Peace.

Rachel Kaplan is a performer, writer, and educator. She was the lead organizer of the Circus of Resistance (2002) and the director of the opening performance at Zeum (1998).

John Jota Leaños is an interdisciplinary social art practitioner, digital muralist, cultural worker, and Assistant Professor of Community Arts and Social Practices at the California College of the Arts.

Genny Lim, a poet, performer, and the playwright of the award-winning *Paper Angels,* was featured on the PBS series *The United States of Poetry.* She was awarded a Rockefeller Fellowship for *A Cantata for Paul Robeson.*

Willy Lizarraga is a Bay Area–based writer. His latest short story, "La Mas Chingona," was short-listed for the 2008 New

South Journal of Arts and Literature Prize. He is currently working on *The Last King of the Mission,* a novel.

Lisa Müllerauh is a photographer who is inspired by the artists who make their mark in the Mission to document and preserve the message, the moment, and their artistry.

Alejandro Murguía teaches at San Francisco State University. His collection of short stories about the Mission District, *This War Called Love* (City Lights Books), won the American Book Award in 2003.

Julie Murray, a painter and experimental filmmaker, was born in Dublin, Ireland. Her work is included in the collections of the Museum of Modern Art, the Whitney Museum of American Art, and the New York Public Library.

Rebecca Najdowski is a photography-based artist living in the Mission.

Aaron Noble is a painter and cofounder of the Clarion Alley Mural Project. He is now based in Los Angeles.

Eric Norberg, a Bay Area–based writer, visual artist, photographer, educator, and cultural worker, has also painted and organized murals in San Pancho, Aztlán, and Cuba.

Fiona O'Connor is a Mission-based photographer who documented the early evolution of the Clarion Alley Mural Project.

Laura E. Perez, author of *Chicana Art: The Politics of Spiritual and Aesthetic Altarities* (Duke University Press), teaches in the Department of Ethnic Studies at the University of California, Berkeley.

Jim Prigoff, the author of the seminal book *Spraycan Art,* is a photographer and leading authority on public art. He serves on the board of SPARC and champions street artists in San Francisco and around the world.

Steve Rotman is a photographer whose books include *Bay Area Graffiti* and *San Francisco Street Art* (www.funkandjazz.com).

Ricardo Richey (APEX), influenced by urban settings, architecture, and graphic design, has been active in the street-art scene since he was very young. He was the cover artist for *San Francisco Magazine*'s feature "San Francisco's Hottest Art."

Isis Rodriguez is an experimental cartoon artist who lives in San Francisco and has exhibited work internationally in galleries and museums.

Will Shank, a former chief conservator at the San Francisco Museum of Modern Art, is a codirector of Rescue Public Murals (Heritage Preservation). He won the Rome Prize in Conservation in 2005 and currently lives in Barcelona.

Mats Stromberg (cover artist), born in Sweden, has published mini-comics and is featured in anthologies such as *Last Gasp Comix 2000, Blab, Real Stuff, Buzzard, Orchid,* and *Legal Action Comix.*

Judith Thorn teaches culture studies in Northern California and is the author of *The Lived Horizon of My Being,* a study of M. M. Bakhtin, Rigoberta Menchu, and Victor Montejo.

Bruce Tomb has an interdisciplinary architectural practice and teaches at California College of the Arts. His collaboration with Ant Farm media artists Chip Lord and Curtis Schreier was featured in the exhibition *The Art of Participation* at the San Francisco Museum of Modern Art.

Peter Whitehead is a writer, musician, and composer of film and dance soundtracks. Currently based in New York, he was a Mission resident for more than twenty years.

Linda G. Wilson, a Mission-based photographer, is a cofounder of The Eye Photography Gallery, a former gallery director at Intersection for the Arts, and the photo archivist for El Tecolote. She has exhibited her work locally and internationally.

Megan Wilson is an artist based in San Francisco, Manila, and Yogyakarta. She was a codirector of the Clarion Alley Mural Project and launched the Sama-Sama project.

Acknowledgments

Funders //
National Endowment for the Arts Historic and Preservation
Program
San Francisco Mayor's Office of Community Development
Enterprise Community Grant
Zellerbach Family Fund
Bank of America Foundation
Wells Fargo Foundation
Elisa and Walter Haas Foundation
California Arts Council Challenge Grant
//

Individual Donors ///
Edward Bloustein and Ruth Ellen Steinman, M.D.
Miguel Bustos
Harry Jacoby
Lisa Müllerauh
Mary Shapiro
Michael and Elizabeth Manwaring
//

Project Development ///
Annice Jacoby, Editor
Susan Cervantes, Director and Founder, Precita Eyes Mural Arts
Association
Lori B, Project Director/Senior Photo Editor
Katherine Gressel, Assistant Editor/Text and Research
Lisa Müllerauh, Assistant Editor/Photo and Research
Elizabeth Manwaring, Design Consulting and Development
Michael Manwaring, Design Consulting and Development
Mary Shapiro, Project Advisor
//

Editorial Contributors ///
Claire Bain, Kate Joyce, Rachel Kaplan, Emilie Ragusso,
Stephanie Sherman, Linda G. Wilson
//

Cultural Partners ///
Billboard Liberation Front Archive
Clarion Alley Mural Project (CAMP) Archive
CELLspace
Galería de la Raza
Community Voices Oral History Project, San Francisco State
University and St. Peter's Church (Dr. Jose Cuellar, director;
Francisco Herrera, organizer; and Carmen Munoz, Mariana
Hernandez, Teresa Almanguer, interviews; Kathy Neice,
translations)
El Tecolote Photographic Archive
H.O.M.E.Y. Project
MissionArt415 Archive
San Francisco Mural Resource Center
Stencil Archive
//

Special Thanks //
Elise Bloustein
M. J. Bogatin
Michael Carabetta
Michael Cecchini
Lisa A. Fontenot
Eric Himmel
Deborah Kirshman
Jaiva Larsen
Kaj Larsen
Frank Müllerauh
Aaron Noble
Jim Prigoff
Will Shank
Barbara Stevenson
Elisa Urbanelli
Martin Venezky
Andrew Voigt

and Brooke Oliver, the San Francisco art lawyer who pioneered
copyright registration and legal protections for murals and
muralists with countless hours of pro bono services. Her office
is still on Balmy Alley, surrounded by murals.
//

Appreciation to the many who contributed time, ideas, material,
labor, connections, history, coaching, access, art, devotions,
research, images, shared passion, and essential support and faith,
including:

Francisco Alarcón, Ruth Asawa, Alan Barnett, Leon Borensztein,
Margo Bors, Mark Brecke, Lisa Brewer, Tim Burgard, Lorna Dee
Cervantes, Luis Cervantes, Kevin Chen, Dean Coppola, Daniell
Cornell, Aiko Cuneo, Francisco Dominguez, Tim Drescher, Judy
Drummond, Sara Foust, Phoebe France, Jennifer Futernick, Robert
Futernick, Elisabetta Ghisini, Jeanne Halpern, Brock Foxworthy
Hanson, Glen Helfand, Ron Hemphill, Francisco Herrera, Juan
Felipe Herrera, Arline Jacoby, Isa Jacoby, Anet James, Marie-
Jeanne Juilland, James Keller, Jo Kreiter, Steve Lambert, Luis
Leon, Margareta Lunes-Robles, devorah major, Nancy Mirabel,
Nola Marino, Jet Martinez, Victor Martinez, Lydia Matthews, Eric
Norberg, Joseph Norris, Fiona O'Connor, Laura E. Perez, Patrick
Piazza, Eduardo Pineda, Peter Plate, Carolina Ponce de Léon,
Randolph and Lisa @ MissionArt415, Ricardo Richey, Rigo, Frank
Roche, Cynthia Roman, Diana Scott, Cheryl Snook, Patricia Rose,
Andrew Schoultz, Susan Schwartzenberger, Viki Sprague, Anne-
Marie Theilan, Fran Valesco, Andy Weiner, Steve Winn, Megan
Wilson, Steve Winn, René Yañez, Tomas Ybarra-Frausto, Jonathan
Youtt, Masha Zackheim.
//

And to the late Victor Miller, editor of the much-missed *New
Mission News,* with its masthead banner that serves as a motto
for Mission Muralismo: "Afflicting the Comfortable, Comforting the
Afflicted."
//

Photograph Credits

Key: t = top, b = bottom, l = left, r = right, c = center

Juana Alicia: 104br

Courtesy of Juana Alicia: 10–11, 39 (inset), 106t, 273t

Lori B: 1, 4, 13b, 14, 18tr, 19, 22, 27b, 28, 41b, 43tl, 43bl, 43br, 44, 50, 51tl, 52bl, 55bl, 57t, 67t, 74b, 77t, 79tr, 79b, 86, 90–91c, 91r, 94r, 95l, 95r, 97, 100, 104t, 109t, 110t, 110b, 111, 120tr, 121r, 125bc, 130t, 130b, 131t, 136tl, 136bl, 137b, 144, 148r, 154b, 156t, 156b, 157, 166c, 166b, 169tl, 169tc, 169tr, 169b, 170, 176, 180l, 180r, 181l, 181r, 184b, 186bl, 187tl, 196bl, 197, 201, 219b, 221t, 225, 227tl, 227bl, 229t, 235, 242tr, 244b, 247tl, 247tr, 247b, 254l, 254tr, 255, 256, 257b, 258, 271cl, 282, 283t, 285, 294b, 295tr, 296–297

Jeroen Balemans, permission of Precita Eyes Muralists Archive: 16l, 20, 51br

Courtesy of Joel Bergner: 172, 173t, 173b

Courtesy of the Billboard Liberation Front: 230t, 230b, 233 (1st, 2nd, and 5th)

Courtest of Break the Silence Collective: 175

Courtesy of Francisco X. Camplis: 77b

Susan Kelk Cervantes: 17r, 21br, 26, 67b, 69t, 88, 93b, 98r, 101b, 105, 107t, 107b, 117, 148t, 150l, 153, 154t, 160, 184t, 200tl, 264, 276l, 276r, 278t, 278b, 279t, 280, 286l

©City College of San Francisco. All rights reserved. Unauthorized public performance, broadcasting, transmission, or copying, mechanical or electronic, is a violation of applicable laws. www.riveramural.com: 33

Clarion Alley Mural Project (CAMP) Archive: 32, 48–49c, 52t, 80, 81, 83, 84l, 84r, 112, 114b (Elektra™ and ©2009 Marvel Characters, Inc.), 121l, 126r, 126–127, 128t, 196tr, 250

Marvin Collins: 27t, 37tl, 37tr, 158–159, 161 (all), 231, 233 (4th), 277r

Ruben C. Cordova: 90l, 244t, 286r (3)

Courtesy of Colette Crutcher: 272

Tony Deifell: 38–39

Lou Dematteis: 2, 55t, 72, 73, 287

Francisco J. Dominguez: 189

Timothy W. Drescher: 24–25, 82b

Myra Fourwinds: 109b

Katia Fuentes: 126l

Courtesy of Galería de la Raza Archive: 3, 24l, 54b, 64l, 79cr, 202t, 202c, 248tl

David Goodyear, permission of René Yañez: 46–47

Elizabeth Gorelik, permission of FlyAway Productions: 190tl, 190tr

Katherine Gressel: 51bl, 133b, 196tl, 212tl

Rubén Guzmán: 48l, 57b, 70b

Brock Foxworthy Hanson: 131b, 168t, 221b, 223tl, 292tl, 293b

Patrick "Pato" Hebert: 164t, 164b

Talia Herman, courtesy of El Tecolote Photographic Archive: 54tl

Courtesy of Ester Hernandez: 64br, 261

Russell Howze, Stencil Archive: 40cr, 180tr, 199cr, 220tl, 223br, 263r

Bob Hsiang: 273b

Annice Jacoby: 31tl, 31bl, 41 (inset), 120tl, 174tr, 186br, 188b, 206b, 271bl

Larry Jones: 6, 177

Rik Klingerman: 151, 279b

Steve Lambert: 222tl, 223tr

John Jota Leaños: 18b, 202b, 204b

Adal Maldonado, permission of René Yañez: 60l

Ralph Maradiaga, courtesy of Galería de la Raza Archive: 54tr, 63t

Eric Melder: 162–163

Emmanuel Montoya: 13t, 288tl

Courtesy of Emmanuel Montoya: 178–179

Frank Müllerauh: 180tl, 227br, 229br

Lisa Müllerauh: 15, 16–17c, 18tl, 21bl, 40t, 40cl, 40b, 49r, 53, 56, 64t, 92, 94l, 96, 108–109, 114tl, 119tl, 119b, 120b, 124l, 125tl, 125tr, 125bl, 125br, 129l, 133t, 134t, 134b, 135t, 135b, 136r, 137t, 140–141, 142r, 166t, 174b, 182tl, 182tr, 182bl, 182bc, 185bl, 185br, 187r, 188tl, 188tc, 207b, 209, 217t, 217b, 218, 220tr, 220b, 224r, 228, 229bl, 238t, 238bl, 240 (all), 242tl, 242cl, 242b, 243t, 243b, 246, 249, 251, 252t, 252b, 253, 254br, 263l, 268r, 270, 274, 275, 290, 295tl 295b

Randolph @ MissionArt415: 132, 182br

Rebecca Najdowski: 87, 93t, 114tr, 119tr, 124r, 129r, 138–139, 188tr

©Lee W. Nelson, www.inetours.com 2000: 42t

Courtesy of New Mission News: 58–59

Aaron Noble: 122

Courtesy of Aaron Noble: 82t, 234l

Eric Norberg: 70t, 236t, 236bl, 236br, 239t, 245t, 245b

Courtesy of Josef Norris: 143

Billy O'Callaghan: 43tl, 227bl, 257tl, 257tr

Fiona O'Connor: 31tr, 118, 122 (inset), 123 (Wolverine™ and ©2009 Marvel Characters, Inc.), 239b, 293t, 294t

Courtesy of Txutxo Perez: 225tr, 283b

Courtesy of Precita Eyes Muralists Archive: 31br, 37b, 69b, 106b, 145l, 145r, 146t, 146b, 147t, 147b, 149, 150r, 152, 168b, 200tr, 219t, 242cr, 266, 281l

Jim Prigoff: 41t, 52br, 60r, 62t, 63b, 66, 74t, 98l, 99, 101t, 102–103, 104l, 116, 128b, 185t, 199t, 199bl, 260t, 268l, 269, 271r, 284–285, 288–289

Courtesy of Public Art Review: 34

Michael Rauner: 192, 194–195

Nicole Repack: 85, 222b, 248tr (3)

Courtesy of Rigo: 42b

Courtesy of Faviana Rodriguez: 213br

Courtesy of San Francisco Print Collective: 186t, 190, 196br, 206t, 248b

Courtesy of Segura Publishing Company: 234r

Will Shank: 174tl, 199br, 200b, 288bl, 292b

Courtesy of SPIE: 224l

Courtesy of El Tecolote Photographic Archive: 55br, 142l, 155, 215, 262

Bruce Tomb: 21t, 210t, 210b, 212 (all but tl), 213b

Kenny Trice, by permission of Rigo: 8, 208

Weiferd Watts, permission of FlyAway Productions: 191b

Linda G. Wilson: 5, 62b, 78, 79tl, 171t, 171b, 183, 214, 216, 233 (3rd), 238br, 260b, 265, 271t, 281r, 291, 292tr

Courtesy of Megan Wilson: 207t

Collection of René Yañez: 12t

Courtesy of Rio Yañez: 51tr

Index of Artists

At the **Bank of the Third Chakra** first right, second left, third on the right past the shoe shop, close to the corner of *17th & Poverty Sucks,* I discovered I was overdrawn on my Karmic debt. Maybe it was time to follow up on the flyer I'd seen on the notice board at **Real Expensive Foods.** //
The **Totally Radical Women's Socialist Take Back the Shoes, the Dress, the Handbag, the Jewelry, the Scarf, the Guy You Met at Burning Man and the Horse You Rode in on Club** was offering a weekend workshop entitled "Money is the root of all chakras." //
"In this workshop," the flyer read, "we will learn how to visualize money in large denominations moving up the spine and out the top of the head." Apparently the secret is in coordinating the breathing with the shopping & learning how to relax afterwards with an expensive sidewalk meal within sight of a beggar passed out in a doorway and two drunks pissing in the bus shelter. /////////////////////////////
In the alleyway behind **Pets Not Bombs** the **Che Guevara/Frida Kahlo Art, Revolution, Sex, two beers, a double cappuccino, a California roll, two deluxe falafels, one without hot sauce, a piece of baklava, and three chicken tacos Mural Project** was organizing a group of neighborhood teenagers to paint out graffiti that had recently appeared. ///////
Overnight someone had spray-painted in red "Hang Mumia Now" across Nelson Mandela's face, and elsewhere, across Carlos Santana's guitar, "Mumia Is Guilty as Hell." //
//